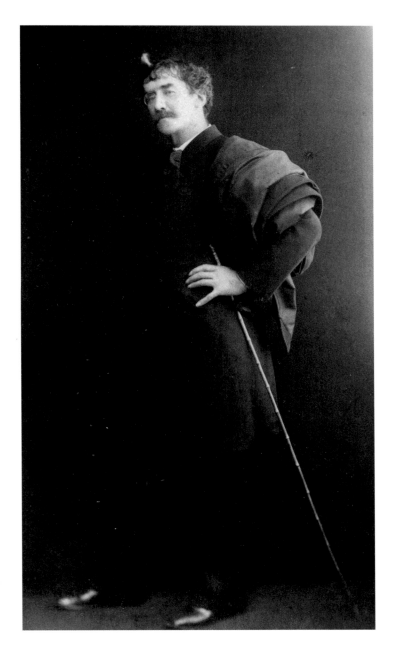

To Whistler, American

On the loan exhibit of his paintings at the Tate Gallery

You also, our first great,
 Had tried all ways;
Tested and pried and worked in many fashions,
And this much gives me heart to play the game.

Here is a part that's slight, and part gone wrong,
 And much of little moment, and some few
Perfect as Dürer!
"In the Studio" and these two portraits, if I had my choice!
And then these sketches in the mood of Greece?

You had your searches, your uncertainties,
And this is good to know—for us, I mean,
Who bear the brunt of our America
And try to wrench her impulse into art.

You were not always sure, not always set
To hiding night or tuning "symphonies";
Had not one style from birth, but tried and pried
And stretched and tampered with the media.

You and Abe Lincoln from that mass of dolts
Show us there's chance at least of winning through.

—*Ezra Pound*

After Whistler: The Artist and His Influence on American Painting was organized by the High Museum of Art, Atlanta.

Generous support was provided by The Rich Foundation, Henry Luce Foundation, the National Endowment for the Arts, the Jim Cox Jr. Foundation, John and Mary Franklin Foundation, The Philip and Irene Toll Foundation, and a friend of the Museum.

After Whistler: The Artist and His Influence on American Painting was on view at the High Museum of Art, Atlanta, from November 22, 2003, through February 8, 2004, and at The Detroit Institute of Arts from March 13 through June 6, 2004.

"To Whistler, American," by Ezra Pound, from *Personae* © 1926 by Ezra Pound. Reprinted by permission of New Directions Publishing Corp.

Library of Congress Cataloging-in-Publication Data
 After Whistler : the artist and his influence on American painting / Linda Merrill . . . [et al.].
 p. cm.
 Catalog of an exhibition held at the High Museum of Art, Atlanta, Nov. 22, 2003–Feb. 8, 2004 and the Detroit Institute of Arts, Mar. 13–June 6, 2004.
 Includes bibliographical references and index.
 ISBN 0-300-10125-2 (hardcover : alk. paper)—
ISBN 0-939802-99-6 (softcover : alk. paper)
 1. Whistler, James McNeill, 1834–1903—Influence—Exhibitions.
2. Painting, American—19th century—Exhibitions. I. Merrill, Linda, 1959– . II. Whistler, James McNeill, 1834–1903. III. High Museum of Art. IV. Detroit Institute of Arts.
ND237.W6A4 2003
759.13'09'034—dc21 2003008668

FOR THE HIGH MUSEUM OF ART
Nora Poling Bergman, Chief Project Editor
Kelly Morris, Manager of Publications
Janet S. Rauscher, Associate Editor
Christin Gray, Publications Coordinator

Cover and page 97: Albert Herter, *Portrait of Bessie* (detail, cat. 46)
Back cover: James McNeill Whistler, *Symphony in White, No. 1: The White Girl* (detail, cat. 1)
Frontispiece: James McNeill Whistler, 1886, photograph by H. S. Mendelssohn, The Baltimore Museum of Art, The George A. Lucas Collection, purchased with funds from the State of Maryland, the Bequest of Laurence Bendann, and contributions from individuals, foundations, and corporations through the Baltimore community, BMA1996.48.9092
Page 3: James McNeill Whistler, *Arrangement in Grey: Portrait of the Painter* (detail, cat. 8)

Designed by Susan E. Kelly
Proofread by Laura Iwasaki
Indexed by Valerie Sensabaugh
Color separations by iocolor, Seattle
Produced by Marquand Books, Inc., Seattle
 www.marquand.com

Printed and bound by SDZ, Ghent, Belgium

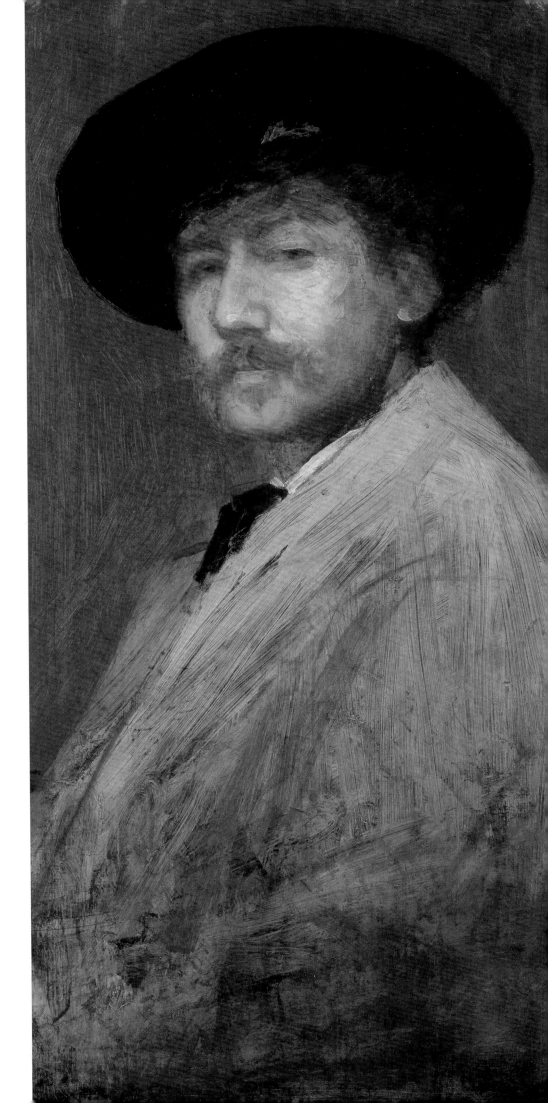

Linda Merrill

Robyn Asleson

Lee Glazer

Lacey Taylor Jordan

John Siewert

Marc Simpson

Sylvia Yount

After Whistler

The Artist and His Influence on American Painting

High Museum of Art

Note to the Reader

Figure illustrations are numbered consecutively throughout the book. Endnotes to each essay appear immediately after the essay. Endnotes to the entries begin on page 246 at the end of the catalogue section.

Shortened references have been used in the endnotes. For full citations, please refer to the Bibliography. The following abbreviations have been used to refer to manuscript collections:

AAA Archives of American Art

FGAA Freer Gallery of Art Archives,
 Charles Lang Freer Papers

GUL Glasgow University Library, Special Collections

PWC Pennell Whistler Collection, Library of Congress

Contents

Director's Foreword

Arrangement in Grey and Black, No. 1: Portrait of the Painter's Mother, otherwise known as "Whistler's Mother," may be the single most famous painting by an American artist, yet James McNeill Whistler has always occupied an uncertain status in the annals of American art. He was himself ambivalent about his nationality, once testifying under oath of law that he had been born in St. Petersburg, Russia, when his birthplace was actually Lowell, Massachusetts. And because, in 1855, he left the United States for Europe at the age of twenty-one, never to return, his style developed independently of contemporary American art currents. *After Whistler: The Artist and His Influence on American Painting,* organized in observance of the centenary of Whistler's death, reveals that the artist's significance as an American derives less from his parentage or his birthplace than from the impact he exercised on the art of his own country. Whistler was one of the most celebrated and controversial artists of his time, and his distinctive artistic manner and modernist aesthetic informed the work of a generation of American painters.

After Whistler is the first major exhibition to detail Whistler's importance to American art and artists around the close of the nineteenth century. Some Americans studied his works in major exhibitions held in the United States and abroad; some sought out the artist himself in his London or Paris studios. Others were affected at one remove, through such influential intermediaries as William Merritt Chase on the East Coast and Arthur Mathews on the West, or through the unparalleled profusion of illustrated publications about Whistler's life and art. By juxtaposing a dozen or so of Whistler's most important oil paintings with works by other artists, the exhibition demonstrates how Whistler's American contemporaries were variously affected by his aesthetic principles, painting techniques, color schemes, compositional strategies, subject matter, and abstract titles. And by placing analogous paintings side by side, we hope that this illuminating exhibition will suggest new ways of looking at works of art.

The exhibition was conceived and organized by Linda Merrill, formerly the curator of American art at the High Museum and an authority on Whistler's art. Lacey Taylor Jordan, as interim curator, kept the project moving along efficiently, and Sylvia Yount, Margaret and Terry Stent Curator of American Art, ushered the exhibition through completion. Graham Beal, Director, and James W. Tottis, Curator of American Art, at The Detroit Institute of Arts have been valuable partners in this enterprise. We are also grateful to the forty-five public and private lenders who agreed to part with their Whistlerian treasures for the duration of the exhibition. Generous grants from The Henry Luce Foundation and the National Endowment for the Arts supported both the publication and exhibition.

MICHAEL E. SHAPIRO
Nancy and Holcombe T. Green, Jr. Director
High Museum of Art

HAVING SPENT MY ENTIRE PROFESSIONAL LIFE at the Freer Gallery of Art in Washington, as curator of the most comprehensive collection of Whistler's works in the world, I moved to Atlanta in 1998 to take charge of the broader range of American art at the High Museum. For a while, I worried that the intensity of my former experience might have permanently distorted my vision, for I seemed to see Whistlers everywhere I looked. Dusky nocturnes glowed from gilded frames in the upper reaches of Museum storage racks; tiny, tonal landscapes turned up on little easels in the homes of local collectors; understated portraits of eloquently posed figures in low-toned color schemes appeared on the walls of art galleries nearby; and catalogues reproducing paintings of women in stark white dresses or elegant kimonos, or seated in profile and facing left in the manner of Whistler's Mother, or some combination of those familiar themes, crossed my desk with surprising regularity. It never took more than an instant to determine that the works were not, in fact, by Whistler, but as time went on and I continued to discern elements of that artist's distinctive style embedded in an array of paintings by a variety of artists, I came to realize that American art from around the turn of the century was permeated with Whistler's influence. This art, redolent of emulation, appeared to bear out the prophecy that Whistler had voiced in his "Ten O'Clock" lecture—that after his death, "the ephemeral influence of the Master's memory" would linger in the works of his disciples. He knew it would happen because his style and aesthetic philosophy had already begun informing works by his younger contemporaries during his lifetime, when Whistler had the good fortune to meet and even to instruct a host of ardent admirers, most of them American.

My "discovery," of course, only confirmed a well-established truth. That Whistler's radically original style and eccentric persona exercised a decisive influence on American art has never really been in doubt. Nearly every study of late nineteenth-century art in the United States makes reference to the impact of Whistlerian aesthetics. His immediate and profound effect on American print-making has been explored in a number of exhibitions, notably Robert H. Getscher's *The Stamp of Whistler* (1977), and his influence on American photography and the media of watercolor and pastel has also been the subject of several studies, though on a smaller scale. *From Realism to Symbolism: Whistler and His World*, organized by Allen Staley and others at Columbia University in 1971, examined Whistler's place among his contemporaries but was decidedly international in approach. And the Grand Central Art Galleries in New York, in 1973, staged *La Femme: The Influence of Whistler and Japanese Prints on American Art, 1880–1917*, an exhibition that considered Whistler's use of Japanese style and its dissemination among American artists—a highly important aspect of his influence, but certainly not the only one. More recently, the catalogue accompanying the Whistler retrospective organized by the Tate Gallery in 1994 (and presented at the Musée d'Orsay and the National Gallery of Art in 1995) featured an essay by Nicolai Cikovsky and Charles Brock that related an intriguing tale of Whistler's relations with Americans, artists and otherwise, although the topic was not a theme of the exhibition itself.

The particular purpose of this catalogue and the exhibition it accompanies is to demonstrate the importance of Whistler's oil paintings—his most abstract and misunderstood works—to artists in the United States during the forty years or so surrounding his death in 1903, a critical moment in the history of American art. *After Whistler* aims to present a visual narrative, to tell the story of Whistler's impact on American art by outlining his contacts with

artists and demonstrating the effects of those encounters on their art. It reveals which painters actually knew Whistler, which of his works were known in America, and how a decade's delay in the recognition of his talents on this side of the Atlantic affected his American reputation and helped to shape Impressionism and modernism in the United States.

The exhibition itself is organized around works by Whistler that held special significance for Americans (particularly *The White Girl,* the inestimably famous portrait of Whistler's mother, and the notorious *Falling Rocket*) and around works exemplifying themes that became prevalent in contemporary American painting, such as images of women in rarefied interiors and low-toned, atmospheric landscapes. It is by no means comprehensive: countless artists who are known to have emulated Whistler's example and many others who are suspected to have had ties with the artist have necessarily been left out of the exhibition in the interest of keeping it focused and coherent. Its object is simply to provide a variety of examples of Whistler's influence illustrating the range of the phenomenon. Once the distinctive characteristics of his style have become familiar, I suspect that I will not be alone in seeing "Whistler" everywhere I look.

WHISTLER SCHOLARSHIP HAS TRADITIONALLY BEEN concentrated in Britain, where as a graduate student I studied the artist in the context of Victorian painting. Despite his American birth and citizenship (which Whistler never surrendered), his papers and a great number of his works are preserved in Scotland, at the University of Glasgow, which also houses the enormously productive Centre for Whistler Studies. Partly as a result, Whistler's impact on American art has been given less attention than his divergence from traditional Victorian art or his influence on developments in France, an imbalance this exhibition aims to correct. Most of the contributors to this catalogue are historians of American art (though some have also worked in the field of British art), allowing them to take a fresh perspective on Whistler's work. Robyn Asleson, Lee Glazer, John Siewert, Marc Simpson, and Sylvia Yount have not only made valuable contributions with their essays, but have added to the integrity of this project with thoughtful suggestions and excellent advice. Lacey Taylor Jordan, who prepared most of the catalogue entries relating the American works to Whistler's art, employed her broad understanding of American painting in this period to keep the exhibition balanced between works that declare their Whistlerian origins rather too emphatically and those that offer more subtle and ambiguous evidence of influence.

I would also like to acknowledge the many staff members at the High Museum and The Detroit Institute of Arts who have given indispensable assistance. Michael E. Shapiro, Director of the High Museum, perceived the possibilities of this project when it was in its roughest conceptual stage and has continued to support it with extraordinary understanding; Ned Rifkin, the former director, provided the initial encouragement required to launch the exhibition planning. Philip Verre, Deputy Director, handled a welter of administrative details, and Jody Cohen, Manager of Exhibitions, coordinated the exhibition with competence and grace. Linnea Harwell and Saskia Benjamin, as Exhibition Coordinators, expedited our work in countless ways, and Laurie Carter, Curatorial Assistant in American Art, has been a willing and able colleague from the very beginning. Maureen Morrisette, Associate Registrar, managed the countless logistic details attending a large loan show. Sylvia Yount, Margaret and Terry Stent Curator of American Art, was extraordinarily generous with her own research while still curator at the Pennsylvania Academy of the Fine Arts, and, upon arriving at the High Museum in 2001, took up this project with keen understanding and enthusiasm. Kelly Morris and Nora Poling Bergman have been patient and perfect editors. In Detroit, Graham Beal, Director; James W. Tottis, Curator of Paintings, and Justin Clark, Administrative Assistant, Department of American Art; and Tara Robinson, Curator of Exhibitions, stood behind us and lent support on numerous occasions, for which we are sincerely grateful.

Only the generosity of many public and private lenders has made this assembly of Whistlerian works possible. We extend special thanks to the following, who facilitated our loan requests and provided information on works in their collections: Warren Adelson, Adelson Galleries; Laura Fleischmann and Janice Lurie, Albright-Knox Art Gallery; Judith Barter, Field-McCormick Curator of American Arts, and Andrew Walker, Assistant Curator, The Art Institute of Chicago; Barbara Dayer Gallati, Curator of American Painting and Sculpture, Brooklyn Museum of Art; Louise Lippincott, Curator of Fine Art, Carnegie Museum of Art; Henry Adams, Curator of American Art, The Cleveland Museum of Art; Myron Kunin, President, Curtis Galleries; Jeff Fleming, Senior Curator, Des Moines Art Center; Timothy Anglin Burgard, Curator of American Art, and Steven A. Nash, Associate Director and Chief Curator, Fine Arts Museums of San Francisco; Mary Anne Goley, Fine Arts Program Director, Federal Reserve Board; Jeffrey W. Andersen, Director, and Jack Becker, Curator, Florence Griswold Museum; Laura A. Foster, Curator, Frederic Remington Art Museum; William U. Eiland, Director, Georgia Museum of Art; Anne Morand, Curator, Gilcrease

Museum; Nigel Thorp, Director, Centre for Whistler Studies at the University of Glasgow, and David Weston, Keeper of Special Collections and Head of Preservation, Glasgow University Library; Marie and Hugh Halff; Judith K. Zilczer, Curator of Paintings, and Anne-Louis Marquis, Museum Specialist, Curatorial Division, Hirshhorn Museum and Sculpture Garden; Marcus B. Burke, Curator of Paintings, Hispanic Society of America; Michael Botwinick, Director, The Hudson River Museum; Ellen Simak, Curator, Hunter Museum of American Art; Alan Chong, Norma Jean Calderwood Curator of the Collection, Isabella Stewart Gardner Museum; Sue Rice, The Louise and Alan Sellars Collection of Art by American Women; Sally and Allen P. McDaniel; Kip Peterson, Registrar, Memphis Brooks Museum of Art; H. Barbara Weinberg, Alice Pratt Brown Curator of American Paintings and Sculpture, The Metropolitan Museum of Art; Russell Bowman, Director, and Jane E. O'Meara, Registrar's Assistant, Milwaukee Art Museum; Henri Loyrette, former director, and Serge Lemoine, Director, Musée d'Orsay; Jorge Santis, Curator, Museum of Art, Fort Lauderdale; Maureen O'Brien, Curator of Painting and Sculpture, Museum of Art, Rhode Island School of Design; Erica E. Hirshler, John Moors Cabot Curator of Paintings, and Courtney Rae Peterson, Department Assistant, Art of the Americas, Museum of Fine Arts, Boston; Andrea Henderson Fahnestock, Curator of Paintings and Sculpture, and Eileen K. Morales, Manager of Collections Access, The Museum of the City of New York; David B. Dearinger, Chief Curator, National Academy of Design; Franklin Kelly, Curator of American and British Paintings, National Gallery of Art; Mel Ellis, Director of Administration, New Britain Museum of American Art; Harvey Jones, Senior Curator, and Lori Lindberg, Archivist/Librarian, Art Department, the Oakland Museum of California;

Trudy Kramer, Director, The Parrish Art Museum; Kim Sajet, Deputy Director, and Cheryl Leibold, Archivist, Pennsylvania Academy of the Fine Arts; Joseph J. Rishel, The Gisela and Dennis Alter Curator of European Painting and Sculpture before 1900, Darrel Sewell, Curator of American Art, Jennifer Vanim, European Painting Department, and Mike Hammer, American Art Department, Philadelphia Museum of Art; Jay Gates, Director, The Phillips Collection; Sandy Nairne, Director of National Programmes, Tate Britain; Cathy Ricciardelli, Director, Exhibitions and Collections Services, Terra Museum of American Art (Daniel J. Terra Collection); Tom Vieulleux, Tom Vieulleux Gallery; Jean and Glenn Verrill; Michael H. Lally, Executive Director, Whistler House Museum of Art; Maxwell L. Anderson, Director, and Darlene Oden, Registration Department Assistant, Whitney Museum of American Art; David R. Brigham, Director of Collections and Exhibitions, Worcester Art Museum; Malcolm Warner, Curator, and Julia Marciari Alexander, Acting Curator, Yale Center for British Art; and those private collectors who have chosen to remain anonymous.

In addition, many good friends and model colleagues have generously lent information, suggested pictures, offered encouragement, and offered help in various ways—particularly Nancy Anderson, Eric Baumgartner, Faith Andrews Bedford, Richard Boyle, Betsy Broun, Sarah Cash, Nick Clark, David Cleveland, Jeff Cooley, David Curry, Susan Galassi, William Gerdts, Colleen Hennessey, Susan Hobbs, Patti Junker, Tim Keny, Betty Krulik, Susan Larkin, Susan Macallan, Margaret MacDonald, Emily Neff, the late Ronald Pisano, Helen Sloan, Martha Smith, Anita Vogel, Bruce Weber, and Melissa Williams.

LINDA MERRILL

Linda Merrill

Whistler in America

AT THE HEIGHT OF HIS FAME IN 1885, WHISTLER nurtured the dream of a triumphant return to America. "Of course, everybody will receive me," he imagined of his homecoming—"tug-boats will come down the Bay; it will all be perfect!"[1] He had conceived the notion in the company of William Merritt Chase (see cats. 22–28), the American artist who would do more than any other to foster Whistler's reputation in the United States and who undoubtedly assured Whistler that his compatriots would shower his art with the attention and respect it often failed to attract abroad. An exhibition of what Whistler described as "works which have won for me the execration of Europe" was to take place in New York and Boston,[2] while Whistler himself delivered his idiosyncratic manifesto of aestheticist belief, the "Ten O'Clock" lecture, in several American cities. Disdaining the nuisance of business, Whistler asked John White Alexander (see cats. 15–16), an American admirer who was in London to produce his portrait (fig. 1), to select paintings for the exhibition.[3] Throughout 1886, the American press published announcements of Whistler's imminent arrival, and eventually Whistler conceded that the venture was set for the end of the year. "This is no time for hesitation," he declared. "One cannot continually disappoint a continent."[4]

Yet he did not come. The many details attending the organization of an ambitious overseas exhibition may finally have overwhelmed him, for Alexander was called away from London before he could complete his commission and several owners of Whistler's works proved unwilling to "subject them to the manifold & considerable risks of transit by sea & land."[5] Whistler also began to fear he might be "wrecked by the reporter on the pier," as he put it, or "met with suspicion by my compatriots and resented as the invading instructor."[6] The risk of falling short in the country he considered his last resource "threw

James McNeill Whistler, *Nocturne in Black and Gold: The Falling Rocket* (detail, cat. 7)

him into a mild panic," Rollo Walter Brown observed, "from which he demanded the one sure escape—remaining where he was."[7]

Whistler had been only twenty-one when, thirty years earlier, he left the United States with the intention of living a bohemian life in Paris. He had announced his determination to become an artist as a child, when living with his family in the cosmopolitan city of St. Petersburg (his "Russian cradle," as he called it),[8] and had longed for European culture ever since. His sojourn back in the United States was not happy or productive: he disliked the two years spent in school at Christ Church Hall in Pomfret, Connecticut; he never fit into the Military Academy at West Point; and he could not sustain employment at the U.S. Coast and Geodetic Survey in Washington, D.C. To an aspiring artist who had spent his formative years abroad and failed to find a niche for himself at home, Paris must have seemed the perfect place to launch a career.

Within a few years of settling there, however, Whistler decided that London was the more promising environment, and it was in that city that he worked to establish himself professionally. His first major work, a dignified portrait of his sister and niece called *At the Piano* (fig. 2), was accepted for exhibition at the Royal Academy in 1860, received with critical acclaim, and purchased by a prominent Academician, promising future success in England. For the next

FIG 1 John White Alexander (1856–1915), *Portrait of Whistler*, 1886, charcoal on paper, 32½ × 17 inches, The Metropolitan Museum of Art, New York, gift of A. E. Gallatin, 1923, 23.230.2.

FIG 2 James McNeill Whistler (1834–1903), *At the Piano*, 1858–1859, oil on canvas, 26⅜ × 36⅛ inches, Taft Museum of Art, Cincinnati, Ohio, bequest of Louise Taft Semple, 1962.7.

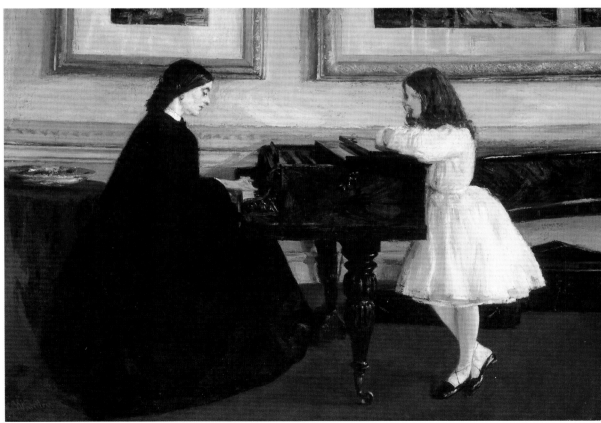

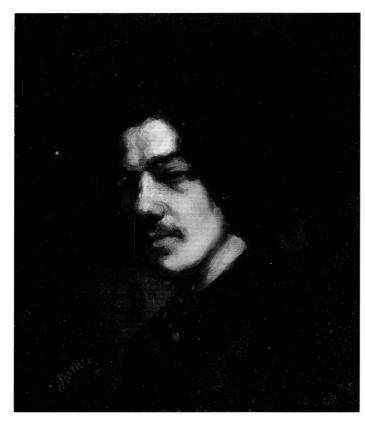

FIG 3 James McNeill Whistler (1834–1903), *Portrait of Whistler with a Hat*, 1857–1858, oil on canvas, 18¼ × 15 inches, Freer Gallery of Art, Smithsonian Institution, Washington, D.C., gift of Charles Lang Freer, F1906.57.

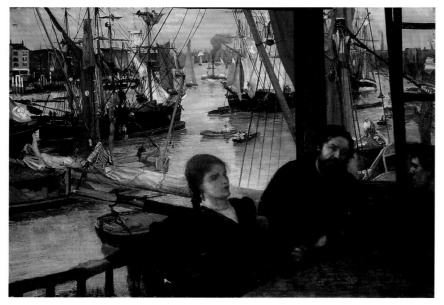

FIG 4 James McNeill Whistler (1834–1903), *Wapping*, 1860–1864, oil on canvas, 28⅜ × 40¹⁄₁₆ inches, National Gallery of Art, Washington, D.C., John Hay Whitney Collection.

twenty-five years, Whistler rarely looked back across the Atlantic. He did take a trip to Chile in 1866, ostensibly for his health but actually to deliver arms to the South Americans to use against the Spanish (see cat. 3), but that was as close as he ever came to returning to his native land.

Nevertheless, a number of Whistler's works represented him in the United States, beginning in the year of his South American escapade. Two paintings were shown at the Artists' Fund Exhibition in 1866, held at the National Academy of Design in New York City: an early self-portrait painted in Paris (fig. 3) that combined something of the style of Rembrandt (1606–1669) with the uncompromising Realism of Gustave Courbet (1818–1877); and *Wapping* (fig. 4), a puzzling scene of three dubious characters seated on a balcony overlooking the wharves and warehouses of the river Thames.[9] The latter painting gave at least one New York critic hope that "the masters are not dead." Especially in comparison with other contemporary works, "Whistler's picture is capable of giving you an original sensation; it surprises you; at first you do not know what to say; you simply recognise its power, its reality, and you admit the presence of a rapid and daring painter."[10]

That first American review of Whistler's works is remarkably positive, considering the artist's virtual anonymity in this country at the time. It is revealing, then, that the single phrase the artist selected to abstract and reprint in an 1883 catalogue was: "Whistler does not take much pains with his work." This apparently damning statement was, in fact, part of a positive point, for the critic went on to say, "how refreshing is Whistler's work, which shows that he can express so much and take such little trouble about it!"—but Whistler characteristically focused on the minor undercurrent of negativity.[11] The tendency to overreact to American criticism would persist throughout his career, giving Whistler an enduring "impression of offensive aggressiveness" in the press,[12] which suggests an acute sensitivity to American opinion. The next year, for example, when *Symphony in White, No. 1: The White Girl* (cat. 1) was poorly placed in the American section of the Exposition Universelle in Paris, Whistler cursed the "Yankees" for their inconsideration, even though the Americans had exhibited a painting that both the English and the French had summarily rejected a few years earlier.[13]

Whistler's mother, on the other hand, never wavered in her conviction that her eldest son's works were destined to be appreciated in America. A Southern sympathizer, Anna Matilda McNeill Whistler had left war-torn North Carolina in December 1863 to settle in London with her son; but unlike him, she never quite adjusted to life abroad

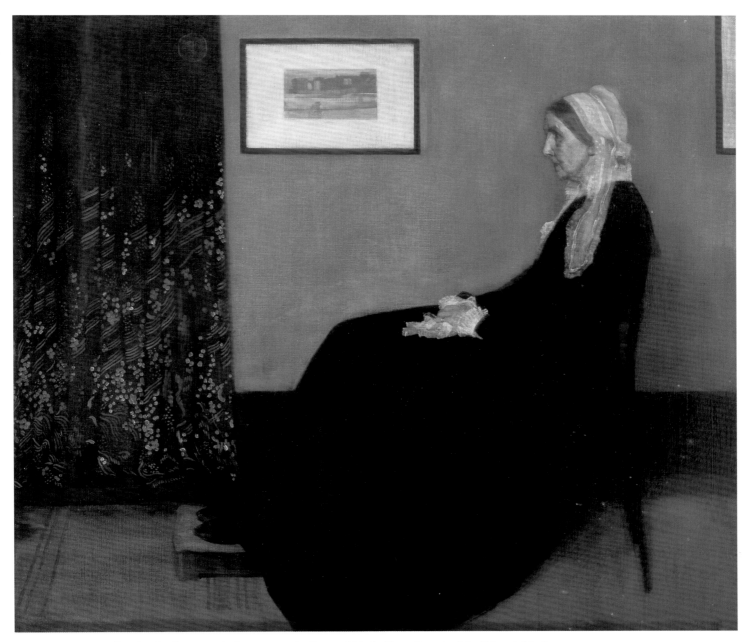

FIG 5 James McNeill Whistler (1834–1903), *Arrangement in Grey and Black, No. 1: Portrait of the Painter's Mother,* 1871, oil on canvas, 56¾ × 64 inches, Musée d'Orsay, Paris.

or relinquished the hope of going home again. She became a sort of American agent and propagandist for Whistler, forwarding favorable criticism to relatives in hopes that it might be published by New York newspapers—"for we see that Whistler's works as an American Artist are claimed," she wrote, with little evidence to support the assertion, "and they seem proud to publish notices of them."[14] Anna Whistler's heartfelt wish was that her son would demonstrate his own patriotism by sending works to the first American world's fair in Philadelphia.[15]

In early March 1876, when the American journalist E. D. Wallace interviewed Whistler for a series of articles on "our American geniuses in London," Whistler was planning to send four or five paintings to the Centennial Exposition in Philadelphia, including *The White Girl* and, significantly, *Arrangement in Grey and Black, No. 1: Portrait of the Painter's Mother* (fig. 5).[16] The plan was reportedly contingent on the cooperation of the pictures' owners, who were said to be "reluctant to commit them to the dangers of the sea," even though several of the works Whistler mentioned to Wallace remained in his possession at the time. There must have been some other reason for his failure to send anything to Philadelphia. Anna Whistler regretted that neither her son nor his works would appear that year in their "native land." "It would have been so gratifying," she said, "if he could have attended our national exhibition

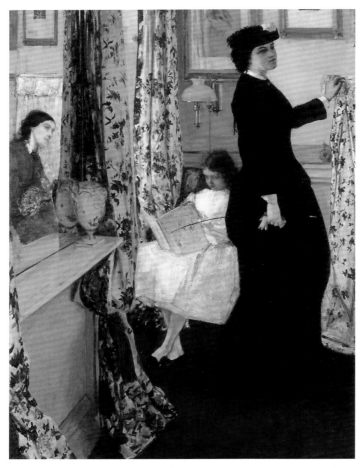

FIG 6 James McNeill Whistler (1834–1903), *Harmony in Green and Rose: The Music Room*, 1860–1861, oil on canvas, 37¹⁵⁄₁₆ × 28¼ inches, Freer Gallery of Art, Smithsonian Institution, Washington, D.C., gift of Charles Lang Freer, F1917.234.

in person, but you know he has never left England since he established himself among its competitors for distinction in art."[17]

As it happened, an impressive group of Whistler's paintings was in fact displayed in the United States in 1876—not in Philadelphia, but in Baltimore, the city that Whistler preferred to Lowell, Massachusetts, as his birthplace. Baltimore was happy, that year, to claim Whistler as one of its own. Although the impact of the Charity Art Exhibition was limited by its provincial location, it featured five major works by Whistler, making it "the most important exhibition of pictures ever held in this country, up to that date," according to Harper Pennington (1855–1920), a Baltimore native and one of Whistler's most devoted acolytes. He recalled that Whistler's pictures "simply swamped everything else, making strange, disquieting spots upon the walls among the 'pretty' pictures and the . . . ancestral portraits to which the Baltimoreans were quite accustomed."[18] One critic, acknowledging their startling originality, concluded that Whistler's works signaled a "new departure" in art.[19]

Two paintings, both belonging to the children of Whistler's late half-brother George, made their American debut in Baltimore: *The White Girl* and *Harmony in Green and Rose: The Music Room* (fig. 6). A third, *Coast of Brittany* (fig. 7), had been shown in New York City two years earlier, at the annual exhibition of the National Academy of Design,[20] but it had hung inconspicuously, and ignominiously, above a door. That placement infuriated at least two members of the selection committee, John La Farge (1835–1910) and Augustus Saint-Gaudens (1848–1907); in indignation, they resolved to secede from the National Academy, which led, indirectly, to the foundation of the Society of American Artists in 1877.[21] Many of its members were younger artists who had been trained abroad, and one measure of their modernity, as David Huntington has pointed out, "was the degree of their receptivity to the aestheticism of Whistler."[22] Indeed, Whistler and his aesthetic philosophy were to exercise an enormous influence on the Society (in 1879, Whistler was aptly described as its "demiurge," the deity who fashioned it),[23] even though at the time of its foundation he was, according to Will H. Low (1853–1932), "quite without honour in his own country." As if to demonstrate its revised allegiance, the Society spared no expense to obtain for its inaugural exhibition in 1878 the very work that had been skied at the Academy and hung it at last in an honorable position.[24]

Yet *Coast of Brittany,* an early and somewhat sentimental genre scene, was a curiously conservative choice for the Society of American Artists, which was meant to represent the avant-garde of American art; and *Wapping,* the other Whistler painting on view that year, was also out of date. Meanwhile, in London, Whistler's more recent and abstract works were generating enormous controversy upon their exhibition at the Grosvenor Gallery, an alternative to the Royal Academy, which had opened the same year that the American artists' society was founded. "I will not speak of Mr. Whistler's 'Nocturnes in Black and Gold' and in 'Blue and Silver,' of his 'Arrangements,' 'Harmonies,' and 'Impressions,' because I frankly confess they do not amuse me," wrote Henry James of those later works for an American journal: "The mildest judgement I have heard pronounced upon them is that they are like 'ghosts of Velasquezes'; with the harshest I will not darken my pages."[25] The Whistler whom James dismissed in 1877 was one unknown to most Americans who, on the basis of such paintings as *Coast of Brittany,* could not possibly have imagined *Nocturne in Black and Gold: The Falling Rocket* (cat. 7), the painting that was to become the most notorious of Whistler's works and the object of the eminent art critic John Ruskin's scorn.

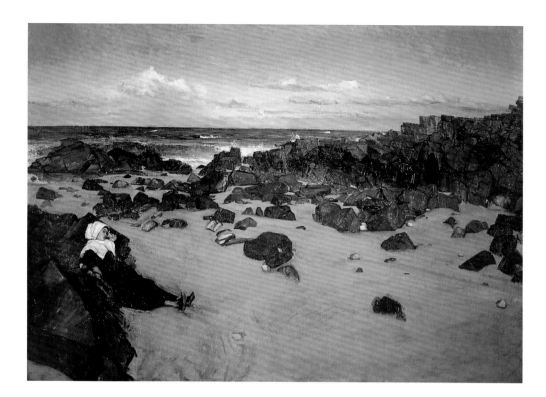

FIG 7 James McNeill Whistler (1834–1903), *Coast of Brittany (Alone with the Tide)*, 1861, oil on canvas, 34⅜ × 45½ inches, Wadsworth Atheneum, Hartford, Connecticut, in memory of William Arnold Healy, given by his daughter, Susie Healy Camp.

In his scathing critique of Whistler's Grosvenor Gallery exhibits, Ruskin characterized the American artist as a "Cockney coxcomb" and accused him of "flinging a pot of paint in the public's face." Whistler sued the critic for libel, claiming a thousand pounds in damages. That summer, soon after the lawsuit was announced, the artist J. Alden Weir (see cats. 65–67)—whose father, Robert W. Weir (1803–1889), had been Whistler's drawing master at West Point—paid a call on Whistler at his home in Chelsea and, contrary to expectation, found a man "thin, slick, frizzled haired and," he observed, "to all appearances a coxcomb."[26] Although impressed by his etchings, Weir was "agreeably disappointed" in Whistler's paintings: "They are fine as far as they go," he reported to his father, "but are not more than commencements."[27] Weir's initial reactions to Whistler and his work were remarkably similar to those voiced by the participants in *Whistler v. Ruskin,* which took place in November 1878. Whistler's dandified persona made it difficult for the court to take him seriously, and his incomprehensible Nocturnes (which Weir described as "hemi, demi, semi, quasis")[28] were widely considered admirable beginnings of works, but not finished pictures. The jury's ambivalence was reflected in the verdict, which went in Whistler's favor but granted only the contemptuous damages of one farthing.

Because so few of Whistler's works had been seen in the United States at that time, Americans reading excerpts from the trial would have been ill equipped to understand the testimony or evaluate the verdict.[29] A critic for the *New York Tribune,* who considered Ruskin's criticism as peevish as Whistler's action was unnecessary, confessed that he could only assess the case "from a distance, without the opportunity to inspect the nocturnes in blue and silver, amber and black, and for ought we know in kalsomine and plumbago, which . . . drew Mr. Ruskin's eye of wrath."[30] The revolutionary definition that Whistler offered of his paintings in court—artistic impressions rather than literal transcriptions of nature, closer in spirit to music than to literature—probably perplexed the American audience as much as Henry James supposed the works themselves had puzzled the British jury, which he thought hopelessly unprepared to sit in judgment of art. "If it had taken place in some Western American town," James wrote of the trial in a letter published in *The Nation,* "it would have been called provincial and barbarous; it would have been cited as an incident of a low civilization. Beneath the stately towers of Westminster it hardly wore a higher aspect."[31]

Nevertheless, the American cultural community took note of the controversy, which among other things drew attention to the tribulations of a renegade American artist trying to make a name for himself abroad. Despite his statement, under oath, that he had been born in St. Petersburg, Whistler was emphatically identified as an American in the wake of the Ruskin trial. An unsigned letter published in the *New York Semi-Weekly Tribune* in December 1878 provided a detailed account of his early life in the United States, one of the first biographical sketches of Whistler to appear in the American press.[32] He expected more from

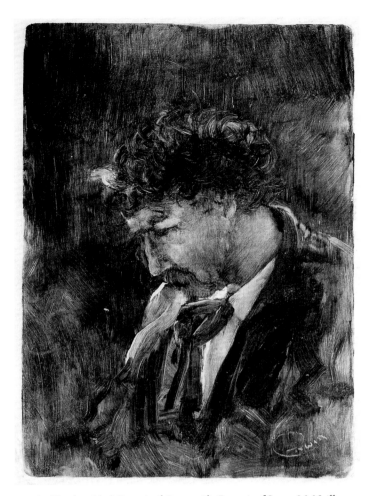

FIG 8 Charles Abel Corwin (1857–1938), *Portrait of James McNeill Whistler*, 1880, monotype in black ink, 8¹³/₁₆ × 6¹/₁₆ inches, The Metropolitan Museum of Art, New York, The Elisha Whittelsey Collection, The Elisha Whittelsey Fund, 1960, 60.611.134.

American critics than the mixed reaction he received, and he told one reporter, "half bitterly," that "they have not been quite fair to me in my own country; the journals and papers of the day have given me scant justice."[33] But it was Whistler's relationship with England that suffered most. He had initially assumed that his fellow artists would rally to his cause; in the event, he was abandoned by almost all of his colleagues and, as Harper Pennington remarked, became "thoroughly disgusted with the whole fraternity."[34] Afterward, Whistler came to believe that the artists of England had conspired to bring about his defeat. "They all hoped they could drive me out of the country, or kill me!" he told his biographers Elizabeth and Joseph Pennell. "And if I hadn't had the constitution of a Government mule, they would [have]."[35]

At least one of his acquaintances surmised that "Yankee-land" would soon get Whistler back for good,[36] yet he seems not to have considered returning to his native country in that disappointed period. Instead, he departed for Italy in the autumn of 1879, planning to produce etchings of Venice to repair his broken finances and reputation. For the first bitterly cold months away, he was inconsolably miserable. "I pine for Pall Mall and I long for a hansom!" he wrote to his sister-in-law soon after arriving in Venice;[37] but some weeks later, he assured his mother that he was not lonesome and, "notwithstanding the fearful climate, not absolutely forlorn and cheerless."[38] Indeed, he had found solace in the community of American expatriates resident in Venice, particularly Katharine de Kay Bronson, a distant relative of Whistler's whose palazzo on the Grand Canal was a gathering place for "the famous and the famished," as the artist Ralph Curtis (1844–1922) put it—and Whistler, that year, was both.[39] In exile from his adopted country, he reconnected with his native one, finding comfort in his American nationality.

It was also in Venice that Whistler enjoyed his first sustained interaction with American artists (fig. 8). Frank Duveneck (1848–1919), a gifted portraitist from Cincinnati who for many years had taught painting to American art students in Munich, providentially moved his class to Venice in the summer of 1880, when Whistler was hard at work producing etchings and pastels. The twenty or so young and high-spirited Americans who came to be called the Duveneck Boys were all in awe of Whistler's art and celebrity and basked in the glow "of Whistlerian sunbeams," as one later recalled, "emanating from one of the unique personalities of this age."[40] Whistler himself, undoubtedly rejuvenated by memories of his own comparatively carefree student days, settled with the Duveneck Boys in cheap rooms in the Casa Jankovitz and returned their adoration with fond attention, delighted with these artists who took his methods seriously. He could often be seen traipsing about the city with one or two pupils in tow, demonstrating how to set up a scene or memorize it for later drawing and painting.

In the light of his interest, many of the Duveneck Boys fell under Whistler's lasting influence. When they exhibited their own Venetian works the next year, both Frank Duveneck and Robert Blum (see cat. 19) were identified as his "followers," as though he had a "school."[41] The Boys also carried Whistler's gospel back to the United States, where they would be instrumental in converting others to his creed, and helped to keep his memory alive in Venice. Several years after Whistler's legendary visit, Elizabeth Pennell found that whenever two or three artists came together, stories about Whistler were inevitably recounted—never in jest but always with affection—convincing her of "the power of his personality and the force of his influence. He seemed to pervade the place, to colour the atmosphere."[42] The immediate effect of the Duveneck Boys' exuberant and

unqualified admiration was to restore Whistler's badly damaged ego, allowing him to return to London that November in a more optimistic frame of mind, ready to resume his professional life. Indeed, he seems to have undergone what Ralph Curtis described as a "renaissance in Italy."[43]

MEANWHILE, AMERICANS AT HOME WERE STILL waiting to see the controversial works that had established Whistler's reputation abroad. In the spring of 1879, a few months before Whistler left London for Venice, the American artist E. A. Abbey (1852–1911) met him at the home of a fellow expatriate, George Boughton (1833–1905). Abbey mentioned having seen and admired *Coast of Brittany* in New York, and even though Whistler's memory of the work was indistinct (he would have seen it last in 1863), he recollected that it "was a good picture" and took special pleasure, a few days later, in showing Abbey his more current paintings.[44] Recognizing that Americans "generally have a very vague idea of Whistler's work," and considering Whistler to be "a very tremendous artist," Abbey proposed to Charles Parsons of *Harper's New Monthly Magazine* that "a paper on Jimmy Whistler would be of interest, with reproductions of his etchings, and some of his pictures, which would engrave admirably."[45]

In August 1879, a richly illustrated article, "Whistler in Painting and Etching" by the critic W. C. Brownell, appeared in the rival publication *Scribner's Monthly*. This was not only the first substantive essay on Whistler to be published in the United States, but one of the earliest discriminating accounts of Whistler's art—taken separately from the peculiarities of his personality—to be published anywhere. It seems to have been written on commission, before Brownell had even seen Whistler's work in person,[46] and prompted by publicity attending the Ruskin trial, which had made Whistler's name "so familiar to persons who are usually unaccustomed to take much interest in the personality of painters, or the peculiarities of paintings."[47] It was Whistler's audacity in the courtroom, as much as his originality in the studio, that underlay his early reputation in America.

Although Brownell's article frequently wanders away from Whistler's works, it cogently sets forth the aestheticist principles necessary for understanding them. "It would be difficult to find a better example of a pure painter, a painter to whom art is so distinct a thing in itself, and so unrelated to anything else. . . . In other words his art is self-dependent, and is not to be referred to nature for its excuse or its justification."[48] Brownell hardly touched upon the Nocturnes, which would have been especially difficult to criticize without having seen them (and they do not reproduce well in black and white), but he prepared his readers to appreciate

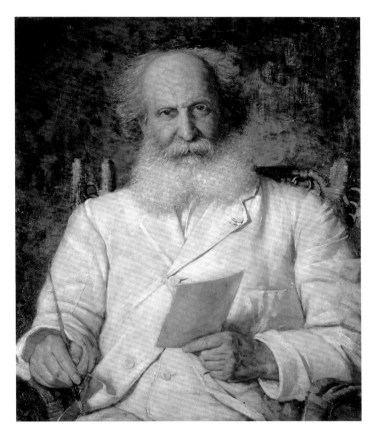

FIG 9 George Willoughby Maynard (1843–1923), *Edward Maynard (The Inventor)*, 1881, oil on canvas, 30½ × 25 inches, National Portrait Gallery, Smithsonian Institution, Washington, D.C., transfer from the National Museum of American Art, gift of the artist, 1910, NPG.71.3.

Whistler's portraits by explaining that they were equally paintings: "the pictorial quality is as prominent as the portraiture, and there is an exact equipoise between the two." Whistler was principally concerned, he explained, "with aspect always and never with meaning."[49] Among the illustrations to Brownell's article were wood engravings of the two works that were to exercise the most decisive influence on American painting: *The White Girl* and *Arrangement in Grey and Black, No. 1: Portrait of the Painter's Mother.*

Whistler's *White Girl*, as *The Woman in White*, made its New York debut in the spring of 1881 at a private event—an art exhibition at the Union League Club—but moved the next month to a public venue, The Metropolitan Museum of Art, where it remained on view throughout the summer.[50] Its impact upon the New York art world was enormous and immediate. By the time of the Society of American Artists' next exhibition in April 1882, several artists had already produced paintings that were identified as "experiments in Mr. Whistler's original vein." These included such works as George Willoughby Maynard's *The Inventor* (fig. 9), which to modern eyes appears to have nothing to do with Whistler's work apart from a

predominance of white in the color scheme—but that, because of *The White Girl*'s fame, was becoming a hall-mark of Whistlerian style in America.[51]

Ultimately more important for Whistler's American reputation was the premier exhibition of the now ines-timably famous painting known as Whistler's Mother. Though the portrait was already ten years old in 1881, it was the most current of Whistler's works yet to be seen in the United States—and the only one to demonstrate the qualities of aesthetic reticence and coherence that distinguish his mature artistic style. Moreover, it was the first painting that Whistler himself chose to exhibit in America. Anna Lea Merritt (1844–1930), another American artist resident in London, had approached him on behalf of the Pennsylvania Academy of the Fine Arts, which was organizing a special exhibition titled *Americans at Home and in Europe*. On the whole, Merritt and her colleague W. J. Hennessey (1839–1917) found the task of persuading their fellow Americans in London to send paintings to Philadelphia "very uphill work," as the artists felt that Americans generally showed interest in nothing but French pictures.[52] Whistler, however, was surprisingly amenable to the idea and promised Merritt at a dinner party that he would lend one of his most acclaimed works—a victory that made all their efforts worthwhile.[53]

Arrangement in Grey and Black, No. 1: Portrait of the Painter's Mother had not been publicly displayed since Whistler's first solo exhibition in 1874. Since 1878, it had been in the hands of the London print dealers Henry Graves & Co., who held it as security for a loan, but in January 1881, Whistler had begun to repay his debt in hopes of reclaim-ing the painting.[54] That very month, Anna Whistler died suddenly in Hastings. Whistler was filled with remorse for all the ways he had disappointed his mother,[55] which may account for his decision to send her portrait to Philadelphia in 1881, as she had wanted him to do for the Centennial Exposition in 1876. Graves agreed to lend the painting on the condition that it be returned to his firm "and to no one else." Despite later assertions to the contrary, the portrait of Whistler's mother was not for sale.[56]

The exhibition at the Pennsylvania Academy lasted from early November through Christmas 1881. That momentous encounter with Whistler's work gave direction to the career of Joseph Pennell (1857–1926)[57] and also affected a number of other art students at the Academy and young artists in Philadelphia, including Henry Ossawa Tanner and Cecilia Beaux (see cats. 17, 59). Many artists from New York City doubtless made the journey to Philadelphia to see it, and the Society of American Artists (possibly represented by Weir, who was on the exhibition committee) successfully entreated the Academy to allow the painting to be shown in its own exhibition that spring.[58] And so Whistler's Mother made its first New York appearance in 1882, the year that Oscar Wilde toured the United States dissemi-nating Whistlerian aesthetics. Will H. Low, then secretary of the Society, assured his colleagues in Philadelphia that "the picture met with the success it merits while in our exhibition."[59]

Curiously, though, *Arrangement in Grey and Black, No. 1: Portrait of the Painter's Mother* seems to have attracted less attention from the critics than Thomas Eakins's now comparatively forgotten *Crucifixion* (1880, Philadelphia Museum of Art).[60] The review in *The Art Amateur* that pointed out the number of Whistlerian "experiments" in the manner of *The White Girl*, for example, mentioned Whistler's Mother only in passing.[61] *The Critic* noted that the portrait's title, in emphasizing the work's formal quali-ties above the subject's identity, "puts something of a slight on the lady who sat for it" but advised forgiving "the snub

FIG 10 James McNeill Whistler, 1878, Department of Special Collections, Glasgow University Library, Scotland.

in order to enjoy the picture," as Whistler's mother herself must have done.[62] It was left to Henry James, reviewing Whistler's works at the Grosvenor Gallery that year, to place the portrait ("painted some years ago, and exhibited this year in New York") in historical perspective. It was "so noble and admirable a picture," he wrote, "such a masterpiece of tone, of feeling, of the power to render life, that the fruits of his brush offered to the public more lately have seemed in comparison very crude."[63]

From New York, the painting went directly to London, where it was seen in Whistler's studio by Otto Bacher (1856–1909), one of the Duveneck Boys, late in 1882.[64] The next spring, it was sent to Paris for exhibition at the Salon (as *Portrait de ma mère*) and awarded a third-class medal. Brownell, who saw the painting there, elevated his estimation of Whistler's abilities. "If in modern times there has been painted a picture thoroughly imbued with the tradition of the golden age of art, it is Mr. Whistler's portrait of his mother." In that review, published in *The Magazine of Art* and illustrated with an engraving of Whistler's Mother, Brownell effectively declared the painting to be Whistler's masterpiece. It was only the public's preoccupation with the artist's eccentricities ("fewer in number than is popularly supposed") that precluded acknowledging him as "the most thorough, the most perfect, the most typical artist of our time."[65]

Whistler's eccentricities were much in evidence that year in an exhibition that moved from the Fine Art Society in London to H. Wunderlich & Co. in New York and then toured to Baltimore, Boston, Philadelphia, Chicago, and Detroit. Titled *Arrangement in White and Yellow*, like one of Whistler's paintings, this exhibition comprising mostly Venetian etchings was described by a writer for the *New York Times* as "the latest freak of Mr. Whistler. It is clever, if somewhat affected and impertinent."[66] The affectation was not in the prints, but in the gallery's decoration—an unrelenting, floor-to-ceiling arrangement of yellow and white that extended even to the attendants' uniforms. In the United States, the etchings were accompanied by a photograph of Whistler taken in the year of the Ruskin trial (fig. 10) and the famous *Nocturne in Black and Gold: The Falling Rocket,* which hung separately in a room of its own. In many ways, the exhibition provided the most comprehensive view of the artist that had taken place in the United States. It not only displayed works that affirmed Whistler's stature as an artist, but its installation demonstrated his sense of all-encompassing design, which was beginning to inform the American Aesthetic movement. And because it included, incongruously, the most audacious of Whistler's paintings and a striking image of the artist as a formidable personality who would not suffer fools,

it seemed to test of the sensibilities, and the tolerance, of American audiences.

In those early years, William Merritt Chase was working behind the scenes to construct Whistler's American reputation. He had been elected president of the Society of American Artists in 1880, the year Whistler was elected into membership, and would have been instrumental in arranging for the exhibition of Whistler's Mother in New York in 1882. He seems to have considered himself Whistler's counterpart on this side of the Atlantic: Chase may have been the first American artist to paint a "Woman in White" of his own (his was described as looking like "Oscar Wilde's grandmother in her teens"),[67] and his works, like Whistler's, were sometimes criticized for their lack of content.[68] Because he participated in the international art world, Chase also had an unparalleled view of Whistler's works. His *Dora Wheeler* (cat. 22), for instance, was shown at the Paris Salon in 1883 along with Whistler's portrait of his mother; and *At Her Ease* (cat. 23) represented him in 1884 at the first exhibition of La Société des Vingt in Brussels, where Whistler showed *Harmony in Grey and Green: Miss Cicely Alexander* (fig. 11).[69]

It may have been in Brussels that Chase first saw that celebrated portrait of a little girl in the pose of a Spanish princess; he undoubtedly came across it later that year, when it went on view at the Paris Salon. The experience changed his life. "It was delightful, marvelous, fascinating," Chase later recalled, "and along with its subtle charm there crept into my mind that natural desire to see and know the artist." His courage faltered and he continued on to Madrid, where "the same resolve was born anew. Every Velasquez seemed to suggest Whistler."[70] In recounting the story fifteen years later, Chase rearranged his recollections to more closely connect the portrait of Cicely Alexander with his momentous introduction to Whistler himself, which confirms that the essential, immutable link between the artists was their mutual regard for the art of Diego Velázquez (1599–1660).[71]

On his "pilgrimage" to Europe the next summer, Chase steeled himself to call on Whistler, who, much to his surprise, welcomed him warmly—"and in a moment," he recollected, "we were chatting like old friends." Whistler was well disposed toward Chase because he had heard about him from the Duveneck Boys and must have regarded him as another potential partisan. Accordingly, he "overwhelmed" Chase with attention and persuaded him to postpone his intended journey back to Spain.[72] In July, Chase wrote to his future wife, Alice Gerson, that Whistler was "the most amusing fellow" he had ever met, and that he would probably remain in London longer than expected.

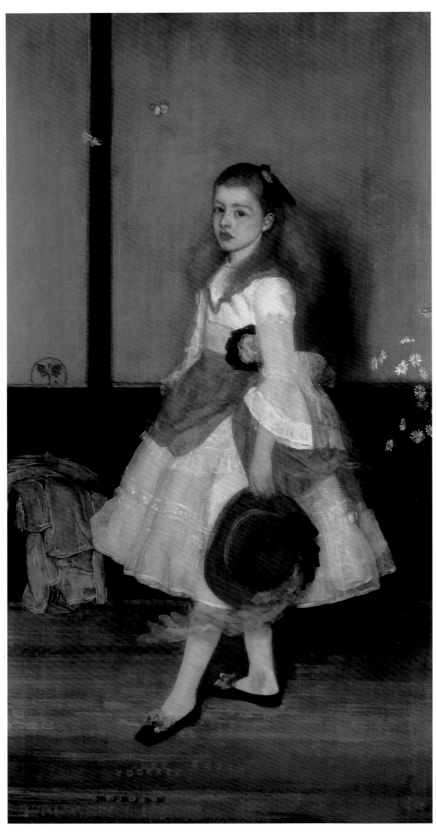

FIG 11 James McNeill Whistler (1834–1903), *Harmony in Grey and Green: Miss Cicely Alexander*, 1872–1874, oil on canvas, 74⅞ × 38½ inches, Tate Britain, London, bequeathed by W. C. Alexander, 1932.

A month later, he added, "I have a great deal to tell you about friend Whistler when I get home, things that I think are better said than written."[73] The interlude was not without discord, though Whistler explained that he quarreled only with his friends—"It is commonplace, not to say vulgar, to quarrel with your enemies."[74] In the end, Chase agreed to stay in town for the purpose of painting Whistler's portrait (cat. 24) and posing for his own, a project that kept them occupied, and interdependent, throughout the summer. They planned to exhibit the works together in New York, when Whistler himself would be present to share the glory.[75] In Chase—reelected president of the Society of American Artists that spring—Whistler had identified an invaluable ally and advocate in the American art world, making the prospect of a visit to the United States seem possible, perhaps even profitable, for the first time.

The summer culminated in an ill-fated journey to Belgium and Holland. According to Mortimer Menpes (1860–1938), an Australian art student who became one of Whistler's "followers" and may have accompanied them abroad, Whistler "was in one of his peevish moods" and made the trip miserable for everyone.[76] Whistler knew that he had been insufferable. After they parted, he wrote an uncharacteristically long letter of apology to Chase: "Your stay here was charming for me and it is with a sort of self-reproach that I think of the impression of intolerance and disputatiousness you must carry as characteristic of my own gentle self—which also I suppose it will be hopeless for me to attempt to efface by even the mildest behavior when I return your visit to New York."[77] Chase replied good-naturedly that he looked forward to seeing Whistler again soon,[78] supporting his later assertion to the Pennells that "they were friends when he started for home at the end of the summer." But at some point after his arrival in New York, Chase heard that Whistler had accused him of telling lies—and that, he told the Pennells, was "too much to accept amiably." In the spring, he returned to London, writing to ask Whistler whether there was any truth to the rumor, but Whistler never answered his letter,[79] which does not survive and may never have been received. That October, an article heralding Whistler's trip to America and printed on the front page of the *New York Tribune* published a letter from Whistler to an unnamed friend in which Whistler refers to Chase's portrait of him as a "monstrous lampoon."[80] That single phrase, probably born of some miscommunication, effectively ended their relationship.

In later years, Chase inadvertently incited Whistler's wrath by praising him in public. His lectures were largely anecdotal reminiscences along the lines of his memoir published in 1910, "The Two Whistlers," and were sometimes criticized in the same terms as his portrait of Whistler—

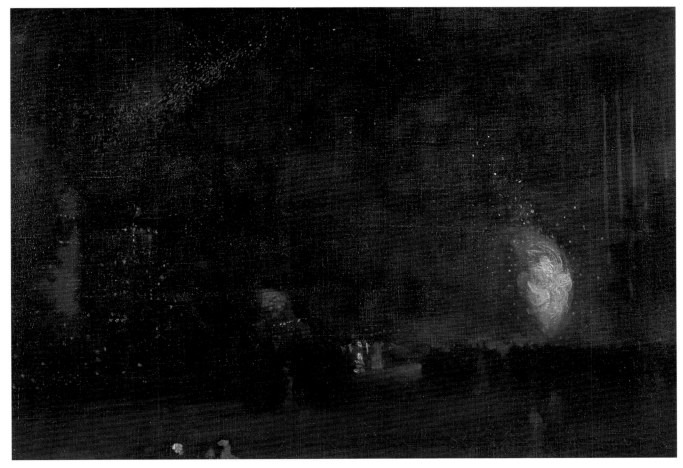

FIG 12 James McNeill Whistler (1834–1903), *Nocturne: Black and Gold—The Fire Wheel*, 1875, oil on canvas, 21⅜ × 30 inches, Tate Britain, London, bequeathed by Arthur Studd, 1919.

for treating a serious subject too lightly. As one reviewer noted in 1909, "While praising Mr. Whistler's ability as exemplified in certain of his most notable works, Mr. Chase devoted rather more attention to the 'incidental' Whistler than to the great artist whose influence is felt to-day in every art-producing country of the world."[81] Whistler himself could not abide the thought of the lecture even though, as the critic Royal Cortissoz remarked, he "was not quite sure whether it would please him or not."[82] In 1901, Whistler accepted as accurate an unfounded (and still unidentified) report of an alleged "attack" on him by Chase, raging to E. G. Kennedy, his agent in America, about his former friend's "unseemly conduct."[83] Weir tried to intervene, insisting that Chase had always been "a Loyal admirer," but Whistler would not be appeased. For him, the brief interlude of their friendship was negated by its long aftermath, for he objected to Chase speaking as "an intimate, a *confrère*."[84] There can be little doubt, however, that Chase's lectures played a large part in generating and sustaining American interest in Whistler's art, and through his own teaching he inspired a generation of American artists with Whistlerian principles.[85]

WHISTLER, OF COURSE, HAD INTENDED TO LECTURE in America himself, which may partly account for his irritation with Chase. One Boston critic stated in 1889 that because Americans were inherently more open than the British to Whistler's art, it was unnecessary for Whistler to declaim his philosophy in person: "We are willing here to judge him by his pictures, without discussing theories."[86] Indeed, Whistler's failure to deliver the "Ten O'Clock" lecture in the United States may even have assisted the rise of his American reputation, since his personal idiosyncrasies invariably distracted the public from his artistic achievements. More damaging, perhaps, was the loss of the exhibition that Whistler had intended to celebrate his homecoming. "I find art so absolutely irritating in its effect upon the people," he reportedly explained, "that I really hesitate before exasperating another nation."[87] But in March 1889, the New York gallery H. Wunderlich & Co. presented a substitute, *'Notes'—'Harmonies'—'Nocturnes.'* As the title suggests, the show did not include Whistler's portraits (usually titled "Arrangements" or "Symphonies"). It featured two Nocturnes—*The Falling Rocket* and *Black and Gold—The Fire Wheel* (fig. 12), another equally abstract

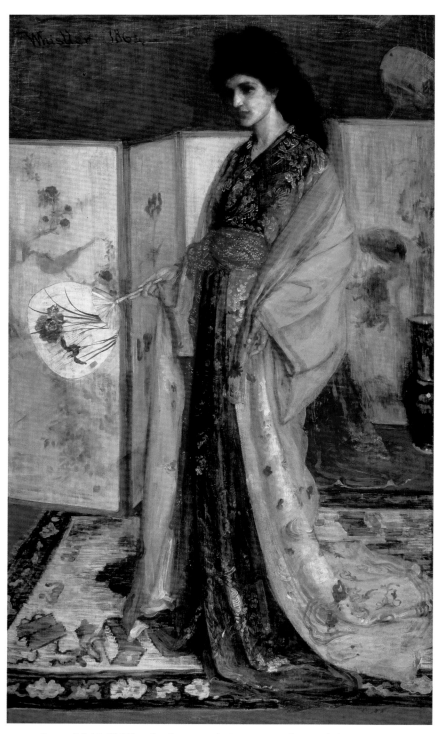

FIG 13 James McNeill Whistler (1834–1903), *La Princesse du pays de la porcelaine* (*The Princess from the Land of Porcelain*), 1864–1865, oil on canvas, 78¹¹/₁₆ × 45¹¹/₁₆ inches, Freer Gallery of Art, Smithsonian Institution, Washington, D.C., gift of Charles Lang Freer, F1903.91.

rendition of fireworks that Whistler was eager to sell.[88] On the whole, the pictures on display were small, epigrammatic works in oil, watercolor, and pastel that Whistler considered "Notes," using a literary and musical term to suggest their spontaneous, sketchlike qualities and their elemental nature, as possible components of larger compositions (see cats. 11–14). These eminently accessible works of art—not expensive and imposing, like the portraits, or abstract and bewildering, like the Nocturnes—attracted several Americans who were to become leading collectors of Whistler's art, including Charles Lang Freer, Howard Mansfield, Harris Whittemore, and Henry O. Havemeyer.

The Wunderlich show may have given Whistler hope that his future success lay in the United States, for in spite of an invitation from the Prince of Wales to exhibit with the British that year at the Exposition Universelle in Paris, he made the patriotic gesture of sending two paintings and a group of etchings to the American section. The jury, however, rejected ten of his prints, making the artist Edward Simmons (1852–1931), one of the overridden jurymen, ashamed of his country.[89] Whistler immediately redirected his works to the British section, where they were awarded a gold medal, and he was consequently inducted into the Légion d'Honneur—not as an American, but as an "exposant anglais."[90] Nevertheless, American critics and artists alike tended to regard Whistler as one of their own—as Brownell put it, "Mr. Whistler is himself more of an American than anything else"[91]—eliding the fact of his placement among the British. Theodore Child devoted disproportionate attention to Whistler ("the most eminent of all the American artists resident in Europe") in his substantial and insightful account of American art at the Exposition published in *Harper's*, and Childe Hassam (see cats. 43–44) spoke of his conviction, after reflecting upon the exhibits of Whistler, George Inness (1825–1894), and John Singer Sargent, "of the capability of Americans to claim a school."[92]

It was not until the next world's fair, the 1893 Columbian Exposition in Chicago, that Whistler was given his first official honor—a gold medal—by the country of his birth. He had been invited to exhibit with the British again and, mindful of his experience in Paris, might well have agreed were it not for the pleas and assurances of E. A. Abbey, who chaired a special commission in England to secure American works for the fair.[93] Whistler determined to assemble a comprehensive group of works demonstrating his achievement, and possibly even to appear in Chicago himself.[94] Ultimately, he was represented only by a selection of etchings and six oil paintings, including *La Princesse du pays de la porcelaine* (fig. 13), which he had hoped to display at the

last American exposition in Philadelphia.[95] American critics were gratified to find Whistler's works among those of his countrymen, for as Lucy Monroe observed in *The Critic,* "his work is not antagonistic to theirs as it is to the English."[96] The noted collector Arthur J. Eddy (see cat. 10) also remarked the sympathy of Whistler's works with the other American exhibits: "That they could not hang with entire fitness among the English pictures even the English would admit; that their sober harmonies were distinctively at variance with the brilliant and superficial qualities of the French pictures was apparent to even the unpractised eye."[97] This was the first time that a significant selection of Whistler's paintings had been shown amid recent American works that reflected his influence, such as Chase's *Lydia Field Emmet* (cat. 27), displayed on the same wall as its apparent prototype, Whistler's *Arrangement in Black and Brown: The Fur Jacket* (cat. 9). In Chicago, Whistler was repatriated in the eyes of his contemporaries, considered American in both nationality and artistic sensibility.

The timing was auspicious, for it was only in the 1890s that Whistler decided to focus on the United States as the most promising market for his art. Though he had not previously wanted to "force himself on this side of the water,"[98] he wrote to one of his dealers in 1892 that Chicago was the place "where all the thousands will come . . . for these pictures of mine—and I do want them to go out of England."[99] His change in attitude toward the United States was brought about not by desperation, but by a dramatic change for the better in his fortunes. In 1891, the City of Glasgow had purchased his portrait of Thomas Carlyle (fig. 14), and a few months later the French government acquired *Arrangement in Grey and Black, No. 1: Portrait of the Painter's Mother* for the Musée du Luxembourg (the national collection of works by living artists), meaning that it was destined, eventually, for the Louvre. "That is the greatest distinction which can be conferred upon an artist," declared G. W. Smalley in a New York newspaper; "there is no other which ranks with it in Europe."[100]

In the wake of that success, Whistler worked with the dealer David Croal Thomson to organize *Nocturnes, Marines & Chevalet Pieces,* a retrospective exhibition in London that concluded with a photograph of Whistler's Mother (fig. 15) and a notice, for anyone who might not have heard, of its recent placement in the French national collection.[101] The Goupil Gallery exhibition proved to be "a complete triumph," in Whistler's words, "crowning all my past victories." Indeed, because the exhibition elevated the market for Whistler paintings, dozens were sold afterward at enormous profit to their original owners, leaving Whistler with an acute sense of betrayal and a renewed bitterness toward

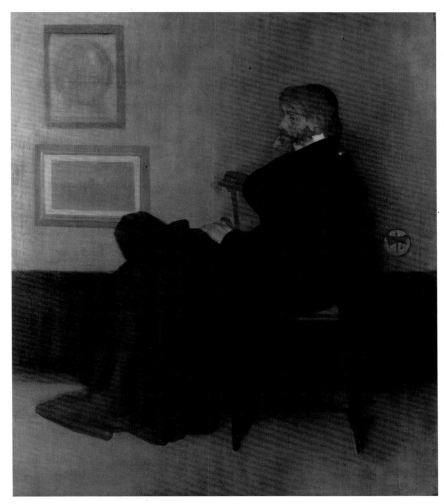

FIG 14 James McNeill Whistler (1834–1903), *Arrangement in Grey and Black, No. 2: Portrait of Thomas Carlyle,* 1872–1873, oil on canvas, 67⅜ × 56½ inches, Glasgow Museums: Art Gallery & Museum, Kelvingrove, Scotland.

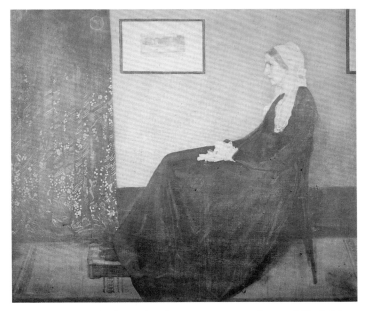

FIG 15 Photograph after Whistler, *Arrangement in Grey and Black, No. 1: Portrait of the Painter's Mother,* ca. 1892, silver gelatin print, Department of Special Collections, Glasgow University Library, Scotland.

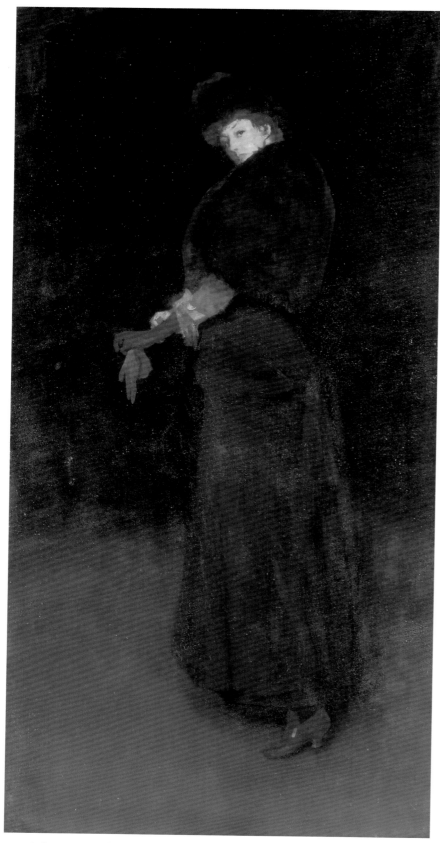

FIG 16 James McNeill Whistler (1834–1903), *Arrangement in Black: La Dame au brodequin jaune—Portrait of Lady Archibald Campbell (The Yellow Buskin)*, ca. 1883, oil on canvas, 86 × 43½ inches, Philadelphia Museum of Art, W. P. Wilstach Collection, 1995.

the English. That fall, he and his wife, Beatrix, moved to Paris—"this land of light and joy," as he described it, "where honours are heaped upon me and peace threatens to take up her permanent abode in the garden of our pretty pavilion."[102]

The pavilion was a little house at 110, rue du Bac, where, on Sunday afternoons, "a remarkable collection of people were in the habit of assembling," according to Elizabeth Alexander, who with her husband, the artist John White Alexander, was a frequent visitor: "All who were most interesting in the fields of art and literature of that day gathered to do Whistler homage."[103] Some were French, but the greater part of Whistler's social circle comprised Americans, including the artists Frederick MacMonnies (1863–1937), Augustus Saint-Gaudens, and Walter Gay (1856–1937). American art students also flocked to Whistler's home and studio: "He had a great charm for youth," Gay remarked; "the society of young people brought out his best qualities, and they were fascinated by his personal magnetism."[104] Consequently, as French critics were quick to point out in reviews of Salon exhibitions, Whistler's presence in Paris had a noticeable effect on the art of Americans working there. In 1893, for example, Alexander exhibited a trio of figure paintings including *Portrait gris* (cat. 16), all of which emphasized formal concerns above the identity of the sitter—an approach to portraiture that was, by then, firmly identified with Whistler's aesthetic.[105] By the end of the decade, this genre of decorative figure painting was regarded as the great strength of the American "school," of which Whistler, according to Léonce Bénédite, curator of the Musée du Luxembourg, was "son grand directeur de conscience"—its great spiritual director.[106]

In Paris in the 1890s, Whistler finally attained international success and professional recognition. As George du Maurier wrote of Joe Sibley, the character in his novel *Trilby* (1894) who was obviously based on Whistler, "He is now perched on such a topping pinnacle (of fame and notoriety combined) that people can stare at him from two hemispheres at once."[107] But that idyllic interlude in Whistler's life was shattered by the death of his beloved Beatrix in 1896. Afterward, he seems to have become more mindful of his own mortality and the need to ensure "the ephemeral influence of the Master's memory," as he described the artist's legacy in the "Ten O'Clock," "the afterglow, in which are warmed, for a while, the worker and disciple."[108] In 1898, he and his former model Carmen Rossi founded an art academy in Paris. Although open to students of all nationalities, Americans made up the majority in the Académie Carmen. Few stayed for long, since Whistler's visits were unpredictable and infrequent, but even a fleeting acquaintance with "the Master" could affect the course of a career.

Alson S. Clark (1876–1949), for instance, recalled a New Year's Eve party in 1898 when Whistler showed his students every canvas in his studio and "established a rapport never achieved by any other master."[109] But Whistler's primary importance to American painters at this time came from his example, for he had managed to fulfill the dream of winning professional success abroad. As the expatriate poet Ezra Pound reflected some years later, "What Whistler has proved once and for all, is that being born an American does not eternally damn a man or prevent him from the ultimate and highest achievement in the arts."[110] In Paris in the 1890s, American art students such as Hermann Dudley Murphy and Henry Ossawa Tanner produced paintings that clearly paid homage to Whistler's works, while implying their own elevation in status by association (see cats. 51, 59).

Yet, as Whistler himself acknowledged, an artist's influence is ephemeral; his legacy should be everlasting. During the final decade of his life, Whistler's determination to place his work in American collections became even more specific: he became intent upon seeing his art represented in American museums, where it would be safely preserved for posterity, immune to the vicissitudes of the marketplace. Although three major paintings purchased privately in 1892 would eventually end up in public collections,[111] it was not until 1895 that a painting by Whistler was purchased for an American art museum: *Arrangement in Black: La Dame au brodequin jaune* (fig. 16), popularly known as *The Yellow Buskin,* for the Philadelphia Museum of Art. A portrait from the early 1880s of Whistler's friend Lady Archibald Campbell, *The Yellow Buskin* was one of the works exhibited at the World's Columbian Exposition in 1893. Afterward, it traveled to Philadelphia for display at the Pennsylvania Academy of the Fine Arts, whose director, Harrison S. Morris, made strenuous efforts to purchase it or one of the other Whistler portraits sent from Chicago. When his efforts with the Academy board failed, Morris appealed to a prominent Philadelphian, John G. Johnson, who had recently purchased *Purple and Rose: The Lange Lijzen of the Six Marks* (cat. 2), a stunning example of Whistler's early, Asian-inspired figure paintings that was itself to exercise an influence on American painting. Johnson's "enlightened knowledge in art made him a very receptive confidant," Morris said, and after the Academy awarded *The Yellow Buskin* the Temple Gold Medal for best figure painting, Johnson purchased it for the Wilstach Collection of the Philadelphia Museum.[112] Whistler learned of that important acquisition from Morris himself, who visited the artist in Paris a few months later, and received the good news with "great satisfaction & exceeding relief."[113]

Another of the Chicago paintings, *Arrangement in Black and Brown: The Fur Jacket* (cat. 9), was then under consider-

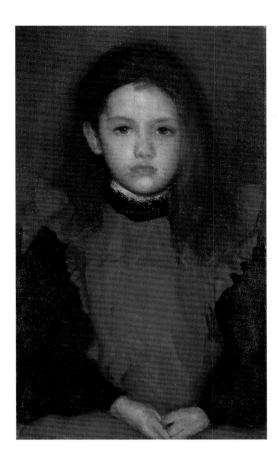

FIG 17 James McNeill Whistler (1834–1903), *The Little Rose of Lyme Regis,* 1895, oil on canvas, 20 × 12¼ inches, Museum of Fine Arts, Boston, William Wilkins Warren Fund, 1896, 96.950.

ation by the Museum of Fine Arts in Boston,[114] and *The White Girl* was on extended loan to The Metropolitan Museum of Art, where Chase and Weir were lobbying for its purchase.[115] Although neither of those sales came about, the Boston museum did acquire two, more recent Whistler paintings in 1896, *The Little Rose of Lyme Regis* (fig. 17) and *The Master Smith of Lyme Regis* (1895–1896). These were relatively conservative works—as William Howe Downes remarked, "To one unfamiliar with the cosmopolitan Whistler's paintings they would not convey an adequate idea of his individuality of style, of what he stands for in the art of our time"—but it was unusual at that time for museums to purchase works by living artists at all.[116] A notable exception was the new Carnegie Institute in Pittsburgh, founded by Andrew Carnegie with the purpose of collecting the "Old Masters of tomorrow." When Whistler submitted *Arrangement in Black: Pablo de Sarasate* (fig. 18) to the Carnegie's first international exhibition in 1896, the Department of Fine Arts promptly purchased it as the second acquisition for its permanent collection, making Whistler's portrait a cornerstone of the first American museum of modern art.[117]

"Everyone has appreciated the skill which brought that black figure out of the black background," wrote the novelist Willa Cather of Whistler's portrait of Sarasate, "and has felt the almost malignant mystery about that dark,

FIG 18 James McNeill Whistler (1834–1903), *Arrangement in Black: Pablo de Sarasate*, 1884, oil on canvas, 97¹³⁄₁₆ × 55⅜ inches, Carnegie Museum of Art, Pittsburgh, purchase, 96.2.

lithe man, the character in the nervous hands and bold black eyes, and the full red lip." Like many others of her time, however, Cather had reservations about Whistler's "more extreme pictures," the Nocturnes: "the lack of detail in some of his night scenes is calculated to puzzle the unimaginative."[118] It was not until 1900 that one of Whistler's Nocturnes was acquired for a public institution. As Theodore Child pointed out, those paintings were "absolutely original, personal, and unlike anything that has ever been done before,"[119] making them risky investments for a museum—certainly less desirable (if less expensive) than the portraits, whose worth had been affirmed with the French acquisition of Whistler's Mother.

The most famous of Whistler's Nocturnes in America, *Nocturne in Black and Gold: The Falling Rocket*, had been purchased in 1892 by Samuel Untermyer (see cat. 7), and later in the decade John G. Johnson, Isabella Stewart Gardner, and Charles Lang Freer all acquired Nocturnes for their collections (see cat. 5).[120] But The Art Institute of Chicago's purchase in 1900 of Whistler's *Nocturne: Blue and Gold—Southampton Water* (cat. 4) was a signal acquisition for an American museum; it gave official sanction to a genre that had yet to be taken seriously abroad. In the following decade, scores of American painters produced variations on the nocturnal theme. Although none adopted Whistler's art-for-art's-sake position wholeheartedly, they employed his aestheticism to edge their own art toward the borders of abstraction. It was Whistler's "love for pure art," Kenyon Cox (1856–1919) observed in 1904, that "pushed painting as far from imitation as it can well go without ceasing to be painting; and all the influence he may exert is likely to be salutary for a generation whose natural tendency is toward the opposite extreme from his."[121]

THE SINGLE MOST IMPORTANT ACTION WHISTLER took to ensure the survival of his legacy was to cultivate the patronage of Charles Lang Freer. They met in 1890, when the young businessman from Detroit framed an arrangement to purchase prints directly from the artist. In 1899, the year in which Freer retired from active business with a small fortune to spend on art, Whistler made the timely proposition that Freer assemble "a fine collection of Whistlers!! perhaps *The* collection."[122] From then until his death in 1903, Whistler worked diligently to educate Freer's eye and introduce him to the most important collectors of his art in Britain so that if his works became available, Freer would be among the first to know. As a result, Freer began to construct what would become the single largest collection of Whistler's works. The artist died in July 1903 (Freer, Abbey, and George Vanderbilt were pallbearers at his funeral), and afterward Freer took

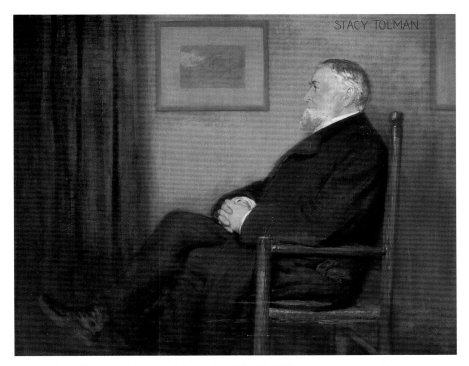

FIG 20 Xavier Martinez (1869–1943), *Afternoon in Piedmont (Elsie at the Window)*, ca. 1911, oil on canvas, 36 × 36 inches, Oakland Museum of California, gift of Dr. William S. Porter.

FIG 19 Stacy Tolman (1860–1935), *Portrait of John H. Nisbet*, ca. 1900–1908, oil on canvas, 48 × 60½ inches, Museum of Art, Rhode Island School of Design, Providence, gift of Jack C. Lehrer.

steps toward instituting a plan to bequeath his holdings to the people of the United States—a corollary, surely, of Whistler's original proposition. Although Freer's collection also included works of Asian art and paintings by other Americans whom he believed to share Whistler's aesthetic sensibility—notably Abbott H. Thayer (1849–1921), Thomas W. Dewing (see cats. 33–34), and Dwight W. Tryon (1849–1925)—public interest centered on the Whistlers. When the Smithsonian Institution accepted Freer's gift in 1906, complete with conditions and contingencies designed to safeguard the collection for posterity, it implicitly established Whistler's art as a national treasure.[123]

Whistler's American canonization was nearly complete. By the end of the 1890s, critics were placing him in the first rank of modern painters, even as "the greatest artistic genius America has ever produced."[124] In 1903, Joseph Pennell went so far as to declare that Whistler had single-handedly positioned his country "first and foremost among the artistic nations of the world. No tribute that can be bestowed upon him by the United States will be too great for his glory, nor fail to redound with honor upon his native land."[125] The artist's ascendancy was affirmed by the Memorial Exhibition in Boston, which opened early in 1904, "the most important and interesting art exhibition ever held in America," according to William Howe Downes, "and the most remarkable event of the year, so far as art is concerned, anywhere in the world."[126]

Impressive memorial exhibitions were also held in London and Paris in 1905, but without the cooperation of Freer and Rosalind Birnie Philip (Whistler's sister-in-law, heir, and executor), they could not match Boston's remarkably complete presentation of Whistler's achievement.

It is impossible to know how many American artists made the pilgrimage to Boston, but few, it seems, would willingly have missed the opportunity. By then, as the critic John C. Van Dyke observed, Whistler's influence had "spread far and wide," and "every picture exhibition of the last dozen years has had its modicum of Whistler-esque pictures."[127] After the Memorial, signs of Whistler's "afterglow" continued to be seen in paintings by scores of American artists, and by 1919, Van Dyke could declare that "his influence has been more far-reaching than that of any modern," for American exhibitions still displayed "his color schemes and arrangements as comprehended by his admiring young converts."[128] Some of those exhibits, of course, were more imitative than original—simple homages to the master that said little of interest about the artist's own creativity (fig. 19); others paraphrased Whistler's works in more telling ways, assimilating his aesthetic practices into their own style (fig. 20). Whistler's principles, as Charles H. Caffin remarked, "were diversely used by others."[129] Indeed, even those artists whose realist orientation made them hostile to Whistler's aestheticist philosophy could betray an awareness, even an admiration,

FIG 21 Thomas Eakins (1844–1916), *Frank Jay St. John,* 1900, oil on canvas, 23⅞ × 19⅞ inches, Fine Arts Museums of San Francisco, gift of Mr. and Mrs. John D. Rockefeller III, 1979.7.37.

of his art. Thomas Eakins's portrait of Frank Jay St. John (fig. 21), for instance, is clearly indebted to Whistler's portrait of Thomas Carlyle (see fig. 14).

The wave of Whistler's American celebrity had apparently crested by 1910, when an important exhibition of his oils and pastels at the Metropolitan Museum (its first show ever devoted to a single artist) failed to attract the public's attention.[130] As one critic reflected on that occasion, "He does not seem so wonderful as he did two decades ago."[131] In 1913, the few minor paintings that represented Whistler at the International Exhibition of Modern Art (the Armory Show) failed to live up to their reputation as precursors to the vivid works on display by the European avant-garde,[132] and even though Whistler was still said to dominate American painting several years later, critics were beginning to regret that he had "led many a commonplace artist who might have done good, conscientious work in the old way to imitate his style, with pitiful results."[133] The modernist Max Weber (1881–1961) went so far as to blame Whistler and his followers for the paucity of "strong works of art full of freshness, power and renewal" that he found in the collections of American museums.[134] Nevertheless, a number of artists continued to work under Whistler's influence into the 1920s and even the 1930s (see, for example, cats. 38, 40). In the age of modernism, their art looked not old-fashioned but quaintly nostalgic, as though intended to comfort those whose aesthetic sensibilities were offended by the progressive movements that were revolutionizing American art. When the Freer Gallery of Art opened in Washington in 1923 as a monument to the artist's work, the qualities that had once made Whistler's paintings appear radical had been so fully assimilated into modernist practice that they appeared unremarkable, if somewhat faded by the passage of time. Perhaps the subtlety of his influence was a sign of success: through his insistence on the primacy of formal values, his rejection of narrative content, and his example as a creative force unfettered by convention, Whistler quietly paved the way for the art that followed. As Caffin summed up the situation in 1903, Whistler "did better than attract a few followers and imitators; he influenced the whole world of art. Consciously or unconsciously, his presence is felt in countless studios; his genius permeates modern artistic thought."[135]

Notes

1. Pennell and Pennell, *Life of Whistler,* vol. 2, p. 29.
2. From a letter published in "Whistler Coming to America."
3. Pennell journal, November 2, 1908, PWC, box 352. On the portrait commission, see "How Whistler Posed for Alexander."
4. From a letter published in "Whistler Coming to America." On Whistler's reported arrival date, see Nicolai Cikovsky Jr. with Charles Brock, "Whistler and America," in Dorment and MacDonald, *James McNeill Whistler,* p. 35.
5. Pennell journal, November 2, 1903, PWC, box 352; and John Cavafy to Whistler, October 25, 1886, GUL, Whistler C272.
6. From a letter published in "Whistler Coming to America."
7. Brown, *Lonely Americans,* p. 58.
8. Pennell and Pennell, *Whistler Journal,* p. 181.
9. *Portrait of Whistler with a Hat,* owned by Samuel P. Avery, was shown again in New York in 1873 at the Dusseldorf Gallery and The Metropolitan Museum of Art. *Wapping,* owned by Thomas de Kay Winans of Baltimore, was exhibited on that occasion as *On the Thames.* It may also have been exhibited at the National Academy of Design in 1868 as *View on the Thames.* In 1873, both paintings were again shown in New York at the Dusseldorf Gallery.
10. "Some Pictures at the Artists Fund Exhibition," unidentified New York newspaper, ca. November 1866, GUL, Whistler Press Cuttings, vol. 1, p. 5.
11. The phrase is attributed to "New York Paper" in *Mr. Whistler and His Critics,* the catalogue for *Etchings and Drypoints, Venice, Second Series,* an exhibition of fifty-one etchings held at the Fine Art Society, London, in February 1883; the text is reprinted in Whistler, *Gentle Art,* p. 102.
12. From a letter published in "Whistler Coming to America."
13. Pennell and Pennell, *Whistler Journal,* p. 154. *The White Girl* had been rejected by the Royal Academy in 1862 and by the Salon in 1863 (but shown at the Salon des Refusés).
14. Anna Whistler to her sister, Kate Palmer, November 3, 1871, enclosing a review of Whistler's works at the Dudley Gallery, in Thorp, *Whistler on Art,* no. 13, p. 46.
15. Anna Whistler to James H. and Harriet Gamble, September 9, 1875, GUL, Whistler W548.
16. E. D. Wallace, "The Fine Arts Abroad," *Forney's Weekly Press* (Philadelphia), April 1, 1876, GUL, Whistler Press Cuttings, vol. 1, p. 91. The article is dated March 6. A letter from Whistler to Mrs. Wallace indicates that he saw, and approved, a draft of the article ([March/April 1876], Collection of Gerald A. J. Stodolski).
17. Anna Whistler to a friend in Philadelphia, Mary Emma Eastwick, July 19, 1876, PWC, box 34; and to James H. Gamble, September 8–9, 1876, GUL, Whistler W553.
18. Pennington, "The Whistler I Knew," p. 769.
19. Unidentified press cutting (review of the Charity Art Exhibition, Baltimore), March 18, 1876, GUL, BPII Press Cuttings, vol. 1, p. 73.
20. The painting was exhibited in Baltimore as *On the Brittany Sea-coast* and at the National Academy of Design as *Scene on the Coast of Brittany.* The other works exhibited in Baltimore were *Portrait of Whistler with a Hat* (see fig. 3) and *Wapping* (see fig. 4).
21. Interview with John La Farge in Pennell and Pennell, *Whistler Journal,* p. 156.
22. Huntington, *Quest for Unity,* p. 22.
23. *New York Evening Post,* March 21, 1879, quoted in Dorment and MacDonald, *James McNeill Whistler,* p. 34.
24. Low, *Chronicle of Friendships,* p. 246.
25. Henry James, "The Picture Season in London," *Galaxy* (August 1877), reprinted in *Painter's Eye,* p. 143. *Nocturne in Black and Gold: The Falling Rocket* was not shown at the Society of American Artists' exhibition until 1902.
26. J. Alden Weir to John [Weir], August 22, 1877, in D. Young, *Life and Letters of Weir,* p. 134.
27. Weir to his parents, August 3 and 10, 1877, in ibid., p. 133.
28. Weir to John [Weir], August 22, 1877, in ibid., p. 134.
29. The verdict of the case was announced in "Current Topics Abroad," *New York Times,* November 27, 1878, and an account of Whistler's testimony reprinted from the *Pall Mall Gazette* appeared on December 8, 1878.
30. "Critic and Painter."
31. Henry James, "On Whistler and Ruskin," *The Nation,* December 19, 1878, reprinted in *The Painter's Eye,* p. 173.
32. "Artist who Sued Ruskin."
33. De G. S., "Whistler."
34. Harper Pennington, "James Abbott McNeill Whistler," typescript of an unpublished essay, PWC, box 297.
35. Pennell and Pennell, *Life of Whistler,* vol. 1, p. 231.
36. Dante Gabriel Rossetti to Jane Morris [August 26, 1879], in Bryson, *Rossetti and Jane Morris,* no. 76.
37. Whistler to Helen Whistler, Venice [November/December 1879], GUL, Whistler W680, in MacDonald, *Palaces in the Night,* p. 141.
38. Whistler to Anna Whistler [March/May 1880], GUL, Whistler W559, in ibid., p. 147.
39. Pennell and Pennell, *Life of Whistler,* vol. 1, p. 273.
40. Willis Seaver Adams, "Reminiscences of Whistler. By a Brother Artist, who Lived in Venice in the Same House," *Springfield Republican,* July 23, 1903, PWC, box 199.
41. At the American Water Color Society's annual exhibition in January 1881, Blum showed three Venetian subjects (none located) in which the critics detected Whistler's influence (see Weber, "Robert Frederick Blum," p. 111). When Duveneck exhibited three Venetian etchings at the Hanover Gallery, London, in the spring of 1881, Whistler's brother-in-law Francis Seymour Haden mistook them for Whistlers, provoking a lengthy correspondence eventually published by Whistler as *The Piker Papers. The Painter-Etchers' Society and Mr. Whistler* (London, 1881) (see Bacher, "With Whistler in Venice," p. 216).
42. E. Pennell, *Nights,* pp. 93–94.
43. Pennell and Pennell, *Life of Whistler,* vol. 1, p. 272.
44. Lucas, *Edwin Austin Abbey,* vol. 1, pp. 79, 81.
45. Abbey to Charles Parsons, June 15, 1879, in ibid., vol. 1, p. 85.
46. According to John C. Van Dyke, who wrote to Joseph Pennell from Rutgers College on December 1, 1919, PWC, box 301.
47. Brownell, "Whistler in Painting and Etching," p. 481.
48. Ibid., p. 487.
49. Ibid., pp. 492, 486–487.
50. "The Union League. The Regular Monthly Meeting of the Club and an Exhibition of Pictures," unidentified New York newspaper [April 10, 1881], GUL, Whistler Press Cuttings, vol. 4, p. 61. The painting was shown at the Metropolitan Museum as part of *Loan Collection of Paintings,* May to October 1881, along with *Coast of Brittany* and *Portrait of Whistler with a Hat.*

51. "American Artists' Exhibition," p. 114. Also mentioned was J. Alden Weir's "lady in white wreathing white roses into a garland against a white wall" (*Flora [Carrie Mansfield Weir]*, Brigham Young University Museum of Art) and a work by William Merritt Chase (possibly *Woman in White*, Brigham Young University Museum of Art) that had been exhibited the previous year. The Society of American Artists would show *The White Girl* (as *The Woman in White*) in its 20th Annual Exhibition in 1898.

52. W. J. Hennessey to George Corliss, secretary of the Pennsylvania Academy, September 13, 1881, Archives of the Pennsylvania Academy of the Fine Arts.

53. Anna Lea Merritt to Joseph Pennell, December 12, 1907, PWC, box 293; and Hennessey to Merritt, September 10, 1881, Archives of the Pennsylvania Academy of the Fine Arts.

54. See Young et al., *Paintings of Whistler*, no. 101.

55. Pennell and Pennell, *Life of Whistler*, vol. 1, p. 295.

56. Henry Graves & Co. to Anna Lea Merritt, September 5, 1881, Archives of the Pennsylvania Academy of the Fine Arts. See also George Corliss to F. Dielman (of the Society of American Artists), March 28, 1882: "Whistler's portrait of his mother was not sent to us for sale; and we were placed under special obligations to see it returned to Henry Graves & Co., 6 Pall Mall, London" (Archives of the Pennsylvania Academy of the Fine Arts). The Pennells state that the painting "could have been bought for twelve hundred dollars," and this assertion has often been repeated, without foundation (Pennell and Pennell, *Life of Whistler*, vol. 1, p. 298).

57. J. Pennell, "James McNeill Whistler," p. 379.

58. Weir told the Pennells "that it was he who got the Mother over to America and had it shown in New York" (Pennell journal, November 8, 1908, PWC, box 352).

59. Will H. Low to George Corliss, June 2, 1882, Archives of the Pennsylvania Academy of the Fine Arts.

60. Gallati, *Chase: Modern American Landscapes*, p. 26.

61. "American Artists' Exhibition," p. 114.

62. "The Fine Arts. The Society of American Artists," *The Critic* 2 (April 22, 1881), p. 119, quoted in Weber, "Robert Frederick Blum," pp. 153–154.

63. Henry James, "London Pictures and London Plays," *Atlantic Monthly* (August 1882), reprinted in *Painter's Eye*, p. 209.

64. Bacher, *With Whistler in Venice*, pp. 41–42.

65. Brownell, "American Pictures at the Salon," pp. 498, 499.

66. "Varied British Topics."

67. "American Artists' Exhibition."

68. Gallati, *Chase: Modern American Landscapes*, p. 26.

69. Newton, "Whistler and La Société des Vingt." The only Americans whose works were shown with those of the avant-garde Belgian group were Chase, Whistler, and Sargent.

70. Chase, "Two Whistlers," p. 219.

71. Chase recalled seeing *Cicely Alexander* at the Grosvenor Gallery in the spring before he met Whistler, which would have been 1884, but that is impossible since the painting was on display at the Salon that year. (It had been shown at the Grosvenor in 1881.) He could not, then, have been "jogging along toward Chelsea" within minutes of admiring it. At the Grosvenor in 1884, Chase would have seen Whistler's later portrait of Lady Archibald Campbell, *The Yellow Buskin* (see fig. 16). Other factual errors in Chase's account include the date of their meeting—1885, not 1886—and the location of Whistler's London studio, which was not on King Street, but on Fulham

Road. Chase would later produce a series of paintings of young girls that appear to owe their inspiration to Whistler, beginning with *Hattie* (ca. 1886, Collection of Mr. and Mrs. Richard J. Schwartz) and including *Girl in White* (ca. 1898–1901, Akron Art Museum) and *Dorothy* (ca. 1902, Indianapolis Museum of Art) (see Gallati, *William Merritt Chase*, pp. 97–99).

72. Chase, "Two Whistlers," p. 219.

73. Chase to Alice Gerson, July 5 and August 8, 1885, William Merritt Chase Papers, AAA, microfilm N69-137.

74. Chase, "Two Whistlers," p. 224.

75. Whistler to Chase, September 1/3, 1885, quoted in Roof, *Life and Art of Chase*, pp. 140–141.

76. Menpes, *Whistler as I Knew Him*, p. 145. Menpes claimed to have gone with Whistler and Chase, at Whistler's insistence, but Chase told the Pennells that Menpes did not go (Pennell journal, July 23, 1906, PWC, box 353).

77. Whistler to Chase, September 1/3, 1885, in Roof, *Life and Art of Chase*, p. 140.

78. Chase to Whistler, September 3, 1885, GUL, Whistler C94.

79. Pennell journal, July 23, 1906, PWC, box 353.

80. "Whistler Coming to America."

81. "Art Lectures."

82. Cortissoz, "Field of Art," p. 218.

83. Whistler to E. J. Kennedy [February 1901], New York Public Library, Rare Books and Manuscripts Division, Kennedy III, 145.

84. Weir to Whistler, July 30 [1901], quoted in D. Young, *Life and Letters of Weir*, p. 204; and Pennell and Pennell, *Whistler Journal*, p. 204.

85. Among the students of Chase whose works reveal Whistler's influence are Edward A. Bell (see cat. 18), Arthur B. Carles, Alson Clark, Ethel Ellis De Turck, Ruger Donoho (see cat. 35), Marshall Fry, Alice Schille, Adeline Albright Wigand, Irving Ramsey Wiles, and Theodore Wores.

86. *Boston Evening Transcript*, March 9, 1889, quoted in Dorment and MacDonald, *James McNeill Whistler*, p. 36.

87. "James Abbott McNeill Whistler," p. 259.

88. The exhibition title had been used before, in similar exhibitions of Whistler's works held at Messrs. Dowdeswells' gallery, New Bond Street, London, in 1884 and 1886. The American show included sixty-two works of art—thirty watercolors, fifteen pastels, twelve oils, and a few drawings.

89. Simmons, *From Seven to Seventy*, pp. 223–224.

90. Susan Grant, "Whistler's Mother," p. 8. Whistler sent nine etchings, *Arrangement in Black: La Dame au brodequin jaune—Portrait of Lady Archibald Campbell*, and *Variations in Flesh Colour and Green: The Balcony* (1864–1870, Freer Gallery of Art) to the British section of the Exposition (see Blaugrund, *Paris 1889*, pp. 228–229).

91. Brownell, "Paris Exposition," p. 34.

92. Child, "American Artists," pp. 490–500; Hassam quoted in Adelson, Cantor, and Gerdts, *Childe Hassam*, p. 29.

93. Lucas, *Edwin Austin Abbey*, vol. 1, p. 265.

94. See Whistler's letters to Alexander Reid, August 2, 1892, GUL, Whistler Letterbook 4, p. 40; to Sidney Starr, September 26, 1892, FGAA, no. 78; and to Samuel Untermyer [September/October 1892], GUL, Whistler U15.

95. The other paintings Whistler exhibited were *Blue and Silver: Trouville* (1865, Freer Gallery of Art), lent by the American artist J. J. Shannon; *Nocturne: Blue and Gold—Valparaíso* (see fig. 50); *Arrangement in Black: La Dame au brodequin jaune—*

Portrait of Lady Archibald Campbell; and *The Chelsea Girl* (see fig. 46).

96. Monroe, "Chicago Letter," p. 351.

97. Eddy, *Recollections and Impressions*, p. 65.

98. "A Day with Whistler," *Detroit Free Press*, March 30, 1890, reprinted in Merrill, *With Kindest Regards*, appendix A, pp. 194–198.

99. Whistler to Alexander Reid, June 26, 1892, GUL, Whistler Letterbook 4, pp. 47–48.

100. Smalley, "Mr. Whistler." Whistler suggested to Smalley that he make this point (see Pennell and Pennell, *Whistler Journal*, pp. 84–85). *Arrangement in Grey and Black* entered the Louvre in 1925, becoming the first American painting to be given this distinction. It was not, however, the first American painting to be purchased for the Luxembourg: Henry Mosler's *Le Retour*, Walter Gay's *Le Bénédicité*, and Alexander Harrison's *Paysage—Rivière* were in that collection by 1890 (Susan Grant, "Whistler's Mother," p. 7).

101. MacDonald, "Painting of the 'Mother,'" pp. 83–84. The Goupil Gallery exhibition was held in March and April 1892.

102. Whistler to Sidney Starr, New York, September 26, 1892, FGAA, no. 78.

103. Alexander, "Whistler as We Knew Him," p. 16.

104. Walter Gay's recollections, sent to Joseph Pennell on September 20, 1906, PWC, box 283.

105. Moore, "John White Alexander," p. 126. On Whistler and decorative portraiture, see Quick, *American Portraiture*, pp. 67–68.

106. Léonce Bénédite, "Les Salons de 1898. III," *Gazette des beaux-arts* 19 (July 1898), p. 72, quoted in Moore, "John White Alexander," p. 218.

107. Du Maurier, "Trilby," part 3, p. 578. After Whistler objected to du Maurier's "mendacious recollection and poisoned rancour," the publisher Harper & Bros. wrote a letter of apology to Whistler, assuring him that the book would disguise the figure (see "Trilbyana" and "Du Maurier and Whistler"). In an American slapstick parody of *Trilby*, the artist Robert Henri took the part of Svengali, John Sloan of the heroine "Twillbe," and Everett Shinn of "James McNails Whiskers" (B. Rose, *American Art since 1900*, p. 14).

108. Whistler, "Ten O'Clock," printed as a marginal note in *Gentle Art*, p. 157.

109. Stern, *Alson S. Clark*, p. 12.

110. Pound, "Patria Mia."

111. *Variations in Flesh Colour and Green: The Balcony* (1864–1870), purchased by Charles Lang Freer, was eventually placed in the Freer Gallery of Art; *Nocturne in Black and Gold: The Falling Rocket* (cat. 7), purchased by Samuel Untermyer, eventually went to The Detroit Institute of Arts; and *Harmony in Blue and Silver: Trouville* (1865), purchased by Isabella Stewart Gardner, eventually went to the Isabella Stewart Gardner Museum, Boston.

112. Morris, *Confessions in Art*, pp. 45–46.

113. Ibid., p. 49; and Whistler to Alexander Reid, June 20 [1895], GUL, Whistler R64.

114. Whistler to Reid, June 20 [1895]; and Reid to Whistler, July 11, 1894, GUL, Whistler R59.

115. See cat. 1. See also Pennell and Pennell, *Whistler Journal*, pp. 183–184: "The Metropolitan Museum is unfortunate in having some of the most unimportant and least desirable Whistlers of any collection in the world, when it might have had the best." *The White Girl* was sold to Harris Whittemore

for $6,500 in February 1896; it passed through the family and in 1943 was given by Harris Whittemore Jr. and his sister, Mrs. Charles H. Upson, to the National Gallery of Art, Washington, D.C.

116. Downes, "American Paintings," pp. 204–205.

117. Strazdes, *American Paintings and Sculpture*, pp. 481–482.

118. Willa Cather [Goliath, pseud.], "A Philistine in the Gallery: Some Remarks on the Pictures at the Carnegie," *Library* (April 21, 1900), pp. 8–9, reprinted in *World and the Parish*, vol. 2, pp. 763–764.

119. Child, "American Artists," p. 498.

120. Johnson purchased *Nocturne: Grey and Silver* (ca. 1873–1875, Philadelphia Museum of Art) through M. Knoedler & Co., New York, in 1894 (see Merrill, *With Kindest Regards*, p. 95 n). Gardner purchased *Nocturne: Blue and Silver—Battersea Reach* (cat. 5) in 1895. Freer purchased *Nocturne in Black and Gold: Entrance to Southampton Water* (ca. 1875–1876, Freer Gallery of Art) in 1897 and *Nocturne: Blue and Silver—Bognor* (see. fig. 114) in 1899.

121. Cox, "Whistler and 'Absolute Painting,'" p. 638.

122. Whistler to Freer [July 19, 1899], in Merrill, *With Kindest Regards*, pp. 122–124.

123. For more on Freer's gift to the nation, see Lawton and Merrill, *Freer*.

124. Payne, "Living Old Master," p. 552; and O'Malley, "Whistler and the Expatriated," p. 340.

125. J. Pennell, "James McNeill Whistler," p. 384.

126. Downes, "Whistler and His Work," p. 15. *Oil Paintings, Water Colors, Pastels and Drawings: Memorial Exhibition of the Works of Mr. J. McNeill Whistler,* held at Copley Hall, Boston, included 184 oil paintings, watercolors, and pastels and 318 etchings, drypoints, and lithographs.

127. Van Dyke, "Talk about Whistler," p. 10.

128. Van Dyke, *American Painting*, p. 182.

129. Caffin, "James McNeill Whistler," p. clvi.

130. Pennell journal, July 12, 1910, PWC, box 352. The exhibition, *Paintings in Oil and Pastel by James McNeill Whistler,* was held at The Metropolitan Museum of Art, New York, March 15–May 31, 1910. On this being its first exhibition devoted to a single artist, see Richard A. Canfield to Joseph Pennell, November 2, 1908, PWC, box 280; and Annie Nathan Meyer, "New York's Notable Whistler Exhibition," *Harper's Weekly* (1910), pp. 17–19, PWC, box 294.

131. James Huneker, "Certain American Painters: Whistler," in *Pathos of Distance*, p. 105.

132. New York, Association of American Paintings and Sculpture, *International Exhibition of Modern Art,* Armory of the 69th Infantry, February 15–March 15, 1913. The Whistler paintings included *Copy after Ingres's "Roger délivrant Angélique"* (1857, Hunterian Museum and Art Gallery, University of Glasgow), as *Andromeda*; *Study in Brown* (ca. 1884, Muskegon Museum of Art), as *A Study in Rose and Brown*; *Blue and Coral: The Little Blue Bonnet* (ca. 1898, Liebes Collection); and *Rose et or: La Napolitaine* (ca. 1897, Kennedy Galleries).

133. G. Rose, "Whistler and His Influence," p. 12.

134. Max Weber, letter to the *New York Sun*, "Mr. Pennell, Mr. Weber, Mr. Chase, Mr. Whistler," March 10, 1918, vertical file (Chase), Thomas J. Watson Library, Metropolitan Museum of Art, New York.

135. Caffin, "James McNeill Whistler," p. clvi.

Marc Simpson

Venice, Whistler, and the American Others

DURING HIS LIFETIME, THE LOWELL-BORN, St. Petersburg–raised, West Point–educated, Paris-trained, London-residing, Europe-ranging James McNeill Whistler could influence others of his profession through several means: exhibited work, published responses to it, general reputation, instruction, and social contact. From the time of the Civil War through 1879, his American colleagues felt the first three of these. They rarely, however, came into contact with Whistler himself as either teacher or acquaintance. All this changed in Venice in the summer and early fall of 1880. Whistler was nearing the end of a fourteen-month stay in the city and was racing to complete the etchings and pastels with which he hoped to recoup his financial status in London. Suddenly, serendipitously, he found himself amid a set of younger American artists eager to observe and learn from him. Venice was the site of his first great impact on other Americans as instructor and personality.

Venice was awash with painters of all nationalities in the 1870s and 1880s. One American wrote in 1871 that it "swarms with artists," and a decade later Pierre-Auguste Renoir (1841–1919) joked, "I did the Palazzo Ducale as seen across from San Giorgio, something that was never done, I think. We were at least six in line there."[1] Whistler, arriving mid-September 1879 and planning a stay of three months,[2] fraternized with some of these others, even beginning, in spite of his poverty, a series of Sunday noontime meals for them.[3] But he soon came to realize that he saw about him a city different from the one they perceived. In January 1880, when the manager of the Fine Art Society wrote to ask about the status of the dozen commissioned prints due the month before, Whistler responded eloquently, if evasively:

Robert Frederick Blum, *Venetian Gondoliers* (detail, cat. 19)

The "Venice" my dear Mr. Huish will be superb . . . only I can't fight against the Gods— with whom I am generally a favorite—and not come to grief—so that now—at this very moment—I am an invalid and a prisoner— because I rashly thought I might hasten matters by standing in the snow with a plate in my hand and an icicle on the end of my nose.—I was ridiculous—the Gods saw it and sent me to my room in disgrace. . . . You see when I promised to come here and complete a set of etchings within a given time, I undertook a Herculean task with- out knowing it—but as far as the mere plates went—doubtless I should have carried out my contract had not Providence interfered [through a record bout of cold weather] greatly to the advantage of us both—and now I have learned to know a Venice in Venice that the others never seem to have perceived, and which, if I bring back with me as I propose will far more than com- pensate for all annoyances delays & vexations of spirit.[4]

"A Venice in Venice that the others never seem to have perceived." This was neither hyperbole nor excuse but the simple truth.

It was not a matter of new places or motifs. Whistler had tried that, but even he—in a city so well studied— could not manage it. Venice was too well-trod to allow an explorer-painter's discoveries. With time, rather than novel things, Whistler learned to see the well-known in a novel way. Earlier in London, with his Nocturnes, he had located pictorial quality within the commonplace, transforming the prosaic through the revelations of "sheer observation and the utmost humility and awe."[5] In Venice, however, the everyday—from the monumental to the modest—already possessed an aura of picturesque beauty:

I can't tell you how intoxicating this place is— I mean it without any exageration [sic]. . . . You say I will do this and I must do that and I ought to do the other! and if not carefull [sic], it all ends in dizziness and craze! . . . [I]t is not merely the "views of Venice" or the Streets of Venice, or the "Canals of Venice" such as you have seen brought back by the foolish sketcher—but great pictures that stare you in the face—complete arrangements and harmonies in color & form that are ready and waiting for the one who can perceive.[6]

FIG 22 James McNeill Whistler (1834–1903), *Upright Venice*, 1879–1880, etching, 9¹⁵⁄₁₆ × 7 inches, Freer Gallery of Art, Smithsonian Institution, Washington, D.C., gift of Charles Lang Freer, F1905.187.

The challenge was to avoid what he called the bewildering "entanglement of beautiful things" while celebrating the wonder of their existence—to have their energies collabo- rate with his receptive sensibility to create art.[7] Whistler's pictures of Venice—which he elsewhere called "this amaz- ing city of palaces . . . really a fairyland—created one would think especially for the painter"[8]—do not gentrify the place or promote its exoticism. They instead testify to full and unself-conscious observation and appreciation. Whistler's pride derives not from his technical dexterity but from his perceptions. As he wrote to a friend, "The work I do is lovely and these other fellows have no idea! No distant idea! of what I see with certainty."[9]

Whistler's Venetian works include a very few surviv- ing paintings, which have a respected place among his Nocturnes;[10] etchings (fig. 22) that are widely regarded as among his most beautiful and revolutionary; and pastels

FIG 23 James McNeill Whistler (1834–1903), *The Steps*, 1879–1880, chalk and pastel on brown paper, 7⅝ × 11⅞ inches, Freer Gallery of Art, Smithsonian Institution, Washington, D.C., gift of Charles Lang Freer, F1917.4.

(fig. 23) that are often seen as catalysts for the revival of the medium in the late nineteenth century. When the etchings were first shown in London, even negatively inclined critics could sense the absolute nature of the prints' recording of the site:

> What has been done, and done with a cleverness so great as to be almost genius, is to sketch the passing, every-day aspect of canal, lagoon and quay; to give, in fact, to those who have not seen the city some notion of that outside aspect, in which wealth and poverty, grandeur and squalor, life and death, are so strangely mingled. . . .
> It is not the Venice of a maiden's fancies or a poet's dreams, but the tangible Venice known to tourists.[11]

More positive writers, such as Théodore Duret, eulogized their evocative veracity: "Never has anyone attempted to render so much with so little apparent work and such simple means. Yet how this etching captures the impression we recall having had ourselves at the sight of Venice!"[12] The pastels elicited from the critics an even more favorable acknowledgment of collaboration between painter and site. The writer for *Artist,* for example, lauded Whistler as an "artist who has the eye to see and skill to preserve these beautiful realities, and who does not go about to evolve . . . an ideal Venice from his inner consciousness."[13] Whistler himself characterized his achievement when he wrote of the pastels to his son: "Every body who has seen them here is very much struck by them and all acknowledge that I have found something quite new and entirely different from any views of Venice ever done before."[14] Found, not made.

THE CITY PRESENTED WHISTLER WITH NOVELTIES beyond its picturesque populace and extravagant architecture: for the first time in his maturity, Whistler's social and artistic communities centered on Americans. Early in his stay there were two gathering places in which he felt welcome: the home of the American consul, Dr. John Harris, and the Ca' Alvisi, where Katharine de Kay Bronson (a distant relation) lived.[15] "Whistler shines at Mrs. Harris's Monday evenings," wrote one British companion.[16] Whistler later reported to his mother that Mrs. Harris "has been very charming—always asking me to her house and presenting me to all her best acquaintances—She is a dear old lady and I know you would like her."[17] The ménage at the Ca' Alvisi sparked even greater enthusiasm. Years later Whistler paid his homage: "Venice is only really known in all its fairy perfection to the privileged who may be permitted to gaze from Mrs. Bronson's balcony."[18] While the Harrises and Mrs. Bronson provided Whistler with drawing-room society and the mix of culture, wealth, and professional achievement that he was accustomed to in London, he also fraternized with artists—especially the Englishmen William H. Jobbins (active 1872–1886), William Scott (1848–1918), and Henry Woods (1846–1921) and the Americans William Graham (1841–1910) and Franklin R. Grist (1828–after 1890).[19] In mid-1880, however, the ranks of the Americans expanded dramatically, augmented by such artist-visitors as Frank Duveneck and John Singer Sargent (see cats. 56–57), young men already famous for their distinctive styles. More significant, in terms of both quantity and quality of contact, were ties with less-experienced Americans—some self-proclaimed students of Duveneck and others, such as Robert Blum (see cat. 19), who arrived independently but gravitated to the orbit of the Duveneck Boys. Here Whistler's companionship and teaching provided lasting impact.

Duveneck and his entourage of students arrived mostly over the course of April and May, coming from Florence, where they had held classes the previous winter. Whistler and Duveneck—each wildly different in person, manner, and sensibility from the other—socialized often. Whistler later claimed Duveneck as "a great personal friend."[20] The clearest testimony to their companionship is a group of etchings that each made during the summer of 1880.[21] Duveneck was new to etching, working with one of his students, Otto Bacher, to learn the craft. Nevertheless, many scholars have compared Duveneck's *Riva degli Schiavoni, No. 1* (fig. 24) and *The Riva, No. 2* (Poole 13) with prints of the site by Whistler (fig. 25 and Kennedy 192).

The overt similarities apparently come from Whistler following Duveneck's lead. Bacher later wrote that Whistler, watching as Bacher helped Duveneck bite the *Riva* plates, "frankly said: 'Whistler must do the Riva also.'"[22] Shared subject (and, apparently in the eyes of some, manner) led in 1881 to "a storm in an 'aesthetic tea-pot,'" when Duveneck's works were shown in London and a group of experts—including Whistler's hated brother-in-law, Francis Seymour Haden (1818–1910)—hinted that they were instead by Whistler. The accusation called Whistler's honesty and his relationship to the Fine Art Society into question. The debate was aired in the press, with Whistler, characteristically, having the last word.[23]

While Duveneck's prints generally do not have Whistler's variety of line, lightness of touch, and openness of composition, a number of the other plates that he etched in 1880 bear a resemblance to Whistler's and argue for sustained contact between the two. *The Archway* (fig. 26) records a subject—looking through a doorway or portico—that had engaged Whistler since his arrival in Venice, as evidenced in such plates as *San Biagio* (fig. 27); suffering from a cold over the winter, Whistler had joked, "Dear me I have had too many Sottoporticos for my health!"[24] Both Whistler and Duveneck, in fact, chose to show the same site, the Sotoportego Secondo de le Colone.[25] Duveneck's treatment and *mise en page* bring, as well, Whistler's ambitious but unfinished *Venetian Court* (Kennedy 230) to mind. Duveneck's *Salute* (fig. 28), with its open foreground—an unusual format for this artist—and schematically rendered gondolas and gondoliers, reveals many of the same decisions that Whistler made in the first state of his *Upright Venice* (see fig. 22).[26] The Cincinnati impressions of both Duveneck prints have their Whistlerianism augmented by being printed on antique laid paper, the sheet of the latter bearing on its verso an old Italian account; Duveneck rarely again succumbed to this preciosity of paper choice, which was key to Whistler's sensibility.

With the exception of the confusion in London, few of the artists' contemporaries mistook the work of the one for the other. The talented critic Mariana Griswold Van Rensselaer wrote of Whistler in 1883:

> Of late years he has worked largely in Venice, and has had about him there from time to time a group of younger workmen who, while not imitating him in any servile fashion, yet show the impress of his example. Among them is Mr. Duveneck—far too strong a man to be beholden even to a Whistler for thoughts or manner. Though doubtless inspired by Whistler's plates to work from similar themes, his products

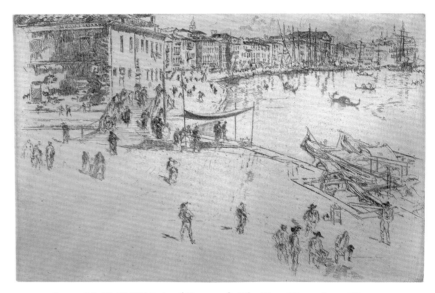

are of an original sort. It is hard to explain such differences in words; but I may say that his plates are more massive, more full of detail and color, while showing less individuality of sentiment and a less free and graceful linear beauty than Mr. Whistler's.[27]

The period when Duveneck and Whistler were working along parallel paths, "much amongst all the etching business" together, was brief.[28] Others of Duveneck's prints from 1880, such as the mistitled *The Riva, Looking toward the Caserna* (fig. 29),[29] have an emphasis on dark lines that

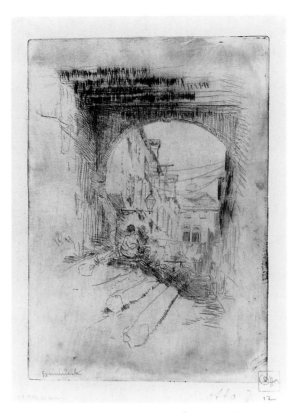

FIG 26 Frank Duveneck (1848–1919), *The Archway*,
1880, etching, 9¼ × 6¾ inches, Cincinnati Art
Museum, Ohio, 1910.29.

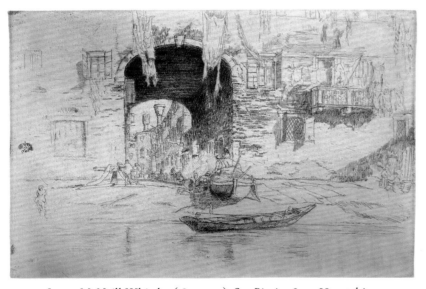

FIG 27 James McNeill Whistler (1834–1903), *San Biagio*, 1879–1880, etching,
8¼ × 11¹⁵⁄₁₆ inches, Freer Gallery of Art, Smithsonian Institution, Washing-
ton, D.C., gift of Charles Lang Freer, F1887.4.

fill the surface of the plate, defining forms and adhering
to portrayed shapes, looking more like Whistler's Thames
works than any of his Venetian etchings. Duveneck's later
plates—he worked in the medium through 1885—moved
toward ever greater linearity and darkness.

Duveneck was surrounded in Venice by nearly a score
of Americans known as the Duveneck Boys.[30] The centers
of their Venetian community were the casas Jankovitz and
Kirsch on the Riva degli Schiavoni. The rooms to the south
looked out over the Riva and across the lagoon toward all
the city's principal monuments.[31] Both *pensioni* proved to be
splendid places for work and play, yielding an environment
"more intensified, more concentrated" than elsewhere, as
one participant, John White Alexander (see cats. 15–16),
later reminisced.[32]

Whistler first encountered several of the Duveneck Boys
as he was walking near the Accademia. Bacher, writing more
than a quarter of a century after the fact, recalled seeing
Grist with a "curious, sailorlike stranger coming down the
steps of the iron bridge that crosses the Grand Canal":

> "These are all American boys," I heard the
> consul say, and when we reached him, he said,
> indicating us all, with a motion of his hand:
> "Boys, let me introduce you to Mr. Whistler."
> "Whistler is charmed," was the greeting to
> each one, as we shook his hand.
> When my turn came, the consul said,
> "Mr. Whistler, this is the boy who etches."
> "Ah, indeed! Whistler is quite charmed, and
> will be glad to see your work."[33]

Bacher next met Whistler at a small dinner. Talk at the
table turned to Bacher's etching press and its capacity,
as well as to the Whistler etchings that Bacher knew,
undoubtedly including *Billingsgate* (Kennedy 47), which
he owned and had carried to Venice.[34] Whistler promised,
"I will come and try your ink and press, and take a look
at your collection of Rembrandts and the prints you have
of mine. . . . I'm coming to see you soon."[35]

Alexander later recorded his own unmediated meeting,
with Whistler making the first contact:

> One day I was painting on one of the canals,
> surrounded by the usual little crowd of idlers
> who watch an artist over his shoulder when he
> paints outdoors. Suddenly I became conscious
> that somebody unusual was behind me. . . . I
> couldn't help turning my head, and instantly
> I jumped to my feet as if the stool had suddenly
> become red hot. It was Whistler, posing charac-
> teristically and flourishing his mustaches.[36]

Whistler's approach to Julius Rolshoven (1858–1930) was the same, but had a different effect; the younger man was painting in San Marco a few mornings after his arrival in Venice when, he recalled, "there stood in back of me one who uttered—Hym—Oh!—A—ha—yes etc. I turned to see—it was the dapper man in black. Not knowing who he really was I payed [*sic*] little attention & went about my work. Often since I have been amused at the naïveté of a youngster."[37]

In spite of his promise to Bacher to call "soon," it was perhaps as late as June before Whistler visited the Casa Jankovitz. He came unannounced, surveyed the house's bohemian atmosphere, returned almost daily for two weeks to work on views in pastel or etching from the windows, and then moved there, into "a single room with two windows looking toward the Doge's Palace, San Giorgio, and the Salute."[38] By July, Bacher could write, "We are nicely situated here—have a good view from our windows and the advantage of the fellow students to look at what you are doing and helping you, beside the good influence of Duveneck and Whistler. The latter lives in our house—he seems to have taken to the boys and likes their company."[39] The mood was easy among them, the atmosphere informal. Henry Rosenberg (1858–1947) later recounted, "Whistler used to say to the 'Boys': 'You can run into my room any time.'"[40]

Whistler, fifteen or twenty years older than most of the Duveneck Boys, soon found himself mentoring them, both by example and critique. Generosity and enthusiasm for others' work are not part of the popularized Whistler persona, but there is recurring testimony of it. Bacher, recalling Whistler's fierce criticism of a celebrated painting by the Italian Ettore Tito (1859–1941), observed, "His criticism of a student's work was in an entirely different tone."[41] Alexander, too, marveled that at their first meeting Whistler was a kind and perceptive commentator of his work, helpful rather than hurtful: "Instead of criticizing the picture, he spoke only in the kindliest manner, suggesting where the composition might be improved, and where a bit of color needed a higher tone. . . . He did not try to be censorious at all, only helpful."[42] Harper Pennington recorded that

> it was impossible to describe how gently Mr. Whistler, poking a little kindly fun, taught us to see the stupidity of our garish efforts. Never once was there a word spoken by him which could offend the touchiest of touchy geniuses. With unending patience, by his own example chiefly, the great man led the small ones on from point to point until some of his own sweet reasonableness was grasped by his eager followers.[43]

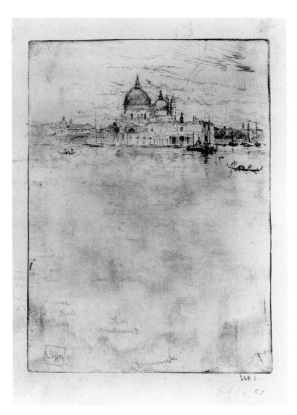

FIG 28 Frank Duveneck (1848–1919), *Salute (Large Plate)*, 1880, etching, 9⅝ × 6¾ inches, Cincinnati Art Museum, Ohio, 1910.27.

FIG 29 Frank Duveneck (1848–1919), *The Riva, Looking toward the Caserna*, 1880, etching, 9¾ × 14¾ inches, courtesy of the Royal Society of Painter-Printmakers, London.

These lessons, in tandem with others, allowed a number of the Munich-trained painters, known for the rich darkness of their palette and their often thick, markedly applied paint, to develop a smoother, less obvious technique, with reduced emphasis on the act of making.

Even more important than his words was the example of Whistler's continual creativity, bolstered by his physical stamina and concentration. While some of his immediate instruction involved oil painting, much of it revolved around the art of etching—the reason, after all, that Whistler was in Venice. Bacher was the Duveneck Boy best prepared to benefit from Whistler's example.[44] He later remembered how Whistler expanded his notion of the medium:

> He made his etched lines feel like air against solids; that is the impression some of his rich doorways of Venice gave me. He was the first to show me how to etch a deep, variegated door with a deeper figure somewhere in that darkness, all contrasted against something in the near opening that was much darker and which made the doorway effective.[45]

"Air against solids" means that the lines themselves are no longer used solely to describe form. This had a notable impact on the character of Bacher's plates. Rosenberg recalled that, before Venice, Bacher had etched, "but he knew little of its possibilities, using it more as line drawing than as tonal material. It was not till after he had met Whistler that his work became more solid in tone and planes."[46] He also, under Whistler's influence, altered the manner of

biting his plate.[47] "It is a treat for us to see his work, I can assure you," Bacher wrote in July. "I have never been placed in a better position than now to do copper work. With ten or a dozen of Whistler's coppers around my room."[48]

Whistler was preoccupied with how to evoke the Venetian panorama at night. He worked at the problem in oil and pastel, where the darkness of the ground and the softness of objects' contours, together with a few bright spots evocative of lights, convey "night." He dashed off summary pencil sketches of moored ships and gondolas enveloped in darkness.[49] He talked about his method in these processes, too, expatiating to at least Bacher, Woods, and Pennington on the paintings and drawings. It is not clear, however, that he was quite so open about his plans for the nocturnal effects in the most innovative of his Venetian prints, such as *Nocturne* (fig. 30) and *Nocturne: Palaces* (Kennedy 202). Here Whistler relied not on a traditional web of linear hatching, but on plate tone—ink left on the plate and manipulated with hand or rag—to convey the impression of night. This technique, known as artistic printing, was controversial.[50] When *Nocturne* was first exhibited in England, one critic claimed that it "can hardly be called, as it stands, an etching; the bones as it were of the picture have been etched. . . . [B]ut when it comes to 'painting' the plate with dilute ink it can scarcely be called etching."[51]

Whistler obviously planned to use smeared ink to give his thin-boned Nocturnes their final look. But he seems not to have printed these while in Venice.[52] This would explain his later note to Bacher: "You have no idea of the

FIG 30 James McNeill Whistler (1834–1903), *Nocturne*, 1879–1880, etching and drypoint, 7¹⁵⁄₁₆ × 11⅝ inches, Freer Gallery of Art, Smithsonian Institution, Washington, D.C., gift of Charles Lang Freer, F1898.379.

success of the etchings and pastels—but better still you have no idea of their real beauty—especially the etchings. If you could see the lovely proofs I have pulled."[53] It would also explain why Bacher, who had earlier experimented with monotypes (artistic printing without any etched lines whatsoever), eschewed manipulated plate tone in his nocturnal etchings. Instead, in such works as *A Rainy Night, Venice* (fig. 31), he covered the sky, the undefined silhouettes of the darkened architecture, and the lights reflected on water with a welter of parallel, near-vertical lines. These suggest rain, yet hold ink, and so augment a literal darkness across the sheet, creating a screen that defines the picture plane as readily as it does the fictive elements of rain and night. This is an effect very different from the softened, ineffable darkness of Whistler's inky fume. More in keeping with Whistler's manner, although still distinct from it, is Bacher's large vertical plate *Bridge of Sighs* (fig. 32). Sometimes printing with green ink, Bacher suggests the famed architecture with an orderly weaving of lines that give form to the monument near the top of the picture, then fall, long and ever fewer, to limn the canal and its reflections; large expanses of the plate are untouched by the needle. Bacher's generally even plate tone, however, does not mime blackness. Night comes with a pastel green tone, a haunting lack of detail, and the suggestion of radiant lamps.

Bacher and Duveneck were not alone among the Casa Jankovitz printmakers responding to Whistler. Charles Corwin, Joseph DeCamp (1858–1923), Charles Freeman (1859–1918), George Hopkins (1855–1923), Rolshoven, Rosenberg, Ross Turner (1847–1915), and Theodore Wendel (1859–1932) all made etchings there, many of them redolent of Whistlerian traits: motifs of archways or small, anonymous canals with arching bridges; cunningly suggested figures subordinate to architecture; relatively open line work and vignetting; and, using doorways and windows,

FIG 32 Otto Bacher (1856–1909), *Bridge of Sighs (Ponte dei Sospiri)*, 1880, etching, 14⅜ × 6⁷⁄₁₆ inches, The Metropolitan Museum of Art, New York, Rogers Fund, 1919, 19.14.11.

a geometrically keen ordering of the composition.[54] Their interaction is exemplified by an impression of Bacher's *Two Boats, Venice*. The sheet, according to the catalogue of his estate auction, was "Printed by Maud Whistler on Japan Paper. Very Rare. In the lower margin Mrs. Whistler has penciled her monogram." According to Bacher himself, "Madame Whistler printed this etching upon my press, Whistler was present while printing was in progress."[55]

The extent of the etching activity in the Casa Jankovitz by the Duveneck Boys became evident at various international venues. Bacher showed eighteen prints (more than any other exhibitor, among them fourteen new Venetian scenes) at the inaugural exhibition of the Society of Painter-Etchers in London in 1881, where Duveneck's three Venetian prints had caused a stir.[56] The critics associated these, too, with Whistler: "M. O. Bacher sends a series of etchings of Venice, which reminds us of Mr. Whistler's work."[57] For the Society's exhibition of 1882, Rosenberg and Wendel sent Venetian scenes to join three Italian views sent by Bacher.[58] The Americans also showed in the United States. Bacher sent eighteen Venetian etchings to the Society of American Artists exhibition in New York in 1881.[59] Corwin, Hopkins, Rosenberg, and Wendel—in addition to Bacher and Duveneck—showed Venetian scenes at the *Exhibition of American Etchings* in the spring of 1881 at the Museum of Fine Arts, Boston.[60] In 1882, at the *First Annual Exhibition of the Philadelphia Society of Etchers,* a private collector lent twenty works by Whistler, including six Venetian scenes, while Hopkins and Wendel sent two and four, respectively.[61] These men stood apart from the others who were reviving the medium in America.[62] Van Rensselaer articulated the distinction in 1884, noting a group formed by "Mr. Whistler and a few who have been inspired by him and Venice."[63] She praised not only the manner of the etchings but the approach to the subject matter, with emphasis on the discovered rather than the imagined:

> It should be noted—as a happy sign once more—
> that, from Whistler and Duveneck down to their
> last young pupil, it is not the Venice of tradition
> or of fantasy which has inspired the needle, but
> the Venice of to-day,—that modern life where the
> nineteenth century utilizes the relics of the *cinque
> cento;* where great ships loom up amid the hurry-
> ing gondolas, and where smoke and steam play
> their not ignoble part in the gorgeous panorama
> of Venetian skies.[64]

Venice, the city of color, had through the impetus of Whistler and Duveneck inspired some of the most advanced black-and-white visions among American artists.

Starting in September, Duveneck and his Boys moved back to Florence to carry on with their classes. Several of them, however, maintained their ties with Whistler for years. Being younger, most survived Whistler and wrote about him and their times together; Bacher's efforts dominated, but Willis Seaver Adams (1844–1921) and Pennington both published accounts, and others—Rosenberg, Curtis, and Alexander—shared their memories with biographers and collectors. Together, they ensured that their few months with Whistler in Venice in the summer of 1880 would long be remembered.

OF THE AMERICAN CIRCLE IN VENICE DURING the summer of 1880, Robert Blum evidently felt the impact of Whistler's presence most profoundly.[65] Although a year younger than Bacher, Blum had been earning his living as an illustrator for two years. He was in Europe for the first time, part of a campaign to win a name for himself through his paintings and watercolors; the latter, when shown in 1879, had prompted one critic to complain of "radicalisms and technicalities which made Whistler seem rather sane and commonplace."[66] Blum arrived in Venice on May 28, 1880. A week later, probably drawn by friendship with DeCamp, Louis Ritter (1854–1892), and Wendel from their days together in Cincinnati studying with Duveneck, he rented a room at the Casa Jankovitz.[67]

Whistler soon made Blum's acquaintance, made free use of his room, and encouraged the younger artist. Blum wrote to his family on June 27, "Whistler is here, and I know him well, and he is very busy making an etching from my window and he seems very much interested in me and though I am sometimes dissatisfied with my work he always encourages me. He is a nice man."[68] The familiarity was sufficient for Blum to draw Whistler at work (fig. 33).[69] Whistler seems to have been Blum's principal companion for the two months of his stay (Blum left Venice on August 6).[70] There was something about the older man that allowed the young ones to cavort in his presence. At least once, Blum's sense of the bizarre worked to their mutual advantage: the two wanted to cross one of the city's bridges but had no money for the toll; Blum, perhaps to mimic Whistler's signature monocle, stuck "in his eye a little watch with a split second hand that went round so fast the keeper thought he had the 'evil eye,' and they got over without paying."[71]

For most of his time in Venice, Blum worked on watercolors (fig. 34), the medium through which he had attracted most attention in New York art circles. On his return to the United States he exhibited six Venetian scenes in the American Water Color Society's annual exhibition, which

FIG 33 Robert Frederick Blum (1857–1903), *No Doubt This Is "Jimmy,"* 1880, pencil on paper, 6⅞ × 4⅛ inches, Cincinnati Art Museum, Ohio, purchase from the W. J. Baer Folsom Fund, 1916.119.

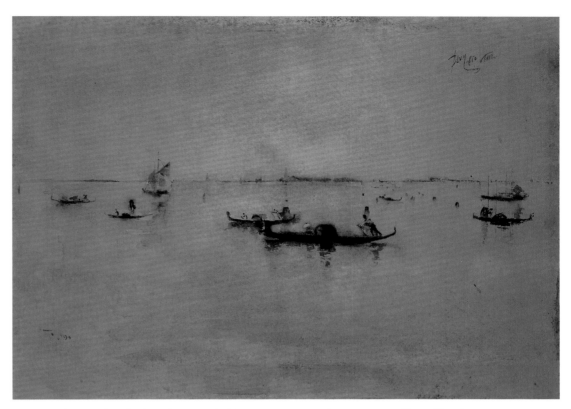

FIG 34 Robert Frederick Blum (1857–1903), *Venice*, 1880, watercolor on paper, 10¾ × 14¾ inches, Spanierman Gallery, LLC, New York.

opened in January 1881. Although Whistler worked hardly at all in watercolor while in Venice (and his earlier works in the medium were little-known in the United States), the New York critics had no hesitation in associating Blum's watercolors with Whistler: "Mr. Blum is skillful, but whether individual or not cannot yet be seen. At any rate his work is like that of only a few other painters, men of distinguished ability. Fortuny or Whistler are the names which are surest applied to Mr. Blum."[72] The same kind of criticism would recur in later years as Blum exhibited further watercolors from subsequent stays in Venice: "Mr. Blum's drawings this year [1882] are simply and purely tinted Whistler etchings."[73] (Blum had etched before his arrival in Venice; he, too, doubtless contributed to the etching activity at the Casa Jankovitz—although he does not seem to have participated in the revival of etching through the public exhibition of his Venetian works in 1880 or 1881, nor are any of his extant Venetian plates dated to 1880.)[74]

Aside from his art, Blum manifested the influence of Whistler in his presentation of himself and his position in society. Blum's extravagant studio designs, described on the back of a Venetian drawing of 1880, can be linked directly to Whistler in terms of color and motifs.[75] His advocacy of aesthetic dandyism, too, derives from his

Venetian friendship with Whistler, as he suggested in a note of 1882: "Last week I made the acquaintance of Oscar Wilde of whom you have certainly heard through the newspapers. We became very good friends because he knows my friend Mr. Whistler."[76] And although there is no further documented contact after 1880,[77] Blum and Whistler continued to think of one another. When a dealer friend from London was planning a trip to New York in 1888, Whistler was full of advice as to whom he should meet, including "Young Blüm—Robert Blüm—a delightful chap—and one of my chums in Venice [—] give him all sorts of messages for me."[78]

It was principally through Blum that Whistler had a further, profound impact on the art world of the United States: the promotion of the medium of pastel. Whistler's pastels of Venice were revelatory, as he, with characteristic immodesty, wrote: "I assure you the people—painter fellows—here, who have seen them are quite startled at their brilliancy."[79] Indeed he predicted, "I fancy that the pastel business will become quite the fashion—that is lots of chaps will be sure to go in for pastels!"[80] And he was right. Although pastels were exhibited by advanced artists in France in the 1870s and 1880s, it was the exhibition of Whistler's Venetian pastels at London's Fine Art Society in January 1881 that transformed the status of the medium

FIG 35 Robert Frederick Blum (1857–1903), *Somber Venice*, ca. 1886–1887, pastel on dark gray paper, 8 1/16 × 11 15/16 inches, Sterling and Francine Clark Art Institute, Williamstown, Massachusetts, 1955.1567.

in the Anglophone world.[81] As Bacher, blessed with hindsight, observed, "Whistler lifted pastels from the commonplace to a very artistic medium. . . . It was really left to Whistler to inspire future artists to use this medium as a rapid record of facts."[82]

This impression of rapidity is key to the success of Whistler's works; they seem almost to be thoughts of contours and colors rather than the physical application of line and pigment. Slight as many of them seem, however—with overt skeletons of black lines, patches of unblended color, and expanses of blank paper—they are fully finished. Decades later, when asked whether he ever carried his pastels further, Whistler replied, "slowly and thoughtfully, 'My dear boy. Never carry a medium farther than it ought to go.'"[83] In spite of their lack of detail, Whistler's Venetian pastels attained for him a signal critical success, even from the writers who habitually derided his oils and prints.[84] Financially, too, they were a resurrection for the artist. A friend reported, tongue-in-cheek, that Whistler "fears his pastels are not so good as he supposed—for they are selling."[85]

As he had predicted, others followed his lead, including Americans, Blum foremost among them. In 1884, Van Rensselaer celebrated, "We cannot but rejoice that still another medium has recently found favor with our younger workmen. The first annual exhibition of the 'Society of Painters in Pastel' was held in New York in the month of March." In a long article she traced the history of the medium, including a consideration of Whistler's impact, claiming that he "gave it fresh impulse and popularity with his exquisite, subtile [*sic*],

yet freely handled and brilliantly colored Venetian studies."[86] Blum was the president and leading spirit of this Society of Painters in Pastel.[87] Sometimes he made large, detailed pastels that approached the scale and effect of finished paintings with blended colors and carefully worked details. On more than one occasion, however, he followed Whistler in capturing a glimpse of a scene, leaving the toned paper exposed, using simply drawn architecture as scaffolding, and providing individual color accents as points of interest.[88] These Whistlerian characteristics were most evident in the second exhibition of the Society in 1888, when Clarence Cook fumed over the evident impact of Whistler visible on Blum's thirty-one Venetian and Dutch scenes:

> I do not understand why, with such undoubted talent of his own, Mr. Blum should linger so long as he does in the imitative stage. Almost everything of his in this exhibition reminded one of Mr. Whistler, and did that artist the doubtful service of showing how easy it is to hold the mirror up to his favorite aspects of nature. . . . [S]ince these aspects of Venice have been, once for all, recorded by Whistler in a way it would be idle for any one else to rival, why should not the field be left to him, and laurels be sought in some other place by young ambitious artists whom the older's laurels will not let sleep?[89]

Among Blum's works on exhibit was a sheet called *Somber Venice* (fig. 35), described approvingly by a writer for the *New York Times* as "drawn on dark-gray cartridge paper . . . a street paved with smooth stones and peopled with shadowy figures."[90] The paper provides the tone and atmosphere of the chill scene, with shawl-wrapped women moving through the city's glistening streets. Van Rensselaer, in her review of the exhibition, may have been thinking of this work when she praised Blum's "hasty, brilliant sketches in which the gray-toned paper was largely left uncovered, while the high notes and the low accents were given by the crayon."[91] Blum's open technique and appreciation of materials—letting them have voice—brought Whistler to the minds of several writers: one noted Blum's "facile cleverness" and saw in his work "the same brilliant touch and the same leaning to Whistlerism, with sometimes an exaggerated estimate of the tone-value of the paper."[92]

Blum's decision to limn the architecture of *Somber Venice* in different colors, however, with lighter gray at the edges moving to deep black at the center, signals a shift from Whistler's technique. Moreover, while the architectural setting rhymes with Whistler's, as do distinctive individual

colors (such as the lime green of the distant shutters), Blum's color combination of turquoise, orange, lilac, and lime green exceeds even the most outrageous of Whistler's chromatic harmonies. Nor would the older artist have washed liquid over the lilac powder of the sky, flattening it into a paste and affixing it to the paper like gouache. Blum's horizontal format, too, and his portrayal of people in motion, set *Somber Venice* apart from most of Whistler's genre pastels, which generally feature still figures in narrow, vertical spaces.[93] Although Blum died young, the same year as Whistler, and so did not write a series of memoirs or acknowledgments to the older man, much of his work, and even the way he lived and the surroundings he chose, reveals their strongly shared sympathies.

In September 1880 (after Whistler had had at least one farewell send-off, Blum had left the city, and Duveneck and his Boys were heading back to Florence), a fresh young American arrived in Venice: John Singer Sargent. There is no record of Sargent and Whistler meeting in Venice, although it seems likely that they did, with their common interests and many mutual friends— Mrs. Bronson and Ralph Curtis among them.[94] Bacher implies their acquaintance: "Whistler had many friends outside of Duveneck's class of boys. . . . John Sargent he looked upon as a clever man."[95] There are certainly points of contact between their works. Foremost, they shared sites and subjects. Sargent's *Venise par temps gris* (fig. 36) looks westward toward the Grand Canal from a point midway along the Riva degli Schiavoni, achieving through different means the same tonal interest and figural dynamism that Whistler attained in his print *The Riva, No. 2* (see fig. 25)—especially given the contrast between the painting's wintry dawn and the etching's bright summer's day. Sargent's emphasis on atmosphere and his limited color choices, summary details, and high, panoramic viewpoint (a relatively unusual choice for him) all combine to make *Venise par temps gris* the most "Whistlerian" of his oils.[96] Recent scholars, however, have pointed out that many fashionable Parisian painters were undertaking urban views in tonal palettes during these years, and that it is unlikely Sargent had Whistler's London Nocturnes in mind while he painted this canvas.[97] Indeed, Sargent's painting technique is wholly unlike that of the older artist, with the tracks of his dynamic and fluent brush obvious, the color balance evenly divided and contrasting, and the tonal range moderated.

More suggestive is the fact that at different times Sargent and Whistler worked in the same room, Sargent on a cluster of oil paintings—*A Venetian Interior* (ca. 1882, Clark Art Institute), *Venetian Bead Stringers* (ca. 1882, Albright-Knox

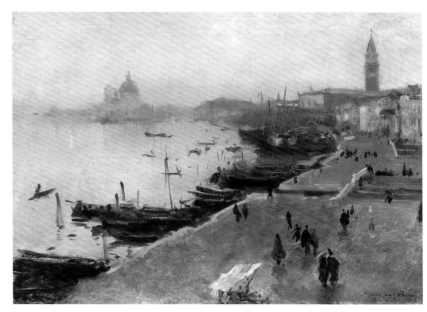

FIG 36 John Singer Sargent (1856–1925), *Venise par temps gris*, ca. 1880, oil on canvas, 20 × 27½ inches, private collection, U.K.

Art Gallery), and *Venetian Interior* (fig. 37)—Whistler on a small pastel, *The Palace in Rags* (fig. 38). The precise location of this room is uncertain—a "provoking" fact, writes the scholar who has tracked down the sites of nearly all the other of Whistler's works and who notes that it "*may* show a *portego* in the palace [Ca' Rezzonico—where Whistler is reported as having a studio in 1879, and where Sargent certainly did in 1880] before restoration started but the proportions seem wrong."[98] In any event, the contrast between the works overwhelms their shared locale.

When Whistler set about drawing the place, he positioned himself squarely in the middle of the stairwell at one end of the room, placing a single point of brightness— the distant doorway—at the center of his sheet. Otherwise he kept the room dark and set his figures far away, so that shadowed, empty space dominates the quiet composition. Sargent, by contrast, set himself to the side of the hallway, making one of the two long walls fill the canvas, while the other, nearer one recedes precipitously. The distant light of door or window is thus off-center, setting the scene into motion—an oblique approach characteristic of Sargent's early Venetian views. Sargent likewise establishes secondary bright spots through streaks of light that punctuate the length of the hallway and, more important, positions some of the characters close to the picture plane, emphasizing their bodies as of at least equal importance to the play of light in the hallway. More crucially, Sargent establishes a dynamic among his figures that transmits the idea of their inner lives and motivations. The viewer may not be able to discern them clearly—indeed, their mysterious indecipherability is a consistently appealing part of his

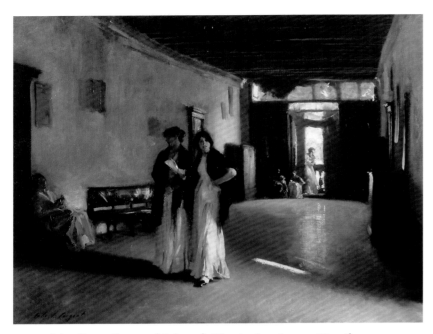

FIG 37 John Singer Sargent (1856–1925), *Venetian Interior,* ca. 1882, oil on canvas, 26⅞ × 34³⁄₁₆ inches, Carnegie Museum of Art, Pittsburgh, purchase, 20.7.

FIG 38 James McNeill Whistler (1834–1903), *The Palace in Rags,* ca. 1879–1880, chalk and pastel on paper, 11 × 6 inches, private collection, England.

paintings' charm—but it is certain that Sargent's people live their own lives, existing for reasons quite apart from the painter's pictures. So if Sargent met Whistler, or saw any of the works that Whistler had undertaken in Venice, it seems that they did not directly inspire him. More to the point were shared sensitivities to spots away from the tourists' main sites, a period eye to darker tonalities and schematic rendering, and a shared admiration for the city and its inhabitants.

VENICE (WHICH WHISTLER WAS LATER TO CALL A "marvelous City—the Sapphire of the Seas!") stayed long on the artist's mind.[99] As late as the 1890s he wrote to one of his Venetian colleagues, "Long before now I hoped to have returned—and then perhaps to do myself, and that most beautiful city, something more like justice—It is still my dream."[100] His return, however, was never more than metaphoric, in the contemplation of his completed work and in the continuing obligation to print his Venetian etchings. But if Whistler did not set foot in Venice after the winter of 1880, his spirit lingered, dictating how others would come to see the city. When Elizabeth and Joseph Pennell visited Venice in the fall of 1885, staying with Duveneck on the Riva, they found that Whistler was still "the hero of the cafés and trattorias Duveneck introduced us to." They recalled that it was "a little more than four years since Whistler, in his wide-brimmed hat and flowing tie, penniless and waiting for payment, watched over by Maud, tireless, working from dawn to dusk, had become a rival of Duveneck with the 'Boys,' and created the Whistler Legend."[101] The effect was pervasive. "At any *café* or restaurant or house or gallery where two or three artists were gathered together, Whistler stories were always told before the meeting broke up."[102] Along with the anecdotes, Whistler's works exerted a powerful influence on those who followed him to Venice.[103] More than coincidence prompted one observer to note—just after the third of Whistler's London exhibitions of his Venetian work—the "rise of a whole school of English and American artists who owe their inspiration to Venice," and to claim that at "no time have painters and etchers been more actively engaged in Venice than they are to-day."[104]

Among the Americans, Joseph Pennell saw the First Venice Set of etchings on its American tour in 1881 and a larger number of Whistler prints in the *First Annual Exhibition of the Philadelphia Society of Etchers* the next year.[105] When he first traveled to Venice in 1883, his choice of subjects and points of view echoed those of Whistler— as is evident in his illustrations to the article that proclaimed the rise of the "whole school of English and American artists."[106] And Pennell's later pastels, made to accompany

a gathering of Henry James's essays on Italian sites, reveal that the influence grew stronger over the decades (unsurprisingly, given his friendship and work on the authorized biography), causing him to use dark papers, black outlines of the vignetted scenes, and light touches of generally unblended color.[107] Francis Hopkinson Smith (1838–1915), in his immensely popular compilation of writings and pictures, *Gondola Days*, of 1897, went so far as to title one of his drawings—showing the characteristic view of a *sottoportego*—"The One Whistler Etched." And the points of view and tonalities employed by Maurice Prendergast (1858–1924), who visited the city first in 1898 and 1899 and then again in 1911, are Whistlerian in feel. Even among younger men, Whistler's Venetian works continued to exert a powerful pull; John Marin (1870–1953), who visited Venice in 1907, made pastels on dark-toned papers and, in his own Whistlerian words, "incidentally knocked out some batches of etchings which people rave about everywhere."[108] Many others followed.[109]

When Whistler died in 1903, numbers of artists paid tribute to his memory and addressed the question of his influence. Some of these tributes were bizarre: "Now that Whistler is dead it is, it must be frankly said, far better that what may be called his visible influence should die with him."[110] Edwin Austin Abbey, though not one of the Americans who shared Venice with Whistler in the summer of 1880, was more perspicacious. He grasped the essential point of Whistler's impact on his fellow artists: "Few men have made so great a mark upon their time and few men have left their work so complete. He taught men to see something very subtle that *he* saw. He painted completely what he wished to show them, and left no loose ends behind him for others to perfect. I think very few artists have done that. Some have—but mighty few."[111] Venice was one of the key sites where that teaching, the sharing of that subtle and complete seeing, took place.

NOTES

For their aid I am grateful to William and Abigail Gerdts; Linda Merrill; Fronia Wissman Simpson; Julian Brooks (Ashmolean Museum, Oxford); Simon Fenwick (Bankside Gallery, London); Bruce Weber (Berry-Hill Galleries, New York); Kristin Spangenberg and Julie Aronson (Cincinnati Art Museum); Constance McPhee, Dana Pilson, Catherine Sill, and Thayer Tolles (The Metropolitan Museum of Art); Sue Welsh Reed (Museum of Fine Arts, Boston); Esther Bell, James A. Ganz, Bong Hee Liss, Paul Martineau, and Nancy Spiegel (Sterling and Francine Clark Art Institute, Williamstown, Massachusetts); Lee Dalzell (Williams College Libraries, Williamstown, Massachusetts); and Stefanie Spray Jandl (Williams College Museum of Art, Williamstown, Massachusetts).

1. Charles Caryl Coleman to Elihu Vedder, October 1871, quoted in Lovell, *Venice*, p. 34; and Renoir to Charles Deudon, ca. fall 1881 ("J'ai fait le palais des Doges vu de Saint-Georges en face, ça ne s'était jamais fait, je crois. Nous étions au moins six à la queue leu leu"), French quoted in White, "Renoir's Trip to Italy," p. 347.

2. "I . . . now rush off to Italy instantly where I am to be in Venice until December. I am to do the long promised set of etchings and have engaged to finish them by the 20th Dec" (Whistler to George A. Lucas, September 13, 1879, quoted in Mahey, "Letters of Whistler to Lucas," p. 254. Mahey dates the letter to May 3; MacDonald provides the more reasonable date of mid-September [*Palaces in the Night*, p. 17]).

3. "There was no room for many guests at one time, but Henry Woods, Ruben, W. Graham, Butler, and Roussoff (at that time just taking up art) were often with us. The latter, a brilliant talker, masterful, combative, intolerant, had many a wordy battle-royal with Whistler" (Scott, "Reminiscences of Whistler," pp. 97–98).

4. Whistler to Marcus B. Huish, ca. January 21–26, 1880, quoted in MacDonald, *Palaces in the Night*, pp. 143–144.

5. Sickert, *Whistler*, p. 32.

6. Whistler to Matthew Robinson Elden, ca. April 15–30, 1880, quoted in MacDonald, *Palaces in the Night*, pp. 148–149.

7. Ibid., p. 148.

8. Whistler to Anna Matilda Whistler, ca. March–May 1880, quoted in MacDonald, *Palaces in the Night*, p. 147.

9. Whistler to Charles Augustus Howell, January 26, 1880, quoted in MacDonald, *Palaces in the Night*, pp. 144–145.

10. The two most notable are *Nocturne in Blue and Silver: The Lagoon, Venice* (1879–1880, Museum of Fine Arts, Boston) and *Nocturne: Blue and Gold—St. Mark's, Venice* (1879–1880, National Museum of Wales). Grieve has further suggested that a Nocturne previously catalogued as being of the Thames (*Nocturne*, Hunterian Museum and Art Gallery, University of Glasgow) may instead be a view eastward from the Casa Jankovitz toward the Public Gardens with the Lido in the distance (Grieve, *Whistler's Venice*, p. 124).

11. [Harry Quilter], "Mr. Whistler's 'Venice' at the Fine-Art Society, New Bond Street," *The Spectator* 53 (December 11, 1880), pp. 1586–1587, quoted in MacDonald, *Palaces in the Night*, p. 95.

12. Théodore Duret, "English Artists—James Whistler," *Gazette des beaux-arts* (March 1881), translated and reprinted in Spencer, *Whistler*, p. 197.

13. "Mr. Whistler's Pastels," *Artist* (March 1, 1881), p. 72, quoted in MacDonald, *Palaces in the Night*, p. 106.

14. Whistler to Charles James Whistler Hanson, May 2, 1880, quoted in MacDonald, *Palaces in the Night*, pp. 149–150.

15. MacDonald, *Palaces in the Night*, p. 23.

16. Henry Woods to Luke Fildes, spring 1880, quoted in Fildes, *Luke Fildes*, p. 64.

17. Whistler to Anna Matilda Whistler, ca. March–May 1880, quoted in MacDonald, *Palaces in the Night*, p. 147.

18. Whistler to Katharine de Kay Bronson, ca. 1885–1890, quoted in MacDonald, *Palaces in the Night*, p. 23. Anticipating her visit to London, Whistler wrote to Mrs. Bronson in an undated letter: "How very glad I shall be to see you again—you who have always been so bienveillante for me—and whose kindness and hospitality to me in Venice I can never forget" (PWC, box 14).

19. Woods wrote of Whistler and Jobbins's relationship: "Whistler, I hear, has been borrowing money from everybody, and from some who can ill afford to spare it. He shared a studio for five or six months with a young fellow named Jobbins. Jobbins never could work there with him in it. He (Whistler) invited people there as to his own place, and has never paid a penny of rent" (Woods to Luke Fildes, late August 1880, quoted in Fildes, *Luke Fildes*, p. 65). For a devastating portrait of Jobbins, see E. Pennell, *Nights*, pp. 90–91, 95–96.

Whistler wrote of Graham, who had married a Venetian woman in 1874 and was at home in the city, "My kind friend Mr Graham whom you remember my writing to you about, has been away some weeks in Rome—returning only the other day—I was glad to see him for he had been most courteous and persistent in his good services to me" (Whistler to Anna Matilda Whistler, ca. March–May 1880, quoted in MacDonald, *Palaces in the Night*, p. 147). Graham and Whistler corresponded at least until 1895.

Grist was a graduate of Yale who later served as an artist with Harold Stansbury's surveying expedition to Utah. In 1850 he was in Northern California and then Washington, D.C., where he painted portraits (Abstract of the Elizabeth Washington Grist Knox Papers no. 4269, Southern Historical Collection, Manuscripts Department, Library of the University of North Carolina at Chapel Hill). Grist stayed in Europe for thirty-five years. In 1884, when he was unsuccessfully nominated as deputy consul of Venice, his sponsor wrote, "Mr. Grist has lived in Venice for a number of years, is conversant with the language and customs of Italy, and is a gentleman most thoroughly respected, both by natives and foreigners" (McWalter B. Noyes to William Hunter, July 9, 1884, in *Despatches from United States Consuls in Venice, 1830–1906*, National Archives, microcopy no. 153, roll T-5). He was vice-consul from 1885 until his return to the United States in 1890.

A letter written by Whistler to Graham in the winter of 1879–1880, from his lodgings on the Fondamenta dei Felzi, complaining of sore throat and seeking a doctor, concludes with the passage: "If you like to bring the Californian with you, do so" (Whistler to Graham [December 1879–January 1880], Freer Gallery of Art, copy GUL, Whistler Letterbook 4, p. 15). Perhaps Grist is the "Californian," brought into the orbit by Graham.

20. Maud Franklin to Otto Bacher, ca. April 12–30, 1881, quoted in Bacher, *With Whistler in Venice*, p. 139.

21. For an overview of Duveneck as a printmaker, see Poole, "Etchings of Duveneck."

22. Bacher, *With Whistler in Venice*, p. 144. Getscher complicates the order by positing that two of Duveneck's views of the Riva, Poole 11 and 13, preceded Whistler's works, whereas Poole 12 follows them (Getscher, *Stamp of Whistler*, p. 157).

23. Whistler, *Gentle Art*, pp. 52–65. For a summary of the exhibition at the Hanover Gallery in 1881, see Hopkinson, *No Day without a Line*, pp. 15–17.

24. Whistler to William Graham [December 1879–January 1880].

25. Grieve, *Whistler's Venice*, p. 138.

26. Getscher speculates that Whistler added the foreground view of the Riva in the second state of *Upright Venice* "to increase the difference between his print and Frank Duveneck's *Salute*" (Getscher, *Stamp of Whistler*, p. 73).

27. Van Rensselaer, "American Etchers," p. 492.

28. Maud Franklin to Otto Bacher, ca. April 12–30, 1881, quoted in Bacher, *With Whistler in Venice*, p. 139.

29. Poole reports that *The Riva, No. 1* (Poole 12) was published with the title *The Riva Looking toward the Caserna* (Poole, "Etchings of Duveneck," p. 451). However, the Royal Society of Painter-Printmakers holds an impression bearing the latter title by Duveneck, presented in 1881 as his diploma work, showing a markedly different subject—looking along a curve in the Riva across the water toward San Giorgio Maggiore. This print is, so far as I know, unrecorded outside publications on the Society and its holdings. Getscher speculates that the "term 'Caserna' is probably a misspelling made in the 1881 catalogue. The 'Caserma' or barracks in Venice are found on the Isola S. Pietro, east of the Arsenale, the ship-building yards, and north of the Giardini Pubblici" (Getscher, *Stamp of Whistler*, p. 155). The titles of all four of Duveneck's prints of the Riva have been variously published and confused with one another.

30. They included John White Alexander (see cats. 15–16), John O. Anderson, Otto Bacher, Charles A. Corwin, Joseph DeCamp, Charles Stuart Forbes, Charles H. Freeman, Oliver D. Grover, George E. Hopkins, Charles E. Mills, Albert G. Reinhart, Louis Ritter, Julius Rolshoven, Henry M. Rosenberg, and Theodore Wendel. Others in the Venetian orbit of Duveneck—joining him during the summer of 1880—included Harper Pennington, Julian Story, and Ralph Curtis. The circle also apparently included Ross Turner, Theodore Wores, Charles Gifford Dyer, Gordon Greenough, Willis Seaver Adams, and Jerome Elwell.

31. Pennell and Pennell, *Life of Whistler*, vol. 1, pp. 266–267. For a detailed discussion of the Casa Jankovitz and the works Whistler undertook from there, see Grieve, *Whistler's Venice*, pp. 106–111.

32. Alexander to Norbert Heerman, quoted in Wylie, *Explorations in Realism*, p. 16. Wylie's is the most thorough, recent exploration of the Duveneck Boys in Venice.

Heerman elsewhere wrote: "It was Corwin who had discovered the most ideal lodgings there for them in two rooming houses, one called 'Casa Yankowitz [sic],' the other 'Casa Kirsch.' Both were located near each other with most of their windows toward the south, over the shimmering lagoon and some of Venice's grandest themes swimming in the midst of it.... In the foreground they looked down upon the ever moving picture of the most fascinating street in Venice, the Riva degli Schiavoni, winding its way in one sumptuous curve and

skipping various little canals with graceful bridges toward the Doge's palace. Duveneck took a large room on one of the upper floors of the Casa Kirsch. . . . The proprietor of the Casa Yankowitz [sic] was an old Italian clock maker who also dealt in Marine instruments. The real 'Padrone' of the Casa was his wife who rented rooms above. Carmela Yankowitz [sic] was a gay, pleasure loving voluptuous signora. Her eyes sparkled and her true latin temperament could change instantly from laughter to a flashing sort of 'furia.' She used to look out of the window and smile at the Gondoliers loafing along the quay. Carmela had a great crush on the 'Boys' but became particularly sentimental about a young American. . . . This was Robert Blum" (unpublished mss. biography of Frank Duveneck, quoted in Bruce Weber, "Robert Frederick Blum," p. 106).

33. Bacher, *With Whistler in Venice,* pp. 4–8. Throughout his account, Bacher frequently records Whistler as speaking in the third person, an affectation no other commentator or friend noted. In referring to "the consul," Bacher evidently confused Grist, who was appointed vice-consul only in 1885, with John Harris who, although consul in 1880, was unlikely to have been out strolling. In February 1881, after Harris's death that month at the age of eighty-eight, his vice-consul Valentino Giordani wrote that "Dr. Harris died after having been an invalid for more than a year" (February 28, 1881, National Archives, microcopy no. 153, roll T-4).

34. Bacher, who wrote the most extended history of the Duveneck Boys in Venice, seldom used any names other than Whistler's or Duveneck's and so has assumed the central role in the narrative. According to later correspondence, however, the press also belonged to A. G. Reinhart.

35. Bacher, *With Whistler in Venice,* pp. 9–10.

36. "How Whistler Posed for Alexander," pp. 5993–5994.

37. Julius Rolshoven, unpublished memoirs, pp. 54–55, courtesy the William and Abigail Gerdts Art Reference Library.

38. Bacher, *With Whistler in Venice,* p. 14.

39. Bacher to Harold Fletcher, July 1, 1880, Fogg Art Museum, Harvard University, quoted in Andrews, *Otto H. Bacher,* n.p.

40. Henry M. Rosenberg, interview by Norbert Heerman, pp. 2–3, courtesy the William and Abigail Gerdts Art Reference Library. In spite of this invitation, there was a tacit hierarchy: "We all had great respect for Whistler. Only a few intimates would dare call him Jimmy. He was Mr. Whistler to most of us." On the other hand, Rosenberg recounted, "Duveneck was 'Duve'" (Rosenberg interview, p. 10).

41. Bacher, *With Whistler in Venice,* pp. 286–287.

42. "How Whistler Posed for Alexander," p. 5994.

43. Pennington, "Artist Life in Venice," p. 837. The author continues to record how Whistler urged an appreciation of certain of the Old Masters, especially Tintoretto.

44. Bacher owned a copy of Philip Hamerton's *Etching and Etchers* (London: Macmillan, 1868), which had provided the plans for the press he had had built in Germany and as a technical manual. Whistler and Hamerton did not see eye to eye on many issues, although Bacher reports that Whistler consulted his copy of the book (Bacher, *With Whistler in Venice,* p. 151).

45. Ibid., pp. 101–102.

46. Rosenberg to Margery Austen Ryerson, August 17, 1923 (or 1928?), courtesy the William and Abigail Gerdts Art Reference Library.

47. He changed from the recently developed methods promulgated by Hamerton to a more traditional and controlled manner of acid application. Van Rensselaer noted, "Mr. Bacher has usually etched directly from nature. At first he worked in the bath, but while in Venice he found the older process of biting and stopping out indoors to be more convenient" (Van Rensselaer, "American Etchers," pp. 492–493).

48. Bacher to Harold Fletcher, July 1, 1880, quoted in Andrews, *Otto H. Bacher,* n.p.

49. G. A. Storey wrote of being in Venice in 1880 and meeting Whistler and Woods at Florian's in the Piazza San Marco: "It was moonlight, and the waters shone like silver, the black gondolas looking intensely dark against them. Whistler was in ecstasies of delight—and made three strokes in his notebook. 'I've got it!' he exclaimed—'That's it—that reminds me of the whole scene'" (MacDonald, *Whistler: Drawings, Pastels, Watercolours,* p. 299).

50. For a strong overview of this controversy as reflected in the British press, see Bell, "Fact and Fiction," pp. 44–52.

51. *British Architect* (December 10, 1880), quoted in Fine, *Drawing Near,* p. 133. For a good discussion of the various sources of this technique and the surrounding debate, see Lochnan, *Etchings of James McNeill Whistler,* pp. 194–211.

52. An impression of *Nocturne: Palaces* appears in an early photograph of the sitting room in the Ca' Alvisi (Meredith, *More Than Friend,* p. xxxiii). It is fully inked and reliant on plate tone for its effect. Unfortunately its early history is not known. It is possible that Whistler created a few prints for a select patronage while in Venice. But Whistler and Bronson were in contact through at least the mid-1880s, with Bronson visiting London, so she could have acquired the print later.

53. Whistler to Otto Bacher, spring 1881, quoted in Andrews, *Otto H. Bacher,* n.p.

54. See, for example, Corwin's *Courtyard, Venice* and *Scene along Venetian Canal;* DeCamp's *Doorway;* Hopkins's *Venice* and *Sotto Portico del Traghetto;* Rolshoven's *Italian Courtyard;* Rosenberg's *Venetian Scene;* and Wendel's *Doorway in Venice* and *Venetian Canal.* Without exception, these young men avoided the major monuments in favor of out-of-the-way locales. Impressions of these works are in the collection of the Cincinnati Art Museum, gifts of Frank Duveneck; the plates for many of them are dated to 1880. Rolshoven's *Italian Courtyard* (Cincinnati Art Museum) is one of the few etchings of the group to use plate tone in a narrative fashion, using a cleaner wipe across the architecture while leaving the pavement and shadowed doorways a darker hue.

55. Anderson Auction Company, March 2, 1910, lot 17. Maud Franklin sometimes styled herself "Mrs. Whistler"; although she and Whistler lived together as husband and wife, there is no record that the relationship was ever formalized. The Pennells' unpublished journals record a meeting with William Scott on September 12, 1910: "He did not have anything new to tell. But he says positively that Whistler was not married to Maud—who was charming. Whistler never took her with him anywhere—never to see the Curtises or the Bronsons— and once when an official census for some reason was made in Venice and she wanted to enter her name as Mrs. Whistler, Whistler refused to let her" (PWC, box 352).

56. The catalogue of the exhibition lists Bacher's entries as nos. 7–21, 193, 194, and 475, with nos. 8–21 being Venetian subjects. Whistler unsuccessfully sought to have Bacher withdraw his submissions. Both Bacher and Duveneck were elected to membership in the Society in May 1881.

57. "The Society of Painter-Etchers," *The Spectator* 54 (April 9, 1881), p. 473, quoted in Getscher, *Stamp of Whistler*, p. 176. Getscher also notes that about 1881 Bacher produced a portfolio of a dozen etchings, *Etchings of Venice*, emulating in subject and number Whistler's First Venice Set.

58. Rosenberg sent *The Zattere, Venice*; Wendel, *Scene in Venice* and *Gemona*; Bacher, *Market—Florence*, *San Vio, Venice*, and *Wash-house, Venice*. Duveneck did not show in 1882. Wendel, as a result of his entries, was elected to membership in the Society.

59. *Society of American Artists: Fourth Annual Exhibition*, cats. 116–133.

60. Koehler, *Exhibition of American Etchings*. Bacher showed German etchings in addition to five Venetian views (cats. 7–11); Corwin had two (cats. 78–79), Duveneck three (cats. 80–82), Hopkins two (cats. 192–193), Rosenberg one (cat. 376), and Wendel two (cats. 465–466). Whistler had only British and French subjects on view (cats. 467–476).

61. *Catalogue of the First Annual Exhibition of the Philadelphia Society of Etchers*. James L. Claghorn lent the works by Whistler (cats. 978–997). Hopkins's works were cats. 109–110; Wendel's, cats. 352–355.

62. For a good overview of the American movement, see Schneider, "American Etching Revival." Neither Whistler, Duveneck, Bacher, nor any of the other men in Venice in the summer of 1880 were members of the New York Etching Club by 1882, according to Schneider's list (pp. 40–41 n. 1).

63. Van Rensselaer, "American Etchers," pp. 492–493. While giving credit to both Whistler and Duveneck in this passage, earlier the writer had made it clear that Whistler was the leading character of the group. Others also recognized the distinction. Sylvester R. Koehler surveyed works seen in London, Boston, and New York in 1881 and noted "a family likeness . . . to the set of Venetian etchings lately published by Mr. Whistler." He continued, "The explanation of this phenomenon is found in the fact that Messrs. Bacher, Corwin, Wendel, Rosenberg, and Hopkins worked together in Venice under the guidance of Mr. Duveneck, and that they all took to etching under the inspiration of Mr. Whistler, who was also in Venice at the same time, and was frequently among them. Imitation, therefore, is out of the question. The similarity is due only to the influence of teaching and the power of example" (Koehler, "Mr. Bacher's Venetian Etchings," p. 231).

64. Van Rensselaer, "American Etchers," pp. 492–493.

65. The principal work on Blum is the well-documented and thorough 1985 dissertation, "Robert Frederick Blum" by Bruce Weber, which has been my principal resource on the painter.

66. "Fine Arts. The Growing School of American Water Color Art," *The Nation* 28 (February 6, 1879), p. 107, quoted in Weber, "Robert Frederick Blum," p. 74. The writer was referring to works by Blum and Alfred Brennan.

67. Weber, "Robert Frederick Blum," p. 104.

68. Blum to his family, June 27, 1880, quoted in ibid., p. 108.

69. The drawing originally belonged to the artist William Baer, whom Blum visited in Munich in August 1880 on his way home from Venice; Baer inscribed the drawing.

70. Weber, "Robert Frederick Blum," p. 114.

71. Pennell and Pennell, *Life of Whistler*, vol. 1, p. 270.

72. "The Fine Arts. The Water-Color Exhibition (Second Notice)," *The Critic* 1 (February 12, 1881), p. 39, quoted in Weber, "Robert Frederick Blum," p. 120.

73. Cook, "Water-Color Society's Exhibition," p. 75. Van Rensselaer leapt to Blum's defense in "Art Matters," p. 419.

74. Blum did have one non-Venetian etching exhibited in Koehler's *Exhibition of American Etchings* in Boston in 1881, *A Difficult Place* (no. 528), which was submitted too late for insertion in its alphabetical position in the catalogue. Van Rensselaer reported in early 1883 that Blum had shown "only two or three plates of his work thus far" (Van Rensselaer, "American Etchers," p. 497). Of one of Blum's most Whistlerian plates, *Gondolas and Venetian Palace*, Weber has observed that it "reflects the general influence of Whistler's Venetian etchings. He synthesized elements of Whistler's approach and technique" (Weber, "Robert Frederick Blum," pp. 111–113).

75. The drawing is now in the Cincinnati Art Museum, accession no. 1916.118 (Weber, "Robert Frederick Blum," pp. 116, 160 n. 45).

76. Blum to his family, December 11, 1882, quoted in ibid., p. 188. Weber reports that Blum and Wilde established a mutually enjoyed relationship, with Wilde frequently visiting Blum's studio, advising sitters on color harmonies, and entertaining Blum's other guests, while Blum adopted an aesthetic-style haircut and began wearing yellow clothing (pp. 189–190).

77. When Blum was in London in 1885, on his way to Venice, he "fully expected to call on Whistler," but his stay in London was too brief (Blum to William Merritt Chase, July 5, 1885, Chapellier Gallery Papers, AAA). In late 1886, again in London on his way back to New York in the company of Bacher, he met T. R. Way (as evidenced by greetings to Blum from Way in a letter [Way to Otto Bacher, December 13, 1886, Otto Bacher Papers, AAA]). Since Bacher and Way dined with Whistler on this trip, it seems possible that Blum, too, would have been along (Bacher, *With Whistler in Venice*, p. 50).

78. Whistler to Charles Deschamps, March 9, 1888, PWC, box 1.

79. Whistler to Helen Whistler, February or March 1880, quoted in MacDonald, *Palaces in the Night*, p. 146. For detailed discussions of the pastels, see Getscher, "Whistler and Venice," pp. 101–140; and MacDonald, *Palaces in the Night*, pp. 37–63.

80. Whistler to Matthew Robinson Elden, ca. April 15–30, 1880, quoted in MacDonald, *Palaces in the Night*, pp. 148–149.

81. The principal text on pastel is Geneviève Monnier, *Pastels: From the 16th to the 20th Century* (Geneva: Editions d'Art Albert Skira, 1984). The title of the major exhibition of the French Impressionists organized by Durand-Ruel for America is of note: *Exhibitions of Paintings in Oil and Pastels by the Impressionists of Paris* (New York: American Art Association, 1886). For American interest in the eighteenth-century mode, see Champney, "Golden Age of Pastel." Champney closes her text with the passage: "So strong is the movement lately begun by the leading French artists that we may even hope that the renaissance will surpass the brilliancy of the golden age" (p. 274).

82. Bacher, *With Whistler in Venice*, pp. 77–78.

83. "Pastels of Edwin A. Abbey," p. 138.

84. For analysis of the critical responses in London, see Bell, "Fact and Fiction," pp. 75–115.

85. [E. W. Godwin] "Notes on Current Events," *British Architect* 15 (February 4, 1881), quoted in MacDonald, *Palaces in the Night*, p. 101.

86. Van Rensselaer, "American Painters in Pastel," pp. 205, 207.

87. The principal sources for the movement are Pilgrim, "Revival of Pastels"; W. Gerdts, *American Impressionism*, pp. 33–35; Nelson, "Society of Painters in Pastel"; and Bolger et al., *American Pastels*.

88. In such titles as *A Scheme in Reds and Grays*, a work exhibited in 1884 at the first exhibition of the Society of Painters in Pastel, there is a conscious echo of Whistler's voice. The work, once in the collection of Thomas B. Clarke, is known now only through a photograph. For a discussion of it and the other pastels displayed by Blum in 1884, see Weber, "Robert Frederick Blum," pp. 215–225.

89. Cook, "Painters in Pastel."

90. "Professors of Pastels."

91. Mariana Griswold van Rensselaer, "An Exhibition of Pastels," *The Independent* (New York), May 24, 1888, p. 647, quoted in Weber, "Robert Frederick Blum," p. 309.

92. "Art Notes," *Critic* 12 (May 12, 1888), p. 234, quoted in Weber, "Robert Frederick Blum," pp. 308–309; and "Art Notes," 1888, p. 161. Blum must have been aware of charges of this sort, for he wrote tongue-in-cheek to Bacher, "Lots of foggy effects now—don't have to draw in so damned much detail, just sort of blurr [*sic*] over the thing and there you are" (Blum to Bacher, December 1885, Otto H. Bacher Papers, AAA).

93. Blum's sensibility here resonates with works by John Singer Sargent, as in *Sortie de l'église* (1882, oil, Hugh and Marie Halff), and by F. Hopkinson Smith, as in *Venetian Well* (n.d., charcoal, Vance Jordan Fine Art).

94. Sargent and Curtis were distant cousins and friends of long standing. In 1888, Sargent wrote to Mrs. Bronson about time spent in the Ca' Alvisi: "Ralph Curtis tells me that you are surrounded with your guests as ever. It is difficult for me even to fancy your parlour without a glowing fire, yourself sitting near it in a particular chair; and asking the Montalbas and me to write witty and beautiful verses, while . . . Miss Chapman brews pick-me-up at the Arabian bar" (quoted in Meredith, *More Than Friend*, p. 17 n. 3). Meredith elsewhere writes that Bronson "helped Whistler financially by buying some of his pastels, and consulted Sargent as to which he thought the best" (p. 9 n. 4).

95. Bacher, *With Whistler in Venice*, p. 25.

96. Numerous scholars have associated the work with Whistler (see, for example, Honour and Fleming, *Venetian Hours*, p. 59). Sargent most often in his Venetian works chooses a low point of view that has the spectator looking slightly up at the scene portrayed. Margaretta Lovell, observing this, has analyzed Sargent's works in Venice as being in Northrup Frye's "ironic mode" (see Lovell, *Visitable Past*, pp. 85–87, 90–98).

97. Richard Ormond, "Venise par temps gris," in Kilmurray and Ormond, *John Singer Sargent*, p. 75.

98. Grieve, *Whistler's Venice*, pp. 72, 74. Grieve also rules out the Palazzo Barbaro, ultimately suggesting that the extended *portego* might be that of either the Palazzo Lini or the Moro-Lin, favoring the latter.

99. Whistler to Mayor Grimani of Venice, ca. 1898, quoted in MacDonald, *Palaces in the Night*, p. 134.

100. Whistler to William Graham, ca. February 1890–1893, FGAA, no. 76.

101. Pennell and Pennell, *Whistler Journal*, p. 7.

102. E. Pennell, *Nights*, pp. 93–95.

103. Getscher, *Stamp of Whistler*; and MacDonald, *Palaces in the Night*, pp. 134–140.

104. Cartwright, "Artist in Venice," p. 17.

105. Pennell and Pennell, *Whistler Journal*, p. 2.

106. Cartwright, "Artist in Venice."

107. Henry James, *Italian Hours* (Boston: Houghton Mifflin, 1909). See especially the drawings *Flags at St. Mark's, Venice*; *A Narrow Canal, Venice*; *Palazzo Moncenigo, Venice*; and *Casa Alvisi, Venice*.

108. Quoted in Benson, *John Marin*, p. 3.

109. See, for example, works by George Charles Aid, Cadwallader Lincoln Washburn, and Ernest David Roth.

110. Baldry, "James McNeill Whistler," pp. 241–242.

111. Abbey to Walter James, July 17, 1903, quoted in Lucas, *Edwin Austin Abbey*, vol. 2, pp. 396–397.

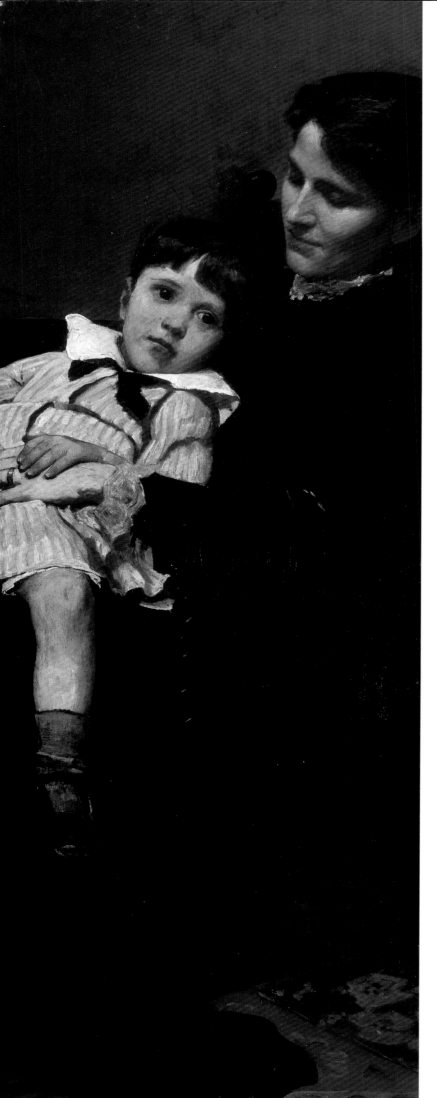

Whistler and
Philadelphia
A Question of Character

THE MATTER OF JAMES MCNEILL WHISTLER'S
influence and inspiration in the late nineteenth-century
Philadelphia art world is rich and problematic. While
local patronage by private collectors was minimal—the
formidable triumvirate of Alexander J. Cassatt, John G.
Johnson, and P. A. B. Widener notwithstanding—Whistler
drew consistent support from the leading art institution
in the city, the Pennsylvania Academy of the Fine Arts
(fig. 39). Between 1881 and 1907, through exhibitions,
awards, and lectures, Whistler's art and persona were
avidly promoted to critics, collectors, art students, and
general viewers with more regularity than anywhere else,
at home or abroad. Yet the ultimate endorsement—the
purchase of a painting for the Academy's permanent
collection—eluded the artist. This essay explores Phila-
delphia's Whistler conundrum, shedding new light on
his artistic reception and legacy in America.

The Whistler chronology at the Pennsylvania Academy
begins with a bang: the American debut, in late 1881, of
*Arrangement in Grey and Black, No. 1: Portrait of the Painter's
Mother* (see fig. 5). The soon-to-be-iconic image was the
only Whistler painting featured in *American Artists at
Home and in Europe* (fig. 40), a special exhibition organized
by the Academy, working with committees of expatriate
artists in Paris, Munich, and London. Anna Lea Merritt
and William J. Hennessey, who headed the English effort,
were responsible for obtaining the loan of Whistler's paint-
ing from the London print dealer Henry Graves & Co.[1] In
the ten years since it was painted, *Arrangement in Grey and
Black, No. 1: Portrait of the Painter's Mother* had attained a
measure of fame due as much to Whistler's growing celeb-
rity in America as to the picture's exhibition in London.[2]
The copious correspondence between the organizers in
both cities makes clear that the work was viewed by them
as the coup of the show and a precious commodity. As

Cecilia Beaux, *Les Derniers jours d'enfance (The Last Days of Infancy)*
(detail, cat. 17)

Merritt wrote to George Corliss, secretary of the Academy, "Mr. Whistler's picture needs very careful management as the canvas is weak and brittle. If anything happens to it you will ruin me."[3]

The striking simplicity of this unconventional portrait—the first work referred to by Whistler as an "arrangement" of colors, with its nearly monochromatic tonal massing—would have stood out even in the exhibition of some 428 works, primarily academic landscapes and genre scenes by an assortment of local favorites, many of them former Academy students. It occupied a prominent place in the north corridor, where it would have been among the first works that visitors encountered.[4] Yet only a few critics paid it much attention; the Academy graduate Earl Shinn (1838–1886), writing as Edward Strahan, did not even mention the portrait in his glowing review of the exhibition.[5] Those who did, however, recognized its importance as "the great picture of the exhibition . . . better than one's highest anticipations." In its "aggressive originality of treatment," Whistler's Mother vindicated his "right to be eccentric."[6]

As Sarah Burns has noted, the relationship between the artist's famous personality and his creative "genius" was mutually reinforcing and critical to the reception of Whistler's work in America. The Academy display provided one of the first stateside opportunities to view a major picture by Whistler, while his "eccentricities" were more well known to the reading public.[7] The portrait's effect on artists, particularly those associated with the Academy, was even more considerable and long lasting. Cecilia Beaux and Henry Ossawa Tanner (who was a student at the time) were two of the younger Philadelphia painters directly inspired by the work. Beaux's *Les Derniers jours d'enfance* (cat. 17), begun just two years later, marked the artist's debut as a serious talent and won a major prize in the Academy's 1885 annual exhibition. That Beaux based her first ambitious portrait composition—like Whistler's, of family relations—on the famous image underlines her desire to be seen as a progressive painter.

Tanner's *Portrait of the Artist's Mother* (cat. 59) is a more literal homage to Whistler. Perhaps a reference to the younger artist's own recent successes—Tanner's *Raising of Lazarus* (1896, Musée d'Orsay) had been purchased by the Musée du Luxembourg in 1897—it also reveals the influential reach of Whistler's portrait, which the Philadelphia-based Tanner family would have first seen at the Academy over a decade earlier.[8] Acquired by the French government for the Luxembourg in 1891, Whistler's Mother was the work that accorded the artist "Old Master" status. Thus, Tanner's appropriation of the composition made a different claim than Beaux's, outlining the trajectory of the painting from its avant-garde beginnings to its establish-

FIG 39 Pennsylvania Academy of the Fine Arts, 1876–1877, Pennsylvania Academy of the Fine Arts Archives, Philadelphia.

ment end. Additional Academy associates—including the critic Christian Brinton and the painter and famous widow Susan Macdowell Eakins (1851–1938)—continued to refer to Whistler's portrait decades later, regarding it as the artist's most significant work.[9]

Other American cities took note of the Academy's 1881 effort to secure the Whistler for its exhibition. Representatives from Boston's Museum of Fine Arts (reportedly on the advice of the artist himself) made an unsuccessful attempt to exhibit the painting before its return to England, while New York's progressive artist organization, the Society of American Artists, secured it, through the Academy's offices, for its 1882 exhibition.[10] The revelatory reception of the work in Philadelphia, at least among artists, certainly encouraged the Academy to maintain a connection to Whistler, if always through liaison, in the coming years. Furthermore, the overall popularity of *American Artists at Home and in Europe* convinced the Academy's board of the importance of featuring work by expatriates in their exhibitions, an effort to which they devoted a great deal of time and money throughout the 1880s.[11]

The mythmaking that surrounds the display of Whistler's portrait in Philadelphia—namely, that the Academy passed on the opportunity to purchase the famous painting for $1,500—can be partly ascribed to Harrison Morris, the institution's first managing director and a leading progressive tastemaker in the late nineteenth-century Philadelphia art world. Morris's 1930 memoir, *Confessions in Art*, is filled with vitriolic accounts of his frustrations with the Academy's management, a situation that had led to his departure in 1905.[12] While his attacks on the limited aesthetic vision of the Academy's board were in many instances warranted, his claim about the missed opportunity to purchase

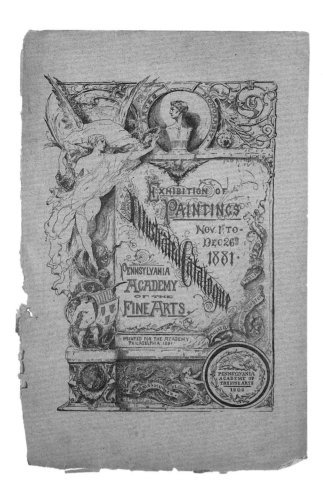

FIG 40 Catalogue cover and page 12, *American Artists at Home and in Europe,* November 1–December 26, 1881, Pennsylvania Academy of the Fine Arts Archives, Philadelphia.

Arrangement in Grey and Black was unfounded. At least one document in the Academy's archives states that the portrait was not available for sale when it came to Philadelphia.[13] Morris was probably misinformed by his friends Joseph and Elizabeth Pennell, Whistler's biographers.[14] (Joseph was a student at the Academy in 1881.) A similar story is recounted by another Whistler devotee, the Chicago collector Arthur Jerome Eddy (see cat. 10), concerning the display of Whistler's Mother in New York, where it is said to have been offered for $1,200.[15] In effect, the tales follow a pattern of anecdotes endlessly repeated in accounts of the artist, revealing much about Whistler's lifetime and posthumous reputation in America as a misunderstood maverick and figure of curious admiration.

The next showing of Whistler's work at the Academy took place in the spring of 1884. The artist's highly theatrical exhibition *Arrangement in White and Yellow,* first seen at London's Fine Art Society a year earlier, had been reconstituted by H. Wunderlich & Co. of New York in the fall of 1883. Wunderlich circulated it to five American cities: Baltimore, Boston, Philadelphia, Detroit, and Chicago. The Academy was the only museum on the tour (the other stops being commercial art galleries), an indication of its adventurous exhibition planning at the time.[16] Interest in Whistler's project may have been piqued by two lectures on "Etching and Etchers" by Frances Seymour Haden, the artist's brother-in-law, a printmaker himself, delivered at the Academy in late December 1882. The lectures were in conjunction with the first exhibition of the Philadelphia Society of Etchers, held in the museum's galleries from December to February and referred to in the Academy's annual report as the "most important exhibition of modern etchings ever opened to the public in this country." The 1,070 works by "modern painter-etchers, of all countries and schools," included twenty by Whistler.[17]

The *White and Yellow* exhibition comprised fifty-one etchings, mostly of Venetian scenes, with one featured oil, *Nocturne in Black and Gold: The Falling Rocket* (cat. 7)—the notorious image at the heart of Whistler's 1878 libel suit against the art critic John Ruskin. On its showing in New York, the *Evening Post* declared the artist's latest effort "the most important exhibition of [Whistler's] work yet seen in this city."[18] Notwithstanding its recognized aesthetic significance, *Arrangement in White and Yellow* had greater import as spectacle, a highly successful example of the artist's showmanship. With its felt-covered walls— "the color of unbleached flannel," stenciled with yellow lines and butterflies—gilded moldings and borders, "genuine Indian matting of straw colour" on the floor, domestic trappings such as a yellow-tiled mantelpiece (above which

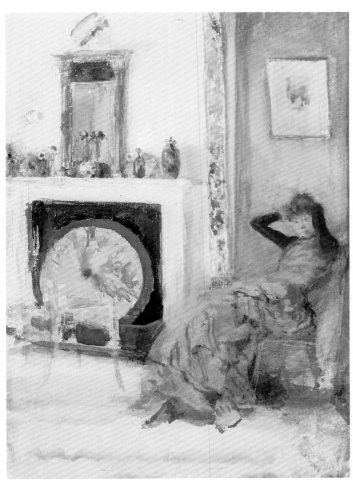

FIG 41 James McNeill Whistler (1834–1903), *The Yellow Room*, ca. 1885, watercolor on paper, 9¹³⁄₁₆ × 7 inches, private collection.

delivered in London the previous year (fig. 42). While the trip did not occur, *Arrangement in White and Yellow* proved that Whistler did not need to be physically present to excite the interests of the American public. In fact, his distance lent him an even greater mystique.

The organizers of the 1883–1884 exhibition tour were surely banking on Whistler's notoriety, stemming from his libel case a few years earlier, as a draw for the American public; the offending painting, *Nocturne in Black and Gold: The Falling Rocket*, had not been part of the London display. The addition of the oil to the group of more recent Venetian etchings suggests that Whistler's growing celebrity in the United States was used to further his artistic reputation.[24] The catalogue of the exhibition—*Etchings and Drypoints: Venice: Second Series*, subtitled *Mr. Whistler and His Critics*—offered a text that turned negative quotations about the artist's work on their head. Described by one reviewer as a "perfect gem of satire,"[25] the publication, along with a framed photograph of the artist (see fig. 10), completed the entertainment package.

hung *The Falling Rocket*), white caned chairs with yellow trim, and a gallery attendant "in a livery of white, trimmed with canary color," the installation was a striking expression of Whistler's aesthetic philosophy and flamboyant gesture.[19] The interior design paralleled a decorating scheme Whistler had introduced in his London home two years earlier (fig. 41), suggesting the fluidity between the artist's public and private practice that informed his celebrity.[20]

It is tempting to view the circulation of the controversial *White and Yellow* exhibition as Whistler's exploration of the idea of an American tour, perhaps inspired by the highly lucrative 1882 visit of another noteworthy aesthete, Oscar Wilde.[21] Although Whistler had exerted the single greatest influence on Wilde's persona after the poet arrived in London from Oxford University, the painter was often popularly lampooned in America as less a mentor than an imitator, a perception that infuriated Whistler.[22] Richard D'Oyly Carte, the entrepreneurial manager of Gilbert and Sullivan, was the mastermind behind Wilde's visit.[23] He attempted to arrange a similar tour for Whistler in 1886, following the artist's famous "Ten O'Clock" lecture,

WHY DO YOU TARRY, MR. WHISTLER?

FIG 42 John White Alexander (1856–1915), *Why Do You Tarry, Mr. Whistler?*, wood engraving published in *Evening Telegram* (New York), December 20, 1886.

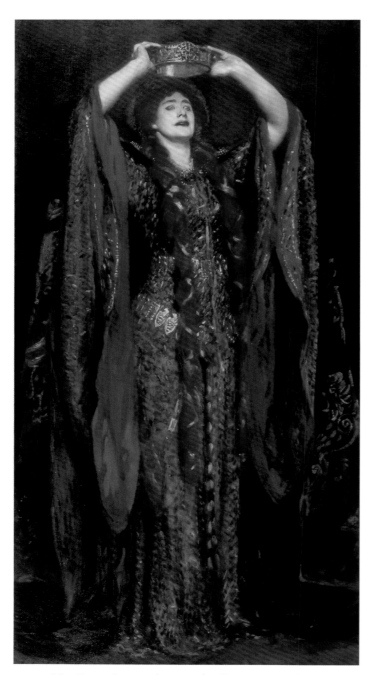

FIG 43 John Singer Sargent (1856–1925), *Ellen Terry as Lady Macbeth,* 1889, oil on canvas, 87 × 45 inches, Tate Britain, London, gift of Sir Joseph Duveen.

Advance publicity in the Philadelphia newspapers promised viewers an aesthetic experience unlike any other, emphasizing Whistler's "odd genius" and playful flair. As one writer noted, "Whistler, the eccentric artist, gets ahead of both Barnum and Forepaugh"—infamous purveyors of peculiarities and humbugs—"his etchings and drypoints are pretty sure to be worth looking at, and the arrangement of them 'as good as a circus.'"[26] Despite these confirmations of Whistler's tireless self-promotion, some local critics approached the exhibition (and the artist) with genuine respect. Most focused on the etchings as much as the installation, with one stating, "the room is in perfect taste, and there is nothing offensive." The same critic praised Whistler's masterful skill and the variety of his work, noting that the etchings "are called eccentric, but they are only unconventional," and drawing a comparison to the works of Rembrandt.[27]

Given the Academy's profile in the city, it is not surprising that the issue of Whistler's impact on other artists—both professionals and students—surfaced in many of the press notices. Erasmus Brainerd, writing at length in the *Philadelphia Press,* declared the etchings "exquisite and most charming and fascinating, and the proof is found not only in the works themselves, but in the impression they have produced on some of the best living etchers, those who live in Philadelphia," citing Whistler's particular influence on Joseph Pennell and Stephen Parrish (1846–1938).[28] As for students, the *Inquirer* reviewer observed:

> It has been said of this exhibition that it might do harm to our younger artists in beguiling them into a free and easy fashion of reaching after effects, which Mr. Whistler seems to produce with such simple means and so little effort. If any of our students should be careless or self-conceited enough to commit such an error, they would find their folly knocked out of them presently in such a summary manner that the lesson might do them more good than harm.[29]

Even the writers who deemed Whistler's etchings sketchy and slight found the arrangement itself "interesting and instructive . . . [having] transformed what is at times the gloomiest gallery in the Academy into the brightest and best."[30] The *Inquirer* reviewer seemed to sum up the general opinion: "The Academy deserves the unqualified thanks of all lovers of art for bringing the exhibition before the community."[31] Clearly, the Academy recognized the importance of its progressive venture—both for its institutional reputation and for Philadelphia's cultural standing at large. In the 1885 annual report, Whistler was described as an "eccentric but skillful artist," while the exhibition was

termed "in every way successful, and the odd decoration especially attractive and satisfactory."[32]

Some scholars have argued for the lasting influence of the installation of Whistler's *Arrangement in White and Yellow* on exhibition design in America.[33] While the spaciousness and harmony of the display did not immediately alter the salon-style hanging practice of the Academy and most other art institutions, it did lead in Philadelphia to a specific exhibition series. A few weeks after the close of the Whistler installation, Peter Moran (1841–1914), president of the Philadelphia Society of Etchers, proposed that the Academy devote the same gallery to a "continuous series of short exhibitions, each representing one or two of the best American etchers." Taking his cue from Whistler, Moran directed "the gallery to have the walls made white in some inexpensive manner. The advertising to be trifling, and the catalogues very plain, simple, and cheap." The proposal was approved and the series ran through 1885.[34]

PHILADELPHIANS, ALONG WITH MOST AMERICANS, had to wait almost ten years for their next significant encounter with Whistler's art, although an 1889 lecture by Arthur J. Eddy, "Days with Whistler," fed local audiences' interest in the intervening years. In 1893, at America's second major world's fair, the Columbian Exposition held in Chicago, Whistler was one of a handful of American "masters"—including William Merritt Chase, Winslow Homer, George Inness, and John Singer Sargent—invited to show more than the standard three works. Characterized by a selection that varied widely in subject, style, and scale, the fair showcased the growing sophistication of American art and revealed the dominance of European-trained talent. While Homer and Inness were acclaimed as the most "American" of the group, Sargent and Whistler embodied the genteel cosmopolitanism that generated the most critical attention. The two expatriates were the subject of much comparison, with Sargent's *Ellen Terry as Lady Macbeth* (fig. 43) representing "the triumph of bravura in painting," according to the *New York Daily Tribune,* and Whistler's *Arrangement in Black: La Dame au brodequin jaune—Portrait of Lady Archibald Campbell (The Yellow Buskin)* (see fig. 16) "the triumph of its antithesis."[35] The dramatic portraits also suggested the blending of the real and the ideal that shaped official taste at the time, an aesthetic enthusiastically embraced and promoted by the Pennsylvania Academy.

In 1892, Harrison Morris (fig. 44) became the Academy's first managing director, overseeing operations in both the museum and the school. Under his enlightened leadership, the institution's exhibition and collecting efforts became increasingly progressive and lively. Reflecting changes in American art at large, the realist agenda promoted by

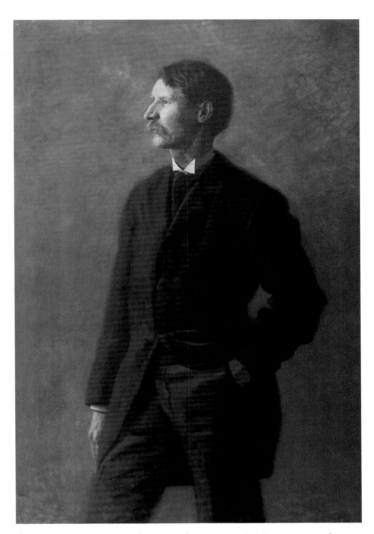

FIG 44 Thomas Eakins (1844–1916), *Harrison S. Morris,* 1896, oil on canvas, 54 × 36 inches, Pennsylvania Academy of the Fine Arts, Philadelphia, partial gift of Harrison Morris Wright and partial purchase with funds provided by the Henry S. McNeil Fund, the Estate of John W. Merriam, the Samuel M. V. Hamilton Memorial Fund, the Women's Committee of the Pennsylvania Academy of the Fine Arts, Donald R. Caldwell, Jonathan L. Cohen, Dr. and Mrs. John A. Herring, William T. Justice and Mary Anne Dutt Justice, Charles E. Mather III and Mary MacGregor Mather, Robert W. Quinn, Herbert S. Riband Jr. and Leah R. Riband, Mr. and Mrs. Joshua C. Thompson, and 36 anonymous subscribers.

Thomas Eakins (who directed the Academy's school from 1882 to 1886) expanded to include other styles, while subject matter continued to diversify. The first major annual exhibition at the Academy for which Morris was responsible ran from December 1893 to February 1894 and featured ninety-four examples of what he called the "best American art" displayed at the Columbian Exposition.[36] Morris had been particularly enchanted by the Whistlers, and of the six paintings by the artist displayed in Chicago, five came to Philadelphia (fig. 45).[37] Referring to the three striking figural works—*La Princesse du pays de la porcelaine* (see fig. 13), *The Yellow Buskin,* and *The Fur Jacket* (cat. 9)—as "the most

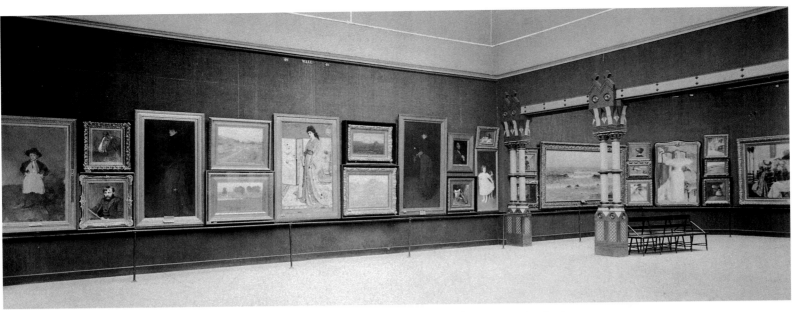

FIG 45 *Sixty-Third Annual Exhibition of the Pennsylvania Academy of the Fine Arts* (featuring Whistlers), 1893–1894, Pennsylvania Academy of the Fine Arts Archives, Philadelphia.

conspicuous examples of American art exhibited" at the fair, Morris stated that "it was necessary to have these, or follow the well-known alternative to mounting Pike's Peak."[38]

Conforming to a pattern typical of Whistler efforts at the Academy—and, it appears, throughout the country—the loan arrangement was not made with the artist directly, but with the Glasgow dealer who had purchased the works, Alexander Reid.[39] Whistler later complained about the presence at the Chicago exposition of *The Chelsea Girl* (fig. 46), a work he had given to Alexander Cassatt, brother of artist Mary Cassatt (1844–1926), as a form of apology for the delayed completion of a commissioned portrait. Calling it "the sketch of *one afternoon*—or rather the first statement or the beginning of a painting—I am not excusing it mind . . . for of course it is a damn fine thing," Whistler protested that it was not a "*representative* finished picture!" and, thus, not something he wanted to be judged by in America. "I ought to have been consulted," he said.[40]

That the same cosmopolitan eclecticism that had made such a grand impression in Chicago was celebrated in Philadelphia reveals Morris's artistic savvy. The hoped-for throngs appeared at the museum, with one local notice claiming that "no exhibition in the recent history of the Academy has won such instant recognition from the public."[41] Sargent's *Ellen Terry* formed the centerpiece of this special display (fig. 47) and shared with Whistler's *Yellow Buskin* the Academy's prestigious Temple Gold Medal for the best figure painting in that year's exhibition.[42] Given this honor, Morris hoped to secure the Whistler, valued at $15,000, for the Academy's permanent collection but, in what he later referred to as the "hardly believable stupidity

in the main-chance speculator," failed to rally the support of the board.[43] Recounting the event in his memoir, Morris alluded to "history repeating itself": "I tried to raise the sum to buy one of [the three full-length portraits by Whistler] for the Academy; but the management that had failed (with Jo Pennell's anathemas!) to take Whistler's 'Mother' when exhibited at the Academy for $1500, would have none of the extravagant canvases that cost so much more. Besides, who was Whistler, anyhow?"[44]

As a last resort, to keep the work in Philadelphia, Morris approached the "enlightened" collector John G. Johnson, who oversaw the yearly income of the Wilstach Bequest—an important fund for a collection that formed the core of the city's municipal art museum in Memorial Hall (later the Philadelphia Museum of Art). In 1893, Johnson had purchased Whistler's *Purple and Rose: The Lange Lijzen of the Six Marks* (cat. 2) for his own collection, so Morris knew he would be receptive to the "preferred opportunity" of acquiring *The Yellow Buskin*. In the end, Johnson bought the painting from Reid, at the cost of $7,500, for the Wilstach holdings, and the work that Morris referred to as "nearly the most brilliant of all Whistler's full-sized figures—one of the greatest works of art in the world" became the first major oil by Whistler to enter an American public collection.[45]

There are several possible reasons for the Academy board's reluctance to add a Whistler to the permanent collection. Although interest in the artist at the institution dated to the early 1880s, the makeup of the Academy's management had changed since that time. Was the work itself the issue? *The Yellow Buskin* was first exhibited in

Europe as *Arrangement in Black: Portrait of Lady Archibald Campbell*; by 1889, Whistler had withdrawn "the name from the work, and the picture ceasing to be a portrait went forth as the 'Brodequin Jaune.'"[46] The title change related to the Campbell family's rejection of the portrait as inappropriate and full of sexual innuendo. While it is unlikely that the work would have met a similar interpretation in the United States—indeed, in both Chicago and Philadelphia it was discussed in primarily formal terms, with only a vague reference to its "certain elusive charm"—this highly ambiguous image clearly had an unsettling effect on many American viewers.[47]

The portrait of Lady Archibald Campbell was the second in Whistler's series of "arrangements in black," the first being a kittenish portrayal of Lady Meux (1881, Honolulu Academy of Art). The third, though numbered 8, was *Portrait of Mrs. Cassatt* (fig. 48), which, given the prominence of the Cassatt family in Philadelphia society, was probably known to many on the Academy's board.[48] Yet not even familiarity with Whistler's approach to the female portrait was enough to make the Campbell picture acceptable. (A more conventional portrait, the image of Mrs. Cassatt was utterly lacking the sensual charge of *The Yellow Buskin*.)[49] Presumably, it was the challenging nature of Whistler's art combined with his personal notoriety that caused the Academy's management to withhold official sanction.[50] As for Morris, his inability to acquire a Whistler for the museum was his greatest disappointment, only somewhat assuaged by his success in retaining one for the city of Philadelphia. Long after his departure from the Academy, Morris continued to be starstruck by "the incomparable Whistler," whom he mentioned in his memoir more often than any other artist and in a tone that verged on hagiography.[51]

From the time of Whistler's 1881 showing at the Academy, he exerted a tremendous influence in both the institution's classrooms and galleries. With one exception, works by the artist were represented in every annual exhibition from 1893 to 1907, years that also saw many Whistlerian entries from younger artists. Along with nine paintings by Sargent, four Whistlers in the 1904 annual were called the "leading features" of an exhibition deemed particularly significant as it marked the first display of his work since his "lamented death" in July 1903.[52] The same year, Arthur J. Eddy, whose portrait by Whistler was featured in the annual exhibition, delivered a second lecture on his artist-hero—"Whistler as a Colorist"—and the following spring, Whistler's former comrade William Merritt Chase spoke on "Whistler: The Man and His Art." Chase's 1905 lecture coincided with the one-hundredth anniversary

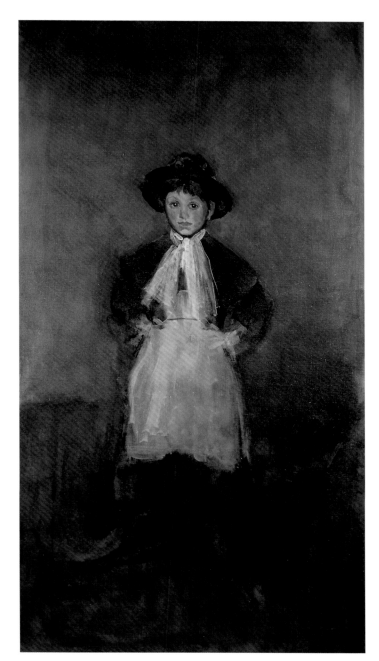

FIG 46 James McNeill Whistler (1834–1903), *The Chelsea Girl*, 1884, oil on canvas, 65 × 35 inches, Melnyk Collection.

of the Academy. That year's annual marked the centennial with major contributions from countless associates, including nine works by Whistler—his largest showing yet at the institution—an unmistakable statement of his significance to the Academy's history despite the lack of formal ties.

Yet it was the art critic Charles Caffin's title for his 1907 lecture, "Whistler as Typical of the Modern Spirit," that may best sum up the artist's legacy in Philadelphia in particular and America in general. Whistler's dual standing as Old Master and American Modern at the turn of the twentieth century has been little explored.[53] While he aspired to and ultimately achieved the status of "living

FIG 47 *Sixty-Third Annual Exhibition of the Pennsylvania Academy of the Fine Arts* (featuring Sargent), 1893–1894, Pennsylvania Academy of the Fine Arts Archives, Philadelphia.

Old Master," Whistler was one of few American artists who continued to be seen as both avant-garde and part of the establishment.

That Whistler's reputation as an "advanced" artist was embraced in Philadelphia both during his lifetime and after his death becomes evident through an examination of the city's modernist culture. The Pennsylvania Academy was at the center of many progressive activities, and through its special exhibitions (including those that featured the work of Whistler) and teaching practices may be seen as having nurtured—sometimes in spite of itself—the avant-garde impulses of its famous student body.

A number of cultural events took place at the Academy throughout the late 1890s and the first two decades of the twentieth century that suggest the pastime of humorous pillorying, which has been linked to the popular reception of modernism in America.[54] From 1894 to 1896, for example, exhibitions of caricatures by Academy students spoofed some of the notable submissions to the institution's annuals. The first exhibition featured parodies of Sargent's *Ellen Terry*, which the young John Sloan reconceived as *Ellen Terrified as Lady MacBroth* (fig. 49). In this work, which won first prize, the figure is pictured pouring a bowl of tomato soup over her head, in effect echoing the cascade of Terry's lush red locks. But it was Whistler's five entries in the 1894 annual that generated the most response. *Nocturne: Blue and Gold—Valparaíso* (fig. 50), for example, became an unidentified student's *Whisker's Knock, Turn, Paralyzo* (fig. 51), in a slapstick vignette featuring an English bobby and thugs.

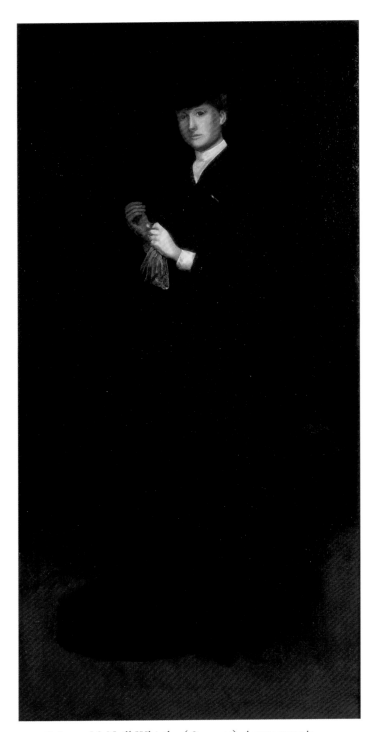

FIG 48 James McNeill Whistler (1834–1903), *Arrangement in Black, No. 8: Portrait of Mrs. Cassatt*, 1883–1885, oil on canvas, 75¼ × 35¾ inches, private collection.

Evidently, the Ashcan artists Sloan and Glackens (see cat. 39), inspired by the teachings of Robert Henri—another Academy graduate who held Whistler in high esteem (see cat. 45)—greatly admired Whistler's uncompromising aesthetic principles. Moreover, they responded to his working-class subjects, such as *The Chelsea Girl*, the "sketch" featured in the 1893 annual that was described by one critic as "a veritable daughter of the people, with all the defiance of an offspring of the *proletaire* in her attitude."[55]

William Merritt Chase, who had originally modeled his cosmopolitan artistic identity on Whistler's, offered yet another connection to the artist. A leading member of the Academy's faculty from 1896 to 1900, Chase likely played a role in the cultivation of such "dandy moderns"[56] as Charles Demuth (1883–1935) and Morton Schamberg (1881–1918) who, along with Charles Sheeler (1883–1965), John Marin, and Arthur B. Carles (1882–1952), studied with him in Philadelphia. Noted critics and tastemakers with modernist sympathies such as Christian Brinton, A. E. Gallatin, and Alfred Stieglitz (fig. 52) were also linked to Whistler through the Academy, the latter perhaps most significantly. In the photographic salons Stieglitz organized at the Academy in the 1880s and 1890s, he and his circle of pictorialist photographers proclaimed their debt to Whistler in both style and subject matter.[57]

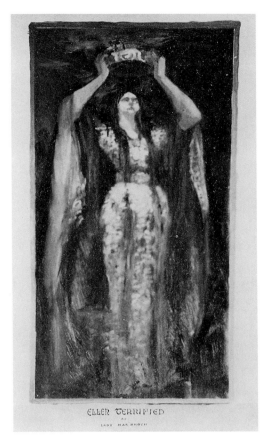

FIG 49 John Sloan (1871–1951), *Ellen Terrified as Lady MacBroth*, 1894, caricature reproduction, Pennsylvania Academy of the Fine Arts Archives, Philadelphia.

left
FIG 50 James McNeill Whistler (1834–1903), *Nocturne: Blue and Gold—Valparaíso*, 1866/ ca. 1876, oil on canvas, 30 1/16 × 19 15/16 inches, Freer Gallery of Art, Smithsonian Institution, Washington, D.C., gift of Charles Lang Freer, F1909.127.

right
FIG 51 Unidentified artist, *Whisker's Knock, Turn, Paralyzo*, 1894, caricature reproduction, Pennsylvania Academy of the Fine Arts Archives, Philadelphia.

FIG 52 Alfred Stieglitz (1864–1946), *The Glow of Night*, ca. 1897, photogravure, 4⅝ × 9⅛ inches, High Museum of Art, Atlanta, purchase with bequest of Charles Donald Belcher.

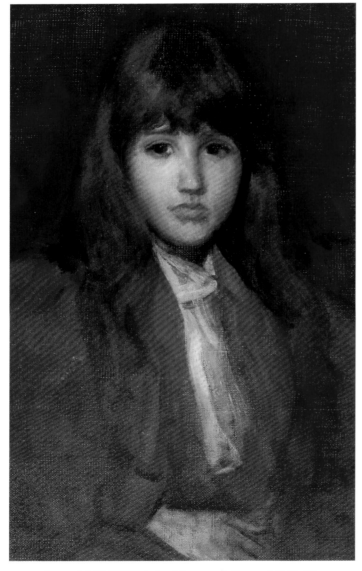

FIG 53 James McNeill Whistler (1834–1903), *Rose and Gold: "Pretty Nellie Brown,"* 1896–1898, oil on canvas, 19¾ × 12 inches, Pennsylvania Academy of the Fine Arts, Philadelphia, gift of Ann R. Stokes.

These different threads came together in a venture that brings near closure to Whistler's Philadelphia story. In 1920, Carles joined forces with the local artists and collectors William Yarrow and Carroll Tyson to organize *Paintings and Drawings by Representative Modern Masters*, the first of three landmark exhibitions of modern art held at the Academy in the early twenties. Like the 1913 Armory Show, the New York exhibition that largely introduced modernism to American audiences, the *Modern Masters* effort surveyed progressive tendencies in both historical and contemporary art. The majority of the more than 250 works came from such noted collectors as Stieglitz, Marius de Zayas, Lillie Bliss, Walter and Louise Arensberg, and Earl Horter. (Manet's *Olympia* and Gauguin's *Ia Orana Maria* were just two of the French icons featured in the exhibition.) In Carles's chronology of evolution versus revolution, the twentieth-century avant-garde was viewed as descending from nineteenth-century "radicals" rather than appearing full-blown on the scene, a didactic agenda that proved highly effective in cultivating a broad public taste for modernism. The exhibition was a great success, attracting over 25,000 national visitors in its three-week run.[58]

Curiously, only three American artists rated inclusion in Carles's curatorial scheme: Whistler, Cassatt, and the Synchromist painter Stanton Macdonald-Wright (1890–1973). This would have been an opportune moment for the Academy to finally add a Whistler to the museum's collection, but all three of his works on display came from private collections.[59] Yet by placing Whistler at the forefront of the modernist lineage, alongside his one-time Realist mentor Gustave Courbet, the Academy celebrated his achievement in no uncertain terms.

The Pennsylvania Academy would have to wait another eighty-two years before it could claim a Whistler for its own. *Rose and Gold: "Pretty Nellie Brown"* (fig. 53), donated to the museum in 2002, is one of the artist's sensitive tonal portraits produced toward the end of his career. The work reflects Whistler's belief that "if you paint a young girl, youth should scent the room . . . an aroma of the personality."[60] That the complex wedding of personality and practice that shaped Whistler's fate in Philadelphia found resolution in the portrait of Nellie Brown—daughter of Ernest G. Brown, director of London's Fine Art Society, which had organized Whistler's famous *Arrangement in White and Yellow*—is a fitting, if unanticipated, outcome. At long last Whistler has had his way: "The Pennsylvania Academy, what? . . . I might have been remembered by it."[61]

NOTES

I am grateful to Linda Merrill and Cheryl Leibold for their assiduous and generous research assistance.

1. Apparently, *Arrangement in Grey and Black* was one of numerous paintings, including *Nocturne in Black and Gold: The Falling Rocket* (cat. 7), that Whistler had pawned to Henry Graves & Co. as security for a loan (see Dorment and MacDonald, *James McNeill Whistler*, pp. 134, 137, 141).

2. Reviews of the Academy exhibition may have assumed readers' familiarity with the portrait due to its reproduction in William C. Brownell's article, "Whistler in Painting and Etching," in *Scribner's Monthly* two years earlier (see "Art in Philadelphia," *New York Daily Tribune*, November 25, 1881, Pennsylvania Academy of the Fine Arts scrapbooks, AAA, microfilm P53, frame 260). E. D. Wallace had introduced Philadelphia readers to the work in 1876, writing that "the homely sincerity of detail wedded to exquisite beauty of color renders this picture one of the most remarkable of modern works" (Wallace, "The Fine Arts Abroad," *Forney's Weekly Press* [Philadelphia], April 1, 1876, GUL, Whistler Press Cuttings, vol. 1, p. 91).

3. See Anna Lea Merritt to George Corliss, September 12, 1881, and W. J. Hennessey to George Corliss, September 13, 1881, Archives of the Pennsylvania Academy of the Fine Arts. Also contained in the Academy's correspondence are lengthy discussions of the logistics of the loan, regarding shipment and insurance, along with detailed instructions as to its return—all attesting to the significance of the agreement.

4. Joseph Pennell, an Academy student at this time, recalled that the painting was not hung "in the place of honour, but in the narrow North Corridor beside the staircase" (Pennell and Pennell, *Whistler Journal*, p. 3).

5. Shinn, "American Artists Abroad."

6. See "Art in Philadelphia," *New York World*, November 28, 1881, Pennsylvania Academy of the Fine Arts scrapbooks, AAA, microfilm P53, frame 277; and "The Philadelphia Exhibition," *Independent* 24 (November 1881), p. 6, quoted in Nicolai Cikovsky Jr. with Charles Brock, "Whistler and America," in Dorment and MacDonald, *James McNeill Whistler*, p. 34.

7. Burns, "Old Maverick to Old Master." As the critic Peter Schjeldahl has observed, "What's required of a successful English artist, beyond being good enough, is that he make a 'character' of himself," an act the Anglo-American Whistler carried off to perfection (Schjeldahl, "Naked Punch," p. 73). According to one contemporary reviewer, Whistler's portrait gave "his compatriots a chance of judging how far he deserves his European celebrity" ("Art Notes," *North American*, October 24, 1881, Pennsylvania Academy of the Fine Arts scrapbooks, AAA, microfilm P53, frame 274). On Whistler's eccentricities, see "Mr. Whistler's Personality," an article that appeared in the same issue of *Scribner's Monthly* as William Brownell's serious consideration of the artist, "Whistler in Painting and Etching." Interestingly, one month later, Brownell published the first account of Thomas Eakins's "radical" teaching practices at the Academy ("The Art Schools of Philadelphia," *Scribner's Monthly* 18 [September 1879], pp. 737–750).

8. Mosby, Sewell, and Alexander-Minter, *Henry Ossawa Tanner*, p. 142.

9. Brinton, a great admirer of Whistler, thought *Arrangement in Grey and Black* his only work to show great "depth"—the "single canvas wherein the artist seemed to lose—and find—himself" (Brinton, "Whistler and Inconsequence"). In response to a query regarding her "idea about pictures," Susan Macdowell Eakins described Whistler's art as "always odd and often true. This portrait of his mother, is the tamest, and one of his best things, but, the whole picture was so quiet, that it was long before it attracted attention, and then he was famous for his odd effects, so often I think the portrait only attracted because it had the name Whistler" (letter to Charles Bregler, July 18, 1934, in Foster and Leibold, *Writing about Eakins*, p. 304).

10. See letters between the Boston Museum of Fine Arts and the Pennsylvania Academy, March 13, 1882, and from the painter Will H. Low, secretary of the Society of American Artists, to George Corliss, June 2, 1882, Archives of the Pennsylvania Academy.

11. Cheryl Leibold, "A History of the Annual Exhibitions of the Pennsylvania Academy of the Fine Arts, 1876–1913," in Falk, *Exhibition Record of the Pennsylvania Academy*, pp. 11–12.

12. Morris, *Confessions in Art*, p. 45.

13. George Corliss to Frederick Dielman, March 28, 1882, Letterbook of George Corliss, Archives of the Pennsylvania Academy.

14. Cheryl Leibold, the Academy's archivist, first suggested the Pennell source to me. In their 1908 *Life of Whistler*, the Pennells assert that the Academy could have bought the painting, evidently based on something that Merritt wrote to them in 1907, long after the exhibition. She had lamented the fact that the Academy "did not secure the beautiful picture for [Whistler's] own country" (Pennell and Pennell, *Life of Whistler*, vol. 1, pp. 297–298). See also Pennell and Pennell, *Whistler Journal*, p. 3, in which the authors claim that Merritt persuaded Whistler to send the picture to Philadelphia "in the hope that it might be purchased by the Academy"—an unsupported inference.

15. Eddy, *Recollections and Impressions*, p. 54.

16. Notes from the Academy's Committee on Exhibitions record a letter of March 12, 1884, from Wunderlich & Co., proposing the exhibition of Whistler's etchings in his "arrangement in yellow and white." The committee voted to accept the offer, provided the gallery reduce the exhibition fee to $100 (the original cost is not given) and furnish catalogues to the Academy to be sold for 25 cents (see Committee on Exhibitions minutes, March 20, 1884, Archives of the Pennsylvania Academy).

17. The Whistlers likely came from the private holdings of James Claghorn, an Academy board member and major collector of the artist's prints (see Cikovsky in Dorment and MacDonald, *James McNeill Whistler*, p. 37). Haden himself was identified as the "foremost living painter etcher" (*Pennsylvania Academy of the Fine Arts Annual Report*, 1882, p. 11, Archives of the Pennsylvania Academy). See also Pennell and Pennell, *Whistler Journal*, p. 2.

18. *New York Evening Post*, November 2, 1883, quoted in Cikovsky in Dorment and MacDonald, *James McNeill Whistler*, p. 35.

19. "The Whistler Exhibition: 'An Arrangement in Yellow and White' Shows by the Anglo-American Artist," *Philadelphia Press*, March 29, 1884, Pennsylvania Academy of the Fine Arts scrapbooks, AAA, microfilm P53, frame 340.

20. For a discussion of Whistler's decoration of his Tite Street home, see Dorment and MacDonald, *James McNeill Whistler*, p. 214.

21. While lecturing in Philadelphia, Wilde socialized with the art educator Charles Godfrey Leland. Leland's niece Elizabeth

Pennell credits her own interest in Whistler to Wilde's visit (see Lewis and Smith, *Oscar Wilde Discovers America*, pp. 72–77; and Pennell and Pennell, *Whistler Journal*, p. 3).

22. According to Erasmus Brainerd, "[Whistler] has been regarded by people who knew nothing of him and who took their cue from the English press as a sort of eccentric young idiot, such as Oscar Wilde pretended to be. Oscar was no fool and anyone who picked Whistler up for a flat found he was very sharp" (Brainerd, "An American Artist: James A. Whistler and His Exhibition at the Academy of the Fine Arts," *Philadelphia Press*, March 30, 1884, Pennsylvania Academy of the Fine Arts scrapbooks, AAA, microfilm P53, frame 340).

23. Both Wilde and Whistler were parodied in Gilbert and Sullivan's satire of the Aesthetic movement, *Patience*, which debuted in London in April 1881 and five months later arrived in America. In fact, Wilde's lecture tour was partially planned to serve as an "advance poster" for the operetta (see Lewis and Smith, *Oscar Wilde Discovers America*, pp. 4–7). In 1887, Whistler put *Arrangement in Grey and Black* on deposit with Carte as security for a loan—an indication of their ongoing relationship.

24. While most Philadelphia reviewers mentioned *The Falling Rocket*'s connection to Ruskin, few commented on its artistic merits. One who did described it as an "evidently honest attempt to render a peculiar effect, while it is not a particularly successful one" (unidentified clipping, Pennsylvania Academy of the Fine Arts scrapbooks, AAA, microfilm P53, frame 340). Another found the painting "strange . . . and . . . as out of place in the setting of the White and Yellow room as it is unworthy the brush of so accomplished a man and artist as Mr. Whistler" ("The Whistler Exhibition," *Progress*, April 12, 1884, Pennsylvania Academy of the Fine Arts scrapbooks, AAA, microfilm P53, frame 341).

25. Brainerd, "An American Artist." Another writer noted, "There is entertainment in the catalogue" (unidentified clipping, *Philadelphia Record*, March 29, 1884, Pennsylvania Academy of the Fine Arts scrapbooks, AAA, microfilm P53, frame 340).

26. Unidentified clipping, *Philadelphia Ledger*, March 29, 1884, Pennsylvania Academy of the Fine Arts scrapbooks, AAA, microfilm P53, frame 340. The *Inquirer* observed, "That Mr. J. McNeil [*sic*] Whistler is a great artist is a fact 'which nobody can deny.' That he is also a bit of a charlatan is a possibility that many will stoutly maintain" ("The Fine Arts," *Philadelphia Inquirer*, March 31, 1884, Pennsylvania Academy of the Fine Arts scrapbooks, AAA, microfilm P53, frame 340). A writer for the *American* held both positions: "There is an air of impudence too about the whole thing which sensibly detracts from one's enjoyment of what is really good in it and the result must be that as far as an addition to the artist's reputation is concerned, the exhibition had better not have been held" ("Art: Mr. Whistler's Etchings at the Pennsylvania Academy," *The American*, April 19, 1884, p. 27, Pennsylvania Academy of the Fine Arts scrapbooks, AAA, microfilm P53, frame 341).

27. Brainerd, "An American Artist."

28. Ibid.

29. "Fine Arts."

30. Unidentified clipping, *Philadelphia Ledger*, April 5, 1884, Pennsylvania Academy of the Fine Arts scrapbooks, AAA, microfilm P53, frame 342. One of the few pointedly negative reviews declared, "The novelty of the White and Yellow room is its chief charm—a room to die in, may be, but never to live in,

unless death were very near, or unless monotony could kill" ("Whistler Exhibition," Pennsylvania Academy of the Fine Arts scrapbooks AAA, microfilm P53, frame 341).

31. "Fine Arts."

32. *Pennsylvania Academy of the Fine Arts Annual Report*, 1885, p. 8, Archives of the Pennsylvania Academy. An entry from the April 14, 1884, minutes of the Academy's Committee on Exhibitions notes, "The Secretary submitted a detailed statement of the receipts and expenses of the Whistler exhibition, showing a net gain of $49.52" (Archives of the Pennsylvania Academy). The infamous *Nocturne in Black and Gold: The Falling Rocket* was exhibited a second time at the Academy in the 1900 annual exhibition.

33. David Park Curry, "Total Control: Whistler at an Exhibition," in Fine, *James McNeill Whistler*, pp. 77–78; and Cikovsky in Dorment and MacDonald, *James McNeill Whistler*, p. 35. Curry is writing a book on the subject.

34. Committee on Exhibitions minutes, May 12, 1884, Archives of the Pennsylvania Academy.

35. Quoted in Carolyn Kinder Carr, "Prejudice and Pride: Presenting American Art at the 1893 World's Columbian Exposition," in Carr et al., *Revisiting the White City*, pp. 93, 100–103.

36. Morris, *Confessions in Art*, p. 17.

37. The only work that did not travel to Philadelphia from Chicago was *Blue and Silver: Trouville* (1865, Freer Gallery of Art), which the owner—the American expatriate artist J. J. Shannon—chose not to send to the Academy.

38. Morris, *Confessions in Art*, p. 17.

39. Ibid. According to Cheryl Leibold, by 1890 most of the works in the Academy's annual exhibitions were procured directly from artists, with less than ten percent coming from private owners. In Whistler's case, all 108 pictures featured in the Academy's annuals between 1893 and 1907 (the artist was not represented in the 1895 exhibition) came from private or public collections.

40. Whistler to E. G. Kennedy, September 21, 1893, New York Public Library, Rare Books and Manuscripts Division, Kennedy I43.

41. "Art Notes," *Philadelphia Bulletin*, December 30, 1893, Pennsylvania Academy of the Fine Arts scrapbooks, AAA, microfilm P13, frame 246.

42. Awarding two gold medals, rather than a gold and a silver, was an unusual occurence for the Academy's jury, likely done in order to offend neither of these major artists (see John Lambert Jr. to Harrison Morris, January 21, 1898, Archives of the Pennsylvania Academy).

43. Morris, *Confessions in Art*, pp. 19, 45. See also Alexander Reid to Harrison Morris, January 11, 1894, Archives of the Pennsylvania Academy, in which the dealer cites the opinion of the English artist Walter Sickert, Whistler's one-time follower, who considered *The Yellow Buskin* to be the artist's "masterpiece . . . as fine as the 'Mother' or 'Carlyle.'" Subsequent letters between the men detail their disappointment over the Academy's failure to buy the work.

44. Morris, *Confessions in Art*, p. 45.

45. Ibid., p. 46. For more on the Wilstach Collection and Whistler's painting, called "easily the gem of the collection," see Henderson, *Pennsylvania Academy*, pp. 294–297.

46. Whistler to Janey Sevilla Campbell [September 1895], GUL, Whistler C21. For a full discussion of the painting, see Dorment and MacDonald, *James McNeill Whistler*, pp. 210–212.

47. On seeing the painting in Chicago, one critic effused, "each time that I approach this painting I feel a repetition of that

first thrill of pleasure in its spontaneity and in the indescribably beautiful color-harmony. . . . It will forever be a joy" (quoted in Carr et al., *Revisiting the White City*, p. 102).

48. With the guidance of his sister Mary, Alexander Cassatt and his wife formed one of the most important early collections of Impressionist art in America. Given this, it is interesting that they approached Whistler for the portrait commission rather than Renoir, whom Mary first recommended (see Dorment and MacDonald, *James McNeill Whistler*, pp. 207–208).

49. Regarding the Academy's rejection of *The Yellow Buskin* on the grounds of sensuality, it is arguable that the board made a similar decision in 1904, when it failed to purchase a provocative work by Mary Cassatt, *The Caress*, which, like the Whistler, it nonetheless chose to honor with a prize.

50. Morris, *Confessions in Art*, p. 17. Reviewing the *White and Yellow* installation at the Academy, a writer for the *American* perhaps best expressed the Academy's Whistler conundrum: "How hard it is to judge an artist by his art, unhindered and unhelped by any knowledge of his personal peculiarities or any interest in his personal affairs" ("Art: Mr. Whistler's Etchings at the Pennsylvania Academy").

51. See Morris, *Confessions in Art*, pp. 48–51, 78–81, 95, 149–151. Whistler and Morris met on only two occasions, in 1895 and 1902, but Morris relished the Whistler tales related to him by the artist's friends William Merritt Chase and J. Alden Weir, as well as by Whistler's later disciples, the Pennells.

52. *Annual Report of the Pennsylvania Academy of the Fine Arts*, 1904, p. 18, Archives of the Pennsylvania Academy.

53. Sarah Burns has demonstrated how the artist's "adroit self-packaging" anticipated the modern construction of the artist-as-celebrity in the age of commodification but largely traces his status from maverick to master as unidirectional (see Burns, "Old Maverick to Old Master," pp. 39, 47; and Burns, *Inventing the Modern Artist*, pp. 221–246).

54. The connection has most recently been made in Leja, "Art, Modernity, and Deception."

55. *Whitehall Review*, June 29, 1884, quoted in Dorment and MacDonald, *James McNeill Whistler*, p. 209. See also Alexander Cassatt to Harrison Morris, July 17, 1893, Archives of the Pennsylvania Academy, in which Cassatt states that the work is misnamed a "portrait" and is in fact a "study." A number of Henri's portraits, particularly his late images of children, suggest Whistler as a source of inspiration. Moreover, Everett Shinn, another Academy student and Ashcan associate, revealed his debt to the famous expatriate—and through him, the pictorialist photographers—in his 1890s pastel series of New York nocturnes. Interestingly, while a student at the Academy, Shinn played the role of "James McNails Whiskers" in *Twillbe*, an art school spoof of George du Maurier's popular novel *Trilby* (see program, Archives of the Pennsylvania Academy).

56. The term was used in Corn, "Who Was Modern?"

57. See Homer, *Pictorial Photography in Philadelphia*.

58. For a discussion of the 1920 exhibition in the context of Philadelphia's modernist scene, see Sylvia Yount, "Rocking the Cradle of Liberty: Philadelphia's Adventures in Modernism," in Yount and Johns, *To Be Modern*, pp. 16–17.

59. The following Whistlers were selected by Carles: *The Chelsea Girl* (lent by Mrs. Plunket Stewart), *Harmony in Grey and Peach Colour* (as *The Woman in White*, ca. 1874, Fogg Art Museum), lent by John Braun, and a pastel, *Nude* (lent by Carroll S. Tyson Jr.) (see *Catalogue of an Exhibition of Paintings and Drawings by Representative Modern Masters*, April 17–May 9, 1920, p. 24, Archives of the Pennsylvania Academy).

60. F. Harris, *Contemporary Portraits*, 1915, quoted in Koval, *Whistler in His Time*, p. 52.

61. The quotation is excerpted from a comment Whistler is said to have made in 1896 regarding a proposed portrait of Joseph Pennell, *The Russian Schube*. Unexecuted due to Pennell's departure from London, Whistler said of the "scheme": "Well, I thought some gallery—the Pennsylvania Academy, what?—would have bought it and you and I might have been remembered by it" (see Pennell and Pennell, *Whistler Journal*, p. 14). This anecdote suggests that Whistler continued to wish to see his work represented in the Academy's collection, despite the 1894 disappointment.

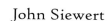John Siewert

Rhetoric and Reputation in Whistler's Nocturnes

WITH THE CLEAR EXCEPTION OF A FAMILIAR portrait of his mother, no aspect of James McNeill Whistler's work has been more readily associated with his name than the paintings he called Nocturnes. In thirty-two canvases—and many related watercolors and prints—Whistler explored the urban terrain of his adopted London, scenes rendered lyrical and mysterious by the atmospheric haze and transfiguring darkness that define the Nocturne. From the time the first paintings were exhibited in the early 1870s, the Nocturnes provided a focal point for the late-Victorian and fin-de-siècle response to Whistler as artist and personality. And, like Whistler's Mother itself, the Nocturnes later represented an enticing artistic example for American painters working in the first decade of the twentieth century (fig. 54). As these artists enthusiastically responded to the Nocturnes with their own versions, they faced the considerable challenge of creating an original expression within a category that Whistler had stamped as distinctly *his*. An attitude of ownership combined with a corroborating critical discourse to surround the Nocturnes with a powerful aura of originality, as if the nocturnal subject had become Whistler's personal property.

Whistler's own words provide ample evidence of his claim to the landscape of London at its most visually indeterminate moments. "They are lovely, those fogs," he observed of the city's defining characteristic, "and I am their painter!"[1] A single example from the critical reaction can stand for many statements like it. Here is an English writer's response to one of the earliest of the Nocturnes (fig. 55), painted in 1872: "*Nocturne in Blue and Silver* renders with exquisite gradations and perfect truth one of those lovely effects of dimly illuminated morning mists on the Thames which nature evidently intended Mr. Whistler to paint."[2] This close identification of the painter with his

James McNeill Whistler, *Nocturne in Blue and Silver*
(detail, cat. 6)

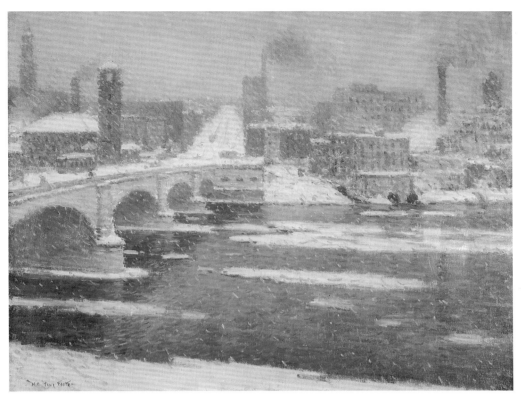

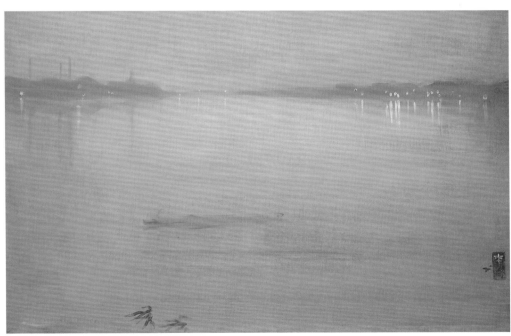

subject yielded both praise and censure, as if his repetition of nocturnal motifs and representational style was an indication of either singular insight or limited outlook and ability. For better and for worse, the Nocturnes became and remain Whistler's signature: images as understated as his public persona was overdetermined—with a reputation that had become no less intractable by the time American painters began to produce nocturnes of their own.

To understand the challenge facing artists who took up the nocturne form in the wake of Whistler's example, it is necessary to view those earlier Nocturnes against the critical contexts from which *they* emerged. For many viewers, Whistler's Nocturnes seemed to test the limits of legibility; at the same time, their conspicuous darkness provided an effective means by which critics could identify and measure the artist's disengagement from conventions of subject,

FIG 56 James McNeill Whistler (1834–1903), *Nocturne: Grey and Gold—Chelsea Snow,* 1876, oil on canvas, 18⅝ × 24⅝ inches, The Fogg Art Museum, Harvard University Art Museums, Cambridge, Massachusetts, bequest of Grenville L. Winthrop.

standards of craft, and the very possibilities of reference to nature. The recognition that this was painting of extreme refinement had become commonplace by the time French novelist and critic Joris-Karl Huysmans offered his assessment of the Nocturnes in 1889: "These places of air and water stretching away endlessly into the distance, suggested pleasant mesmerizing thoughts, carrying us on magical means of transport into unfinished times, into limbo. This was far removed from modern life, far from everything, which seemed to evaporate into invisible wisps of colors, on these delicate canvases."[3]

Huysmans's words suggest Symbolist transformations of the current and the commonplace, invoking the urban subject matter of "modern life" only to suggest the distance from it that Whistler's imagery had traversed. The challenge for this art of exquisite calibration was to sustain its delicate balancing act, to not slip too far into the region where, in the words of another French writer, it "would fall into absolute indeterminacy and could no longer say anything to the eyes."[4] Echoes of these passages appear throughout the American critical response to Whistler's work around the turn of the century, suggesting a continuing interest in how the Nocturnes complicated issues of perception and representation under the cover of darkness.

The public notoriety of the Nocturnes in the 1870s and beyond generated a close association between the artist and the enigmatic, perhaps unsavory nature of night. References abound in the Victorian periodical press to "the nocturnal Whistler."[5] Oscar Wilde is the most memorable among the numerous writers who equated Whistler with the Prince of Darkness, describing the artist as "a miniature Mephistopheles mocking the majority"—an elegant and malevolent character conveyed visually in William Merritt Chase's portrait of Whistler (cat. 24) painted in 1885, the year in which Wilde wrote.[6] These portraits in picture and prose wrap Whistler in aristocratic disdain, setting the artist and his work at some distance from the Victorian world. It was this distance, projected in the painter's public character, that critics came to conflate with the Nocturnes themselves.

Certainly, Whistler himself did much to encourage this situation. In an interview published in 1878, he used *Nocturne: Grey and Gold—Chelsea Snow* (fig. 56) to elucidate his non-narrative aesthetic, describing the painting in deceptively simple terms as "a snow scene with a single black figure and a lighted tavern." He went on to explain, "I care nothing for the past, present, or future of the black figure, placed there because the black was wanted at that spot. All I know is that my combination of grey and gold is the basis of the picture."[7] More than a declaration of a formalist basis for his art, this statement may also be read as an early instance of Whistler's developing preoccupation with a creative stance of detachment and disinterest. He publicly professed to have no interest in the circumstances of the faceless figure he inserted into his composition, who serves as little more than a pictorial punctuation

mark. Neither the figure's personal history nor his motivation matters to the artist, and time—the past, present, and future—like identity is suspended in the encompassing darkness of the scene.

With Whistler's articulation of his *Chelsea Snow* Nocturne, we come to the heart of what many viewers in his British audience found disturbing or distasteful in his work. The question of the artist's investment in the subjects he depicted, a theme established in the popular reaction to Whistler's work of the 1860s, acquired a heightened significance in the context of his Nocturnes of the 1870s, especially in light of such pronouncements as he made about the relationship of the figure in *Chelsea Snow* to the overall composition. With his emphasis on the formal value of that "spot of black," Whistler opened himself up to the charge that such psychological distance from his work's human content discouraged an empathic interest in his imagery on the part of the public.

Henry James, for instance, voiced a widely held opinion when he referred in 1877 to the Nocturnes on display at the Grosvenor Gallery, including *Nocturne: Blue and Gold—Old Battersea Bridge* (fig. 57). "It may be a narrow point of view," James wrote, "but to be interesting it seems to me that a picture should have some relation to life as well as to painting. Mr. Whistler's experiments have no relation to life; they have only a relation to painting."[8] James's remarks might be read, in part, as anticipating a later version of Whistler, elaborated most effectively by Huysmans and other Symbolist critics on the continent, as a figure willfully removed from his milieu and secluded in his studio, concerned with nothing but painting.[9] The accusation that the artist's fascination with darkness signified a retreat into empty formalism is one dimension of what remains the most infamous reaction to the Nocturnes: John Ruskin's 1878 indictment of *Nocturne in Black and Gold: The Falling Rocket* (cat. 7) as a pot of paint recklessly flung into the face of the public.[10] For Ruskin, the idiosyncratic style of the Nocturne displaced the picture's subject, submerging it in layers of darkness, haze, and, most damnable of all, artistic indifference.

Similar observations about Whistler's subject matter and his attitude toward it were raised by his portraiture, the artistic genre most directly associated with issues of human interest. For every critic who found in Whistler's portrait of his mother (see fig. 5) an expression of filial devotion or matronly warmth, another identified in it a subdued and emotionless formality, a studied quality that distanced the viewer from the person portrayed through obvious stylization and an austere, unnatural use of color. As E. F. S. Pattison remarked when the painting was shown publicly for the first time in 1872, "The treatment of the

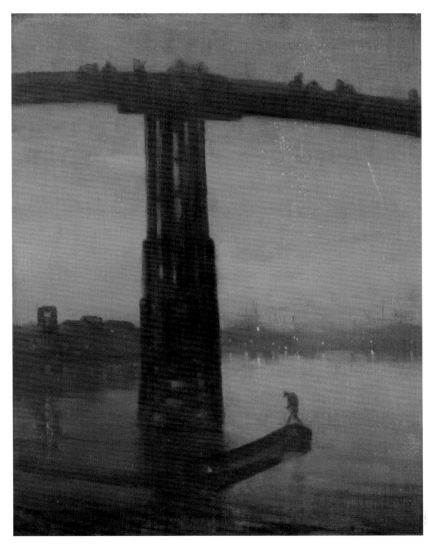

FIG 57 James McNeill Whistler (1834–1903), *Nocturne: Blue and Gold—Old Battersea Bridge*, ca. 1872–1873, oil on canvas, 26¼ × 19¾ inches, Tate Britain, London.

subject is stiff and harsh even to painfulness. . . . Then, the longer we dwell on it, the more cruelly vivid becomes the presentment to us of life with its sources of joy sealed or exhausted."[11] In Whistler's creative process, what Pattison termed his sitter's "mental attitude" supposedly reflects the artist's attitude toward his model, an approach to painting that appears to imply a distance between the artist and the object of his attention. The result may be effective art, the reviewer concludes, but it is art at a considerable remove from the living, breathing human subject that is its source.

In the full-length portraits that Whistler developed concurrently with the Nocturnes, figures draped in black or monochromatic costume nearly merge into their dark backgrounds, a dramatic effect evident in *Arrangement in Black and Brown: The Fur Jacket* (cat. 9), painted in 1876. The Symbolist critic Félix Fénéon, writing about Whistler's portraits, described his impression: "Remote, mysterious creatures emerge with serpentine grace from symphonies

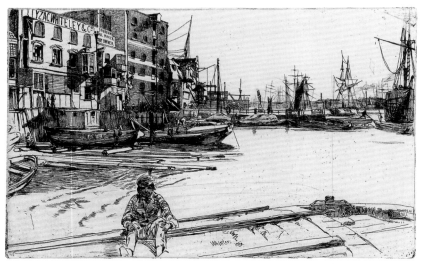

FIG 58 James McNeill Whistler (1834–1903), *Eagle Wharf*, 1859, etching, 5⁷/₁₆ × 8⁷/₁₆ inches, Freer Gallery of Art, Smithsonian Institution, Washington, D.C., gift of Charles Lang Freer, F1998.270.

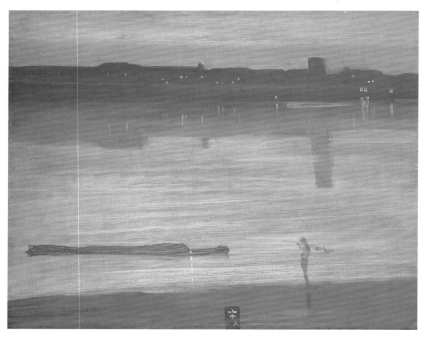

FIG 59 James McNeill Whistler (1834–1903), *Nocturne: Blue and Silver—Chelsea*, 1871, oil on canvas, 19¾ × 23½ inches, Tate Britain, London.

of shadow."[12] In such pictures, the display of personality, social station, and accoutrements conventionally associated with portraiture seems threatened by dissolution, and the physical body appears at odds with its own definition, prompting certain critics to describe Whistler's portraits as imagery of wraiths and materialized denizens of the spirit world.[13] *Arrangement in Black: La Dame au brodequin jaune— Portrait of Lady Archibald Campbell* (see fig. 16), painted in the early eighties, inspired further critical musings on the

theme of remoteness and withdrawal. Huysmans described it as the very image of repudiation, the representation of an elusive figure in retreat.[14] To the fin-de-siècle critic Camille Mauclair, the painting seemed nothing less than a summation of Whistler's artistic achievement. "The entire art of Whistler has retreated beyond the confines of life," he wrote, "and, like the portrait of Lady Campbell, regards it from over the shoulder, drawing on its glove somewhat disdainfully before vanishing into the darkness."[15]

The Nocturnes themselves belonged to this dark and disengaged realm, suggesting to many of their first viewers that the artist did not express a convincing concern for the lives of the people who inhabited and worked the urban landscape sites he painted. In sharp contrast, Whistler's early etchings of riverside London prompted wide appreciation precisely *because* they appeared to register a deeply personal connection with the landscape. Created in the late 1850s but published as a set for purchase only in 1871— at the very time the first Nocturne paintings began to appear—Whistler's Thames Set etchings, including plates such as *Eagle Wharf* (fig. 58), provided a descriptive standard by which the Nocturnes were judged. Bits of signs and other lettering scattered throughout the backgrounds of many of the Thames Set prints further underscore the relative clarity and the manifestly *readable* character of these images. With the simultaneous presence of the published etchings and the exhibited paintings, viewers could set the "disembodied" character of the Nocturnes against the very palpable presence of place that the Nocturnes appeared to deny.

If we are to recover a context for the original response to Whistler's Nocturnes, we need to see them against the backdrop of the artist's London etchings. It was in these graphic works that Whistler's critics found not only a lively image of a particular milieu, but something of a creative life as well, the presence of an artist intently engaged in seeing, transcribing, and interpreting a specific image of a particular place. In plates such as *Eagle Wharf*, *Black Lion Wharf* (Kennedy 42), and *The Pool* (Kennedy 43), a figure prominently positioned in the foreground engages the viewer and stamps the scene as a site inhabited and active with labor. Above all, English audiences appreciated the Thames Set etchings as visual documents of a fast-disappearing locale, as the riverside areas of London were being reshaped by a developing culture of commerce and industry. The earliest commentary on these etchings describes them as "records," "histories," and "chronicles," terms affirming the idea that Whistler was especially responsive to the lively, individual nature of the place and the people who resided and worked there.[16]

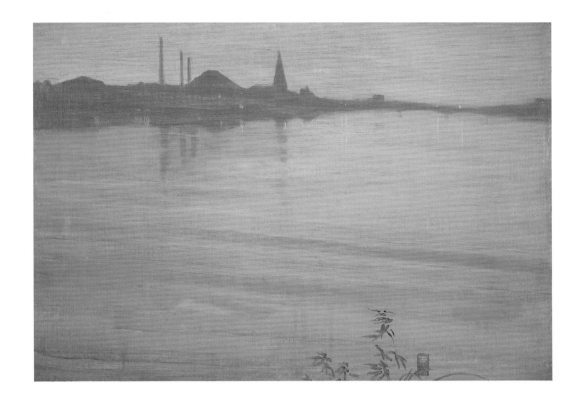

FIG 60 James McNeill Whistler (1834–1903), *Nocturne in Blue and Silver*, ca. 1871–1872, oil on wood panel, 17½ × 23¾ inches, The Fogg Art Museum, Harvard University Art Museums, Cambridge, Massachusetts, bequest of Grenville L. Winthrop.

The Nocturnes, on the other hand, presented a substantially different picture. It was through the Nocturnes that Whistler came to be seen as the interpreter of a distinctly atmospheric, "poetic" London that few artists before him had been inclined, or perhaps able, to notice or to represent on such a sustained level. The Nocturnes defined a particular—and a particularly influential—image of the city, one that largely defined Whistler as a painter and made his reputation, for better or worse. In his London Nocturnes, Whistler offered a muted response to the city subject, a reality and an idea that the artist presented to the very urban audiences that were best positioned to appreciate this interpretation of their shared environment. The pictorial strategies by which he did this extended and departed from the approach he had taken in composing the plates of the Thames Set. The earliest Thames Nocturnes, such as *Nocturne: Blue and Silver—Chelsea* (fig. 59), revise the picturesque context of the etchings by condensing the lines describing buildings on the riverbank into a relatively undifferentiated strip of color pushed toward the upper edge of the canvas. The vacant middle ground that had been framed in the Thames etchings by a linear network moves to the foreground of the Nocturne to become the principal part of the painting, rendered in broad, evenly brushed striations of pigment.

Critics readily associated the evocative line of the Thames Set etchings with the act of recording vanishing sites, as if the rapid pace of topographic change demanded the artist's

incisive, emphatic visual response. Such graphic traces of an eyewitness response marked these prints as vivid documents of Whistler's intimate involvement with the subject matter of the river. By contrast, the first Nocturnes appeared to many of these same critics to revisit that subject with a far greater degree of detachment and an excessive aestheticism that seemed to diminish the notion of landscape as a site of human presence. The emphasis on the figural content of *Eagle Wharf*, for example, is reduced in *Nocturne: Blue and Silver—Chelsea* to the equivocal, fluidly rendered form standing to one side in the foreground. This attenuated presence in the Chelsea Nocturne might have been seen by certain Victorian viewers as an emblem of Whistler's own distanced apprehension of the landscape, an attitude of disengagement, suggesting that the artist thought about the nature of painting rather more than the painting of nature.

If the Nocturnes were landscape paintings born of the studio deliberation that such a shift in emphasis implied, they were even more the products of another kind of interiority grounded in memory and repetition. Two paintings, each titled *Nocturne in Blue and Silver*, suggest the strongly reflexive, self-referential dimension of Whistler's painting project (fig. 60 and cat. 6). Both depict the stretch of riverbank at Battersea Reach near the artist's home in Chelsea, looking across to a triad of factory stacks, a pyramidal pile of industrial waste, and the pointed spire of the parish church of St. Mary's.[17] These paintings were grounded in

FIG 61 James McNeill Whistler (1834–1903), *Sketch for a Nocturne II*, ca. 1872–1875, charcoal with white heightening on brown paper, 5¹¹⁄₁₆ × 10³⁄₁₆ inches, Munson-Williams-Proctor Arts Institute, Museum of Art, Utica, New York, 69.93.

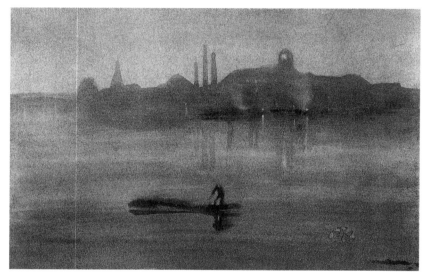

FIG 62 James McNeill Whistler (1834–1903), *Nocturne*, 1878, lithograph, 6¾ × 10⅛ inches, Freer Gallery of Art, Smithsonian Institution, Washington, D.C., gift of Charles Lang Freer, F1905.208.

the small-scale sketches that Whistler habitually made in charcoal and chalk on brown paper, visual memoranda that one contemporary recalled as "drawn in the dark, by feeling not by sight."[18] One such study (fig. 61), drawn sometime in the early 1870s, shows the view readily available as Whistler traversed the Thames from Chelsea toward Battersea. Such sketches, already distanced from direct perception (drawn "by feeling not by sight"), were a key element in the formulation of the Nocturne paintings, where the undifferentiated line of the drawing thickened into a shadowy shape of the skyline's silhouette.

Whistler would reuse that same, distinctive Battersea outline in 1878 to create *Nocturne* (fig. 62), a lithograph that draws upon the features noted in the schematic sketch. The perceptual experience, thus committed to paper and ultimately to the canvas and lithographic stone, became a kind of template, repeatedly rehearsed, that furnished Whistler with material for a performance in his studio at some distance from the actual site. Thomas Robert Way, a printer who regularly gave Whistler technical assistance with lithography, was present at the production of the lithographic version of the Nocturne. According to Way, the artist prefaced his work with a comment suggesting that something like a ritual was about to commence: "Now," Whistler mused before making a mark, "let us see if we can remember a nocturne."[19] The Battersea skyline, inscribed through memory onto paper, had become, through repetition, an intrinsic part of a visual repertoire upon which he could draw at will.

The "ritualistic" aspects of the Nocturne are further borne out in another kind of memory exercise that eschewed the mediation of visual notation altogether. Just as he traced salient characteristics of the nocturnal cityscape on paper, Whistler could systematically commit those perceptual experiences to memory by turning his back on the scene that captured his attention and reciting its essential features to a companion who would check the artist's accuracy. A number of eyewitness accounts describe this practice, most notably those of Way and the artists Mortimer Menpes and Bernhard Sickert (1862–1932), all of whom record the process in the kind of detail that suggests they regarded the activity as a novelty.[20] In Way's version, Whistler refuses the offer of a notebook in which to record the motif of a facade that caught his interest, preferring to internalize the experience by committing it to memory through a process of trial and error; when Way next visited Whistler's studio, he found a recently painted version of that same shop front. Years later, he came upon an ink sketch he recognized as the scene he had studied with Whistler and speculated

that the artist had set it down on paper soon after returning to his studio.[21]

One result, then, of Whistler's methodical memory approach seems to have been to transform aspects of the urban landscape into a kind of convenient and productive formula as evidenced in the pair of closely related Battersea Nocturnes. "All these pictures strike us alike," one critic wrote of Whistler's work on the occasion of his one-man exhibition in 1892. "They seem like half-materialised ghosts at a spiritualistic séance. I cannot help wondering when they will gain substance and appear more clearly out of their environing fog, or when they will melt altogether from my attentive gaze."[22] Although these remarks were directed at Whistler's portraits, they might easily have been aimed at the Nocturnes. The critic's reaction to Whistler's repetition concerns the inescapably *ephemeral* qualities of the pictures, what Michael Fried has termed their "apparitional" aspects.[23] The review employs the critical language of the ethereal and immaterial, by now a familiar device in Whistler commentary, as if to minimize the deliberation and effort involved in the reiteration of a limited number of themes and motifs.

When applied to the Nocturnes, however, the rhetoric of intangibility could acquire a more positive expressive dimension. Whistler contrived in the Nocturnes a perfect convergence of naturalistic motif and its painterly realization, using the nocturnal ambience to mask the subject *and* the process of its representation—or so the artist's own judgment would seem to suggest. "In my pictures," Whistler claimed, "there is no cleverness, no brush-marks, nothing to astonish or bewilder, but simply a gradual, more perfect growth of beauty—it is this beauty my canvases reveal, not the way it is obtained." He summed up much the same idea in one of his favorite aphorisms: "Paint should not be applied thick. It should be like breath on the surface of a pane of glass."[24] Here, then, is a theme taken up and expanded upon in the international critical response to the Nocturnes, as commentators sought to explicate the essential, elusive qualities of the paintings with metaphors that play upon the seemingly organic, incorporeal method of his pictures' making. As early as 1882, Henry James offered this observation: "Mr. Whistler is a votary of 'tone'; his manner of painting is to breathe upon the canvas."[25] In 1892, French critic Gustave Geffroy called *Nocturne: Trafalgar Square—Snow* (ca. 1875–1877, Freer Gallery of Art) "a suggestion, light as a streak of fog, as a breath of air . . . the whole fragmentary landscape wrapped in a silver light, in a bluish lunar mist."[26] In American criticism, too, the analogy of "breath" proved an effective means by which to communi-

cate the delicacy of Whistler's style. Charles Caffin, for example, speaking in 1909 of a Whistler landscape he connected with the Nocturne project, compared it to "the breath of a sleeper as he opens his eyes before he is really awake."[27]

This imagery of the picture as a "breath" severed the intimate connection between the artist's physical touch and the surface of the painting, positing an alternative kind of agency that displaces the painter's hand from the creative process. An even more incorporeal perspective emerges in and around Symbolist criticism at the end of the nineteenth century. In 1893, for instance, the English poet and critic Arthur Symons published an account of the contemporary Decadent movement in literature, which he described as "the poetry of sensation, of evocation; poetry which paints as well as sings, and which paints as Whistler paints, seeming to think the colors and outlines upon the canvas, to think them only, and they are there."[28]

As was the case with the "breath" metaphor, the comparison of the Whistlerian touch to "thought" entered the American critical lexicon. Writing at the turn of the century, the painter Kenyon Cox adopted the critical vocabulary in these words on Whistler: "He has a strong sense for the beauty of material, but it is of material brought to the verge of immateriality. His paint is fluid, thin, dilute; his touch feathery and melting. There may be twenty successive layers of pigment on the canvas, but it is scarce covered, and its texture shows everywhere. It is almost as if he painted with thought."[29] Christian Brinton wrote at the same time about the evolution of Whistler's work: "He soon began to look within, to express things in their briefest terms, to paint, as it were, with the penetrant intensity of thought alone."[30] More emphatically than even the metaphor of an evanescent breath, the idea of painting as if with "thought" establishes a relationship between the painter and the canvas that works against the physical, that constructs creativity as a pointedly *disembodied* enterprise privileging the cerebral over the corporeal experience.

Most important, perhaps, in attempting to convey the effect of Whistler's paintings, these figures of speech ensure the irreducible singularity of his artistic project. The critical metaphors of "breath" and "thought" seem to some degree to distance or even to remove Whistler from the creative process, yet ultimately they reinscribe his presence within an autonomous realm of the aesthetic. As we have seen, these metaphors were applied to Whistler's work with approval. But if we choose to regard the Nocturnes only as the visual embodiment of an aestheticizing distance from the landscape Whistler took as his subject, as many of his early critics did, we risk losing sight of what

is most difficult and ambitious in his art. The textures and aspirations of Whistler's nocturnal landscape are more positive and complex, as the American painter Harper Pennington observed in watching the artist at work:

> His habit of painting long after the hour when anybody could distinguish gradations of light and colour was the cause of much unnecessary repainting, and many disappointments, for after leaving a canvas that seemed exquisite in the dusk of falling night, he would return to it in the glare of the next morning to find unexpected "effects" that had been concealed by the previous twilight. . . . The fascination of *seeing* (it was only that) to have caught the "values" in perfection led him too far into the deceiving shades of night, with, often, disastrous results.[31]

Sequestered in the studio and preoccupied with the process of painting mostly from memory, Whistler unwittingly—or perhaps deliberately—reproduced the elusive properties of the natural, nocturnal subject he sought to represent.

If this enterprise contained the potential for "disaster," as Pennington saw it, the creative tensions contained in that effort suggest something more positive. Painting in the nature of night permitted Whistler a connection to the landscape subject *and* a strategic distance from which to contend with its challenges. Whistler's darkness—both a natural effect *and* anti-nature, in the sense of absence or negation, both a temporal condition *and* a suspension of time—was a kind of liberation, providing him a way to complicate the dynamics of inspiration and execution, the relationship between vision and touch. In the Nocturnes, Whistler could reimagine his stake in the Realist practice of "painting from nature" by painting the urban landscape with a measure of control—control that cast a different light on the ongoing dialogue between the artist's perceptions and their realization on canvas. Subtly expressed within the thirty-two paintings of the Nocturne ensemble, the challenge of representing that conversation is present in every touch of Whistler's brush.

NOTES

1. Whistler to Helen Ionides Whistler [1879], GUL, Whistler W680.

2. *The Athenaeum*, May 6, 1882, GUL, Whistler Press Cuttings, vol. 3, p. 84.

3. J.-K. Huysmans, "Wisthler" [*sic*], in *Certains*, pp. 67–68: "ces sites d'atmosphère et d'eau s'étendaient à l'infini, suggéraient des dodinements de pensées, transportaient sur des véhicules magiques dans des temps irrévolus, dans des limbes. Ç'était loin de la vie moderne, loin de tout, aux extrêmes confins de la peinture qui semblait s'évaporer en d'invisibles fumées de couleurs, sur ces légères toiles." Translations are mine throughout.

4. Duret, *Histoire de Whistler*, p. 58: "tomberait dans l'indéterminisme absolu et ne pourrait plus rien dire aux yeux."

5. See, for example, *The Echo*, May 20, 1889, GUL, Whistler Press Cuttings, vol. 1, p. 89.

6. Oscar Wilde, "Mr. Whistler's Ten O'Clock," in *Oscar Wilde*, p. 14. Wilde's essay reviews Whistler's celebrated "Ten O'Clock" lecture, first presented in London in February 1885 and delivered in the character of "the Preacher," a well-crafted role that Chase's contemporaneous portrait also appears to capture.

7. Whistler, *Gentle Art*, p. 126. The statement originally appeared in "Celebrities at Home. No. XCII. Mr. Whistler at Cheyne-Walk," *The World*, May 22, 1878.

8. Henry James, "The Picture Season in London" [1877], in *Painter's Eye*, p. 143.

9. See Huysmans, *Certains*, p. 73.

10. For the definitive discussion of Ruskin's commentary and the libel suit that Whistler brought against him in response, see Merrill, *Pot of Paint*.

11. Pattison, "Exhibition of the Royal Academy," p. 185.

12. Halperin, *Félix Fénéon*, p. 60.

13. The theme of Whistler's portraits as representations of "specters" and "apparitions" was firmly established by the early 1870s in the British criticism of his work, and it remained a favorite critical image for writers internationally throughout the artist's life and for considerable time thereafter.

14. Huysmans, *Certains*, p. 70.

15. Mauclair, *De Watteau à Whistler*, p. 330: "Tout l'art de Whistler s'est reculé d'un pas hors de la vie, la regardant par-dessus l'épaule et se gantant avec quelque dédain avant de se dérober dans l'ombre, comme le portrait de Lady Campbell."

16. For example, see "Whistle for Whistler," p. 245. See also Frederick Wedmore on the etchings as "varied studies of quaint places now disappearing—nay, many of them already disappeared," which "have been pressed out of the way by the aggressions of great commerce, and the varied line that they presented has ceased to be" (Wedmore, "Whistler's Theories and Art," pp. 342–343).

17. *Nocturne in Blue and Silver* (cat. 6) adds to these features a tower with illuminated clock faces that is no longer in existence but was popularly known in its time as "Mr. Ted Morgan's Folly." The tower served as the office building for the Morgan Crucible Company, importers of graphite and manufacturers of industrial crucibles; it also appears in *Nocturne: Blue and Silver—Battersea Reach* (cat. 5).

18. Way, *Memories of Whistler*, p. 14.

19. Way, "Whistler's Lithographs," p. 286.

20. See Way, *Memories of Whistler*, pp. 67–68; Menpes, *Whistler as I Knew Him*, p. 11; and Sickert, *Whistler*, pp. 108–112.

21. Way, *Memories of Whistler*, pp. 67–68. Way published Whistler's sketch, together with his own memory drawing of the painting (reproduced facing p. 68).

22. *The Echo*, untitled and undated excerpt in Whistler, *Nocturnes, Marines*, p. 24.

23. Fried, *Manet's Modernism*, pp. 222–232. Fried bases his characterization on the abundant commentary prompted by the exhibition of Whistler's *White Girl* (cat. 1) in 1863 at the Salon des Refusés in Paris. Critics there both praised and censured the picture as a "white apparition" and the portrait of a spiritualistic medium, a number of writers focusing on its apparently fugitive character despite its heavily worked surface.

24. Pennell and Pennell, *Whistler Journal*, p. 235.

25. James, "London Pictures" [1882], in *Painter's Eye*, p. 209.

26. Geffroy, *Vie artistique*, vol. 2, p. 323: "une indication, légère comme une traînée de brouillard, comme un souffle d'air . . . tout ce fragment de paysage évoqué dans une lumière d'argent, dans une bleuâtre poussière lunaire."

27. Charles H. Caffin, "The Art of James McNeill Whistler," typescript, FGAA, p. 43. Caffin presented his remarks in a lecture at the Detroit Museum of Art on April 23, 1909, an event underwritten by Charles L. Freer, Detroit industrialist, art collector, and eventual benefactor of the Freer Gallery of Art. Caffin illustrated his lecture with Lumière process autochromes of works in Freer's collection, taken by the American photographer Alvin Langdon Coburn—an early instance of the use of color slides in a public presentation.

28. Symons, "Decadent Movement in Literature," p. 861.

29. Cox, *Old Masters and New*, p. 249.

30. Brinton, "Whistler from Within," p. 16.

31. Pennington to William Heinemann, November 16, 1908, PWC, box 285.

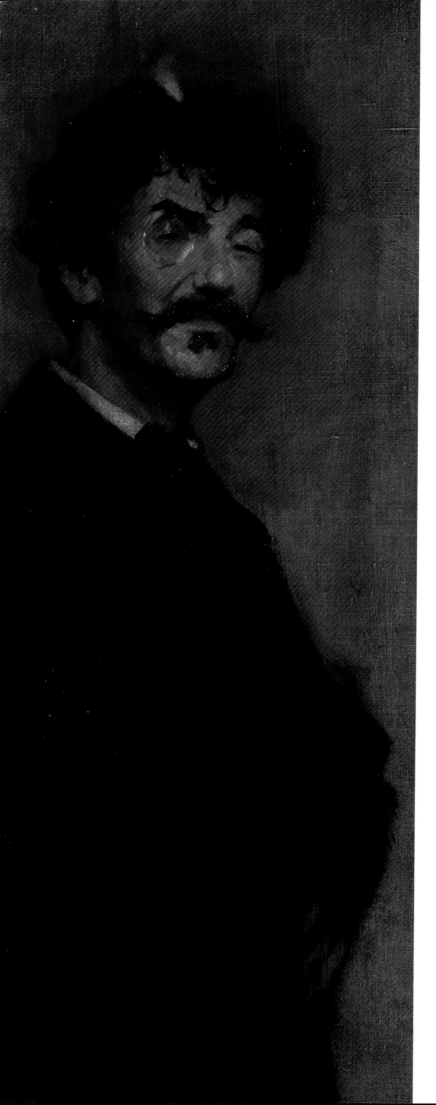

Robyn Asleson

The Idol and His Apprentices

Whistler and the Académie Carmen of Paris

"THERE WERE TWO DISTINCT SIDES TO WHISTLER," William Merritt Chase once observed. "One was Whistler in public—the fop, the cynic, the brilliant, flippant, vain, and careless idler; the other was Whistler of the studio—the earnest, tireless, somber worker."[1] George du Maurier parodied the public Whistler in his serialized novel *Trilby* (1894), representing the artist during his student days in Paris as "the idle apprentice, the king of bohemia, *le roi des truands*"—foil to the more serious-minded "industrious apprentice" (fig. 63).[2] Incensed, Whistler charged that the characterization was libelous and succeeded in having it suppressed. In the years that followed, he took steps to ensure that the public image he consigned to posterity would replace the flimsy caricature of an idle apprentice with a more substantive portrait of himself as a serious artist—an image he had articulated in paint two decades earlier (see cat. 8).

One of the most intriguing projects through which Whistler sought to shape his posthumous reputation was the Académie Carmen in Paris, which provided him with an opportunity to create a school of followers to whom he could impart the "knowledge of a lifetime" in the tradition of the Old Masters.[3] Whistler had no financial interest in the academy; his only wish, he later informed his student assistant Earl Stetson Crawford (see cat. 29), was "to win a few disciples and imbue them with my teachings that they may champion my art when Time shall render me unable longer to voice my own principles."[4] Although Whistler had collected disciples and assistants throughout his career, it was only during the brief life of the Académie Carmen (which opened in October 1898 and closed in April 1901) that he realized his long-deferred plan of training a corps of loyal followers.

Whistler's attitude toward art instruction was paradoxical. Although he often scoffed at the notion that art could

William Merritt Chase, *James Abbott McNeill Whistler* (detail, cat. 24)

FIG 63 George du Maurier (1834–1896), *The Two Apprentices*, plate published in "Trilby," *Harper's Monthly Magazine*, March 1894.

FIG 64 James McNeill Whistler (1834–1903), *Harmony in Rose and Green: Carmen*, ca. 1898, oil on canvas, 22¾ × 17½ inches, Hunterian Art Gallery, University of Glasgow, Scotland, Birnie Philip Bequest.

be taught, his long struggle to school himself in the fundamentals of art practice had yielded insights that he believed he could share with others. His future biographers Elizabeth and Joseph Pennell recalled that Whistler "would have liked to practise the methods of the Old Masters. He would have taught the students, from the beginning, from the grinding and mixing of the colours. The only knowledge necessary for them to acquire was, in his opinion, how to use their tools."[5] Whistler intended this focused approach to art instruction as a corrective to the mode that had been practiced in Paris ateliers since his own student days. He informed a friend:

> I have always believed there has been something radically wrong with all this teaching that has been going on in Paris all these years in Julian's [the Académie Julian] and the rest. I decided years ago the principle was false. They give the young things men's food when they require pap. My idea is to give them three or four colours— let them learn to model and paint the form and line first until they are strong enough to use

others. If they become so, well and good, if not, let them sink out of sight.[6]

During the summer of 1898, Whistler was in Paris working with a favorite model, Carmen Rossi (fig. 64), whom he had known from childhood. A shrewd opportunist, Rossi was keen to capitalize on the burgeoning population of foreign art students in Paris by opening her own academy of instruction. Apparently out of affection for her, Whistler provided the initial financial backing of two hundred pounds and agreed to serve as a visiting professor on a weekly basis. News of the school instantly spread through Paris. The buzz was sufficiently strong by late July 1898 to dissuade the American painter Robert Henri (see cat. 45) from setting up his own teaching atelier as he had done during previous sojourns in France, catering to a predominantly Anglo-American clientele. Competition with Whistler would be futile, Henri feared, for "it would be just that sort who choose me as teacher who would be among the first to hurry to him."[7] Conscious of the transatlantic appeal of her famous patron, Carmen Rossi advertised the new atelier at 6, passage Stanislas as both the "Académie Whistler" and

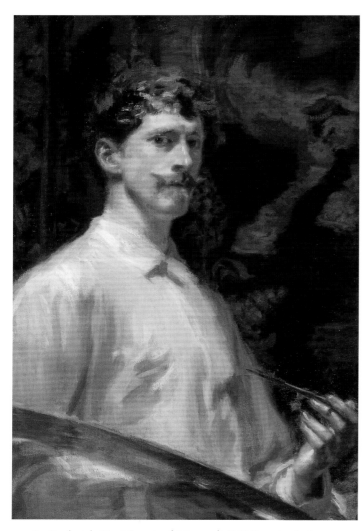

FIG 65 Frederick MacMonnies (1863–1937), *Self-Portrait*, 1896, oil on canvas, 32 × 21⅜ inches, Terra Foundation for the Arts, Daniel J. Terra Collection, 1992.46.

the "Anglo American School," and she marked the place with a sign decorated with the Stars and Stripes and the Union Jack.[8]

In light of Whistler's well-known contempt for art teaching, Rossi's new school could hardly fail to elicit perplexity and surprise. When Whistler invited his friend the American sculptor Frederick MacMonnies (fig. 65) to teach sculpture and drawing there, MacMonnies assumed it was all a joke, as Whistler had always said that the idea of teaching "was shocking, useless, and encouragement of incapables." But he agreed to join Whistler as a visiting professor "and looked forward to high larks, as I was sure things would occur."[9] The story was picked up by newspapers and artistic journals in the United States, England, and France. *Quartier Latin* noted that Whistler and Mac-Monnies "have astonished the Art Colony of Paris by collaborating in a new art-school venture," adding, "That

Whistler should have consented at last to the fetters of routine work and teaching, may be a mortification of the flesh for that gentleman, but it will be a decided gain for future art."[10] Others were more skeptical, as the *New York Times* noted in an article of December 1898: "[Whistler] as a teacher—that was a new rôle, and the art world of Paris was immediately all attention. Talk was rife in the studios and predictions of success or failure plentiful, with the weight of opinion mostly in the latter scale."[11]

To quell bemused reactions to the school (while craftily publicizing the school's existence), Whistler explained the nature of his involvement in a letter that appeared in newspapers in Paris, London, and New York in October 1898. The proprietress had named the school "the Académie Whistler" merely out of gratitude for his support, he claimed, and that support was strictly limited. "In company with my friend, the distinguished sculptor, Mr. MacMonnies, I have promised to attend its classes," he wrote, denying any other responsibility.[12] The disclaimer was disingenuous, for Whistler clearly had specific personal ambitions for the academy and from his first visit he alone dictated its rules of conduct and established the content of its curriculum. Nevertheless, the school was thereafter known as the Académie Carmen.

Very soon, fledgling artists from the United States, Britain, and other countries flocked to Paris in order to study with Whistler. In addition, MacMonnies recalled, "All the schools in Paris were deserted immediately, and the funny little studios of Carmen's place were packed with all kinds of boys and girls, mostly Americans, who had tried all styles of teaching in every direction. . . . The various samples of such awaiting him represented the methods of almost every teacher in Paris."[13] Curious to see what all the fuss was about, Robert Henri visited the Académie Carmen soon after its opening. As he informed his parents on October 12, 1898, the conditions were hardly impressive:

> It was a great many flights of stairs and not [a] very big studio—very small in fact for a class, although I hear other rooms are to be opened shortly, as fast as they fill up. A homely, ugly Italian woman was posing nude and among the shafts of easels I saw the serious faces of about a dozen Americans, men and women— but recognized none of them. I have been told the studio is run by a Madame Rossi—an old model of Whistler's.[14]

It says much for Whistler's charismatic appeal that the fee Carmen charged for this rather ad hoc mode of instruction was about double that of other ateliers and equal to that of

the more systematically organized Académie Julian—the most expensive atelier in Paris.[15]

Several student accounts attest to the state of excitement as the occasion of Whistler's first visit drew near.[16] MacMonnies recalled that Whistler, "having a full sense of a picturesque *grande entrée,*" waited "until the pupils had passed the palpitating stage and were in a dazed state of expectancy and half collapsed into nervous prostration."[17] He satisfied their expectations, arriving (as on all subsequent visits) with an air of grand ceremony, impeccably dressed in black, bearing hat, gloves, and cane.[18] Whistler's self-presentation as a visiting dignitary reinforced the serious sense of purpose that he sought to instill at the school. He immediately distinguished it from other teaching ateliers by insisting on silence and cleanliness, banning the noisy singing, playful banter, graffiti, and smoking that prevailed elsewhere.[19] Whistler's unusually stringent rules were meant to discourage "the ordinary 'roller through Paris'" and to attract only the most serious and gifted students—those who "consider art a science, not a trade."[20] Nevertheless, his celebrity inevitably lured the merely curious to his studio. According to Arthur Jerome Eddy, "it was not uncommon to see carriages with coachmen and footmen in livery before the door on the days that Whistler was expected."[21]

Many students balked at the strict regime instituted by Whistler, and many more were put off by his insistence that they abandon every previously acquired technique and principle and unquestioningly adopt his own approach to painting. According to the Pennells, Whistler's intention was that his students "should work with him as apprentices worked with their master in earlier centuries. Artists then taught the student to work exactly as they did."[22] He recited passages from his *Gentle Art of Making Enemies* as if it were holy scripture, and, early in 1899, extracts from the book were painted on the walls of the studio (in English and French), where they served as constant reminders of Whistler's idiosyncratic views on art.[23]

Perhaps Whistler's greatest deviation from the mode of instruction practiced in other Parisian art academies was his emphasis on painting rather than drawing. His own art study—from his earliest lessons in St. Petersburg in 1844–1846 to his two years, 1856–1858, in the Paris studio of Charles Gleyre (1808–1874)—had emphasized drawing as the foundation of painting. Whistler reversed this premise, informing his students that he taught them how to paint so that they might "really learn to draw, telling them that the true understanding of drawing the figure comes by having learned to appreciate the subtle modellings by the use of the infinite gradation that paint makes possible."[24]

Far from a merely technical skill, painting was presented by Whistler as an exact, penetrating mode of observation. He assured his students that if they followed his teaching, they might "not necessarily learn art, but, at least, absolutely learn to paint what you see," for his method was "based on proved scientific facts."[25]

Reinforcing his analogy with science, Whistler placed remarkable emphasis on an orderly and rational method of setting out the palette. After arriving at the mixture of pigments necessary to match the predominant color of the model, small quantities of similar colors were blended to form incremental transitional tones from the composition's highest light to its darkest shadow. Only when every decision regarding tone and color had been made on the palette was the student permitted to make the first stroke on the canvas, using a separate brush for each sequential note of color.[26] Whistler's insistence on a well-prepared palette was undoubtedly inspired by Gleyre,[27] but the importance that he assigned to the palette as the primary vehicle of painterly perception was his own. "You must see your picture on the palette," more than one student recalled his saying. "Here, not on your canvas, is your field of experiment, the place where you make your choices."[28] Nevertheless, work on the canvas was also to be carried out in a systematic fashion. "It is not sufficient to have achieved a fine piece of painting," Whistler would say. "You must know *how* you did it, that the next time you can do it again . . . and, if you do not remember, scrape out your work and do it all over again."[29]

Many of Whistler's students were skeptical of his methods, and some of the men seem to have supplemented study at the Académie Carmen with attendance at the Académie Julian.[30] To Simon Bussy (1869–1954), who studied at the Whistler academy for two months, it seemed that the palette was the only thing Whistler had to teach, and that his "knowledge of a lifetime" could actually "be had in two lessons."[31] Judging from surviving accounts, Whistler's female students were more deeply impressed. Mary Augusta Mullikin (1874–1964) gleaned profound insights from Whistler's instruction. It was remarkable, she noted, "that a teacher should propose merely to initiate us into some purely technical matters of our art, and should yet succeed—almost without his or our volition—in transforming our ways of seeing!"[32] Several of Whistler's female students disseminated his methods beyond the Académie Carmen. After studying at the school for a few months during the winter of 1898–1899, Gwen John (1876–1939) returned to England and immediately impressed her colleagues with her "insistence on a clean and orderly palette, her exacting attention to the rightness

FIG 66 Edward Dufner (1872–1957), *In the Studio*, 1899, oil on canvas, 28½ × 20 inches, Albright-Knox Art Gallery, Buffalo, New York, Sherman S. Jewett Fund, 1901.

through subtle modulation of tone, thereby establishing a convincing appearance of solidity and atmosphere.[37] The exercise inevitably laid a "softening touch on the gaudy palette," as one pupil recalled.[38]

Although sound in principle, Whistler's tonal theories resulted in an array of preposterously dusky student canvases. "Swarms of imitators of Whistler, mostly Americans, seem to imagine that if they paint black, they get quality and tone," the Australian art student Hugh Ramsay (1877–1906) observed in Paris in 1902.[39] The American artist Will H. Low similarly blamed Whistler's teaching for "steep[ing] much of the effort of our younger men in a cheerless and monotonous gloom."[40] A somber self-portrait by Edward Dufner (fig. 66), painted in 1899 while he was a student of Whistler, illustrates Low's point. But it was not only the Americans who were affected. "We were all painting dreary vague abstractions directly inspired by the master," the Irish painter Paul Henry (1876–1958) admitted of his time at the Académie Carmen.[41] Unaware of Whistler's intentions, MacMonnies was baffled on arriving at the academy and finding "the entire crew painting as black as a hat."[42] MacMonnies reworked one student's palette with brighter pigments—thus arousing the indignation of the class and the consternation of Whistler. The incident seems to have precipitated MacMonnies's decision to leave the Académie Carmen, "as the School had become a tonal modelling school and my criticisms superfluous."[43]

Whistler once remarked that he was teaching his students "neither a method, a trick, a system, nor a dodge," but an entirely new way of seeing.[44] However, it was specifically in pursuit of easy "tricks" that many of them had enrolled in the Académie Carmen in the first place. Hoping to accelerate their professional careers, the men in particular were looking for shortcuts to success: hints on producing pictures for the annual Salon competitions and on painterly sleights of hand that would mark them as students of the great Whistler.[45] These students' impatience to advance their careers was diametrically opposed to Whistler's long-term goal of cultivating a group of apprentices in the manner of the Old Masters. Earlier in his career, he had delighted in collecting followers, whom he encouraged to exhibit under the tag "Pupil of Whistler."[46] Toward the end of his life and with his eye focused on posterity, Whistler was far more selective. It was no longer the quantity of disciples, but their quality that mattered, for they had become disseminators of his legacy. When approached about the Salon exhibitions by some of the men at the Académie Carmen, Whistler told them that they could not possibly present themselves as his pupils after only a few months' study, for he was like "a chemist who puts drugs into bottles, and he certainly should not send those bottles out in his

of tones—particularly in transitional passages—and her repeated instruction 'If it isn't right, *take it out!*'"[33]

Another controversial aspect of Whistler's teaching was his insistence that his students paint in subdued tones. Many of them, previously schooled in the conventions of Impressionism, came to him with a predilection for clear, bright, contrasting pigments. "Why did you paint a red elbow with green shadows?" he demanded of one student, while advising another that her only hope for learning was to keep her brilliant pigments in their tubes.[34] Imagining "crude notes in Nature, spots of red, blue, and yellow in flesh where they are not" had actually harmed their eyes, Whistler told his students. Retraining themselves to see "the real, quiet, subtle note of Nature required long and patient study."[35] As a first step, he had his students regard one another in the cool gray light of the studio and asked them to note the "gentle truth" of actual appearances.[36] Their aim was not to create arrangements of pleasing colors, Whistler said, but to reproduce the contours of objects

name unless he was quite satisfied with, and sure of, the contents."[47] If anything, he was convinced that the majority of the men had failed to comprehend the principles he was striving to inculcate, a lack of understanding that he found increasingly irritating.[48]

In fact, Whistler had begun to distance himself from his male students at an early stage in the academy's history. On his very first visit, he segregated the male and female students into separate classes—an arrangement that is generally chalked up to his prudish objections to their studying the nude together.[49] However, contemporary accounts suggest that Whistler actually had very little interest in instructing the men. The division into two distinct ateliers simply made it easier for him to ignore them. Initially, he visited both the men's and the women's classes each Friday, always seeing the women first.[50] Gradually, his male students found themselves "exasperated by hearing his footsteps dying away down the passage and hearing . . . 'A peut-être demain—pour les messieurs. Au revoir!'" Whistler deigned to visit the men's class only when the spirit moved him, and, as one male student wryly observed, "the spirit moved him very seldom."[51]

When he did critique the men's work, Whistler's manner seems to have been more aloof than when he visited the women's atelier. Paul Henry, who spent the better part of 1899 at the Académie Carmen, recalled, "he could not suffer fools gladly, or the dull or incompetent. All the instruction they got was a shrug of the shoulders and a little cynical smile, with which he looked at their work. . . . [He] went round the studio as quickly as he could, and you felt that as the door closed behind him, he said with relief, 'Thank God that's over.'"[52] Louise Jackson (active 1900) had an entirely different experience with Whistler:

> "The gentle art of making enemies" was certainly never practiced in his classes. From the first he was all that was gracious and "gentle" in a friend. He appeared to take a serious interest in each pupil's studies. . . . It was usually the talk after his tour of the studio which was the real lesson. It was then that we were treated to a sort of Parisian "ten o'clock," and the same epigrams he had expressed in London years before were repeated in his unique and witty manner.[53]

Whistler's indifference to the careerist ambitions of his male students and their impatience with his painstaking methods placed the master and his would-be apprentices at cross-purposes. Many of the men apparently resented his appointment of a female student, Inez Bate (active 1898–1927), as massière (monitor) to oversee the academy and instruct the others in his absence.[54] Various male monitors were also appointed—Cyrus Cuneo (1878–1916), Earl Stetson Crawford, and Alphonse Mucha (1860–1939) among them—but none could be induced to remain for long.[55] Soon, the poor attendance of the male students matched Whistler's own. As early as December 1898, the New York Times was reporting on the great exodus from the academy and predicting that "the failure of the school seems a matter of only a short time."[56] In an effort to appease the men who remained, Whistler invited them to spend Christmas at his studio, where he showed them the paintings he had in progress and assured them "that he used au fond the science he was teaching them." The mutual rapprochement was short lived, however, and the male class continued to hemorrhage members while Whistler neglected his duties. According to Inez Bate, Whistler secretly reviewed the men's work on Sundays, "and often he would declare that nothing interested him among them, and that he should not criticise that week, that he could not face the fatigue of the 'blankness' of the atelier."[57] Bate reinforced Whistler's sense of "blankness" through the reports she issued during his absences from the academy. In response to one, dating from the autumn of 1899, he wrote, "And now my impression is that the men are less interesting than ever—? This, not only because of their evident inferiority in numbers . . . but from their personality—or want of it—for you say nothing about them!—Who are they? and what are they?—and how have you let them in?"[58] Under these circumstances, it is hardly surprising that Whistler refused to visit the men's atelier that year, and the following year there was no men's class at all, only a women's atelier, relocated to the boulevard Montparnasse.

Whistler's preference for female students distinguished his academy from other art schools in Paris, notably the Académie Julian, where "eager, undemanding and docile female students" were made to accept half the teaching for twice the tuition fees that men paid.[59] In establishing the "Académie Whistler," Carmen Rossi had initially followed the same model, charging female students one hundred francs a month to the men's fifty. Whistler revised the policy as soon as he learned of it, reducing the women's fees to those of their male colleagues, while providing them with vastly superior instruction.[60]

Whistler's special rapport with his female students elicited considerable comment. Assessing the Académie Carmen's prospects three months after its opening, the New York Times reported, "The peculiar personality of Whistler had been depended upon, no doubt, to attract women, and the fact is that the majority of the applicants have been women. The men were not convinced."[61] Reporting on five "California girls" who had spent two winters studying with Whistler, an American newspaper noted that the

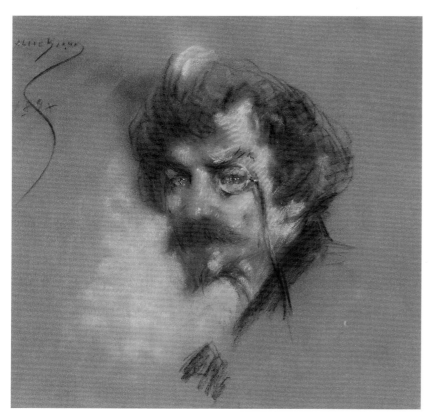

FIG 67 Alice Pike Barney (1857–1931), *James McNeill Whistler*, 1898, pastel on paperboard, 19¼ × 19¼ inches, Smithsonian American Art Museum, Washington, D.C., gift of Laura Dreyfus Barney and Natalie Clifford Barney in memory of their mother, Alice Pike Barney.

artist's disproportionate attention to his female students had infuriated the men. "Whistler, however, serenely disregarded the rising discontent," the report read, "only acknowledging its existence by an emphatic statement that the future of art was in the hands of women—a sufficiently remarkable dictum, but probably only representative of a momentary mood."[62] Whistler no doubt meant to be provocative, but the "dictum" reflects his view that the women were "his stronger class," "much stronger" than the men.[63]

Many women came to the Académie Carmen from the Slade School of Art in London, which, according to Augustus John (1878–1961), "abounded in talented and highly ornamental girl students: the men cut a shabbier figure and seemed far less gifted."[64] It seems likely that Whistler's interest in these women was sustained by their personal attractiveness as well as their artistic merits. They were also a good deal more tractable than their male counterparts. As Henry Tonks (1862–1937), who led the Slade's life class, observed, it was easier to teach women than men because "they do what they are told."[65] Tonks's statement is borne out by the example of Anna Ostroumova-Lebedeva (1871–1955), who joined the Académie Carmen in January 1899 after seven years' study at the St. Petersburg

Academy. Whistler severely criticized her work during their first encounter, informing the stunned Russian that she knew nothing of painting or drawing and that he could not possibly teach her. Despite her shock and although she considered "the complete lack of any freedom or independence and the absolute obedience to all rules insisted on by Whistler" to be "completely absurd," Ostroumova-Lebedeva did not abandon the school in disgust as so many of the men did. Rather, she "decided to submit completely," adding, "it is very interesting to me to be under instruction and to acquire a certain system . . . if it is not good I'll know after some time."[66]

Some of the female students at the Académie Carmen seem to have gratified Whistler's need for female companionship in the lonely years following his wife's death. Alice Pike Barney (1857–1931) claimed that Whistler took great interest in her work and regularly visited her house to chat over tea. When she showed him a portrait she had made of him (fig. 67), he told her, "It is very amusingly done, dear lady . . . but you must not paint at it again, you might spoil it."[67] Barney evidently took pride in the remark, but it has an ironic ring to it, recalling all too plainly Whistler's condemnation of the meretricious modern artist, who "fears to add another touch for fear of concealing the cleverness of the touches that preceded it. His friends stand about him saying, 'For the Lord's sake, don't touch it; you might spoil it!'"[68] It was evidently Barney's tea and sympathy, rather than her artistic gifts, that brought Whistler to her door.

The patently unequal master-student dynamic that Whistler cultivated within his academy was essential to his aim of creating receptive apprentices to perpetuate his legacy. The arrangement worked only because so many of his female pupils viewed him as an idol to be worshiped. Whereas the male students who flocked to Paris generally aimed to rival the famed artists who instructed them, the women more often succumbed to feelings of romantic veneration toward their instructors.[69] The Académie Carmen became notorious for this tendency. Mullikin acknowledged, "Nothing could be funnier than to see the little man [Whistler] picking his way around among the easels, the *massière* with an immaculate 'paint-rag' in readiness, and the rest of us swinging after, like the tail of a comet. Awe and admiration were visible to the naked eye at such times."[70] The American artist Cyrus Cuneo captured this image of Whistler, "surrounded by a bevy of girls who hung on his slightest word," in a drawing of 1906 (fig. 68). In the article that accompanied the illustration, Cuneo observed, "He [Whistler] never had a more ardent lot of followers; they adored him. . . . On certain days the girls appeared more smartly dressed than usual—some were even resplendent—and to the uninitiated in the Quarter

and to look over our Whistler literature." The two women were "following the Master today as faithfully as possible, working at the palette, and straining every nerve to prove ourselves worthy of our great privilege. We have the religious feeling toward Mr. Whistler that the Japanese followers of Rikyu had to their great master. . . . We hope to prove our devotion to Whistler with our lives."[73] Indeed, it was as promoters of Whistler's methods and ideas that the women achieved significance, for neither distinguished herself as an artist. Equally striking is the manner in which Alice Pike Barney defined herself in relation to Whistler. When Frances Benjamin Johnston (1864–1952) photographed her around 1915, the portrait of Whistler that Barney had made while studying at the Académie Carmen was among the props selected to define her exquisite aesthetic sensibilities (fig. 69). Standing in profile next to the portrait, which she appears to fan with a peacock feather, Barney assumes the role of high priestess at Whistler's shrine. Fifteen years later, she used the Whistler portrait as the key publicity

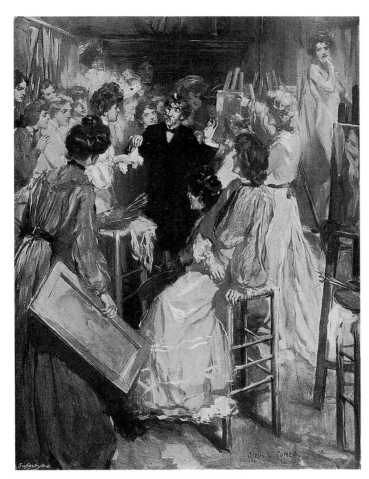

FIG 68 Cyrus Cuneo (1878–1916), *"He never had a more ardent lot of followers than the girl students; they adored him,"* plate published in "Whistler's Academy of Painting," *Nash's Pall Mall Magazine* (London), November 1906.

these gay toilettes almost suggested a festive occasion; but no, it was merely that Mr. Whistler was expected."[71] Alice Woods (born 1871), who studied at the academy during its second year, recalled her colleagues' elaborate sartorial displays with sardonic humor: "Had it chanced that I aimed to dedicate my youth to decorative adoration, then, truly, I'd rather Mr. Whistler than another. . . . But the expense of it! I'd have to send off to Egypt for an assorted string of scarabs, buy a lot of umber and sienna velveteen frocks, and then spend several hours a day doing my hair."[72] If Whistler's appearances at the academy were elaborately orchestrated, those of his female students were even more so.

The most striking proof of Whistler's idolization by his female students occurred after his death, when several of them chose to promote themselves as his faithful disciples. In 1911, Mary H. Halliday (1866–1957) reported that she and Marie von Reitgenstein (active 1899–1911) had become so well known in Berlin for their devotion "that when anyone writes of Whistler they come to borrow our portfolios,

FIG 69 Alice Pike Barney in Studio House, ca. 1915, Smithsonian American Art Museum, Washington, D.C.

EXHIBITION

of

PAINTINGS AND PORTRAITS

by

ALICE PIKE BARNEY

of

WASHINGTON, D. C.

at the

STENDAHL ART GALLERIES

JAMES McNEIL WHISTLER
ALICE PIKE BARNEY

OCTOBER 17th TO 31st INCLUSIVE

AMBASSADOR HOTEL · · · · LOS ANGELES

FIG 70 Flyer advertising an exhibition of paintings and portraits by Alice Pike Barney, 1930, Smithsonian American Art Museum, Washington, D.C.

image for her retrospective exhibition at Los Angeles's Stendahl Art Galleries (fig. 70).

Although many women became self-appointed disciples of Whistler, only one was formally apprenticed to him. By a legal agreement of July 20, 1899, the *massière*, Inez Bate, "bound herself to her Master to learn the Art and Craft of a painter, faithfully after the manner of an Apprentice for the full term of five years."[74] Whistler permitted her to exhibit a study of a head (under the trivializing title *Etude de la Semaine*) in London in 1899, but Bate's artistic career does not seem to have been as important to him as her absolute dependability as the executor of his numerous directives for the Académie Carmen. Obedience, rather than outstanding artistic ambition or talent, was evidently her chief recommendation, and she abandoned painting soon after marrying Clifford Addams (1876–1942), who became Whistler's second apprentice in May 1901.

Whistler's continued absences due to illness caused the Académie Carmen to close on April 6, 1900, to the "large sad stupefaction" of the women who remained.[75] Even before then, however, Whistler seems to have recognized the futility of playing Old Master to a school of would-be apprentices, for he was already pursuing alternative means

of perpetuating his "knowledge of a lifetime." He asked his publisher, William Heinemann, to investigate the possibility of acquiring a gramophone so that his teachings at the Académie Carmen could be recorded and later translated into "a wonderful book."[76] In a conversation with Elizabeth Pennell on July 15, 1899, Whistler proposed that she write an article that would inform the world of the "amazing" things going on at the academy, and he also proposed that his faithful *massière* give a talk on the subject while visiting London.[77] A year later, Whistler asked the Pennells to write his biography, and in a letter of February 8, 1901, he instructed Inez and Clifford Addams to write the full history of the Académie Carmen. Although they were ostensibly the authors, Whistler prescribed the events and subjects they were to address and later amended their draft.[78]

The legacy of the Académie Carmen is difficult to assess. Many of Whistler's former students expressed their indebtedness to him, and much of their work reflects his emphasis on technique and attention to overall harmonies of color and tone. However, more than Whistler's instruction, it was the example of his art and his bold artistic stance that seem to have had the greatest impact on younger artists. His disparagement of modern art movements such as Impressionism fell on deaf ears. Several of his students— among them Alson S. Clark, Edward Dufner, Lillian Genth (see cat. 38), and Henry Salem Hubbell (1869–1949)— consciously imitated Whistler's style for a time but later moved on to the brighter palette and broken brushwork of the Impressionists. Others strayed still further from the master's art. Lydia Longacre (1870–1951) became a miniature painter, while Lucian Abrams (1870–1941) absorbed aspects of Post-Impressionism and Fauvism, and Blendon Reed Campbell (1872–1969) dabbled in a variety of modern styles, including Precisionism. The imitative aspects of his students' work would not have pleased Whistler, for although he demanded that they replicate his own methods while studying with him, he also insisted that independent expression should be their ultimate aim. "I do not interfere with your individuality," he told them. "I place in your hands a sure means of expressing it."[79] Ironically, those students who most closely approximated the apprenticeship Whistler had in mind tended to lack a strong personal vision (Halliday and Reitgenstein, for example), while the more original and talented students (such as Gwen John and Frederick Carl Frieseke) abandoned the Académie Carmen within a few months in order to move ahead with their careers.

Shortly after Whistler's death in 1903, Auguste Rodin designed a sculpture symbolic of Whistler's muse (fig. 71). As his model he employed a former student at the Académie Carmen, Gwen John, who was to be represented as a

colossal nude overstepping a hurdle.[80] The monument was commissioned by the International Society of Sculptors, Painters and Gravers, which had elected Whistler its president in 1898, the year the Académie Carmen was founded. It seems appropriate that this tribute to Whistler's artistic genius should be embodied by one of the female students whom he hoped would perpetuate his legacy. It is equally appropriate that the sculpture immediately became engulfed in controversy. Rejected by the International Society, it was abandoned by Rodin and remains unfinished. The Académie Carmen, too, was an abortive project characterized by struggle. Its ultimate significance is as an expression of Whistler's yearning for posthumous fame and for a corps of disciples to burnish his reputation. The idol need not have worried: his apprentices existed where he least expected to find them and were more numerous than he could have imagined.

FIG 71 Auguste Rodin (1840–1917), *Whistler's Muse*, 1907, Musée Rodin cast IV/IV, 1991, bronze, 88 × 35½ × 42⅞ inches, Iris and B. Gerald Cantor Foundation.

NOTES

1. Chase, "Two Whistlers," p. 222.
2. Du Maurier, "Trilby," p. 577.
3. Pennell and Pennell, *Life of Whistler*, vol. 2, p. 229.
4. Crawford, "Gentler Side of Mr. Whistler," p. 387.
5. Pennell and Pennell, *Life of Whistler*, vol. 2, p. 243; cf. vol. 2, p. 238; Pennell journal, December 23, 1906, PWC, box 353. The analogy with the Old Masters was reinforced by Sadakichi Hartmann in *Whistler Book*, pp. 33–34.
6. Pennell and Pennell, *Life of Whistler*, vol. 2, p. 240. See also Eddy, *Recollections and Impressions*, p. 280.
7. Henri to his parents, July 24, 1898, quoted in Perlman, *Robert Henri*, p. 40; see also pp. 33–35.
8. "Notes."
9. Pennell and Pennell, *Life of Whistler*, vol. 2, p. 239. The initial arrangement was that Whistler would criticize on Wednesdays and MacMonnies on Saturdays; see "Whistler-MacMonnies School."
10. "Notes." The fact that MacMonnies would teach drawing also "ocasioned [*sic*] no little surprise" ("Whistler-MacMonnies School").
11. "Whistler-MacMonnies School." See also "Art Notes," 1898.
12. "No Whistler Academy"; cf. Pennell and Pennell, *Life of Whistler*, vol. 2, p. 228.
13. Pennell and Pennell, *Life of Whistler*, vol. 2, pp. 239–240; see also vol. 2, pp. 229–230; Henry, *Irish Portrait*, p. 18. Anna Ostroumova-Lebedeva, who arrived at the Académie Carmen in January 1899, claimed that all of Whistler's female pupils were American (*Avtobiograficheskie zapiski* [1935–1951], quoted in Anderson and Koval, *James McNeill Whistler*, p. 436).
14. Perlman, *Robert Henri*, p. 40. For more detailed descriptions of the physical setup of the school, see Pennell and Pennell, *Life of Whistler*, vol. 2, p. 229; Cuneo, "Whistler's Academy of Painting," p. 531; and Woods, *Edges*, p. 106.
15. Whistler reportedly offered two or three free scholarships to those in need ("Notes," p. 164).
16. See, for example, Mullikin, "Reminiscences of the Whistler Academy," p. 237; and Roe, *Gwen John*, p. 25. The exact date of Whistler's first appearance is unclear. MacMonnies thought Whistler had arrived during the academy's second week, but Inez Bate, a star pupil who ultimately became the academy's monitor, believed it might have been as late as the third week (Pennell and Pennell, *Life of Whistler*, vol. 2, pp. 230, 240). Another student, Mary Augusta Mullikin, wrote that Whistler did not appear for "several weeks" (Mullikin, "Reminiscences of the Whistler Academy," p. 237).
17. Pennell and Pennell, *Life of Whistler*, vol. 2, p. 240.
18. For descriptions of Whistler's formality of dress and demeanor during his visits to the Académie Carmen, see Crawford, "Gentler Side of Mr. Whistler," p. 387; Ostroumova-Lebedeva quoted in Anderson and Koval, *James McNeill Whistler*, p. 436; and Will Foote's account as paraphrased by his son in Nicholas Kilmer, "Frederick Carl Frieseke: A Biography," in Kilmer and McWhorter, *Frederick Carl Frieseke*, p. 15.
19. Pennell and Pennell, *Life of Whistler*, vol. 2, p. 230. For his witty chastisement of a student (variously described as a South American and an Englishman) who persisted in smoking a cigar despite the ban, see Henry, *Irish Portrait*, pp. 18–19; Crawford, "Gentler Side of Mr. Whistler," p. 388; and Cuneo, "Whistler's Academy of Painting," p. 532.
20. Pennell and Pennell, *Life of Whistler*, vol. 2, p. 234; and Cuneo, "Whistler's Academy of Painting," p. 534. Nevertheless, the academy was not without elements of frivolity. Whistler reportedly promised the students a ball in his studio, for which Ida Nettleship had a dress made of cream muslin (Roe, *Gwen John*, p. 25). According to Alice Woods, there was also a mock-decadent *bal d'ennui*, at which everyone wore sackcloth and ashes (C. Burke, *Becoming Modern*, p. 75). On Saturday afternoons, one of the American students, Cyrus Cuneo, "would clear out the studio and have boxing matches in which a Russian strong woman figured" (Pennell journal, December 16, 1906, PWC, box 353).
21. Eddy, *Recollections and Impressions*, p. 277. One student, a woman who lived in the Champs-Elysées, drove to his studio in her carriage on days when Whistler was expected and dropped out after three weeks, although she had paid for three months (Pennell journal, June 23, 1909, PWC, box 352).
22. Pennell and Pennell, *Life of Whistler*, vol. 2, p. 243.
23. Cuneo, "Whistler's Academy of Painting," p. 536; and Pennell and Pennell, *Life of Whistler*, vol. 2, p. 236.
24. Pennell and Pennell, *Life of Whistler*, vol. 2, p. 231.
25. Ibid., p. 234.
26. Anderson and Koval, *James McNeill Whistler*, pp. 437–438; Pennell and Pennell, *Life of Whistler*, vol. 2, pp. 231–232; Mullikin, "Reminiscences of the Whistler Academy," pp. 237–238; Cuneo, "Whistler's Academy of Painting," p. 536; Eddy, *Recollections and Impressions*, p. 280; and Crawford, "Gentler Side of Mr. Whistler," p. 388.
27. For the debt to Gleyre, which Whistler himself acknowledged, see Boime, *Academy and French Painting*, pp. 61, 63; Pennell and Pennell, *Life of Whistler*, vol. 2, p. 242; and Weinberg, *Lure of Paris*, p. 59.
28. Mullikin, "Reminiscences of the Whistler Academy," p. 237. See also Kling, *Alice Pike Barney*, p. 123; Pennell and Pennell, *Life of Whistler*, vol. 2, p. 232; "Notes from Mr Whistler," unpublished manuscript in the Whistler Collection, GUL, quoted in Thorp, "Whistler and His Students," p. 44; and Cuneo, "Whistler's Academy of Painting," p. 536.
29. Pennell and Pennell, *Life of Whistler*, vol. 2, pp. 234–235.
30. Students who seem to have attended both academies simultaneously include Edward Dufner (see fig. 66), Will Howe Foote, Frederick Carl Frieseke (see cat. 37), Franklyn Harold Hayward, Paul Henry, Henry Salem Hubbell, John Christian Johansen, Lawton Parker, and Alson Clark Whiting. See Fehrer, Kashey, and Kashey, *Julian Academy*, n.p.
31. Pennell journal, June 20, 1909, PWC, box 352.
32. Mullikin, "Reminiscences of the Whistler Academy," p. 241.
33. Taubman, *Gwen John*, p. 23. See also Chitty, *Gwen John*, pp. 48–49; and Roe, *Gwen John*, pp. 24–25.
34. Mullikin, "Reminiscences of the Whistler Academy," p. 238; Roof, *Life and Art of Chase*, pp. 132–133; and Pennell and Pennell, *Life of Whistler*, vol. 2, p. 233.
35. Pennell and Pennell, *Life of Whistler*, vol. 2, p. 234.
36. Jackson, "Whistler as a Teacher," p. 142.
37. Pennell and Pennell, *Life of Whistler*, vol. 2, pp. 232–233.
38. Mullikin, "Reminiscences of the Whistler Academy," p. 241.
39. Fullerton, *Hugh Ramsay*, p. 88.
40. Low, *Painter's Progress*, pp. 152–153. I am grateful to Linda Merrill for providing this reference.

41. S. Kennedy, *Paul Henry*, p. 21. For some of the students' "distrust" of the darkness of Whistler's palette, see the Pennells' notes on the Académie Carmen (PWC, box 7).

42. MacMonnies to J. Pennell, October 25, 1906, PWC, box 293, quoted in Pennell and Pennell, *Life of Whistler*, vol. 2, p. 240.

43. Pennell and Pennell, *Life of Whistler*, vol. 2, pp. 240–241; and Pennell journal, December 16, 1906, PWC, box 353, and November 20, 1908, PWC, box 352. Reporting on MacMonnies's departure toward the end of 1898, the *New York Times* noted, "What most astonished the students was the character of the criticism. Whistler, contrary to all expectations, spoke mostly of the drawing [i.e., modeling through tone], whereas MacMonnies, who would be supposed most interested in form, criticised color exclusively" ("Whistler-MacMonnies School"). Following a visit to Spain in 1904, during which he had closely studied Velázquez's paintings, MacMonnies remarked in a letter to Foote, "I am convinced that *black* is mixed *with* all of his colors, & that Mr. Whistler is nearer right than I thought at first" (Smart, *Flight with Fame*, p. 212).

44. Mullikin, "Reminiscences of the Whistler Academy," p. 237.

45. Pennell and Pennell, *Life of Whistler*, vol. 2, pp. 244–245.

46. Anderson and Koval, *James McNeill Whistler*, p. 274.

47. Pennell and Pennell, *Life of Whistler*, vol. 2, p. 236.

48. MacInnes, "Whistler's Last Years," p. 328.

49. Weintraub, *Whistler*, p. 439; and Pennell and Pennell, *Life of Whistler*, vol. 2, p. 230. For the problem of men and women studying the nude together in Parisian art schools, see Garb, *Sisters of the Brush*, pp. 88–97; and Gabriel P. Weisberg, "The Women of the Academie Julian: The Power of Professional Emulation," in Weisberg and Becker, *Overcoming All Obstacles*, p. 13.

50. Anderson and Koval, *James McNeill Whistler*, p. 436; and Crawford, "Gentler Side of Mr. Whistler," p. 387.

51. Cuneo, "Whistler's Academy of Painting," pp. 531–532.

52. Henry, *Irish Portrait*, pp. 18–19; and S. Kennedy, *Paul Henry*, pp. 20–21, 26, 159 n. 21.

53. Jackson, "Whistler as a Teacher," p. 142.

54. Sarah Field Shaw to Elizabeth and Joseph Pennell, April 30, 1910, quoted in Thorp, "Whistler and His Students," p. 45.

55. According to Inez Bate, Cuneo acted as *massier* on only two or three occasions and was "frightened to death" about what he should say to Whistler (Pennell journal, December 16, 1906, PWC, box 353; see also Frederick MacMonnies to Joseph Pennell, October 15, 1906, PWC, box 293). Mucha, too, lasted only a short while, evidently wearied by his "infinite pains to drive something into some very dull heads" (Henry, *Irish Portrait*, p. 19). Regarding Crawford's stint as *massier*, see Crawford, "Gentler Side of Mr. Whistler," p. 387. In September 1899, Whistler suggested that Lawton Silas Parker or Paul Henry might serve as *massier* to assist Inez Bate (typescript letter, PWC, box 7).

56. "Whistler-MacMonnies School," p. 882.

57. Pennell and Pennell, *Life of Whistler*, vol. 2, p. 238.

58. Whistler to Bate, ca. October 1899, PWC, box 7.

59. Belloc, "Lady Artists in Paris," p. 377; Germaine Greer, "'A tout prix devenir quelqu'un': The Women of the Académie Julian," in Collier and Lethbridge, *Artistic Relations*, p. 55; Fehrer, Kashey, and Kashey, *Julian Academy*, p. 3; and Swinth, *Painting Professionals*, pp. 49–50.

60. Pennell journal, December 16, 1906, PWC, box 353; and Pennell and Pennell, *Whistler Journal*, p. 254.

61. "Whistler-MacMonnies School," p. 882. See also Cuneo, "Whistler's Academy of Painting," p. 531. One of the female students, a Miss Dixon, later recalled that the academy was initially filled with "women who had heard so much about Whistler that they wanted to see him" (Pennell journal, June 23, 1909, PWC, box 352).

62. Jones, *Twilight and Reverie*, p. 9.

63. Cuneo, "Whistler's Academy of Painting," pp. 534, 540.

64. John, *Autobiography*, p. 58.

65. Chitty, *Gwen John*, pp. 36–37.

66. Anderson and Koval, *James McNeill Whistler*, p. 436.

67. Kling, *Alice Pike Barney*, pp. 123–124, 126; see also p. 113 for the fact that John White Alexander (see cats. 15–16) had urged Barney to study with Whistler and had provided her with a letter of introduction.

68. Mullikin, "Reminiscences of the Whistler Academy," p. 238; similarly, Pennell and Pennell, *Life of Whistler*, vol. 2, pp. 234–235. On their first encounter at the Académie Carmen, Whistler had commented on Barney's flashy mode of painting in similarly double-edged terms, exclaiming, "Ts! Ts! Ts!! How clever we are!" For Whistler's ironic use of the word "clever," see Pennell and Pennell, *Life of Whistler*, vol. 2, pp. 234–235.

69. For female hero-worshiping of Robert-Fleury, Lefebvre, and Bouguereau at the Académie Julian, see Greer in Collier and Lethbridge, *Artistic Relations*, pp. 56–57; Weisberg in Weisberg and Becker, *Overcoming All Obstacles*, pp. 40–41; and Swinth, *Painting Professionals*, pp. 47–48.

70. Mullikin, "Reminiscences of the Whistler Academy," p. 237.

71. Cuneo, "Whistler's Academy of Painting," p. 540.

72. Woods, *Edges*, p. 105. For Woods's further observations on the idolization of Whistler at the Académie Carmen, see "Paris-Chizzy," an unpublished manuscript paraphrased in C. Burke, *Becoming Modern*, p. 75. In a letter of August 8, 1899, from Art Village, Southampton, Long Island, Woods had written to Whistler: "Three of us who are sailing for Paris the first of October are very anxious to study with you. Some say you no longer have a school, others that you have a school, but in London. Will you kindly put us in the way of accurate information?" (PWC, box 7).

73. Mary H. Halliday to Sarah Field, April 24, 1911, PWC, box 299.

74. Weintraub, *Whistler*, p. 445, and Pennell and Pennell, *Life of Whistler*, vol. 2, p. 237.

75. MacInnes, "Whistler's Last Years," pp. 328–329.

76. Whistler to Heinemann, n.d., PWC, box 10; and Pennell and Pennell, *Life of Whistler*, vol. 2, p. 246.

77. Weintraub, *Whistler*, p. 444.

78. Whistler to Inez and Clifford Addams, Ajaccio, February 8, 1901, PWC, box 7; and Pennell and Pennell, *Life of Whistler*, vol. 2, p. 247.

79. Pennell and Pennell, *Life of Whistler*, vol. 2, pp. 231–232.

80. Chitty, *Gwen John*, p. 68; John, *Autobiography*, p. 277; and Roe, *Gwen John*, pp. 53–54.

Lee Glazer

Whistler, America, and the Memorial Exhibition of 1904

"WHETHER THE LATE JAMES MCNEILL WHISTLER will stand 100 years from now as the greatest artist of his time . . . is doubtless a question that must be left to the next century to settle," declared the *Baltimore Herald* on February 21, 1904. "But it is safe to say that the death of few great artists of any period has been followed by such a far-reaching wave of interest in their work."[1] Whistler's death the previous July had prompted, on both sides of the Atlantic, a revival of Whistler stories in the popular press. Over the next two years, a series of memorial exhibitions in Boston (1904), London (1905), and Paris (1905) would argue for Whistler's enduring art-historical significance and intensify the revaluation of his art that had begun in the 1890s. Whistler had spent his entire artistic life abroad, working primarily in Paris and in London, but because Boston was the site of the first memorial retrospective, America effectively claimed Whistler for posterity as a native artist. Even more important, the Boston Memorial made a wide range of Whistler's work available to the American public, including collectors, critics, and artists, among them Thomas Dewing (see cats. 33–34), Dwight Tryon, William Merritt Chase (see cats. 22–28), Edmund Tarbell (see cat. 62), J. Alden Weir (see cats. 65–67), and Joseph DeCamp. Reconsidering the installation and objects at the Boston Memorial, as well as the reception the exhibition received, not only illuminates a defining moment in the evolution of Whistler's American reputation, but provides an opportunity to explore Whistler's influence on the history of American art and the uncertain role of aestheticism within its canons.

The *Memorial Exhibition of the Works of Mr. J. McNeill Whistler* opened at Boston's Copley Society with a private viewing on February 23, 1904, and closed, after two extensions, some five weeks later on March 28 (fig. 72). Drawing more than 41,000 visitors (more than any exhibition in the

James McNeill Whistler, *Symphony in White, No. 1: The White Girl* (detail, cat. 1)

Society's history) and dominating art criticism in newspapers across the nation, the Memorial was heralded as the artistic event of the season, intended, as the *Boston Evening Transcript* explained, as "a new revelation of Whistler's artistic genius."[2] The crowded galleries and vast array of pictures notwithstanding, the Boston Memorial's visually compelling orchestration of artistic objects and decorative effects remained remarkably faithful to Whistler's aesthetic philosophy and innovative exhibition practices. By creating a Whistlerian environment in the absence of the Whistlerian personality, the Copley Society hoped to direct public attention to art rather than artist, and thus to answer lingering questions about Whistler's aesthetic sincerity. But precisely because of its fidelity to Whistlerian ideals, the Memorial was fated to have an ambivalent reception that prompted what the critic Royal Cortissoz termed "a curiously drastic reopening of the Whistlerian question."[3]

Throughout the 1890s, Whistler's artistic reputation had seemed assured. The sale of his portrait of Thomas Carlyle (see fig. 14) to the Corporation of Glasgow and of *Arrangement in Grey and Black, No. 1: Portrait of the Painter's Mother* (see fig. 5) to the French government in 1891 was followed in 1892 by a carefully orchestrated retrospective at the Goupil Gallery in London that vastly increased the value of his paintings and prompted a number of works to change hands. Paintings began to enter American collections, and Whistler's work appeared more frequently, and in larger numbers, at American exhibitions. It was during the 1890s that Whistler established a mutually beneficial relationship with the Detroit industrialist and collector Charles Lang Freer, whose unsurpassed collection of Whistler paintings, prints, and drawings would dominate the Boston Memorial and ultimately form the backbone of the national museum that bears his name.[4] Although Freer agreed with Whistler that his art was too refined for popular consumption, he regularly loaned his Whistlers to international expositions and academy annuals and, in a series of small gallery installations in the years following Whistler's death, exhibited his work alongside paintings and pastels by Thomas Dewing and Dwight Tryon, two contemporary artists who Freer believed embodied Whistlerian values of "refinement, knowledge, and soul."[5]

A firsthand knowledge of Whistler's paintings prompted critics to acknowledge his aesthetic accomplishments and consider his importance to American artistic production. A notable example is Royal Cortissoz's 1894 essay for the *Atlantic Monthly,* "Egotism in Art," which argued that Whistler's egotism, far from being unseemly and eccentric, was in fact a positive quality, a manifestation of originality and confident self-expression that served as a welcome antidote to moribund academicism. Implicitly addressing

FIG 72 "'Popular' Throng at the Whistler Pictures," *The Boston Globe,* February 29, 1904, Charles Lang Freer Papers, Freer Gallery of Art and Arthur M. Sackler Gallery Archives, Smithsonian Institution, Washington, D.C., gift of the estate of Charles Lang Freer.

lingering concerns about Whistler's sincerity, Cortissoz argued that the painter who "makes of his personality a fetich [*sic*]" debases disinterested aesthetic values by engaging in a form of self-advertisement. In the hands of a genuine master, however, personality transcends itself: "Mr. Whistler, the greatest selective genius among living painters, the greatest living master of artistic logic . . . [is] setting a lasting example to his generation."[6]

Mistrust of Whistler's personality never entirely disappeared, but during the 1890s, especially in America, personality seemed less significant to assessments of his art. Whistler's death, however, revitalized all of the old Whistler stories. As the *Philadelphia Inquirer* remarked, "By the death of Mr. Whistler many stories of his eccentric and caustic wit have been revived."[7] Obituaries were dominated by anecdotal detail in both American and British newspapers. The *New York Herald,* for instance, focused on Whistler's "strange personality," his beribboned forelock, and his tendentious lawsuits and letters.[8] The *Morning Telegraph* printed a similar obituary, remarking that Whistler, famous for his self-promotion and wit, created art that was "effectively bizarre."[9] *The Times* of London acknowledged

Whistler's originality and praised him for liberating art from Victorian sentiment and morality but also alluded tartly to his "colossal vanity" and to his popularity with American parvenus.[10] The result of these notices was to reopen the question of Whistler's artistic reputation even though, as the New York Sun conceded, "of his fame there can be no doubt."[11]

Those who took Whistler's art seriously were alarmed by these postmortem accounts. In the last week of July, just as the Copley Society was preparing to mail its first circular announcing plans for a memorial retrospective to museum directors, art dealers, and collectors, the New York attorney and print collector Howard Mansfield responded to the Sun's characterization of Whistler with a letter to the editor: "While Whistler's personal peculiarities and eccentricities made him open to the more or less well founded charge of undue egotism and vanity, and his writings seemed to show that he set more store by enmities than friendship, he did enjoy some unbroken cordial relationships."[12] The letter was a tepid defense, but it was picked up by other urban newspapers and appeared as an alternative to more sensational accounts of Whistler's character.

Charles Freer declined to enter the journalistic debate. He did, however, express his feelings in a letter to Mansfield: "I feel a trifle more keenly than you a certain spirit of vindictiveness in the press. However, the venom of the snarling brutes . . . will disclose the low character of the wretched scribblers." He went on to explain that Whistler's true self was inaccessible to the general public. "This," Freer insisted, "is as he wished. So let the others howl!" After such a vehement rejection of popular opinion, however, Freer concluded in a more hopeful vein: "Still, the world at large may some day see the truth more clearly and perhaps that would be well."[13]

Significantly, when Freer conceded that a sympathetic understanding of Whistler might be in the offing, he projected it in visual terms: if the world could see more clearly, its enhanced visual competency would result in a more accurate understanding of Whistler and his art. It is no wonder, then, that Freer, in spite of his professed aversion to publicity, endorsed the Copley Society's plans for a memorial exhibition almost from the outset. As he told Ernest Fenollosa, he believed the officials of the Copley Society were "imbued with the importance of the matter, and are approaching it with due reverence and earnestness."[14]

Boston was a particularly suitable venue for America's memorial tribute to Whistler. In addition to its proximity to Whistler's birthplace of Lowell, Massachusetts, Boston had a long history of cultural refinement. By 1904, New York had been the more concentrated site of artistic production

and consumption for several decades, but in the public imagination, Boston still represented cultivation and discernment. In A Hazard of New Fortunes (1890), William Dean Howells contrasted the two cities, characterizing New York as disconcertingly homogeneous, its public culture of consumption dissolving social and aesthetic hierarchies. Boston, on the other hand, represented a world of enclosed refinement in which the "dream of intellectual achievement" and "intense identification" with moral and aesthetic ideals might develop without the intrusion of commercialism or publicity.[15] Whether or not this were true, Boston's reputation colored critical assessments of exhibitions held in the city. At the time of the Whistler Memorial, its art world was reputedly led by disinterested amateurs who were above the partisan maneuverings of New York artists and the greed of commercial dealers.[16] The New York Evening Post declared that Boston was more hospitable to art than was New York, where a dearth of taste spoiled the abundance of aesthetic offerings: "Everything is present except discrimination and distinction. Our wealth is little appreciated because it is badly displayed."[17]

During the 1890s, Whistler prints and paintings had been regular features at Boston exhibitions, and Freer acknowledged Bostonian taste in 1902 when he wrote to Dewing, "The Boston People really seem to care for Mr. Whistler's work."[18] A small solo exhibition of Whistler etchings from the collection of Howard Mansfield had been held at the St. Botolph's Club in the winter of 1894–1895; and following the success of its Sargent retrospective in 1899, the Copley Society had proposed staging a similarly large-scale, representative Whistler exhibition. Whistler, as Society archives report, had "not quite given" his permission for the show, apparently feeling that its proposed scale and his distance from the scene would jeopardize his efforts to control the display and reception of his work.[19] Kenyon Cox would later explain that during Whistler's lifetime "the artist's fastidious objection to large exhibitions" stood in the way of attempts to stage a comprehensive retrospective: "He preferred to show his works a few at a time, in carefully selected groups and in delicately chosen surroundings, so that each individual picture or etching might have its due of quiet contemplation."[20] Plans for the Whistler retrospective had thus been put on hold, and in 1903 the Society began planning a loan show for the following season composed mostly of works by Rodin and Monet.

That exhibition did open, but not until 1905, for when Copley Society president Holker Abbott learned of Whistler's death on July 17, 1903, he recognized that it was time to revitalize the old scheme for a Whistler retrospective. The earliest stages of planning the Memorial commenced within nine days of Whistler's death, with

Abbott enlisting support from such well-known arts administrators as the Pennsylvania Academy's Harrison Morris and such prominent collectors as Mansfield and Freer. Freer received Abbott's letter on August 9, upon his return from London, where he had spent the first weeks of July with Whistler and had remained after the artist's death to comfort and assist his sisters-in-law, Ethel Whibley and Rosalind Birnie Philip. Even before Whistler's death, Freer and "the ladies," particularly Philip, whom Whistler had named as his heir and executor, had established a close, almost conspiratorial relationship. Both Freer and Philip were devoted to the proper transmission of Whistlerian aesthetics and often joined ranks against outside efforts to interpret, exhibit, or acquire Whistler's art. Freer, therefore, responded cautiously to Abbott's initial request for assistance with the Memorial Exhibition: "I must be fully advised as to the plans for the proposed memorial exhibition, its general scope and aims. . . . I shall . . . consult with Miss Birnie Philip, as I did with Mr. Whistler in the past . . . [and] attempt to carry out as much as possible his expressed wishes."[21]

Freer further justified his hesitation by alluding to "many movements" afoot to organize memorial exhibitions.[22] He was probably thinking of Joseph Pennell, who was hoping to stage a memorial exhibition in London under the aegis of the International Society of Sculptors, Painters and Gravers. Pennell and his wife, Elizabeth, had been gathering material for several years from virtually anyone who had been acquainted with Whistler, intending to publish an authoritative and authorized biography. Although the two-volume *Life* would not appear until 1908, Whistler's intimates were already alarmed by the Pennells' effort, regarding it as opportunistic and intrusive.

Freer's concern that the "weird influence of the ever-active" Pennells and their allies "had overtaken the Memorial Exhibition at the time of its birth" was not entirely unfounded.[23] Joseph Pennell had in fact written to Holker Abbott, suggesting that the objects from the Boston show travel to London, where they would contribute to another, even larger, memorial tribute. This cooperative scheme never materialized, and though Pennell's name appears in the Copley Society's catalogue as part of the Honorary Committee, there is no evidence that he played a role in the exhibition. His exclusion must have rankled, for he wrote to Abbott toward the end of the show, dismissing its carefully designed catalogues as "worthless" and refusing to grant the exhibition any lasting influence.[24] Indeed, when the International Society's exhibition opened at London's New Gallery in February 1905, Pennell and his associates ensured that the show would have a different character from the deliberately, even reverently, aestheti-

cized Boston retrospective. Unlike the Copley Society's exhibition, which was organized by a group of reticent designers, arts administrators, and collectors and was ever-attentive to the wishes of Whistler's most ardent admirers, Freer and Philip, the International Society's memorial was dominated by the more voluble Pennell, who concerned himself less with Whistlerian aestheticism than with literary explication of the artist's work: the illustrated catalogue included descriptions of key works, a feature deliberately omitted from the Boston catalogue.

The Boston Memorial, for obvious logistic reasons, depended almost entirely on loans from American collections, among which Freer's was the most extensive. Abbott must have understood that to accommodate Pennell would mean losing Freer—and the cooperation of Whistler's estate. In September 1903, therefore, he dispatched his associates Edward Warren and Frank Macomber to Detroit, where they apprised Freer of Pennell's overtures and allayed any remaining doubts Freer might have had about the forthcoming exhibition. After meeting with Warren and Macomber, Freer declared them to be "gentlemen of refinement and experience in art matters," and himself "ready to do anything in my power to make the affair a great success."[25]

The Society's diplomatic mission to Detroit had been preceded by a similar journey by Holker Abbott. Toward the end of August 1903, perhaps motivated by Freer's caveat that his participation depended on the approval of Rosalind Birnie Philip, Abbott went to London and called on Philip at her home in Cheyne Walk. Following their meeting, Philip wrote to Freer of her decision to cooperate with the Copley Society.[26] In addition to Philip's goodwill, the Copley Society secured her loans to the exhibition: three oils, two pastels, and nine drawings. These were all works that had been in the studio at the time of Whistler's death, and many had never been exhibited, adding a degree of novelty to the Memorial that might otherwise have been lacking. Also, by involving the artist's estate, the Copley Society could describe its exhibition as an authorized event in which the artist's aesthetic ideals were sure to be honored. Abbott and his colleagues were obliged to consult Philip in matters of the exhibition loans, the décor and hanging, and advance publicity. Her abhorrence of William Merritt Chase's portrait of Whistler (cat. 24), for example, resulted in its elimination from the exhibition (although she could not stop Chase from giving an opening-night lecture). And while Philip was unable to prevent the notorious gambler Richard Canfield from lending his *Arrangement in Black and Gold: Comte Robert de Montesquiou-Fezensac* (fig. 73), her disapproval of the sitter, who had offended Whistler by selling the portrait at tremendous profit, resulted in its hanging far from the place of honor, which

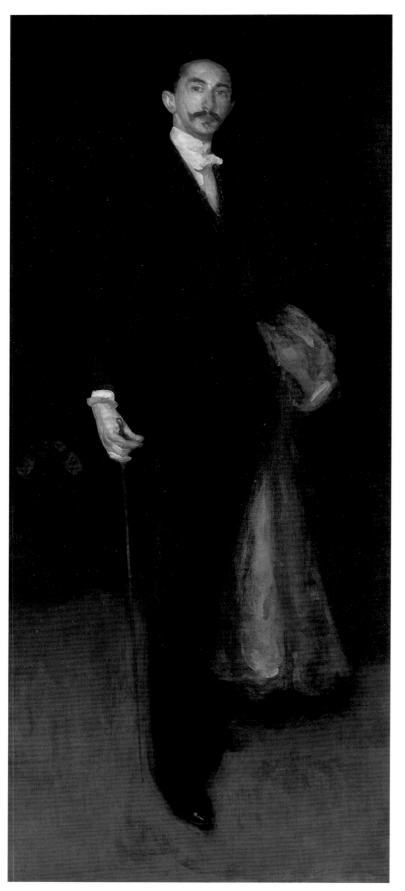

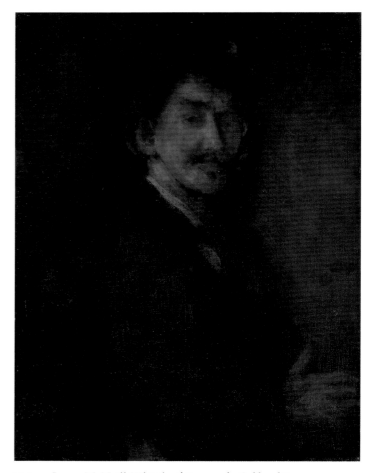

FIG 74 James McNeill Whistler (1834–1903), *Gold and Brown,*
ca. 1896–1898, oil on canvas, 24⁹⁄₁₆ × 18⁵⁄₁₆ inches, National Gallery
of Art, Washington, D.C., gift of Edith Stuyvesant Gerry.

was given to *Gold and Brown* (fig. 74), a late self-portrait.
Philip also, through Freer, advised the exhibition com-
mittee on the design of the catalogue, which followed
Whistler's use of a plain brown-paper cover and a butter-
fly insignia.[27]

In addition to attending to these small details, the Soci-
ety and its collaborators strove to make the exhibition
as a whole meet the demands of Whistler's aestheticism.
Despite the inclusion of more than five hundred works
from all stages of Whistler's career, the Memorial was a
visually compelling installation whose harmonious set-
ting and thoughtfully juxtaposed arrangements defied
didactic explanations or anecdotal descriptions. Freer de-
clared the show a watershed in the history of American
painting, and one Boston critic predicted that the empha-
sis on purely aesthetic visual relationships would lead to
a "general readjustment of opinion" about Whistler.[28]

Pictures began to arrive on February 17, but plans for dec-
orating the galleries and installing the works had been in
progress since November. Creating an installation accord-
ing to Whistlerian principles constituted an important

FIG 73 James McNeill Whistler (1834–1903), *Arrangement in Black and
Gold: Comte Robert de Montesquiou-Fezensac,* 1891–1892, oil on canvas,
82⅛ × 36⅛ inches, Frick Collection, New York.

element of the planning and was a new consideration for the Society, "no previous exhibition having made such a demand for a special setting."[29] To oversee the task, the Copley Society assigned C. Howard Walker (1857–1936) to head the committee in charge of decoration. A member of the Society of Arts and Crafts, where he exhibited as an architect and stained-glass designer, Walker was also the director of design at Boston's Museum of Fine Arts School. Freer maintained that he was "a gentleman of wide experience and great refinement" and, even more to the point, "is devoted to Mr. Whistler's art and seems to be perfectly familiar with it."[30]

At the Memorial, the works were divided according to medium, with the main room, Copley Hall, containing the major oils (fig. 75), a stage beyond housing lithographs (fig. 76), and the adjacent Allston Hall displaying etchings and drypoints (fig. 77). Several small areas were partitioned off of the main gallery for the display of oil studies, pastels, and drawings. The existing dark green wall-covering was removed and each room freshly painted with gray distemper and hung with coverings keyed to the kind of works displayed in it: silvery gray for the oils, creamy white and primrose yellow for the lithographs, pearl white with yellow accents for the etchings and watercolors. The color scheme resonated with Whistlerian values, echoing the décor of Whistler's famous one-man shows and the tonal subtleties of the paintings on display. The overall effect, according to reviews, was of a symphony of silver, pearl, and gold.

Howard Mansfield and Copley Society member Francis Bullard oversaw the decoration of Allston Hall, basing it on Mansfield's installations of Whistler etchings at the 1893 Columbian Exposition in Chicago and the 1901 Pan-American Exposition in Buffalo. These installations had echoed the color scheme of Whistler's first American one-man show, *Arrangement in White and Yellow,* an 1883 exhibition of etchings at the Wunderlich Gallery in New York, which was itself a repetition of an earlier installation in London. Mansfield and Bullard had also organized an exhibition of etchings, drypoints, and lithographs for Boston's Museum of Fine Arts the previous autumn, which the *Boston Advertiser* characterized as an "appetizer" to the Memorial.[31] Given Mansfield's experience (and the fact that he would loan 230 of the 238 etchings exhibited in Allston Hall), his oversight of the Boston installation was practically inevitable.

NOTE: FIGS 75–80, 82–83 Copley Society, Boston, 1904, Charles Lang Freer Papers, Freer Gallery of Art and Arthur M. Sackler Gallery Archives, Smithsonian Institution, Washington, D.C., gift of the Estate of Charles Lang Freer.

FIG 75 Copley Hall, east wall, Whistler Memorial Exhibition.

FIG 76 Copley Hall, stage, Whistler Memorial Exhibition.

FIG 77 Allston Hall, Whistler Memorial Exhibition.

FIG 78 Copley Hall, looking south, Whistler Memorial Exhibition.

FIG 79 Copley Hall, looking north, Whistler Memorial Exhibition.

FIG 80 Copley Hall, west wall, Whistler Memorial Exhibition.

Rather than adopting a preexisting color scheme for Copley Hall, Howard Walker and his committee experimented with effects that were reminiscent, but not imitative, of previous Whistler exhibitions. Ultimately, Copley Hall was decorated with light gray walls overlaid with a shimmering silver grasscloth, a muted brown canvas floor covering, a white velarium, and simple wooden benches topped with potted laurel trees. Regular but sparing placement of gilded woodcarvings punctuated the substantial areas of empty space above the pictures. The Japanese art dealer Matsuki Bunkyō donated two temple *ramma* that were placed over the main doorways; various members of the Society loaned additional Japanese carvings that hung above the doorways between Copley and Allston Halls; and Walker designed small gold butterflies that appeared at widely spaced intervals below the tie beams. A frieze of pale gray distemper showed above the butterflies; beneath was the silvery grasscloth, a silk fabric with wavy horizontal striations and an iridescent surface. The walls became an extension of Whistler's aesthetic vision: marked at regular intervals by a signature butterfly, they were harmoniously composed, chromatically interesting surfaces. And just as Whistler's nearly abstract Nocturnes defied literary description, so the shimmering tonalities of the grasscloth confounded critics' efforts to characterize it accurately: sometimes its highlights seemed pearly, at other times rose or violet. A Chicago critic declared that the entire room—pictures and silk-covered walls—vibrated with artistic atmosphere.[32] Rather than providing a neutral background, the grasscloth contributed a purely optical value that echoed chromatic variations in the works themselves.

The long rectangular space of Copley Hall was anchored at the south end (fig. 78) by *The White Girl* (cat. 1) and at the north (fig. 79) by *La Princesse du pays de la porcelaine* (see fig. 13). The principal entrance was behind the screen on which *The White Girl* hung, so the *Princesse* would have been in one's line of sight upon entering the space. Double-sided benches created a tripartite space repeated in the triple arch on the stage, in the center of which was the *Princesse*, flanked by open arches giving onto the lithographs gallery. The north end of Copley Hall thus took on the appearance of a devotional altarpiece, with the *Princesse* as the central panel of an aestheticist triptych.

The religious allusions were not lost on the critics. Royal Cortissoz described the gallery as a "pious tribute," and Frank Jewett Mather called it a "silver sanctuary."[33] But if Copley Hall paid homage to Whistler's aestheticism, it did not do so through a rigidly hierarchical organization. The side panels in the triptych were not pictures but views into a room filled with other objects. The entryway did not give directly onto the space but required that the visitor

negotiate the screen on which *The White Girl* hung. Rather than directing the viewer's attention to a single work and holding it there, the installation allowed the viewer to gather a general impression of the room, pause to focus on a work, and then move back to a previous point of interest or forward to a new one. In an opening notice, the *Boston Herald* alerted its readers that "a generally lucid arrangement carries the eye along any particular wall."[34]

On the long east and west walls, canvases hung in rhythmic groups: double rows of small paintings clustered into balanced sets, alternating with monumental full-length portraits (fig. 80). Gilded picture rails, placed at heights of about four and seven feet, meant that the lower register of paintings was most effectively seen by viewers standing at close range who might then move back to focus on the upper register. One can also imagine visitors taking seats on the benches. Facing the walls, but at a fair distance, they would perhaps have shifted their focus from individual works to notice formal relationships within and between particular groupings. At the center of the west wall, for instance, three full-length portraits—*Rosa Corder* (1878, Frick Collection, New York), a portrait of Whistler's wife Beatrix, *Harmony in Red: Lamplight* (fig. 81), and the Montesquiou portrait—framed two groups of smaller canvases. Each subgroup, constituted by size and orientation of support, comprised a wide range of subject matter and technique.

To the right of the portrait of Beatrix are (clockwise) *The Last of Old Westminster* of 1862 (Museum of Fine Arts, Boston); the late figure studies *Master Smith of Lyme Regis* (1895–1896, Museum of Fine Arts, Boston) and *A Crimson Note: Carmen* (ca. 1895, Hill-Stead Museum); the early aestheticist experiment *Variations in Flesh Colour and Green: The Balcony* (1864, Freer Gallery of Art); a portrait from the mid-eighties, *Portrait of Madame S—Vert et Violet* (1885–1886, Fogg Art Museum, Harvard University); and a late seascape, *Violet and Silver: A Deep Sea* (1895, Art Institute of Chicago) (fig. 82). The relatively early *Last of Old Westminster*, with its Courbet-like realism, busily populated scene, and earthy palette, provided a marked contrast to the reticent mood and cool tonalities of *Violet and Silver*, above which it was hung. Yet the relationship is not just one of difference or contrast. Even beyond proximity and similar size, the two works share the same rhythmic function on the wall, and both were boldly painted with a French-derived facture.

To the left of *Harmony in Red: Lamplight* were counterparts to these two works. The placement of the early, realist *Thames in Ice* (1860, Freer Gallery of Art) on the upper register and the later, more abstract *Symphony in Violet and Blue* (1893, Hill-Stead Museum) beneath expands

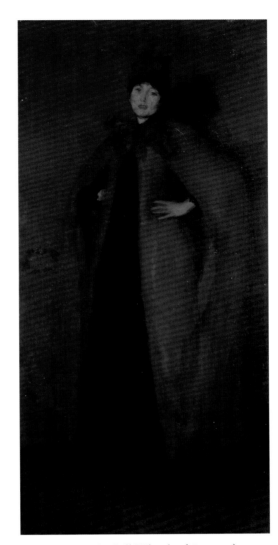

FIG 81 James McNeill Whistler (1834–1903), *Harmony in Red: Lamplight*, ca. 1884–1886, oil on canvas, 75 × 35¼ inches, Hunterian Art Gallery, University of Glasgow, Scotland, Birnie Philip Bequest.

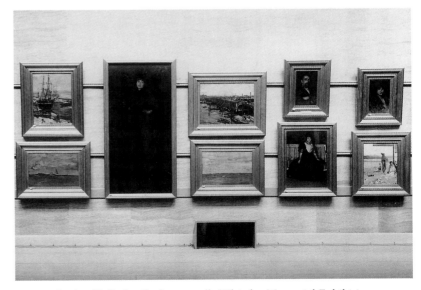

FIG 82 Copley Hall, detail of west wall, Whistler Memorial Exhibition.

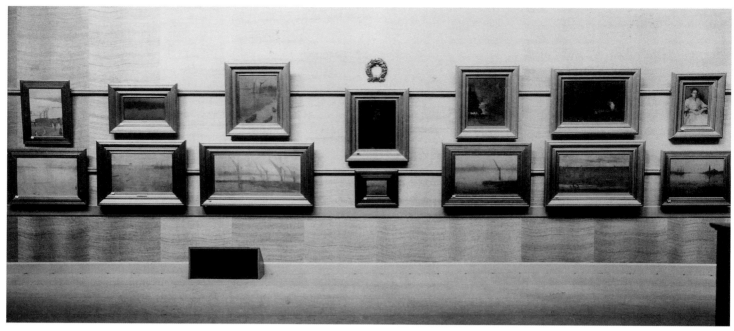

FIG 83 Copley Hall, detail of east wall, Whistler Memorial Exhibition.

on a relationship that is formal, chromatic, and rhythmic. The correspondences extended across the wall, allowing viewers to discover another, larger grouping of related works than the one with which they began. Looked at this way, the full-length portraits, the most obviously referential as well as the most physically impressive works, begin to lose their identities and to function as punctuation marks, rhythmic elements in the eye's progress across the decorated wall surface. Whistler's subjects had not been entirely eliminated, but they were absorbed into a system in which meaning was derived from pictorial relationships and not from the denotation of a real-life referent.

Thus, in the context of the Memorial, even the late self-portrait *Gold and Brown*, occupying the center of the east wall and distinguished by a gold laurel wreath (fig. 83), lost its importance as a biographical subject and was instead associated with the impersonal subjectivity of artistic perception. A few initiates might have been pleased to see an image of Whistler hanging directly opposite one of his beloved Trixie in *Harmony in Red*. But for most viewers, the placement of *Gold and Brown* would have had more to do with the group of Nocturnes clustered on either side of it. The autobiographical element of the artist's self-portrait was impossible to eliminate, but its contiguity with his most original and abstract experiments allowed for an understanding of the artist based on sophisticated artistic vision rather than a superficial (or eccentric) public persona.

Interestingly, the Nocturnes enjoyed a particularly close chromatic relationship with the silk wall hangings. Just as the iridescent fabric left critics unsure of how to describe

it, so too did the modulations of silver, blue, gray, and gold in the Nocturnes. William Howe Downes noted that at first the color in the paintings seemed simple, but that over time an infinite series of tonal variations emerged: "They creep upon the imagination," he wrote, "and take possession of the mind."[35] The usually breezy society paper *Town Topics* maintained that the installation at Copley Hall slowed down the visual process and encouraged viewers to imagine themselves engaging in the poetic vision represented in the works on display.[36] Whistler had insisted that the artist's vocation resided in just this ability to see the world as a series of harmonious formal relationships. This mode of vision is subjective: it is produced by the artist and is not dependent on objective facts. But it is also impersonal and artificial, since its expression is necessarily limited by the visual vocabulary at the artist's disposal.

The Boston press, no doubt prompted by civic pride as well as aesthetic judgment, loved the installation, calling it "just what Whistler would have decided on" and the "most perfect in settings and accessories that Boston has ever seen."[37] The New York *Outlook* concurred, noting that the show repeated "the fastidious care which Mr. Whistler always bestowed on details in the arrangement of his pictures." The results, the writer concluded, were exemplary: "It would be difficult to place pictures more effectively or to give them a more artistic background."[38]

Response to the decoration of the galleries was shaped, in part, by a shift in taste that occurred between the 1880s and the 1890s. James Henry Moser (1854–1913) noted that many of Whistler's decorative techniques that had initially

seemed shockingly novel were now fashionable.[39] For those who praised the exhibition, the familiarity of the décor surely contributed to the propriety of the show and thus of the art and artist. A critic for the *Boston Suburban* explained that this "exceedingly high art" was rendered less obscure, due to "the cult of Japanese which has spread among us."[40] Similarly, James William Pattison of the *Chicago Journal* noted that the overall effect "is not as crazy as I expected to find it." He continued, "The more I study the product as here displayed, the more my feelings are moved and my admiration increases." Yet even as it attracted throngs of viewers and garnered favorable reviews, the Boston Memorial allowed Whistler's art to retain its rarefied appeal. "Some of it," admitted Pattison, "is difficult enough to tax the mentality of the most experienced critic of art."[41] In contrasting the refined paintings and harmonious setting of the Whistler Memorial with the more accessible Sargent show of five years earlier, the Boston *Traveler* hinted that the aesthetic setting contributed to the difficulty of the noninitiate in interpreting Whistler's pictures. Arthur Hoeber announced that despite being the most popular exhibition in the history of the Copley Society, "Whistler never did paint for the dear public," and concluded that much of his work "will remain unintelligible to the multitude."[42]

The critics were unanimous in their opinion that the exhibition perfectly expressed Whistlerian intentions. *New England Magazine* explained that Whistler "proposed that the effect of his paintings should gain from the environment of their frames—that the whole exhibition should, in a sense, be a Whistler picture," and noted the Whistlerian consistency of "secondary considerations of arrangement and background" at Copley Hall. Not all of the critics could agree, however, with the Whistlerian equivalence of high art and decoration. Indeed, the writer for *New England Magazine* worried that too much attention to "secondary considerations" might point to insufficiencies in the works themselves.[43] Royal Cortissoz, whose 1894 essay "Egotism in Art" had seemed to settle the question of Whistler's artistic significance, nevertheless criticized "the peculiarly decorative character" of the Memorial; he thought that it was overproduced, its attention to decoration, lighting, and hanging an unfortunate demonstration of Whistler's "most cherished theories." "Whistler's preoccupation with details absolutely external to art, properly considered," Cortissoz observed, "distracts the eye, teases the mind and ends by arousing suspicion."[44] Kenyon Cox fretted that the grasscloth wall covering was too obtrusive, its iridescent rose and violet lights out of harmony with some of the more golden-toned paintings.[45] Even while acknowledging that the redecorated galleries provided "a proper strangeness of setting," Frank Jewett Mather was uneasy about the way that wall coverings, paintings, and even visitors' dresses echoed one another, pointedly observing that "Whistler loved the changing surface of water as women love lustrous fabrics."[46]

Cortissoz, Cox, and Mather respected the authority of an idealist tradition that favored the disinterested contemplation of pure aesthetic judgment over the supposedly more sensual pleasures associated with decoration, but their distrust of decorative display also came from its more recent associations with the commercial realm. Implicit in Mather's comparison of the Whistlerian palette and luxury fabrics was the modern taint of commodity culture, whose wares and marketing techniques were often indebted to, and difficult to distinguish from, the products of high art.

Not surprisingly, Freer dismissed such criticism. At the end of April, when the critical fallout from the exhibition had finally begun to settle, he wrote to Rosalind Birnie Philip, "The newspapers will continue their silly vaporings." He then assured her, "Have no regret about Boston. It was not perfect, but nearly so."[47] For Freer, as for Whistler, a genuine aesthetic encounter required the viewers to estrange themselves from mundane experience; one must see the world as if it were a series of harmonious formal relationships and engage in the kind of poetic vision that an artist could formally objectify in his paintings. The Memorial Exhibition of 1904 thus did more than present a survey of Whistler's work to an American audience. By "reopening the Whistler question" through its orchestration of artistic objects and decorative effects, the Copley Society strove to make the aestheticizing visual techniques of James McNeill Whistler available to an elite audience of cultivated amateurs and professional artists.

Parts of this essay have previously appeared in Glazer, "Reopening the Whistler Question."

1. *Baltimore Herald,* February 21, 1904, FGAA, Press Cuttings, vol. 5, p. 11.

2. "Whistler Memorial Exhibition," *Boston Evening Transcript,* October 9, 1903, FGAA, Press Cuttings, vol. 3, p. 43.

3. Cortissoz, "Whistler."

4. The history of Freer's relationship with Whistler and the formation of his collection is discussed in the introduction to Merrill, *With Kindest Regards,* pp. 13–46. See also Lawton and Merrill, *Freer,* pp. 31–57; and Curry, *Whistler at the Freer,* pp. 11–33.

5. Freer to Dwight Tryon, July 27, 1893, FGAA.

6. Cortissoz, "Egotism in Contemporary Art," p. 648.

7. "Revenge of the Painters," *Philadelphia Inquirer,* October 4, 1903, FGAA, Press Cuttings, vol. 3, p. 42.

8. "Whistler Wanted Death Kept Secret," *New York Herald,* July 19, 1903, FGAA, Press Cuttings, vol. 3, p. 5.

9. "Jas. M'Neill [*sic*] Whistler Dies Suddenly Abroad," *Morning Telegraph* (New York), July 18, 1903, FGAA, Press Cuttings, vol. 3, p. 5.

10. "Death of Mr. Whistler," *Times* (London), July 18, 1903, FGAA, Press Cuttings, vol. 3, p. 8.

11. "James MacNeill [*sic*] Whistler," *Sun* (New York), July 18, 1903, FGAA, Press Cuttings, vol. 3, p. 11.

12. Mansfield to *Sun* (New York), July 25, 1903, Howard Mansfield Collection, New York Public Library.

13. Freer to Howard Mansfield, August 20, 1903, FGAA, Letterpress Books, vol. 11, p. 379.

14. Freer to Ernest Fenollosa, FGAA, Letterpress Books, vol. 11, p. 464.

15. Howells, *Hazard of New Fortunes,* vol. 1, p. 23; vol. 2, p. 263.

16. See, for example, "Whistler Exhibition at Boston," *London Morning Post,* February 1, 1904, FGAA, Press Cuttings, vol. 5, p. 9.

17. Untitled clipping, *Evening Post* (New York) [February 1904], Copley Society Papers, Boston Public Library, Press Clippings Book, p. 339.

18. Freer to Thomas Dewing, December 12, 1902, FGAA, Letterpress Books, vol. 10, p. 22.

19. *Twenty-Fifth Annual Report of the Copley Society,* p. 9.

20. Cox, "Whistler Memorial Exhibition," p. 167.

21. Freer to Holker Abbott, August 10, 1903, FGAA, Letterpress Books, vol. 11, p. 338.

22. Ibid.

23. Freer to Rosalind Birnie Philip, September 16, 1903, FGAA.

24. Pennell to Holker Abbott, March 14, 1904, Copley Society Records, AAA.

25. Freer to Rosalind Birnie Philip, September 30, 1903, FGAA.

26. See Freer to Rosalind Birnie Philip, September 16, 1903, FGAA, where he notes, "Your good letter of August 30th came a few days ago and yesterday afternoon . . . Mr. Holker Abbott's visit saved the day for his Society and the Memorial. He must be a Napoleon! I shall be scared when first I meet him! And your graciousness equals his bravery."

27. For discussions of Philip's suggestions to the Copley Society, see Freer to Rosalind Birnie Philip, September 30, 1903, FGAA; and Philip to Charles Freer, December 29, 1903, FGAA.

28. "Whistler Exhibit"; and Estelle Hurl, "A Few Whistlerians," *Congregationalist* (Boston), March 26, 1904, FGAA, Press Cuttings, vol. 5, p. 30.

29. *Twenty-Fifth Annual Report of the Copley Society,* p. 11.

30. Freer to Rosalind Birnie Philip, November 10, 1903, FGAA.

31. *Boston Advertiser,* August 11, 1903.

32. James William Pattison, "The Whistler Exhibition, in Copley Hall," *Chicago Journal,* March 26, 1904, FGAA, Press Cuttings, vol. 5, p. 30.

33. Cortissoz, "Whistler"; and Frank Jewett Mather, "Whistler at Boston," *Manchester Guardian,* March 12, 1904, PWC, box 39.

34. "Memorable Exhibition."

35. Downes, "Whistler the Colorist."

36. "Whistler Exemplified at Boston," *Town Topics,* March 3, 1904, FGAA, Press Cuttings, vol. 5, p. 24.

37. "Jam at the Whistler Exhibition"; and "Whistler Pictures."

38. "The Whistler Exhibition," *Outlook* March 19, 1904, Boston Public Library, Press Clippings Book, p. 345.

39. Moser, "Art Topics." Moser was an artist and an instructor at the Corcoran School of Art in Washington, D.C., who sometimes painted in a Whistlerian style, as in *Fireworks across the Potomac* (1902) (reproduced in W. Gerdts, *Art across America,* vol. 1, p. 362; see also Fetherolf, *James Henry Moser*).

40. F. W. Coburn, "The Whistler Exhibition Here," *Boston Suburban,* February 27, 1904, FGAA, Press Cuttings, vol. 5, p. 19.

41. Pattison, "The Whistler Exhibition, in Copley Hall."

42. "Art and Society at the Whistler Show," *Traveler* (Boston), February 29, 1904, FGAA, Press Cuttings, vol. 5, p. 17; Arthur Hoeber, "Whistler Exhibition," *Commercial Advertiser,* February 25, 1904, FGAA, Press Cuttings, vol. 5, p. 18.

43. Baldwin, "Whistler Memorial Exhibition."

44. Cortissoz, "Whistler."

45. Cox, "Whistler Memorial Exhibition."

46. Mather, "Whistler at Boston."

47. Freer to Rosalind Birnie Philip, April 29, 1904, FGAA.

Catalogue

Lacey Taylor Jordan

Linda Merrill

Sylvia Yount

1 | JAMES MCNEILL WHISTLER, 1834–1903
Symphony in White, No. 1: The White Girl, 1862

Oil on canvas, 83⅞ × 42½ inches
National Gallery of Art, Washington, D.C.
Harris Whittemore Collection, 1943.6.2

The White Girl, AS THIS PAINTING WAS ORIGINALLY titled, was begun in Paris early in Whistler's career, when he was working under the compelling influence of the French Realist painter Gustave Courbet. A portrait of an artist's model, weary after a long day of posing, *The White Girl* continues Whistler's series of images of working women portrayed without idealization or sentimentality.[1] Nevertheless, the subject chosen for this exhibition piece, intended for display at the Royal Academy in London or the Paris Salon, suggests Whistler's increasing interest in the process of art-making, a preoccupation that would lead him inexorably away from Realism toward an aestheticist approach that stressed form over content, or art for art's sake.

As Whistler half expected, the painting was rejected by the Royal Academy. It was, however, exhibited at an alternative London venue, where it was advertised as "Whistler's extraordinary Woman in White"—undoubtedly a ploy to attract those Victorian readers who had made a best-seller of Wilkie Collins's contemporary mystery novel of the same title.[2] Whistler was pleased with the exhibition and with the declaration in the catalogue that his work had been rejected by the Academy; but when an art critic described the face of the figure as admirable but unlike that of Collins's heroine, Whistler felt compelled to offer an explanation in the press. He had not meant, he said, to illustrate a novel he had never read, and the misleading title *The Woman in White* had been assigned by the proprietors of the gallery without his sanction. His matter-of-fact explanation—"My painting simply represents a girl dressed in white standing in front a white curtain"—was a statement of Realist intent that would only later be construed as an aestheticist manifesto.[3] Although Whistler had set his heart on the success of *The White Girl* at the Salon, it was again rejected, this time destined for the famous Salon des Refusés where, with Edouard Manet's *Déjeuner sur l'herbe* (1863, Musée d'Orsay), it became a succès de scandale, establishing Whistler's reputation as an artist of the avant-garde.

That clamor of notoriety had dwindled to a whisper by the time the painting reached the United States in 1875. The artist had sold it nearly a decade earlier to his half-brother George William Whistler, who died in 1869

FIG 84 George du Maurier (1834–1896), *An Aesthetic Midday Meal*, plate published in *Punch*, July 17, 1880.

AN ÆSTHETIC MIDDAY MEAL.

At the Luncheon hour, Jellaby Postlethwaite enters a Pastrycook's and calls for a glass of Water, into which he puts a freshly-cut Lily, and loses himself in contemplation thereof.

Waiter. " SHALL I BRING YOU ANYTHING ELSE, SIR ? "

Jellaby Postlethwaite. " THANKS, NO ! I HAVE ALL I REQUIRE, AND SHALL SOON HAVE DONE ! "

without having received the painting. Before finally sending it to the family in Baltimore, Whistler reworked certain features of the painting, focusing on the model's facial expression; he also embellished the frame with a Japanese-inspired fish-scale pattern and his butterfly signature. The next year, the painting was exhibited in Baltimore as *Girl in a White Dress*—"a title which Mr. Whistler is particular about," a local critic noted, "as opposed to the 'Woman in White,' which he says is not the name of the picture."[4] Yet the Baltimore public was unlikely to fix on an association with an English novel published twenty-five years earlier; neither was it inclined to read a narrative or moral message into the painting. Instead, critics concentrated on the model's face—describing it as "a singular and an indescribable face, full of the strangest and subtlest expression," or "attractive and even fascinating"—apparently oblivious to the risqué implications that English and French critics had read into her vacant stare.[5]

The White Girl would not be shown in New York City until 1881, when it appeared at the Union League Club as *The Woman in White* yet again, and was declared to be "eccentric." "A lily is held in or rather lolls from her hand, which hangs listlessly by her side," one critic wrote, "as if she were expecting the poet Postlethwayte to lunch."[6] The reference is to George du Maurier's character Jellaby Postlethwaite, who would have been familiar to American readers of the British comic journal *Punch* as an extravagantly aesthetic poet given to gazing on lilies in lieu of other sustenance (fig. 84). Apparently, Americans in the 1880s perceived Whistler's *White Girl* as an exemplary aestheticist work, a mature example of the artist's emphasis on color and composition over meaning and morality—even though the Aesthetic movement had not yet been under way when Whistler painted the picture.

Subsequently shown at The Metropolitan Museum of Art,[7] *The White Girl* was such a success among American

artists that it created "an epidemic of emulation," in the words of Nicolai Cikovsky.[8] The "Whistler rash," as a contemporary critic termed the condition,[9] persisted for several years, causing such eruptions as Elizabeth Lyman Boott's *Little Lady Blanche* (cat. 20), Thomas Wilmer Dewing's *Portrait of DeLancey Iselin Kane* (cat. 33), and Edward August Bell's *Lady in Gray* (cat. 18). Some years later, *The White Girl* was lent to the Metropolitan Museum for temporary exhibition and subsequently offered for sale.[10] William Merritt Chase (see cats. 22–28) and J. Alden Weir (see cats. 65–67) tried to persuade the museum to buy it, but their efforts failed—either because the director refused to understand Whistler's work in particular or because the trustees bore a prejudice against American art in general.[11]

By 1904, when *The White Girl* was shown at the Memorial Exhibition of Whistler's art in Boston (fig. 85), it was seen to manifest all the salient characteristics of the artist's style, if in an early and primitive form: "his hatred of rotundity and aggressive modelling, his love for delicate oppositions as of white on white or black on black, his beauty of spacing and pattern, his grace of line, and his carelessness of, or inability for, constructive drawing."[12] And by 1910, when it was again exhibited at the Metropolitan Museum, this time in an important retrospective, it was regarded as the seminal work in Whistler's oeuvre, "his first attempt to carry out the principle afterward set down in his *Ten O'Clock*, that 'the artist is born to pick and choose, and group with science, the elements contained in nature, that the result may be beautiful.'"[13] —LM

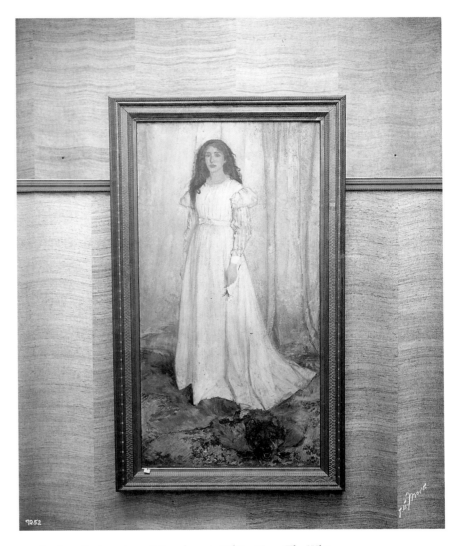

FIG 85 Installation view of *Symphony in White, No. 1: The White Girl,* Whistler Memorial Exhibition, Copley Society, Boston, 1904, Charles Lang Freer Papers, Freer Gallery of Art and Arthur M. Sackler Gallery Archives, Smithsonian Institution, Washington, D.C., gift of the estate of Charles Lang Freer.

2 | JAMES McNEILL WHISTLER, 1834–1903
Purple and Rose: The Lange Lijzen of the Six Marks,
1864

Oil on canvas, 36¾ × 24⅛ inches
Philadelphia Museum of Art, Pennsylvania
John G. Johnson Collection, 1917

The Lange Lijzen of the Six Marks IS THE EARLIEST IN
the series of costume pictures that Whistler produced in
the 1860s, while he was still searching for a distinctive
style. With *La Princesse du pays de la porcelaine* (see fig. 13)
and *Caprice in Purple and Gold: The Golden Screen* (fig. 86),
it announces Whistler's intention to change direction from
the Realism of Courbet, in which art imitated life, to the
more subjective manner of aestheticism, in which art imi-
tated art. The catalyst for the transition was East Asian
art—initially Chinese porcelain and lacquerware, then
Japanese prints, paintings, and folding screens—which
Whistler assiduously collected throughout the 1860s. "To
have loved Japanese art five-and-twenty years before its
productions became polluted by the profane admiration of
millionaire collectors and by the stereotyped enthusiasm
of the aesthetic diner-out," wrote the American art critic
Theodore Child in 1889, "is one of the many evidences
which Mr. Whistler has given of the originality and the
delicacy of his artistic temperament; for it is as much in
the objects of his admiration as in his own productions
that a man shows his personality and taste."[14]

The "enigmatical title," as it was regarded when *The
Lange Lijzen of the Six Marks* was first exhibited in 1864,[15]
refers to the "long ladies," or elegant figural types, that
frequently adorn Chinese blue-and-white porcelain and

to the "marks," or Chinese characters, that make up the
reign dates of the Kangxi era (1662–1722, when this style
of porcelain was perfected) and ornament the frame. The
long, languid form of the woman, who implausibly paints
a pot that is already finished and fired, resembles the atten-
uated figures decorating Chinese porcelain. As Whistler's
mother remarked when she saw this work in progress in
1864, Whistler had come to consider those paintings in
blue "the finest speciments [*sic*] of Art." As a result, his
own "inspirations" during that period tended to be "of
the same cast."[16]

The painting can be read, more simply, as the image of
a privileged Western woman wearing a luxurious Asian
costume, comfortably seated in a refined interior filled
with exotic objets d'art and engaged in nothing more tax-
ing than the enjoyment of beauty. This was the theme,
largely inspired by Whistler's example, that was to become
a commonplace in American painting around the turn of
the nineteenth century. Asian costumes and accessories
signified the painter's or the patron's wealth and sophisti-
cated tastes, while the sitter's anonymity and generalized
features allowed her to be regarded as a decorative object
herself—as fragile and expensive, impractical and desirable
as those that surround her. Among the artists who assimi-
lated Whistler's aestheticist theme were William Merritt
Chase, Frederick Carl Frieseke, and Edmund C. Tarbell
(see cats. 26, 37, and 62). Their purely decorative works
invited appreciation of color and composition, the formal
elements that distinguish painting from the other arts.
As Bailey Van Hook has observed, artists in this period
may have felt a special affinity for the passive and isolated
figures they so frequently portrayed, embodiments of taste
and representatives of culture.[17]

The Lange Lijzen was the first of Whistler's so-called
Japanese pictures to enter an American collection. John G.
Johnson (1841–1917), a lawyer and collector who may have
seen the painting in Whistler's 1892 retrospective at the
Goupil Gallery in London, purchased the work from its
original owner early in 1893 for six hundred pounds; Whis-
tler claimed to have sold it for eighty pounds or less thirty
years earlier, testifying to the rapidly rising value of his
art at that time.[18] In Johnson's home in Philadelphia, *The
Lange Lijzen* hung in bad light amid an assortment of Old
Master paintings, high above a staircase where it could
scarcely be seen at all.[19] Still, there were those—including
Thomas W. Dewing (see cat. 34)—who made the pilgrim-
age to Philadelphia specifically to view *The Lange Lijzen.*[20]
In 1910, the painting went on display in New York City
as part of a Whistler retrospective at The Metropolitan
Museum of Art, and in 1917 it was bequeathed to the City
of Philadelphia. —*LM*

FIG 86 James McNeill Whistler (1834–1903), *Caprice in Purple and
Gold: The Golden Screen*, 1864, oil on wood panel, 19¾ × 27¹⁄₁₆ inches,
Freer Gallery of Art, Smithsonian Institution, Washington, D.C.,
gift of Charles Lang Freer, F1904.75.

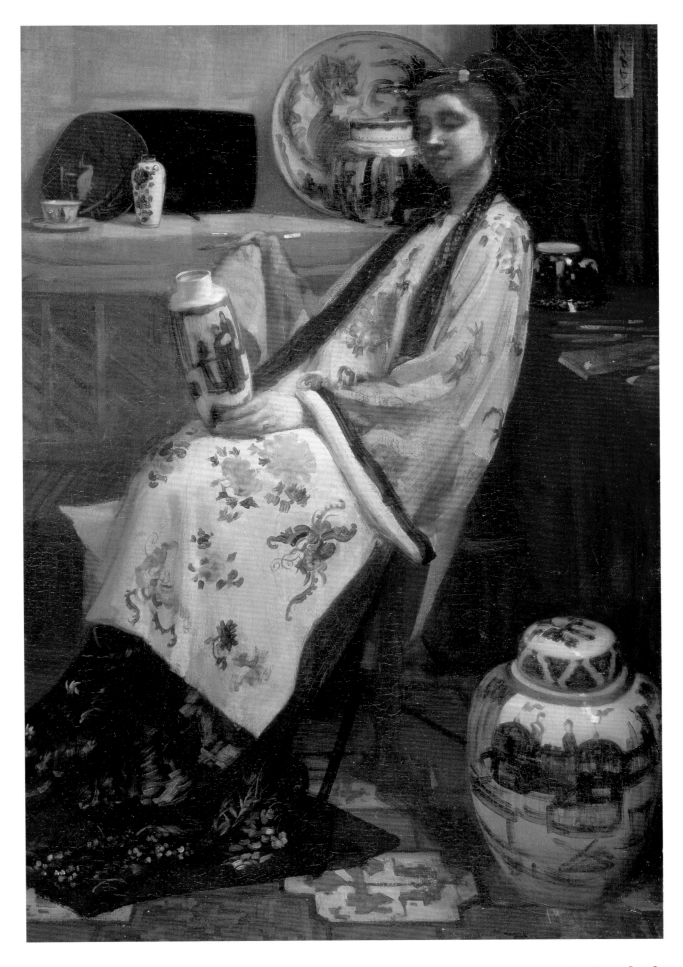

3 | JAMES McNEILL WHISTLER, 1834–1903
Nocturne: The Solent, 1866

Oil on canvas, 19¼ × 35½ inches
Gilcrease Museum, Tulsa, Oklahoma, 0176.1185

IN 1866, SEVERAL YEARS BEFORE HE BEGAN THE series of moonlit paintings he titled "Nocturnes," Whistler precipitously left London for South America. Although the expedition will probably never be completely explained, evidence has recently come to light that he had a financial interest in the trip, having enlisted to deliver torpedoes to be used against the Spanish fleet blockading the harbor at Valparaíso, Chile.[21] Whatever his motives, Whistler took the opportunity on the outward journey to paint a pair of seascapes that he later entrusted to the ship's steward to carry back to England; he never saw either of them again.[22] This one turned up in London in 1910 and, after passing through the hands of several American art dealers and collectors, was sold in 1936 to Washington University in St. Louis, Missouri. Less than a decade later, the painting was auctioned in New York and, by 1955, was acquired by Thomas Gilcrease (1890–1962), whose collection would later be sold to the City of Tulsa.[23]

Whistler's voyage to South America seems to have helped to liberate him from the conventions and confinements of European landscape painting, for this extraordinarily spare and dreamlike scene, in which three ships appear like figments of imagination on the open sea, is set at twilight and drenched in atmosphere, presaging the even more abstract Nocturnes of the 1870s. (This painting was given its present title only in 1947. "The Solent" may refer to one of the ships on which Whistler traveled to Valparaíso, which is mentioned in the diary he kept on his journey.) Although *Nocturne: The Solent* was never exhibited during Whistler's lifetime, it exemplifies the artist's early tonalist style. A number of American painters, including Leon and Theodore Scott Dabo, Eduard Steichen, and John Henry Twachtman, were drawn to such tranquil, evocative portrayals of the natural world at dusk or dawn, when low light and heavy atmosphere narrowed a scene's tonal range and left it empty of distracting detail (see cats. 30, 31, 58, and 63). —LM

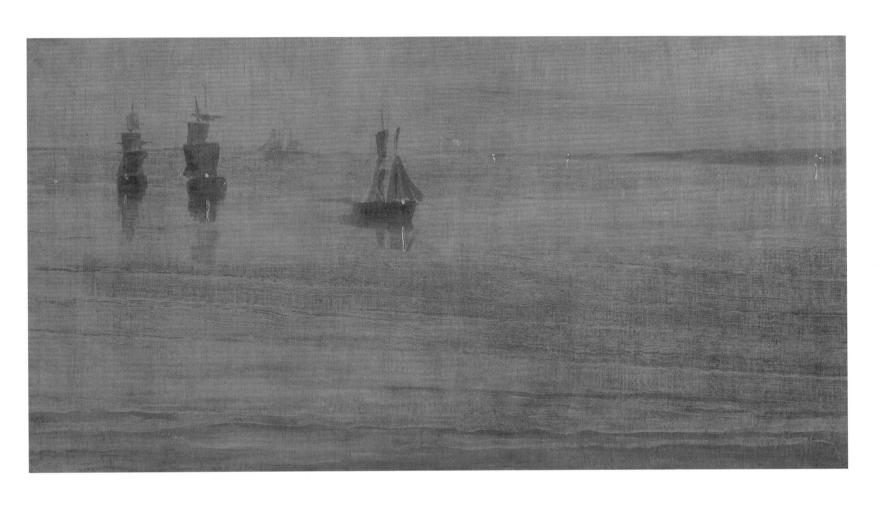

4 | JAMES MCNEILL WHISTLER, 1834–1903
Nocturne: Blue and Gold—Southampton Water, 1872

Oil on canvas, 19⅞ × 29¹⁵⁄₁₆ inches
The Art Institute of Chicago, Illinois
The Stickney Fund, 1900.52
Atlanta only

A VIEW OF SHIPS ON AN INLET OF THE ENGLISH
Channel, *Nocturne: Blue and Gold—Southampton Water* is
among Whistler's earliest moonlight pictures and probably
one of the first works exhibited as a "Nocturne."[24] That
term, redolent of music and nighttime atmosphere, had
been suggested by Whistler's foremost patron of the 1870s,
Frederick R. Leyland. In gratitude, Whistler wrote to
Leyland, "You have no idea what an irritation it proves
to the Critics and consequent pleasure to me—besides it
is really so charming and does so poetically say all I want
to say and no more than I wish!"[25]

The reticence of the title was to prove as puzzling to the
Victorian art public as the understatement of the painting
itself, but one astute London critic observed in 1872 that
"the strength of this picture lies not in its verisimilitude,
but in the super-subtle arrangement and exquisitely delicate
nature of its colour"—the very qualities that made Whis-
tler's Nocturnes emblematic of modernism.[26] A few years
later, in 1879, it was shown at the Grosvenor Gallery with
another example of the genre, *Nocturne: Blue and Silver—
Chelsea* (see fig. 59). Between them hung a gouache paint-
ing of a Newport subject by the American artist William
Trost Richards (1833–1905), who recognized the incongruity
of his own work: "The effect is peculiar," he wrote to a
friend, "an[d] looks like a joke; for my picture is by con-
trast so exceedingly realistic."[27]

Early in 1900, the Nocturne was sold by its original
owner to E. G. Kennedy of Wunderlich & Co., New York
(Whistler's agent in America), and promptly bought for
The Art Institute of Chicago—making it the first Whistler

Nocturne to gain official sanction through its purchase for
a public institution. Although portraits by Whistler had by
then been acquired by three American museums, they were
less controversial works. It was not until 1906 that another
public institution (The Metropolitan Museum of Art) pur-
chased a Nocturne for its collection (under the mistaken
impression that it was the famous one maligned by John
Ruskin), and by then Whistler's works were comfortably
settled in the canon.[28]

As the single Nocturne to enter a public collection during
the artist's lifetime, *Nocturne: Blue and Gold—Southampton
Water* would have wielded enormous influence on American
artists. Before 1890, the only Nocturnes exhibited in the
United States had been the notorious *Nocturne in Black and
Gold: The Falling Rocket* (cat. 7) and another that is almost
as abstract, *Nocturne: Black and Gold—The Fire Wheel* (see
fig. 12). Largely regarded as curiosities, they would have
been emulated only by an extraordinarily courageous art-
ist. During the 1890s and the first years of the twentieth
century, however, a handful of the more conventionally
beautiful "blue" Nocturnes were shown in America, begin-
ning in 1893 with the exhibition at the World's Columbian
Exposition in Chicago of *Nocturne: Blue and Gold—Valparaíso*
(see fig. 50). Having entered the Chicago collection, *Noc-
turne: Blue and Gold—Southampton Water* was lent for exhi-
bition in Philadelphia in 1901, New York City in 1902, and
Boston in 1904 (the only institutional loan of a Nocturne
to the Whistler Memorial), giving it one of the most ex-
tensive exhibition histories of any Whistler Nocturne in
the United States. (Apart from *The Falling Rocket*, the only
Nocturnes shown more often were those in the private
collection of Charles Lang Freer.) The painting played a
vital role, therefore, in the American blossoming of the
Nocturne genre during this period, with such artists as
Birge Harrison, Childe Hassam, Ernest Lawson, Hermann
Dudley Murphy, and J. Alden Weir producing their own
interpretations of Whistler's theme (see cats. 41–43, 48, 52,
and 67). —LM

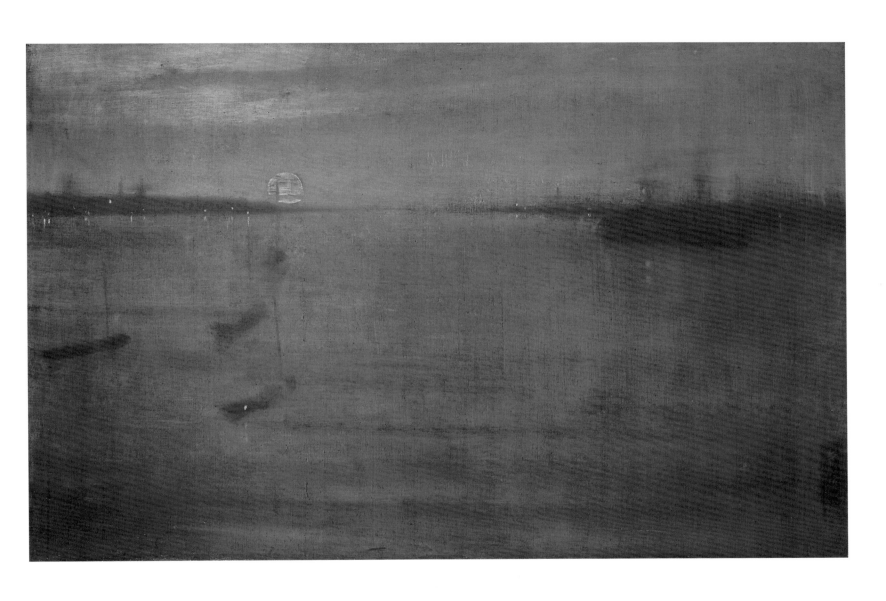

5 | JAMES MCNEILL WHISTLER, 1834–1903
Nocturne: Blue and Silver—Battersea Reach, 1872–1878

Oil on canvas, 15½ × 24¾ inches
Isabella Stewart Gardner Museum, Boston,
Massachusetts, P1e1
Atlanta only

ISABELLA STEWART GARDNER (1840–1924) BECAME
acquainted with Whistler's work in 1879, when she first
saw and admired *Harmony in Yellow and Gold: The Gold
Girl—Connie Gilchrist* (ca. 1876, Metropolitan Museum
of Art) at the Grosvenor Gallery in London. Later that
season, she met the artist himself at a party given by
Lady Blanche Lindsay, the gallery's proprietress, which
she attended on the arm of Henry James.[29] On her next
trip to London, in 1886, Mrs. Gardner charmed Whistler
with a visit to his studio, and he made a quick pastel por-
trait of her in the color scheme he had used for the por-
trait of Connie Gilchrist (fig. 87).[30] He was not entirely
satisfied with his effort, as he wrote to his new patron
afterward: "I only wish you carried away a more brilliant
proof of my appreciation—However you rather beat me
in the hurry of things this time! but you must give me my
revanche when I come to Boston."[31]

FIG 87 James McNeill Whistler
(1834–1903), *Note in Yellow and
Gold: Mrs. Gardner*, 1886, chalk
and pastel on brown paper, laid
down on card, 10⁷⁄₁₆ × 5⁵⁄₁₆ inches,
Isabella Stewart Gardner
Museum, Boston.

In 1891, Mrs. Gardner and John Singer Sargent (see cats.
56–57) were working with E. W. Hooper, one of Whistler's
first American patrons,[32] and Charles F. McKim, architect
of the Boston Public Library, to arrange for Whistler to
decorate a room in the library. "Is it decided?" she wrote
to the artist in 1892. "About the Library I mean—I am so
crazy to have anything so splendid as our great Bates Hall
painted by you, that I am too excited to remain in doubt!"[33]
Whistler evidently agreed to the commission and even
made an oil study for three panels representing Columbus's
landing in the New World—an unlikely theme for Whis-
tler, although the proposed design was "so largely a study
in blues and grays, that the iconography does not spring to
the eye."[34] When sufficient funds could not be raised, the
project was abandoned, and the great curved wall of Bates
Hall that was to have been his remains blank to this day.

The Public Library scheme secured Mrs. Gardner's
friendship with Whistler. In fact, they were so often seen in
each other's company in 1892 that a London paper reported
on "the recently developed fondness of the artist, Whistler,
for the inimitable Mrs. Jack Gardner of Boston who is
sojourning abroad and the lady's reciprocation thereof."[35]
That year she managed to pry from his hands a painting
that he treasured, *Harmony in Blue and Silver: Trouville* (1865,
Isabella Stewart Gardner Museum), together with a pho-
tograph of the portrait of his mother that had recently been
acquired by the French government.[36] In 1895, Mrs. Gardner
considered buying Whistler's most celebrated interior deco-
ration, *Harmony in Blue and Gold: The Peacock Room* (1876–
1877, Freer Gallery of Art), for installation at the Boston
Public Library as a substitute for the unrealized commis-
sion.[37] Although that plan, too, fell through, she did make
the important purchase that summer of *Nocturne: Blue and
Silver—Battersea Reach,* the third Whistler Nocturne to
enter an American collection.[38] A note from Whistler that
may have been delivered with the painting indicates their
mutual admiration: "To Mrs. Gardner, whose appreciation
of the work of Art, is only equalled by her understanding
of the Artist!"[39]

Nocturne: Blue and Silver—Battersea Reach, a foggy evoca-
tion of a scene that Whistler could have observed from
the Chelsea side of the Thames, suggests a cityscape domi-
nated by the illuminated clock face of an extravagantly
Italianate office building known as Morgan's Folly. As
John Siewert has observed, Whistler may have had that
very structure in mind when he made his now-famous
observation in the "Ten O'Clock" lecture "about that noc-
turnal moment when 'tall chimneys become campanili'
and the identity of an ordinary office tower is suspended
momentarily in the transfiguring darkness."[40] —*LM*

6 | JAMES McNEILL WHISTLER, 1834–1903
Nocturne in Blue and Silver, 1872–1878

Oil on canvas, 17½ × 24 inches
Yale Center for British Art, New Haven, Connecticut
Paul Mellon Fund, B1994.19

FIG 88 | Eliot Candee Clark (1883–1980), *Savannah Harbor*, ca. 1924, oil on canvas, 20¼ × 24¼ inches, Morris Museum of Art, Augusta, Georgia.

THIS NIGHTTIME VIEW OF A LONDON RIVERBANK across the Thames from Chelsea, with the aspect of the buildings cloaked in fog and darkness, is one of Whistler's most evocative and characteristic Nocturnes. The pigment is so thin that the roughly woven canvas looks stained, rather than painted, in shades of blue, with a deeper smudge in the foreground suggesting a lonely barge on the river. The extremely still and largely vacant composition is anchored on the left by the illuminated clock tower of the Battersea building known as Morgan's Folly, which seems to have particularly enchanted Whistler: it also appears in *Nocturne: Blue and Silver—Battersea Reach* (cat. 5). Probably painted around the same time, this Nocturne is signed with a butterfly in the style Whistler used in the early 1880s.

Nocturne in Blue and Silver might have attracted the attention of American artists in 1905, when it was shown in London at the enormous Memorial Exhibition of Whistler's works with the curiously composite title *Arrangement in Grey and Gold, Nocturne, Battersea Bridge*. Eliot Candee Clark, for example, a student of John Twachtman (see cat. 63) who later painted nocturnes of his own (fig. 88), made a special pilgrimage to that exhibition, writing to his father afterward that Whistler's works had impressed him "in the use of color, and subtle arrangement of line and balance of masses." (He added, however, that he was not about to join the masses of "Whistlerians.")[41] The Nocturne was later presented, improbably, to the Shakespeare Memorial Gallery in Stratford-upon-Avon but sold in 1911 to the New York dealer M. Knoedler & Co. Harris Whittemore of Naugatuck, Connecticut—then the owner of *The White Girl* (cat. 1)—acquired the painting the next year, and it remained in the family until 1994.[42] Today, this painting by an American artist resides in a distinguished collection of British art, a telling token of the fluidity of Whistler's nationality. —*LM*

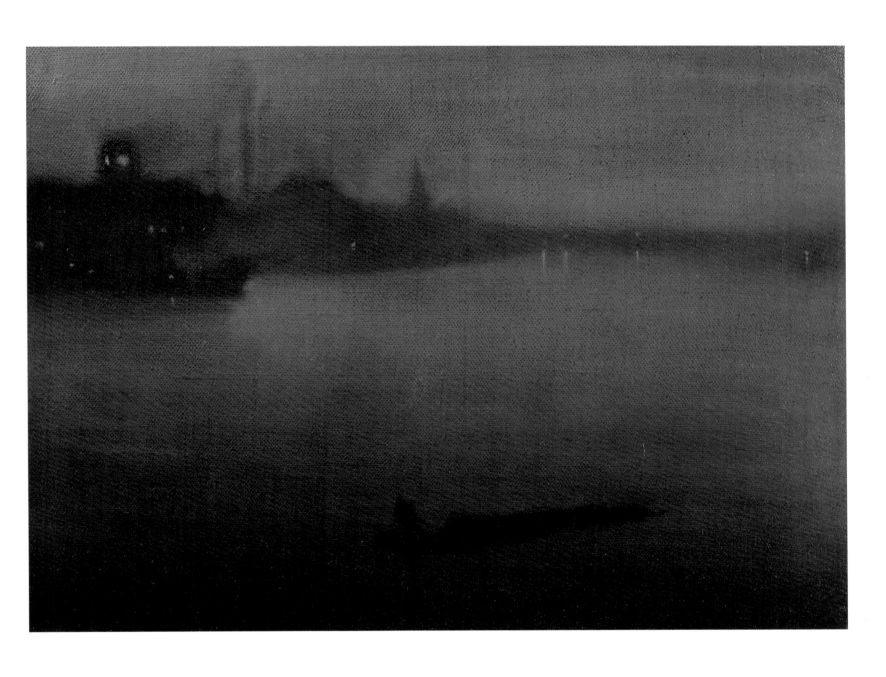

7 | JAMES MCNEILL WHISTLER, 1834–1903
Nocturne in Black and Gold: The Falling Rocket, 1875

Oil on panel, 23¾ × 18⅜ inches
The Detroit Institute of Arts, Michigan
Gift of Dexter M. Ferry Jr., 46.309

AS HIS MOST NOTORIOUS WORK, *Nocturne in Black and Gold: The Falling Rocket* occupies a pivotal place in the establishment of Whistler's American reputation. It was the Nocturne most widely exhibited in the United States before 1890, when more of Whistler's works became available for display, yet it was purchased (by an American) only after its appearance in Whistler's retrospective held in London in 1892. By then, Whistler feared that its "place in history" might have been forgotten and insisted that the new owner be informed that he possessed "the famous Nocturne that was the destruction of Ruskin the immaculate!"[43]

Originally displayed in 1875, *Nocturne in Black and Gold: The Falling Rocket* did not attract much attention until its exhibition in 1877 at the new Grosvenor Gallery in London, where it was discreetly advertised for sale at two hundred guineas.[44] That fact, as much as its abstract nature, impelled the critic John Ruskin to characterize the Nocturne in the pages of *Fors Clavigera*, a publication ostensibly intended for the workmen of Great Britain, as "a pot of paint in the public's face." Whistler sued Ruskin for libel, and the case went to court late in 1878. *The Falling Rocket* was brought into the courtroom, but it could scarcely be seen in the limited light of that November afternoon and could only have weakened the artist's case. Whistler, however, clearly articulated his point of view, testifying that the Nocturne had been painted not "to offer the portrait of a particular place, but as an artistic impression that had been carried away" from the scene. It was an abstract, subjective rendering of an artistic recollection "conscientiously executed," he maintained, summarily refuting Ruskin's charge: "I would hold my reputation upon this," he said, "as I would upon any of my other works."[45] In the end, Whistler won the verdict but only nominal damages, an ambiguous denouement to a trial that had been plagued from the start with muddle and miscomprehension.

Shortly before the trial, Whistler had been forced to pawn the painting, and afterward it temporarily disappeared from the London scene. Yet it was included—incongruously—in the exhibition of Whistler's Venetian prints that toured the United States in 1883, when at least one visitor assumed that it portrayed fireworks in Venice.[46] This not only confirms Whistler's contention that the painting should not

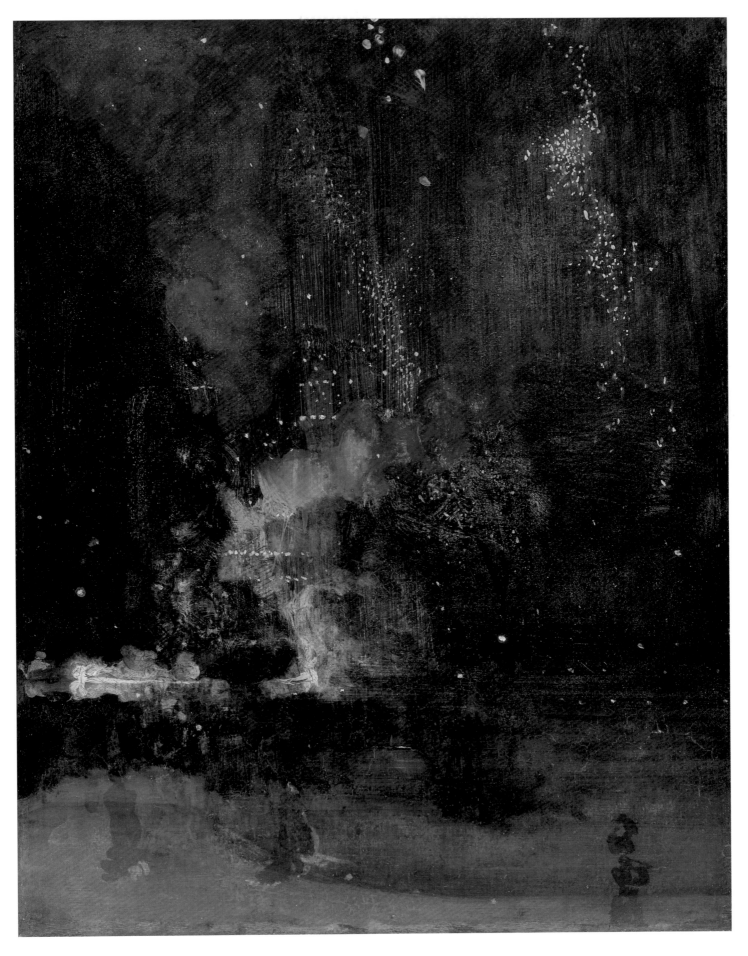

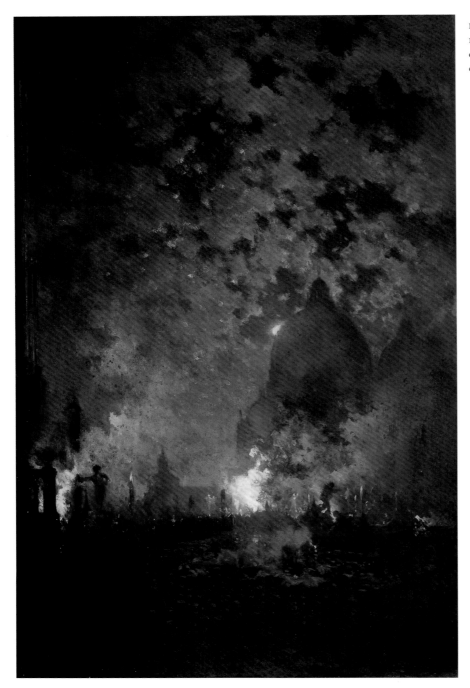

FIG 89 Unknown Artist (attributed to Whistler until 1965), *Grand Canal, Venice (Moonlight)*, after 1890, oil on canvas, 33⅛ × 21⅜ inches, Philadelphia Museum of Art, The George W. Elkins Collection, 1924.

be considered a portrait of a place but suggests that the artist's name had become indelibly attached to the subjects of Venice and fireworks. A painting in the Philadelphia Museum of Art titled *Grand Canal, Venice (Moonlight)* and signed with a spurious butterfly (fig. 89) was acquired as a work by, and for decades mistakenly attributed to, Whistler.[47]

In 1890, the year that Whistler appears to have redeemed *The Falling Rocket*, it was exhibited in Paris and Brussels, and it finally reappeared in London in 1892, when it was sold to the American collector Samuel Untermyer (1858–1940).[48] The price—which Untermyer appears to have accepted without negotiation—was eight hundred guineas, and Whistler was eager to advertise the fact that "the Pot of paint flung into the face of the British Public for two hundred guineas has sold for four pots of paint, and that Ruskin has lived to see it!"[49] Indeed, Whistler perceived the sale of *The Falling Rocket* as the crowning conclusion to his triumphant retrospective at the Goupil Gallery. After the close of the exhibition, he saw no need to remain in London, declaring, "No further fighting necessary."[50]

Whistler was anxious to know how the notorious Nocturne would fare in the United States and repeatedly expressed the hope that Untermyer would lend it for

exhibition the next year at the World's Columbian Exposition in Chicago: "the work has achieved a certain historical reputation," he explained, "and I should much regret its absence."[51] (Untermyer agreed to lend the painting,[52] but for some reason it never turned up in Chicago and was not publicly exhibited again until 1900, when it was shown in Philadelphia with the innocuous title *Fireworks.*) Untermyer confessed that he had "little previous acquaintance" with Whistler's works but considered the Nocturne "startling in its beauty & originality." He also took pride in the fact, he wrote to Whistler, "that an American artist has secured a permanent place in the front rank of the great painters of modern times."[53]

Before Whistler's death in 1903, *Nocturne in Black and Gold: The Falling Rocket* was exhibited in Philadelphia, New York, and Pittsburgh, and it was included in both the Boston and Paris memorial exhibitions of Whistler's work.[54] When it was shown at The Metropolitan Museum of Art in 1910, Gustav Kobbé named it "an epoch-making picture": "It marks the decline of an arrogant school of criticism and the beginning of Whistler's influence on modern art, an influence so subtle that the artists themselves hardly are aware of it."[55] A few years later, Royal Cortissoz wrote that with *The Falling Rocket,* Whistler had taken his theory of art to its "ultimate conclusion, eschewing all tangible facts, and aiming at his effect almost as though he had no pictorial intention at all"—in other words, he had nearly achieved the abstract in painting— and consequently "gave to art a new sensation."[56] And by 1947, when the painting had at last entered the Detroit public collection where it remains today, E. P. Richardson declared it to be "a dramatic landmark in the story of American painting."[57] —*L M*

8 | JAMES MCNEILL WHISTLER, 1834–1903
Arrangement in Grey: Portrait of the Painter, ca. 1872

Oil on canvas, 29½ × 21 inches
The Detroit Institute of Arts, Michigan
Bequest of Henry Glover Stevens in memory of
Ellen P. Stevens and Mary M. Stevens, 34.27

PAINTED AROUND THE TIME WHISTLER FIRST exhibited *Arrangement in Grey and Black, No. 1: Portrait of the Painter's Mother* (see fig. 5)—the painting destined to become his signature work—*Arrangement in Grey* represents Whistler's conscious attempt to place himself among the European Old Masters. The pose, beret, and handful of brushes refer to the well-known self-portraits of Rembrandt, while the muted color scheme and careful placement of the figure within the composition allude to portraits by Velázquez.[58] At the same time, with its shallow picture space, chromatic tonalities, and unsentimental presentation, the work relates to other family portraits that Whistler himself painted in this period, including that of his mother and a roughly contemporary portrait of his younger brother, William (ca. 1871–1873, Art Institute of Chicago).

The portrait shows Whistler posed as a painter, wearing the bohemian costume of a velvet hat, a painter's smock, and a floppy silk tie. In fact, as William Merritt Chase discovered when he spent a summer with the artist in London, "Whistler of the studio" (in contrast to his fastidiously groomed alter ego, "Whistler of Cheyne Walk") customarily wore, when he worked, a heavy pair of iron spectacles "clumsily wrapped with cloth where they rested on his nose." His curly hair, usually his principal vanity, went uncombed, and his dress was careless. When one of the students he met in Venice expressed surprise at the dramatic change his appearance had undergone, Whistler explained that he left all "gimcracks" outside the studio door.[59] In *Arrangement in Grey*, he presents himself as neither the dandy nor the drudge, but as a confident and authoritative professional—precisely the image that American painters were striving to attain for themselves at the close of the nineteenth century.

One of those artists, Hermann Dudley Murphy, might have seen this self-portrait in 1892, at Whistler's Goupil Gallery retrospective in London, or three years later in an exhibition of the collection of Alexander Ionides (1840–1898), the original owner of *Arrangement in Grey*.[60] Murphy's memory of the painting obviously informs his own portrait of his friend Henry Ossawa Tanner (cat. 51), a fellow American art student in Paris, which was recognized at the time as an homage to Whistler. —*LM*

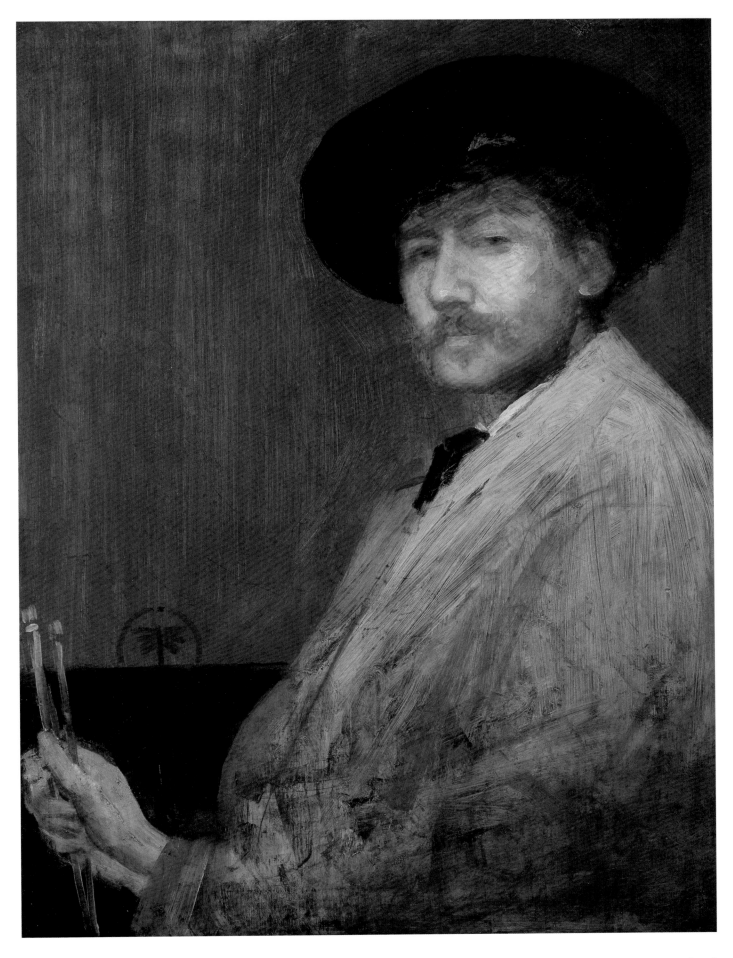

9 | JAMES McNEILL WHISTLER, 1834–1903
Arrangement in Black and Brown: The Fur Jacket, 1876

Oil on canvas, 76⅜ × 36½ inches
Worcester Art Museum, Massachusetts
Museum purchase, 1910.5

ALTHOUGH HER NAME WAS NEVER FORMALLY attached to the painting, this is known to be a portrait of Maud Franklin, Whistler's model and mistress in the 1870s. The style of her costume, coy pose, backward glance, and somewhat downcast expression suggest that Maud may have been pregnant at the time, which could also account for the portrait's scrupulous anonymity. Originally exhibited simply as an "arrangement," by the early 1890s "The Fur Jacket" had been appended to the title, effectively drawing attention away from the sitter.[61] By then, Whistler was happily married to Beatrix Godwin, who might well have encouraged him to expunge Maud's identity from his works. In 1892, Whistler callously informed the art dealer Alexander Reid that the picture portrayed "an obscure nobody."[62]

It was as *The Fur Jacket* that the portrait made its debut in the United States in 1893, among the six oil paintings that Whistler exhibited at the World's Columbian Exposition in Chicago. Essentially "an artists [*sic*] picture," as Whistler himself described it, the painting embodied the most distinctive elements of his mature style of portraiture: a somber palette, abbreviated technique, mysterious mood, and restrained but eloquent pose. Unlike the subjects of *The White Girl* (cat. 1) and *Arrangement in Grey and Black, No. 1: Portrait of the Painter's Mother* (see fig. 5), this sitter appears to emerge from the shadows, an enveloping darkness that blurs the edges of her silhouette. To the many American painters who saw this work in Chicago, *The Fur Jacket* represented a new type of portraiture they were eager to adopt, one that combined the practical advantages of painting portraits on commission with the aesthetic satisfaction of working in the mode of art for art's sake. Even the synecdochic title, which pointed to a minor part of the composition—the woman's Dutch-style, fur-lined jacket—demanded that the work be seen as something more (or, some might argue, something less) than a conventional portrait.[63] This practice would prove influential to turn-of-the-century American artists, who often named their portraits after some decorative element of costume or setting to make the sitter's identity seem secondarily important.[64] Gari Melchers's portrait of Kate Kendall (fig. 90), for instance, which betrays the artist's familiarity with *The Fur Jacket,* bears the title *The Scarlet Jacket.*

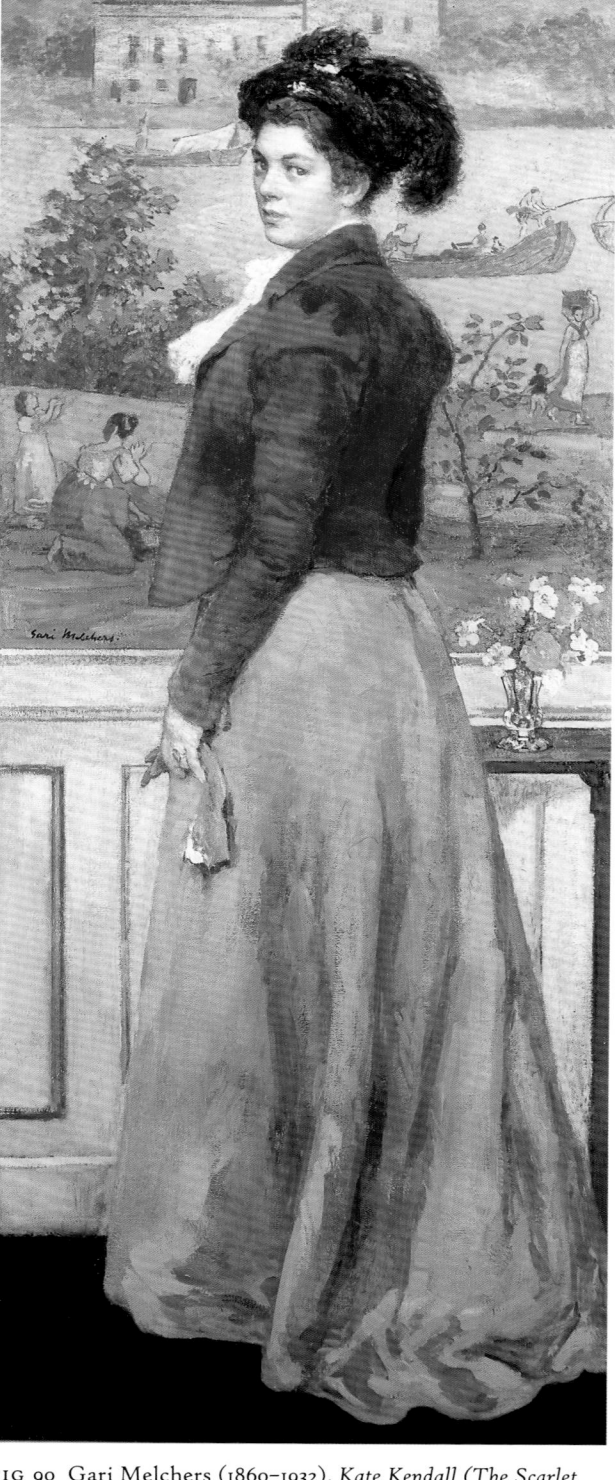

FIG 90 Gari Melchers (1860–1932), *Kate Kendall (The Scarlet Jacket)*, ca. 1919–1920, oil on canvas, 67¼ × 31½ inches, Columbus Museum, Georgia, bequest of Jack Melchers Passailaigue, 98.38.1.

Whistler's portrait of Maud Franklin was first revealed in London at the Grosvenor Gallery's inaugural exhibition in 1877, the event that prompted John Ruskin's vituperative critique of Whistler's work. Although Ruskin had not singled it out for censure, *The Fur Jacket* was produced as evidence at the libel trial by the print dealer with whom it had been deposited as security for a loan.[65] In the following decade, *The Fur Jacket* was exhibited all over Europe—in Edinburgh, Brussels, Paris, and Amsterdam—but efforts to sell it failed, and by 1892 it was back in Whistler's hands and included in his retrospective *Nocturnes, Marines & Chevalet Pieces*.[66] After its appearance in Chicago in 1893, it was sent to the Pennsylvania Academy of the Fine Arts in Philadelphia, where the manager, Harrison Morris, unsuccessfully lobbied for its purchase.[67] It then went to the Museum of Fine Arts in Boston and remained there under consideration for over a year. Alexander Reid, the Glasgow art dealer representing Whistler at that time, hinted that because the artist was particularly eager to have a work in the Boston museum, he might be willing to negotiate the price,[68] but the painting was relinquished in time for exhibition in 1896 at the Carnegie Institute, Pittsburgh, and then returned to Glasgow. The Scots shipowner William Burrell finally purchased *The Fur Jacket*. Recognizing that his acquisition was sure to rise in value, he held on to it until 1909,[69] when he let it go at last to the Worcester Art Museum.

As early as 1903, the year of Whistler's death, the museum
in Worcester had let it be known that it was in the market
for a representative Whistler painting. George E. Francis,
a "friend" of the museum, wrote that year to Whistler's
biographer Elizabeth Pennell asking for assistance—not only
because he admired Whistler's work but also, he explained,
because of a coincidental personal association: he had grown
up in the house in Lowell where Whistler was born.[70] Four
years later, the president of the Worcester Art Museum,
Daniel Merriman, enlisted the aid of Charles Lang Freer
(1854–1919), the foremost collector of Whistler's work in
the United States, who persuaded Whistler's heir, Rosalind
Birnie Philip, to send a half-length portrait of Carmen
Rossi to Worcester on approval; but the trustees were un-
impressed.[71] The next year, the museum considered *The
Fur Jacket,* but again the trustees balked, thinking the por-
trait "too dangerous a work" to purchase at the price asked:
as the director explained, "We are particularly afraid of its
unfinished lower part . . . and by the absence of what is
usually called color."[72] Burrell eventually lowered the price,
and when the painting was sent to Worcester, the nervous
trustees overcame their qualms to buy it for $32,786, ac-
quiring one of the last available Whistler portraits of
importance.[73] —*LM*

10 | JAMES MCNEILL WHISTLER, 1834–1903
Arrangement in Flesh Color and Brown:
Portrait of Arthur Jerome Eddy, 1894

Oil on canvas, 82⅝ × 36⅜ inches
The Art Institute of Chicago, Illinois
Arthur Jerome Eddy Memorial Collection, 1931.501
Detroit only

ARTHUR JEROME EDDY (1859–1920), A PROMINENT
Chicago attorney and art enthusiast, considered the World's
Columbian Exposition of 1893 "one of the wonders, criti-
cally one of the great surprises, of all time." Of the contem-
porary works exhibited there, the ones he most admired
were by Auguste Rodin and Whistler.[74] Consequently, he
was bold enough to commission Whistler to paint his por-
trait, making him famous in Chicago "as the man who
bearded the lion in his den."[75] Whistler portrayed Eddy
as an aesthete, delicate and refined in a subtle arrangement
of brown and gray, in keeping with his practice of painting
gentlemen with exaggerated elegance—and Eddy, according
to the mayor of Chicago, "was a gentleman to the finger-
tips."[76] Nevertheless, the subject's wife did not think the
portrait did her husband justice, and Eddy's friends gener-
ally concurred that it was an unconvincing likeness. Eddy
himself reasoned that it would not be a Whistler if every-
one liked it on first sight. "The quality of a picture," he
said, echoing Whistler's characteristic elitism, "is inversely
[related] to the number of those who propose to admire it."[77]

Arrangement in Flesh Color and Brown, the title Whistler
inscribed on the back of the canvas, was produced in the
artist's Paris studio with almost unprecedented speed,
in six weeks during the autumn of 1894.[78] Eddy later con-
fessed that for the unprofessional model, standing perfectly
still for an hour and a half at a time had been difficult.
(To Whistler himself, Eddy recalled "pain and torture.")[79]
Gradually, however, he came to understand that Whistler
did his best work during the first long session and the final
hours of the day, "when the shadows were deepening," and
learned to concentrate his efforts on those two periods of
posing.[80] Even after the painting arrived at his home, Eddy
feared that the work might not be completed to the artist's
satisfaction.[81] Whistler had in fact dispatched the portrait
to Chicago unvarnished, intending to add that final touch
when he came for a visit.[82]

The prospect of Whistler's triumphant return to the
United States had been among the happier topics Whistler
and Eddy discussed in the studio while the portrait was
in progress. "No one believes for a moment that you will
come to America," Eddy later wrote to Whistler,

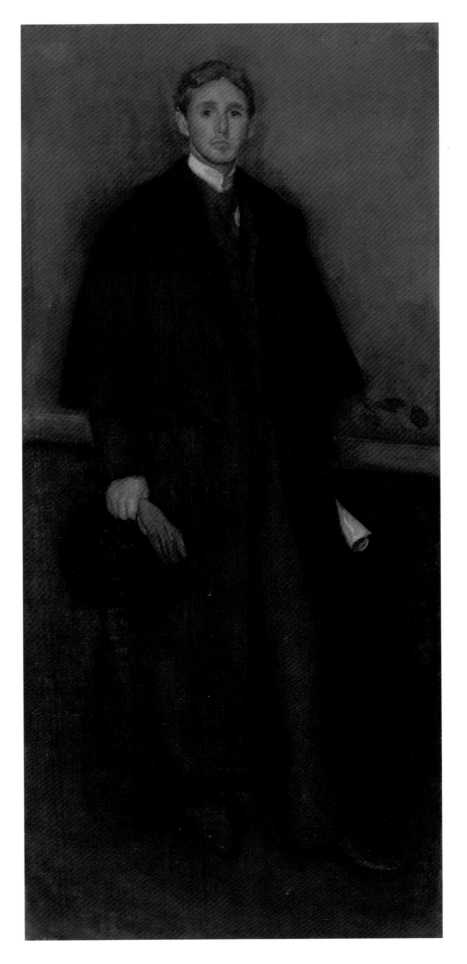

FIG 91 Title page, *Recollections and Impressions of James A. McNeill Whistler,* by Arthur Jerome Eddy, 1903.

so here is a rare opportunity to . . . prove that people in America know nothing—Besides I have talked about you and Mrs. Whistler so much that people begin to look upon me as a monumental liar and will not believe half I say—so you see you must come, speak for yourself and let the timid see that you are something less than a bear even though something more than a man.[83]

Eddy proposed that The Art Institute of Chicago mount a major exhibition, which he assured Whistler would be "the artistic event, not only of this year, but of many years," and also "an expression of appreciation of your commanding position as an American artist."[84] Whistler did not reply. For years, Eddy persevered in his efforts to persuade Whistler to cross the Atlantic, offering to commission another portrait, to make the travel arrangements himself, and finally to cover all expenses, but by the end of 1897 he was nearly ready to concede defeat: "I fear that nothing but main force would get you on a steamer and over here, but you really ought to revisit a country where you have so many warm friends, for while the American people may be slow to appreciate good things in art, when they are once aroused, they go to the other extreme in enthusiasm."[85]

Although they never met again, Eddy savored the memory of his days with Whistler all his life. As early as December 1894, he spoke to a local women's art society about the experience, assuring Whistler afterward that it had been "an *entirely informal* talk, without a note or memorandum of any description," though he had often been asked to commit his recollections to print—and someday, he supposed he might.[86] Eddy's *Recollections and Impressions of James A. McNeill Whistler* was finally published in 1903, one of the first and most substantive of many volumes of reminiscences published in the wake of Whistler's death (fig. 91). Eddy continued to lecture on Whistler and other modern artists and to build a collection of contemporary art, generally buying directly from the artists before they achieved critical acclaim. From the Armory Show of 1913 he made some twenty-five purchases, including a dozen Fauve and Cubist works.[87] The book he published the following year, *Cubists and Post-Impressionism,* positions

Whistler as "the forerunner of recent attempts to do with line and color what the musician does with sound." If Whistler never took his paintings "to the abstract extremes of the Compositionalists and the Cubists," Eddy wrote, his works nonetheless contained the "seeds" of Post-Impressionism.[88] In Eddy's own pioneering collection of modern art, the Whistler portrait took its place opposite a Manet in a room lined with modern pictures by artists such as Wassily Kandinsky (1866–1944), "illustrating the fact that 'good paintings' of all schools, and all times hang well together."[89] —LM

11 | JAMES McNEILL WHISTLER, 1834–1903
Grey and Green: A River, 1883–1884

Oil on panel, 5¾ × 9⅞ inches
Private collection

Grey and Green: A River, A VIEW OF THE HARBOR AT Dordrecht, Holland, is among the diminutive oil paintings on wood panels that Whistler produced in the 1880s and 1890s and regarded as "Notes": not full-scale symphonies, like some of his earlier works, but pleasing and important in spite of their size. The American critic Charles de Kay described them as "pigmy pictures" with "big souls":

> Their size might argue them cabinet pictures of the old sort, which did well for a minimal easel on a table and had to be conned through a magnifying glass. But they are just the reverse, meant instead for the walls of a sitting-room, smoking den or boudoir, nicely calculated to carry each its little message of color and character to the seat on which you may happen to fall.[90]

In keeping with their small scale, the compositions tend to be extremely simple, emphasizing the abstract qualities of the subject. Such cursory renditions of city scenes and landscapes proved inspirational to American artists such as Earl Stetson Crawford, Childe Hassam, Everett L. Warner, and Elisha Kent Kane Wetherill, who hoped to capture the spontaneity of watercolor in the more permanent medium of oil (see cats. 29, 44, 64, and 68). Several also adopted Whistler's practice of stressing the importance of such Notes by placing them in relatively large gilt frames, each toned to harmonize with the picture's color scheme.

Grey and Green: A River was probably among the Dutch scenes displayed in London in 1885 at the Society of British Artists' exhibition,[91] where it would have been seen by William Merritt Chase. Upon his return to the United States, Chase began to produce similar views of the waters around New York, including *Seascape* of 1888 (cat. 25).

—*LM*

12 JAMES McNEILL WHISTLER, 1834–1903
Rose and Red: The Barber's Shop, Lyme Regis, 1895

Oil on panel, 4⅞ × 8¼ inches
Georgia Museum of Art, University of Georgia, Athens
Eva Underhill Holbrook Memorial Collection of
American Art, Gift of Alfred H. Holbrook, 1945.96

THIS TINY OIL PAINTING, ONE OF WHISTLER'S
favorite Notes,[92] was painted in the coastal town of Lyme
Regis, where the artist spent the autumn months of 1895.
Exploring many of the same themes he had portrayed in
his own London neighborhood of Chelsea, Whistler chose
simple, unpretentious subjects: here he paints the facade
of the local barber's shop with a little girl—the barber's
daughter—posing in the doorway in a red pinafore. (Her
presence provides an alternate title, *Red Rosalie of Lyme
Regis.*)[93] Yet the picture lacks any internal clues to the site,
and by focusing on the doorway and cropping the roof line
from the buildings, Whistler eliminates the distinguishing
characteristics of the scene. His memorandum is intended
to emphasize the abstract design, a colorful pattern of
squares and rectangles brilliantly accented in red. Childe
Hassam was among the American artists who emulated
the decorative aspect of Whistler's little street scenes (see
cat. 44), which were, in the words of Charles Lang Freer,
"superficially, the size of your hand, but, artistically, as
large as a continent."[94] —LM

13 | JAMES McNEILL WHISTLER, 1834–1903
Blue and Silver: Dieppe, 1896

Oil on panel, 5 × 8½ inches
The New Britain Museum of American Art, Connecticut
Harriet Russell Stanley Fund, 1948.23

Blue and Silver: Dieppe WAS AMONG THE FIRST OF Whistler's Notes to enter an American collection. Amy Lowell (1874–1925), a young American who would later achieve fame as a poet, essayist, lecturer, and patron of poetry,[95] bought the little picture on a visit to London in the autumn of 1896.[96] She was introduced to Whistler through a friend of his, the publisher William Heinemann, with whom he was living at the time, and she later reported to the Pennells that she had found him to be "charming all through, so that she can but wonder at his reputation for being the other thing."[97]

Lowell, then twenty-two, went to Whistler's studio determined to buy something, and *Blue and Silver: Dieppe,* a small, vigorously painted seascape she later described as "a stretch of green sea with a sloop, a stretch of blue sky above," immediately caught her eye. She was particularly charmed by its scale, "the size that would fit into the top of a small paint box,"[98] and despite Whistler's suggestion that she purchase a different painting of the same size and price that he considered the better work, she held fast to her original selection. Later, she admitted that she had been ignorant and obstinate at the time, but she never regretted her choice, and it seemed to her that Whistler, too, had been pleased with her decisiveness ("for other reasons than

that he had the better one still to sell").[99] Lowell had a box with a handle specially made for the painting so she could carry it home herself, "afraid something might happen to it if she let it out of her hands"[100]—and she hardly ever did. It hung in the library of her Brookline home, Sevenels, until her death in 1925, when she bequeathed it to her nephew George Putnam.

Blue and Silver: Dieppe appears to have been painted during the summer of 1896, during a two-week working holiday around Dieppe and Calais that Whistler took with his friend the American art dealer E. G. Kennedy. Whistler was in a depressed and scattered state, his wife having died that spring, and he seems to have returned to London with little to show for his journey. *Blue and Silver: Dieppe* was begun, but may not have been completed, on the spot; at the time Lowell saw it, its paint was scarcely dry, the signature "quite fresh," and the panel still unvarnished. Whistler advised Lowell to leave the painting in its frame for six months before sending it to Kennedy in New York for varnishing—"and then you will see the picture in all its full brightness, as it was the day it was painted, for the first time."[101]

During Lowell's lifetime, the painting was exhibited only once, at the Whistler Memorial Exhibition in Boston, where it was noticed by the critic William Howe Downes among Whistler's other "cabinet-size pictures, chiefly marines and street scenes, which are fully as good as any of the large paintings, if not better. The beauty of Whistler's color is, indeed, more evident in these little easel pictures, a few inches in dimensions, than in most of his big canvases."[102] —LM

14 | JAMES McNEILL WHISTLER, 1834–1903
Grey and Gold: The Golden Bay, 1900

Oil on panel, 5½ × 9¼ inches
Hunter Museum of American Art, Chattanooga,
Tennessee
Gift of Mr. and Mrs. Scott L. Probasco Jr., 1981.5

WHISTLER PAINTED *Grey and Gold* DURING THE
three weeks he spent in Sutton, near Dublin, Ireland,
late in the summer of 1900.[103] The weather was awful and
the view of Dublin Bay from his house unsatisfactory,
yet Whistler managed to produce a handful of watercolors
and Notes, including this spare and elegant evocation of
the bay at sunset.[104]

Whistler sold *Grey and Gold* in 1902 to an American,
Richard A. Canfield (1855–1914). The proprietor of the
most famous gambling casino in New York, Canfield was
a notorious character who spent many months of his life
in prison, yet he impressed Whistler with his sound opin-
ions and perceptive acquisitions of art. In 1904, Canfield
lent *Grey and Gold* to the Boston Memorial Exhibition,
and in 1911 it was shown as part of Canfield's impressive
collection of Whistler oil paintings and works on paper
at the Albright Art Gallery in Buffalo.[105] —LM

15 | JOHN WHITE ALEXANDER, 1856–1915
Azalea (Portrait of Helen Abbe Howson), 1885

Oil on canvas, 19¼ × 44¼ inches
The Hudson River Museum, Yonkers, New York
Gift of Mrs. Gertrude Farnham Howson, 74.16.6

AFTER BRIEFLY STUDYING IN MUNICH AND THEN in Pölling, John White Alexander traveled to Italy in 1879 with fellow Cincinnati artist Frank Duveneck. Alexander taught some of Duveneck's students in Florence that fall and in Venice the following summer.[106] One day as he was painting the Venetian canals, the artist recalled, he felt an unusual amount of attention behind him and turned to see Whistler watching over his shoulder.[107] That day the artists began a lifelong friendship that would have a decisive effect on Alexander's career. His wife, Elizabeth, later described her husband as "the only person he [Whistler] never quarreled with."[108]

After a farewell party on the canals of Venice reputedly attended by both Duveneck and Whistler, Alexander returned to New York City in 1881.[109] He arrived in time to see one of the most talked-about exhibitions of the year, Whistler's *Symphony in White, No. 1: The White Girl* (cat. 1) at The Metropolitan Museum of Art. The next year Alexander made his American debut as a painter with a portrait of a young girl dressed in white and standing on a white rug, *Portrait of Miss May* (1881, unlocated), one of a host of "white girls" that appeared at the National Academy of Design's annual exhibition that spring.[110]

Despite moderate success, Alexander remained unsatisfied with the progress of his career. "Next spring," he wrote in July 1884, "I hope to have a *picture* in the Ex[hibition]— a subject and not a simple portrait."[111] Alexander may have found such a "subject" with a commission from Charlotte Colgate and George Abbe to paint their daughter Helen (1853–1925), perhaps in honor of her recent engagement.[112] More than "a simple portrait," Alexander's depiction of Helen, titled *Azalea,* places her as an accessory within a dreamy interior. Seated on a divan, she appears to contemplate azalea blossoms in a large ceramic vase. Alexander's asymmetrical composition, with the female figure posed in a shallow space in front of a cropped, framed print, echoes Whistler's *Arrangement in Grey and Black, No. 1: Portrait of the Painter's Mother* (see fig. 5), which Alexander would have seen in New York in 1882. The painting's title reveals the artist's intention to develop a decorative, rather than a mimetic, brand of portraiture; it appears, however, that the work was first exhibited at the American Art Galleries in 1885 as *Portrait.* In a review of that exhibition, one critic described Alexander's painting as "what Mr. Whistler would probably call a nocturne. It looks as if it were painted in green moonlight."[113] —LTJ

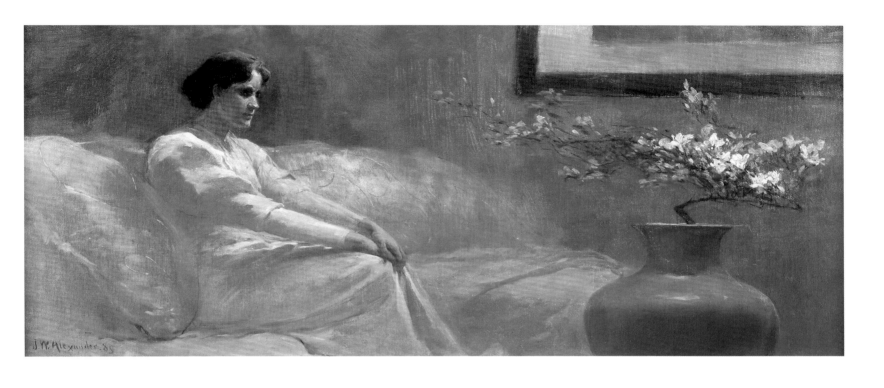

JOHN WHITE ALEXANDER, 1856–1915
Portrait gris (Portrait in Gray), 1892

Oil on canvas, 72⅛ × 35⁷⁄₁₆ inches
Musée d'Orsay, Paris

JOHN WHITE ALEXANDER MOVED HIS FAMILY TO Paris in 1891, a watershed year for Whistler, for that fall the French government honored him with the Chevalier of the Légion d'Honneur and accepted *Arrangement in Grey and Black, No. 1: Portrait of the Painter's Mother* (see fig. 5) into the national collection of modern art at the Musée du Luxembourg. Following those accolades, Whistler, too, relocated to Paris, where he renewed his friendship with Alexander. For the rest of the decade, Whistler included Alexander among the group of critics, writers, and artists who frequented his studio on Sunday afternoons.[114]

Alexander's wife, Elizabeth, later recalled that Whistler introduced her husband to a number of French critics in 1893, saying, "You will see work by Alexander at the Salon this year and I am sure you will be interested."[115] One of the paintings those critics saw was *Portrait gris*, which marked Alexander's debut at the Champ-de-Mars Salon. Hung together with two other narrow, full-length portraits of women in tonal color schemes, *Portrait noir* and *Etude*, Alexander's trio became, in his own words, "the hit of the year in the Salon."[116] Calling them "symphonies in grey or black," or "arrangements," French and American critics identified Alexander's portraits as Whistlerian in subject and composition. Many writers pointed to Alexander's works as evidence of Whistler's influence on modern art, describing Alexander as one of his "prophets" or "disciples."[117]

Portrait gris recalls Whistler's portraits of women seen from the rear with their faces in profile, such as *Arrangement in Brown and Black: Portrait of Miss Rosa Corder* (ca. 1878, Frick Collection) and *Mother of Pearl and Silver: The Andalusian* (fig. 92).[118] *The Andalusian*, which Alexander could have seen in progress on the easel in Whistler's studio, provides an especially close comparison: *Portrait gris* presents a mirror image of its pose, as though the two canvases (of almost identical size) were meant to hang as pendants, and shares its limited tonal range of grays, the color most closely associated with Whistler's style.[119] Alexander's portrait is slightly less severe, with a note of red in the figure's hair bow that offsets the silvery grays of her dress and the pearly gray of the curtain behind her. As the French critic Louis Fourcaud recognized, Alexander adopted the characteristically Whistlerian technique of allowing the coarse weave of his canvases to show through his compositions.[120] "Some have accused him of painting thinly," Elizabeth Alexander recalled, "but it is not true,

for no one was more unsparing of his paints. He rubbed them in as he went, for he felt that they should become an integral part of the canvas; and in this way the picture would be more lasting."[121]

In 1898 one of Alexander's paintings hung in the first exhibition of the International Society of Sculptors, Painters and Gravers in London, for which Whistler served as president. That same year, *Portrait gris* followed Whistler's portrait of his mother into the Musée du Luxembourg.[122] Alexander, whom J. Walker McSpadden called "the painter of the flowing line," continued to embrace a Whistlerian aesthetic throughout his career.[123] —*LTJ*

FIG 92 James McNeill Whistler (1834–1903), *Mother of Pearl and Silver: The Andalusian*, 1888–1900, oil on canvas, 83⅝ × 43¼ inches, National Gallery of Art, Washington, D.C., Harris Whittemore Collection.

17 CECILIA BEAUX, 1855–1942
Les Derniers jours d'enfance
(The Last Days of Infancy), 1883–1885

Oil on canvas, 46 × 54 inches
Pennsylvania Academy of the Fine Arts, Philadelphia
Gift of Cecilia Drinker Saltonstall, 1989.21

BORN IN PHILADELPHIA TO A FRENCH FATHER
and a mother of old New England stock who died at an
early age, Beaux (fig. 93) was raised by a circle of artistic
women relatives. After a period of private study, she en-
rolled in 1876 in classes at the Pennsylvania Academy of
the Fine Arts, an institution with which she maintained a
fruitful relationship throughout her life. From 1879, Beaux
regularly contributed works to the Academy's annual exhi-
bitions, winning prizes and garnering critical acclaim. In
1895, she became the first woman instructor in the Acad-
emy's school, a position she held until 1916. By that time,
Beaux's reputation as one of the preeminent portrait paint-
ers in America was secure.[124]

Les Derniers jours d'enfance, produced under the private
tutelage of William Sartain (1843–1924), marked Beaux's
debut as an ambitious young artist and single-handedly
launched her professional career. The work was exhibited
in the Academy's 1885 annual, where it received the Mary
Smith Prize for the best painting by a "woman resident of
Philadelphia."[125] A significant accomplishment for a young
artist with little experience working on such a scale (Beaux
had previously shown only drawings and china paintings
in the institution's annuals), the work received accolades
from the Academy instructor Thomas Anshutz (1891–1912)
and so impressed Beaux's artist-colleague Margaret Lesley
(1857–1944) that the latter successfully entered it in the
Paris Salon of 1887. The auspicious reception made clear
to Beaux, as she later recounted in her autobiography, that
she had turned "a very sharp corner . . . into a new world
which was to be continuously mine."[126]

This double portrait of the artist's sister Etta (1852–1939)
and her nephew Henry Sandwith Drinker (1880–1965)
reveals Beaux's Philadelphia realist training in its solidly
rendered figures and muted palette—an aesthetic shaped
broadly by Thomas Eakins (see cat. 36), specifically by
Sartain. The painting also suggests, in both form and con-
tent, the direct influence of Whistler's *Arrangement in Grey
and Black, No. 1: Portrait of the Painter's Mother* (see fig. 5).
Beaux would have seen the famous work in the special ex-
hibition *American Artists at Home and in Europe* held in the
Academy's galleries in the fall of 1881. Her central focus on
the relationship between a mother and son (merely implied
in Whistler's image through his own etching on the wall)

FIG 93 Cecilia Beaux in her studio, ca. 1885, Pennsylvania Academy of the Fine Arts Archives, Philadelphia.

as well as her use of a (semi-)profile pose, asymmetrical placement of objects, and attention to limited tonalities all indicate a conscious and creative reworking of Whistler's painting. Curiously, Beaux never admitted to the influence and even denied it outright when the source was suggested by others, revealing her healthy ego and perhaps her sensitivity to Whistler's presence in the international portrait market in which she, along with John Singer Sargent (see cats. 56–57), competed at the turn of the century.[127]

In light of Beaux's earlier experience with Aesthetic design, one can assume her familiarity with and interest in Whistler, whose profile as an "advanced" artist was rising in America in the 1880s. Like Whistler's portrait of his mother, *Les Dernier jours* is highly contrived in its stagelike setting. Decades later, Beaux recounted the complicated development of the work, from a small compositional oil study to the construction of suitable space in her studio for the intended tableau. Family heirlooms—from table to carpet to clothing—along with artist-designed materials gave the work both personal resonance and imaginative flair. The paneling, acquired from a carpenter's shop and stained by Beaux to look like mahogany, suggests her keen sensitivity to aesthetic effect, though one lacking the overall severity of Whistler's formal purpose. Nevertheless, her description of *Les Derniers jours* as a "landscape in form" suggests an allusion to the abstract qualities of his art.[128]

The most significant difference between Beaux's wistful image of maternal devotion and Whistler's more sober treatment seems to lie in the realm of sentiment. Beaux's painting is typically viewed as employing the conventional trope of Victorian womanhood, while Whistler's is said to challenge it. In fact, it is possible to read ambivalence in both pictures. The air of longing in *Les Dernier jours*— manifest in the gazes of young Henry and Etta—may be interpreted as expressing Beaux's own complicated feelings toward motherhood. Whistler's Mother bears the trace of a similar tension, despite the artist's emphasis on the purely formal meaning of the painting. In effect, both artists, through their chosen titles, presented their works as something more than portraits. Whistler's picture was praised by contemporary critics for its "powerful grasp of the Protestant character"[129]—a fitting expression of his mother's devout Christianity—while Beaux's was interpreted not as a family portrait but as a more universal statement about a particular stage of childhood and the complex changes that accompany it.

Whistler continued to exert an influence on Beaux's work throughout her career—whether through the use of her favorite profile pose, as in *A Little Girl: Portrait of Fanny Travis Cochran* (1887, Pennsylvania Academy of the Fine Arts); color harmonies and decorative details, as in *Mother and Daughter* (1898, Pennsylvania Academy of the Fine Arts); or both, as in *New England Woman* (fig. 94). —SY

FIG 94 Cecilia Beaux (1855–1942), *New England Woman*, 1895, oil on canvas, 43 × 24¼ inches, Pennsylvania Academy of the Fine Arts, Philadelphia, Joseph E. Temple Fund, 1896.1.

18 | EDWARD AUGUST BELL, 1862–1953
Lady in Gray, 1889

Oil on canvas, 76⅛ × 49½ inches
Memphis Brooks Museum of Art, Memphis, Tennessee
Gift of the artist, 33.1

EDWARD A. BELL STUDIED AT THE ART STUDENTS League and at the National Academy of Design in New York. Among his first teachers was William Merritt Chase (see cats. 22–28), the leading proponent of the Whistlerian aesthetic in the United States. Following in Chase's footsteps, Bell left New York in order to attend the Royal Academy in Munich, where he studied with the realist painter Ludwig von Loefftz (1845–1910).[130]

The keynote of Bell's international career is the subtly modeled *Lady in Gray.* The sitter was a seventeen-year-old student at the Conservatory of Music who became a successful concert singer but was killed during rioting in Munich following World War I.[131] Bell's portrait won a silver medal at the Royal Academy in Munich in 1889 before traveling to the Paris Exposition Universelle later that year. Over the next decade, *Lady in Gray* appeared in many of the important exhibitions of the day, including the Society of American Artists' exhibition in New York City in 1890 and the Chicago World's Columbian Exposition in 1893.

Like Whistler's famous *Symphony in White, No. 1: The White Girl* (cat. 1) and the host of imitations it inspired, the full-length *Lady in Gray* depicts a young woman standing on a fur rug in front of a pale curtain. Bell had probably seen Whistler's *White Girl* in New York in 1881 and his most famous "gray" painting, *Arrangement in Grey and Black, No. 1: Portrait of the Painter's Mother* (see fig. 5), at the Munich Royal Academy in 1888.[132] With a restrained, neutral palette, Bell skillfully met the Whistlerian challenge of painting within a limited tonal range. The title of his portrait, like that of John White Alexander's *Portrait gris* (cat. 16), derives from the dominant color scheme, the preferred gray tones of Whistler's recent work. *Lady in Gray* accorded Bell international accolades and aligned him with what one American critic called "the 'color arrangement' theory of portraiture."[133] "The charm of [the portrait]," Bell later recalled, "lies in the color."[134] —*LTJ*

19 | ROBERT FREDERICK BLUM, 1857–1903
Venetian Gondoliers, ca. 1880–1889

Oil on canvas, 18½ × 28½ inches
Private collection

ROBERT BLUM TRAVELED TO VENICE FOR THE first time in 1880. A Cincinnati native and a former student of Frank Duveneck, he was immediately welcomed into the circle of "Duveneck Boys." Together with his fellow American artists, Blum stayed in the Casa Jankovitz where Whistler, too, settled for a few months. Blum's sketches from Venice include a pencil drawing of Whistler seen from the rear (see fig. 33) presumably sketched as Whistler worked on an etching from the window of Blum's rented room.[135] In a nod to Whistler's Peacock Room (1876–1877, Freer Gallery of Art), Blum later decorated his Sherwood Building studio in New York in Aesthetic fashion, with green and gold walls painted with peacock-feather motifs.[136]

Blum's encounter with the American expatriate and his experience with the work of the Spanish artist Mariano Fortuny (1838–1874) were the two lasting influences on his career. "Good pictures," he once wrote, "are the best lessons you can get."[137] During the next decade, in pastels, paintings, etchings, and watercolors, Blum portrayed many of the same Venetian subjects that Whistler had embraced: bridges, palaces, canals, bead stringers, and the city at night. A great admirer of Japanese art and culture, Blum shared with Whistler an interest in the asymmetry of Japanese design; he would later travel to Japan as an illustrator for *Scribner's Magazine.*

Venetian Gondoliers, one of Blum's few extant Venetian oil paintings from the 1880s, does not appear to have been exhibited during the artist's lifetime. But when Blum's watercolors from Venice made their first public appearance in 1881 at the American Water Color Society's annual show, critics immediately noted their relationship to Whistler's work. Clarence Cook, for one, called some of Blum's watercolors "simply and purely tinted Whistler etchings."[138] A few years later, upon seeing Blum's pastels, the critic for the *New York Times* concluded, "Mr. Robert Blum rivals Whistler in his ability to give the moods of Venice."[139] In contrast to his major exhibition pictures *Venetian Lace Makers* (1887, Cincinnati Art Museum) and *Venetian Bead Stringers* (1887–1888, private collection), which depict the colorful costumes and activities of Venetian women in focused detail, *Venetian Gondoliers* presents an evocative Whistlerian arrangement: a simplified, less detailed composition in a restrained palette dominated by blue-green tones. As in Whistler's cityscapes and Nocturnes, the figures in Blum's painting appear almost as afterthoughts to a subtle arrangement of harmonious color. —LTJ

20 | ELIZABETH LYMAN BOOTT (DUVENECK),
1846–1888
Little Lady Blanche, 1884

Oil on canvas, 57 × 39½ inches
The Louise and Alan Sellars Collection of Art by
American Women, Indianapolis, Indiana

ELIZABETH BOOTT, LATER DUVENECK, STUDIED
in Boston with William Morris Hunt (1824–1879) and
then in Paris with Thomas Couture (1815–1879). Her
mother had died when she was less than two years old,
and "Lizzie" was raised in a villa near Florence by her
father, a composer. Boott completed her studies with
Frank Duveneck in Munich and then convinced her
teacher to begin a women's class in Florence in the fall
of 1879. After an extended courtship, the two artists mar-
ried in 1886.[140] Although there is no evidence that Boott
ever met Whistler, she would certainly have known about
him through Duveneck, who had lived in the Casa Jan-
kovitz with Whistler in Venice in 1880.

Little Lady Blanche belongs to the group of paintings
inspired by Whistler's *Symphony in White, No. 1: The White
Girl* (cat. 1), which Boott could have seen in New York
after her return to the United States in 1881.[141] Boott's por-
trait takes the subject of Whistler's famous painting, a
young girl dressed in a long white gown standing on a fur
rug before a white curtain. Boott's sitter, like Whistler's,
holds flowers loosely in her hand while others appear to
have fallen at her feet. The title of Boott's painting, with
its use of the French word for white, makes it doubly clear
that the work was painted in response to Whistler's proto-
type. Yet Lady Blanche is a far cry from Whistler's Irish
mistress, Joanna Hiffernan, the red-headed woman of *The
White Girl.* The wholesome American child in Boott's
painting appears in a "quaint, old-fashioned dress" with a
lace collar, pink satin bow, and coordinating bonnet—the
picture of innocence, as though to parody the worldly
Whistler painting that had once scandalized Europe.[142] For
American critics, the predominantly white-on-white color
scheme was the most distinctive and unconventional ele-
ment of Boott's painting, which one linked to Whistler by
calling it an "arrangement in white."[143] —*LTJ*

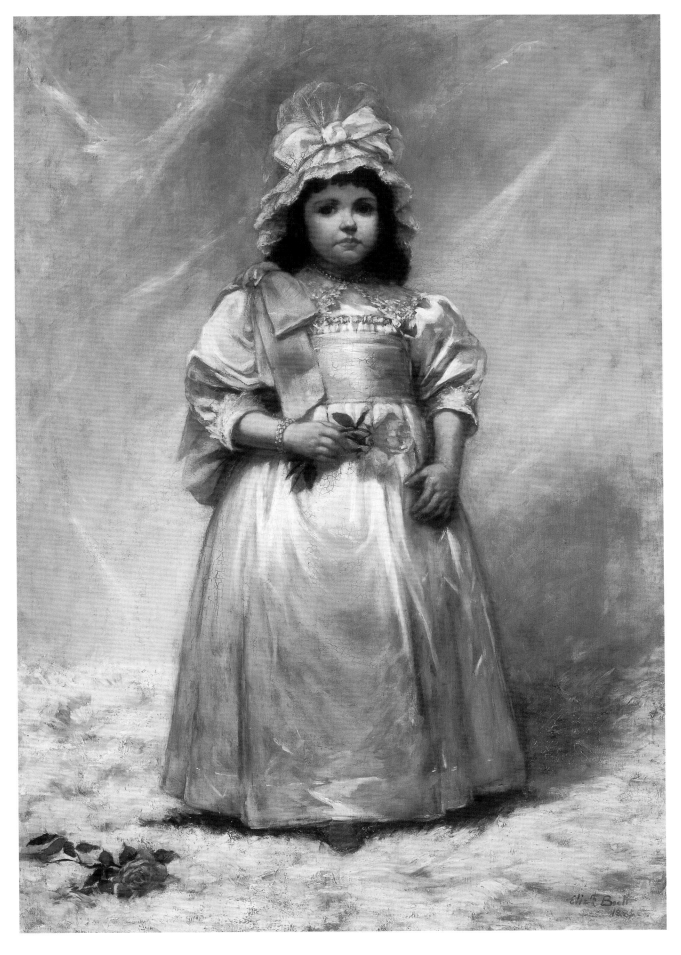

THEODORE EARL BUTLER, 1861–1936
Fireworks, No. 1, 1906

Oil on canvas, 23¼ × 28¾ inches
Kristy Stubbs Gallery, Dallas, Texas

THEODORE BUTLER STUDIED AT THE ART
Students League in New York for four years before leav-
ing the United States to continue his studies in Paris in
1887. The following summer, Butler traveled for the first
time to the small French town of Giverny, where Claude
Monet (1840–1926) had settled. Giverny, a rural retreat
outside Paris, would soon become a popular destination for
American Impressionist painters. Butler, among the first
of the Americans to visit Monet, was one of the few allowed
to enter the French Impressionist's intimate circle. In 1892
he married Monet's stepdaughter Suzanne Hoschedé-
Monet and settled in Giverny, where he remained until
his death in 1936.[144]

FIG 95 Claude Monet (French, 1840–1926), *Waterloo Bridge*, 1900, oil on canvas,
25¾ × 36½ inches, Santa Barbara Museum of Art, California, bequest of Katherine
Dexter McCormick in memory of her husband, Stanley McCormick.

Butler revealed his admiration for Whistler in letters
to his friend and colleague Philip L. Hale (1865–1931).
He described Whistler's *Arrangement in Black and Gold:
Comte Robert de Montesquiou-Fezensac* (see fig. 73) as full of
"simplicity and character"—the best work at the Champ-
de-Mars Salon in 1894. Several years later, upon seeing
Whistler's portrait of his mother at the Musée du Luxem-
bourg, he observed that the painting was as "calm and
fine as ever."[145]

Fireworks, No. 1 is one of a group of paintings that may
have been inspired by the celebration of Bastille Day at
the town of Vernon, a short walk from Giverny. *Fireworks,
Vernon Bridge* (1908, private collection) and *Night Reflections*
(1906, private collection) also depict the view across the
Seine at night with light reflected in vertical bands across
the water.[146]

Monet's foggy views of the Thames, such as *Waterloo
Bridge* (fig. 95), surely inspired Butler's work of this
period. In those London scenes, Monet's broken brush-
work captures the reflective waters of the Thames within
tonally unified compositions. Whistler's Nocturnes were
precedents for Monet's London scenes, and it is likely
that Butler discussed Whistler's paintings with his French
mentor.[147] Butler would have seen Whistler's Nocturnes
for himself in 1905, when he attended the large memorial
retrospective of the artist's work at the Ecole des Beaux-
Arts in Paris.[148] Among the nighttime views on display
were two of Whistler's fireworks subjects, *Nocturne in Black
and Gold: The Falling Rocket* (cat. 7) and *Nocturne: Black and
Gold—The Fire Wheel* (see fig. 12). Butler's own fireworks
nocturne, painted the following year, depicts the shimmer-
ing vagueness of the river at night in a palette of blue, high-
lighted with pink and yellow reflections. —*LTJ*

Oil on canvas, 62½ × 65⅛ inches
The Cleveland Museum of Art, Ohio
Gift of Mrs. Boudinot Keith in memory of
Mr. and Mrs. J. H. Wade, 1921.1239

THE MOST VOCAL ADVOCATE OF WHISTLERIAN aestheticism in the United States, William Merritt Chase disseminated the notion of "art for art's sake" to a generation of students at the Art Students League, the Chase School of Art, and the Shinnecock School of Art. Near the end of his career, he lectured extensively on the expatriate artist, praising him as "one of the *greatest* masters of this time."[149]

A Midwesterner by birth, Chase studied art first in Indianapolis, then in New York at the National Academy of Design. A group of patrons in St. Louis paid the young artist's way to continue his studies at the Royal Academy in Munich from 1872 until 1877. Under the tutelage of Karl von Piloty (1826–1886), Chase developed a rapid painting style that captured the appearance of light and texture. Sending his paintings to exhibitions in the United States, Chase established his reputation as an American artist while still living abroad. In 1877 he traveled to Venice with his Munich colleagues Frank Duveneck and John Twachtman (see cat. 63); the next year he returned to the United States and accepted a teaching position at the newly formed Art Students League in New York.

Although he did not meet Whistler until the summer of 1885, Chase's admiration for Whistler's work began much earlier. As a member of the Exhibition Committee of 1882, Chase played a key role in the display of Whistler's famous *Arrangement in Grey and Black, No. 1: Portrait of the Painter's Mother* (see fig. 5) at the Society of American Artists' exhibition that year.[150] "Of all the art work that I have seen in France," Chase later proclaimed, "there is no modern picture which would not suffer by comparison, were it hung among the canvases of Velázquez—with a single exception . . . that splendid painting in the Luxembourg, the portrait of his mother, by James McNeill Whistler."[151]

The year after Whistler's portrait of his mother appeared in New York, Chase exhibited his portrait of Dora Wheeler, later Keith (1856–1940). Best known today for her children's book illustrations, Wheeler was Chase's most promising pupil. She had been taking private lessons at his studio since 1879 and appeared to be on the brink of a successful career.[152] In Chase's portrait she sits, like Whistler's mother, facing left, but turns toward her teacher with an alert and thoughtful gaze. A luxurious wall hanging that

may have been partly inspired by a Venetian tapestry in Chase's studio (fig. 96) makes a fitting backdrop for Wheeler, whose mother, Candace Wheeler (1827–1923), directed the decorative textile firm Associated Artists.[153] An unusual circular motif at the top left portion of the painting serves as Chase's signature in the same way that Whistler signed his portrait with a schematic version of a butterfly. Chase devised his emblem as one feline creature "chasing" another.[154]

Recognizing the importance of foreign honors to an American artist's career, Chase first exhibited *Dora Wheeler* at the Paris Salon of 1883, where Whistler's portrait of his mother also made its Parisian debut.[155] Later exhibited in New York, the painting met with a cool reception: to contemporary eyes, Chase's portrait of Wheeler appeared to hide the sitter within the decorative scheme, to make her incidental to the display of the artist's virtuoso brushwork.[156] Chase's palette is dominated by vibrant blues and yellows, yet with these color choices he answered the Whistlerian challenge of painting in a scheme of tonal gradations. For American audiences, the yellow-on-yellow elements of the arrangement, such as the daffodils in front of the yellow wall hanging, might have called to mind Whistler's exhibition *Arrangement in White and Yellow*, which had opened in New York City in the fall of 1883, complete with white walls, yellow moldings, yellow and white roses, and yellow velvet drapes.[157] The following spring, one critic aptly described the Society of American Artists' exhibition, in which *Dora Wheeler* held a prominent place, as "a symphony in the key of—Chase."[158]

—LTJ

FIG 96 William Merritt Chase in his studio, Shinnecock Hills, ca. 1896, The William Merritt Chase Archives, The Parrish Art Museum, Southampton, New York, gift of Jackson Chase Storm, 83.Stm.21.

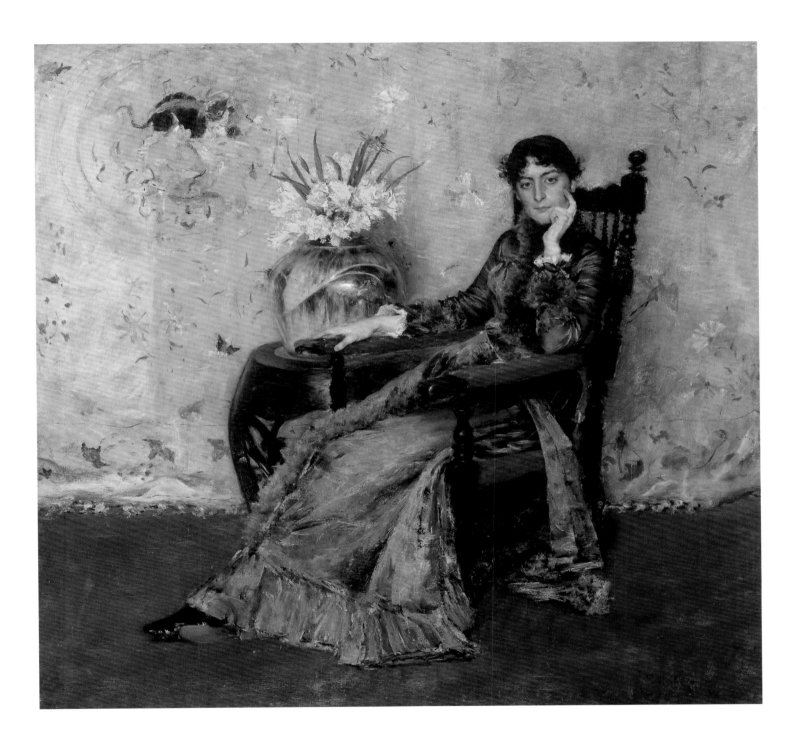

23 | WILLIAM MERRITT CHASE, 1849–1916
At Her Ease, ca. 1884

Oil on canvas, 44 × 42 inches
National Academy of Design, New York, 221-P

"BE LIKE A SPONGE, READY TO ABSORB ALL YOU can," Chase urged his students. "I have never been so foolish and foolhardy as to refrain from stealing for fear I should be considered as not 'original.' Originality is found in the greatest composite which you can bring together."[159] *At Her Ease* is Chase's second "composite," or reworking, of Whistler's portrait of his mother (see fig. 5) following its appearance at the 1882 Society of American Artists exhibition.[160] Chase would have seen Whistler's famous painting again at the Paris Salon of 1883, where his own *Dora Wheeler* (cat. 22) received an honorable mention.

All three compositions are nearly square, a shape that emphasizes the two-dimensionality of the painted surface rather than the illusion of depth. In *At Her Ease,* Chase again borrowed the format of a woman seated, facing left, in a shallow foreground space. This young woman, dressed in black, holds a handkerchief in her lap, as does Whistler's mother, but in many respects presents a contrast to the aged, humble figure in Whistler's painting. Chase's model takes a languid, almost seductive pose, unlike the neatly poised, uncommunicative figure of Whistler's mother, and the warm red tones of the painting create an atmosphere of charged emotion despite her apparent idleness. In its simplified composition, sharply restricted color scheme, and thinly painted surface, however, *At Her Ease* closely resembles the Whistlerian prototype.[161] The asymmetrical arrangement of forms leaves open the top left portion of the composition, where Whistler's portrait of his mother includes the image of a framed print (Whistler's own *Black Lion Wharf*) hanging on the wall. In *At Her Ease,* Chase placed in that space an unusual circular form, conjoining ovals in red tones—perhaps another emblematic signature, an abstract version of the feline forms in the portrait of Dora Wheeler.

Chase chose to show *At Her Ease* for the first time at the inaugural exhibition of the international avant-garde group La Société des Vingt in Brussels in 1884.[162] The critic Emile Verhaeren called it "exquisite," especially in comparison to another predominantly "red" portrait in the exhibition, John Singer Sargent's *Dr. Pozzi at Home* (1881, UCLA Hammer Museum).[163] —LTJ

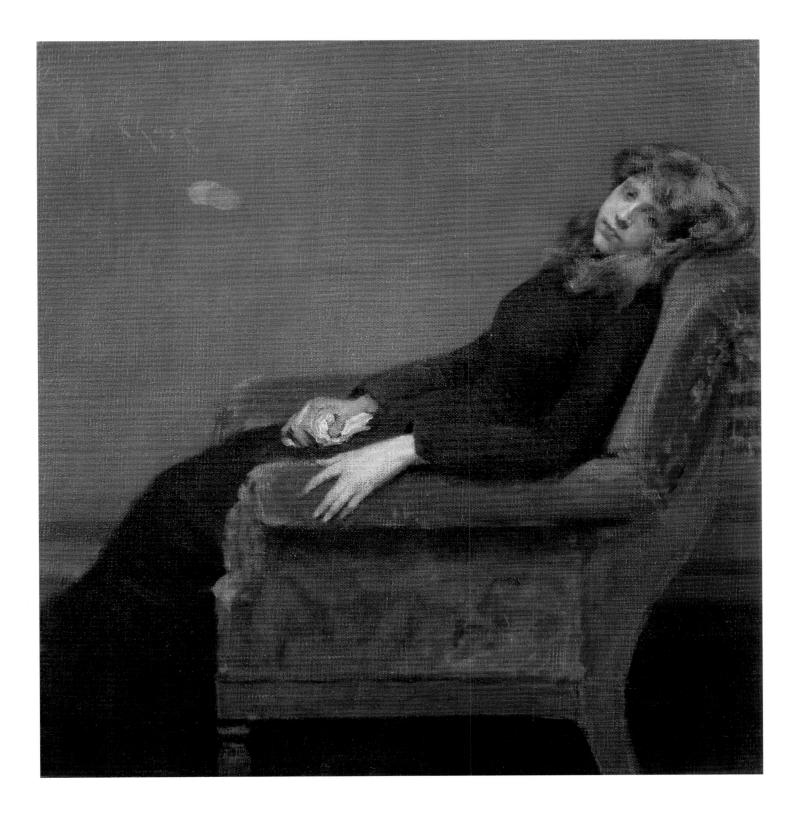

James Abbott McNeill Whistler, 1885

Oil on canvas, 74⅛ × 36¼ inches
The Metropolitan Museum of Art, New York
Bequest of William H. Walker, 1918, 18.22.2

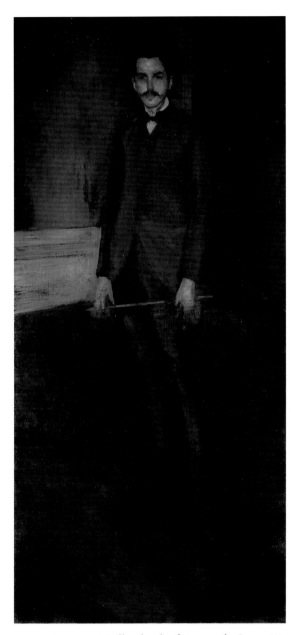

FIG 97 James McNeill Whistler (1834–1903), *George W. Vanderbilt*, 1897–1903, oil on canvas, 82⅛ × 35⅞ inches, National Gallery of Art, Washington, D.C., gift of Edith Stuyvesant Gerry.

CHASE'S PORTRAIT OF WHISTLER HAS ALWAYS stood beneath of cloud of misapprehension and the suspicion of malice. A prominent inscription in the upper left-hand corner dedicates the work "To my friend Whistler" and places its production in 1885, when the artists spent several weeks together in London. The friendship did not survive beyond that summer, however, and it has generally been assumed that Chase's portrait was the cause of its demise. Taking their cue from Whistler, who decried the work as "a monstrous lampoon," the artists' contemporaries tended to regard it as a caricature, all the crueler for its amiable inscription.

According to Chase, the portrait had been Whistler's idea: he persuaded Chase to extend his stay in London with the suggestion that they take turns painting each other's portraits.[164] A letter that Chase wrote to Whistler at the end of the summer, however, implies that he had invited Whistler to paint his portrait,[165] and although he later insisted that neither work was commissioned and that both were carried out "for the mere pleasure of the practice," Chase did pay Whistler thirty pounds (which were returned when Whistler failed to complete the portrait to his satisfaction).[166] This may explain why Whistler began his work first. One month later, the full-length portrait was nearly complete, or so Chase believed.[167] Although it does not survive,[168] a photograph of the portrait last seen in 1906 showed Chase wearing the stylish flat-brimmed top hat that Whistler so admired, in the debonair pose later assumed by George W. Vanderbilt (fig. 97), standing and holding a cane across his legs.[169] Whistler, then, portrayed Chase not as a hardworking professional, but as a man-about-town.

Chase's portrait of Whistler was "getting on well" by early August[170] and similarly represented the artist in his public guise, striking a self-consciously theatrical pose that emphasized the elegant cut of his costume and the proud assurance of his manner. Chase never refers to it directly in "The Two Whistlers," his memoir of 1910, but the narrative makes clear that he had intentionally portrayed "Whistler in public"—"a dainty, sprightly little man, immaculate in spotless linen and perfect-fitting broadcloth," who "carried his wand poised lightly in his hand" and sported a "slight imperial," a waxed mustache, and a monocle.[171] In the portrait, Whistler is not wearing a hat, which would have hidden his trademark tuft of white hair; otherwise, it closely corresponds to his dapper image in a photograph taken that same summer (fig. 98), in which he appears overdressed for an afternoon stroll in the park.

Chase's portrait flatters Whistler by depicting him from a low vantage point that makes the lines of his figure appear longer than they actually were—a typical Whistlerian

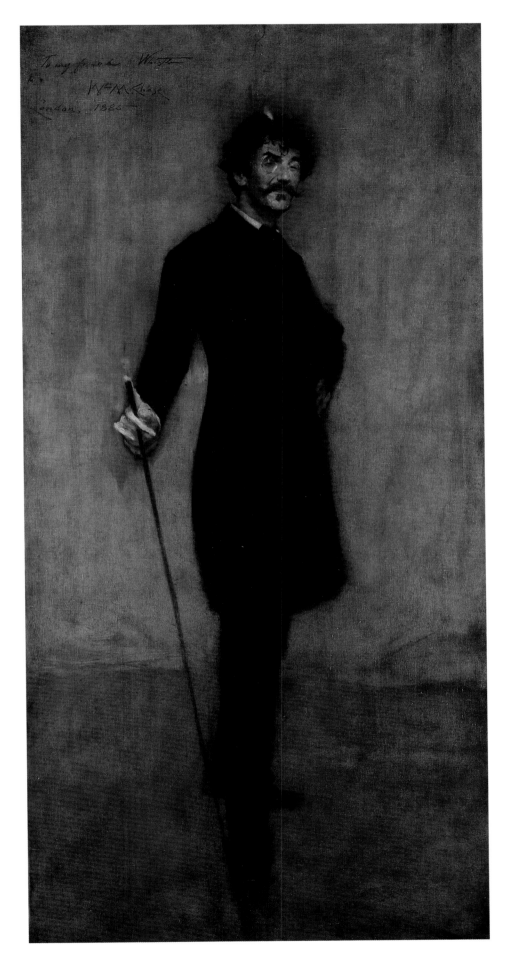

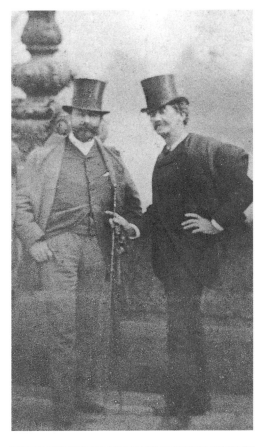

FIG 98 William Merritt Chase (left) and James McNeill Whistler, 1885, The William Merritt Chase Archives, The Parrish Art Museum, Southampton, New York, gift of Jackson Chase Storm, 89Stm.2.

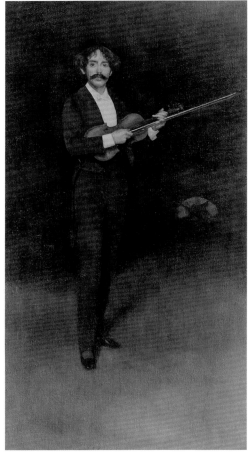

FIG 99 Photograph after Whistler, *Arrangement in Black: Pablo de Sarasate*, ca. 1885, silver gelatin print, Glasgow University Library, Department of Special Collections, Scotland. A copy of this photograph was shown in the exhibition of the Society of British Artists, London, 1885.

device. He also painted thinly and broadly in the somber, restricted palette that Whistler favored for portraits in that period. As Ronald Pisano pointed out, it was common practice for Munich-trained painters to portray their colleagues in their own distinctive styles as a way of demonstrating technical ability.[172] Chase was simply showing off his mastery of the methods he had learned that year from the artist.

Though already acquainted with Whistler's art when he arrived in London, Chase was urged to see as many of Whistler's works as possible.[173] The portrait he would have had the opportunity to study most closely and to discuss at length with its author was *Arrangement in Black: Pablo de Sarasate* (see fig. 18), which was on display in the Society of British Artists' exhibition; Whistler was so intent on its popular success that he advertised it at the entrance with a photographic reproduction that was available for purchase (fig. 99).[174] The famous virtuoso violinist was small and slight, with delicate features, dark hair, and a graceful demeanor; his portrait calls to mind the aspect of Whistler himself as he stood alone, elegant in evening dress on a darkened stage, to deliver the "Ten O'Clock" lecture in February 1885. Although Chase had not been present on that occasion, he had undoubtedly heard about Whistler's bravura performance and must have seized upon the similarity. In his portrait, Whistler strikes the same stance as Sarasate, as though about to play an instrument, creating a vibrant presence that enlivens the vacant setting.[175]

If conceived as a student exercise, the portrait seems to have gained importance as it progressed. In August, Chase predicted that it would be "the best thing" he had ever done, and Whistler seems also to have approved of it, since he employed the idiosyncratic vocabulary he used for his own works to describe Chase's painting not as a portrait, but as an "impression of Whistler with his wand."[176] He is said to have shown it proudly to his friends, claiming never to have posed for any other portrait (though he had already been the subject of countless caricatures), an irrefutable sign of his confidence in Chase's ability.[177] Whistler also became enamored of his portrait of Chase, who tells of the artist standing back from the canvas to exclaim over the beauty of his work.[178] At some point, the artists hit upon the idea of exhibiting the pair in the United States as pendants; Chase would take them home with him to New York City, and Whistler would follow within the year.[179]

Both artists seem to have considered their works complete when they left London for an excursion to Holland in August, but when Whistler returned in early September he decided that his was not yet in "perfect condition"—

and, for some reason, that Chase's wasn't either. "Neither master is really quite fit for public presentation as he stands on canvas at this moment," Whistler wrote. "So we must reserve them, screening them from the eye of jealous mortals on both sides of the Atlantic until they burst upon the painters in the swagger of completeness." (The operative word is "swagger," which suggests the attitude of both artists' portraits.) He proposed to keep his until he could complete it in New York, when he would pose again as well, he promised, so that Chase could "finish the 'pendant'— my artless self."[180] Concerned that the portrait was causing Whistler vexation, Chase implored his friend to abandon it altogether "and forget that it was ever begun."[181] In the end, that is exactly what Whistler did.

A year passed, and Chase honored Whistler's request by refraining from exhibiting his portrait of the artist. But in mid-October 1886, the *New York Tribune* published a letter from Whistler referring to "Chase's monstrous lampoon": "How dared he—Chase—do this wicked thing? And I, who was charming and made him beautiful on canvass, the masher of the avenues?"[182] It has generally been assumed that Whistler's letter was prompted by a negative report in the press, but that seems unlikely since the portrait had yet to be exhibited. Possibly some "jealous mortal"—even the unnamed "friend" to whom Whistler wrote his letter—had seen the portrait in Chase's studio and dispatched a venomous report to London. Or perhaps, as one scholar has suggested, Whistler's words in this private communication were meant in jest.[183] Chase took them seriously, however, and assumed that Whistler had consigned him to the ever-growing ranks of his enemies, though he was never quite sure why.[184] Presumably convinced that he had nothing to lose, Chase displayed the maligned portrait one month later in his first solo exhibition at the Boston Art Club.

Whistler's remarks had set the tone for the critical response. "All the eccentricity of person and bearing that one hears of in relation to Whistler is here so broadly accentuated that it is hard to take even the artist's word for it that it is not a caricature," one critic wrote, implying that he had questioned Chase about his motives, and concluded that the portrait was "woefully suggestive of a spice of malice on the part of the painter." One problem was that it appeared to treat a serious subject frivolously:

> Whistler is a man of large, subtle and varied intellectual powers, and the foremost etcher of his generation, with certainly more art resources in brain and at fingertips than any man in England to-day. But there is nothing of this indicated here.

He looks like a finical, half-decayed old fop, with a good deal of the petit maître of the old school suggesting itself.[185]

In England, where Whistler's stylish persona was familiar, Chase's portrait might have been received as the clever likeness that it was; but in the United States, where Whistler was known more by his ever-growing reputation, it was taken as a burlesque. One critic, however, writing for *The Art Amateur* after the portrait's appearance at Moore's Gallery in New York during the spring of 1887, remarked that "at first sight the picture certainly does look like a caricature of Whistler's person, as well as of his method, but those who know the eccentric genius will recognize it to be the truth—the harsh truth—neither more nor less."[186]

Chase himself never publicly defended his position and referred to the portrait only obliquely in "The Two Whistlers." "Among those who knew him well," he wrote (presumably including himself in that category), "Whistler made no pretense at concealing the fact that his public life was a deliberate pose. At home he doffed his mask completely. Why, then, the question naturally arises, should he bring home with him his quarrelsome spirit? Why did he choose also to war with his friends?"[187] Perhaps Chase had captured Whistler's public pose too accurately for comfort. When Whistler saw the portrait again in 1891, at an exhibition in Paris of American paintings, he wrote to his wife of "that horrible 'lampoon' of Chase's—Shocking—I told them so."[188] By then, Whistler's reputation as an American master was firmly established, making the harmless affectations preserved in the portrait appear more exaggerated and disrespectful than ever.

Despite the continuing controversy, Chase never repudiated the portrait. He may have originally intended to present it as a gift to Whistler—which would explain the prominent dedication—but in the end he kept it with him most of his life and only sold it (to William Hall Walker, a noted philanthropist said to be "a great admirer of Whistler's") on the condition that it eventually be given to The Metropolitan Museum of Art.[189] When this came to pass in 1917, Joseph Pennell called for a public protest, condemning the work as "vile as art and abominable as a portrait."[190] The artist Max Weber concurred, describing it as "a bare, naked pin floating in the firmament, flirting with the laws of gravity."[191] Weber's complaint, of course, encompassed Whistler's style as well, which by then looked hopelessly old-fashioned, and implicated the many American artists who, like Chase, had emulated his example. —*LM*

25 | WILLIAM MERRITT CHASE, 1849–1916
Seascape, 1888

Oil on panel, 6⅜ × 9⅜ inches
Mr. and Mrs. Allen P. McDaniel

WORKING MORE FREQUENTLY IN THE OUTDOORS during the mid-1880s, Chase began to produce small-scale landscapes in the areas outside New York City. Several art critics at the time were calling on the younger generation of artists, most of whom had been trained in Europe, to depict American subjects. Following that directive, Chase found his first American views in Brooklyn and resorts off the New York coast such as Coney Island.[192]

Seascape is a tiny panel that would have been easily portable for Chase's early experiments in outdoor painting; the format resembles that of Whistler's Notes, small paintings with simplified, sketchlike compositions and limited color schemes. During the summer of 1885, Chase, with Whistler, had visited an exhibition in London where he would have seen a selection of Whistler's small seascapes from Holland and northern France (see cat. 11).[193]

Chase compared the process of painting landscapes to reproducing "something of the harmony which I see in nature."[194] This process led Chase, like Whistler, to compose views such as *Seascape* in a narrow range of tones with a few thoughtfully placed brushstrokes. "Have somebody's work in mind," Chase urged his students at the Shinnecock School of Art, where he taught outdoor landscape classes each summer from 1891 to 1902.[195] Perhaps he had Whistler's early views of London in mind when he proclaimed that the area around New York City held "every bit as good material as that on the banks of the Thames."[196] —LTJ

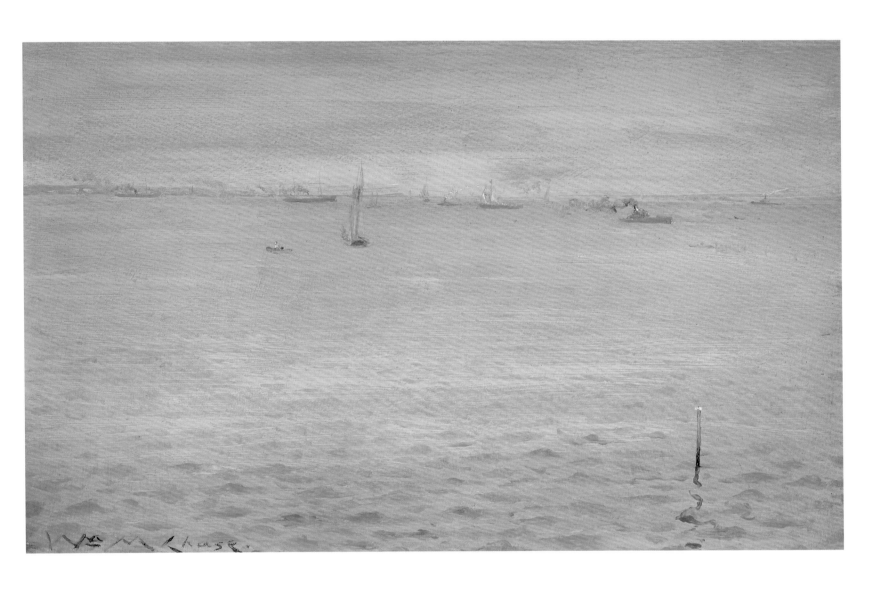

26 | WILLIAM MERRITT CHASE, 1849–1916
The Blue Kimono, ca. 1888

Oil on canvas, 57 × 44½ inches
The Parrish Art Museum, Southampton, New York
Littlejohn Collection, 1961.5.21

AT THE CHICAGO WORLD'S COLUMBIAN EXPO-
sition in 1893, Chase would have seen Whistler's *La Prin-
cesse du pays de la porcelaine* (see fig. 13), which inspired a
number of kimono scenes by American artists. In *The Blue
Kimono* an unknown sitter, perhaps Chase's wife, Alice,
or his sister, Hattie, appears in a blue Japanese kimono, a
costume that Chase used repeatedly during the 1890s.[197]
She sits in front of a gold folding screen holding a Japa-
nese fan in one hand and resting the other on a silk pillow.
Whistler played a key role in introducing American art-
ists to such East Asian accoutrements. *Purple and Rose:
The Lange Lijzen of the Six Marks* (cat. 2), another kimono
subject, features a woman wearing a Chinese robe and
gazing intently upon the Chinese porcelain in her hands.
Chase's subject, though surrounded by similar objects,
presents a more confident aspect, in keeping with her
frontal pose and the artist's more assertive style.

The Blue Kimono and Chase's other kimono pictures may
also have been inspired by the work of his close friend
Robert Blum (see cat. 19), who lived in Japan from 1890
to 1892, and by the paintings of Alfred Stevens (1823–1906),
which Chase and Whistler had traveled to see in Antwerp.
Chase's embrace of Asian art was an important component
of his aesthetic and significantly influenced his students
and fellow American artists. By the 1890s, Chase, who
was considered an arbiter in matters of taste, had become
an inveterate collector as well; as early as 1879, one writer
had found that in Chase's studio, "Japanese hand-wrought
robes lie side by side with Venetian brocades and Spanish
velvets."[198] Chase filled his later studios, including his
famous Tenth Street one, with objects acquired on his
travels or purchased at Yamanaka's in New York, such as
kimonos, umbrellas, porcelains, books, and Japanese and
Chinese musical instruments.[199] Chase also collected
works by his colleagues, including several unidentified
compositions by Whistler.[200] —LTJ

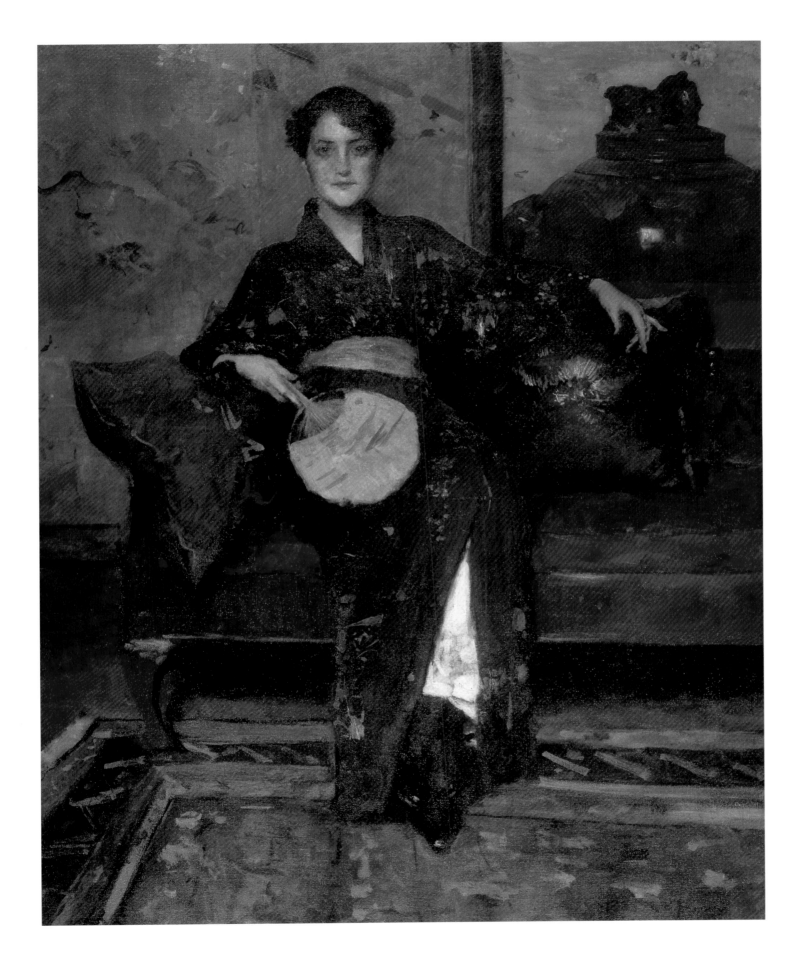

27 | WILLIAM MERRITT CHASE, 1849–1916
Lydia Field Emmet, ca. 1892

Oil on canvas, 71⅞ × 36¼ inches
Brooklyn Museum of Art, New York
Gift of the artist, 15.316

RECALLING THE LONG, NARROW FORMAT OF
Whistler's characteristically dark, shadowy portraits,
Lydia Field Emmet is an uncommissioned portrayal of one
of Chase's most capable students. It was exhibited at the
World's Columbian Exposition in Chicago in 1893, where
Emmet (1886–1952) won an award for mural work.[201] Chase's
portrait depicts the young woman in an unusual attitude,
her hand on her hip and her elbow to the viewer, that
specifically recalls the backward glance of Maud Franklin
in Whistler's *Arrangement in Black and Brown: The Fur Jacket*
(cat. 9). Chase shared with Whistler an admiration for
Dutch artists of the seventeenth century, who often used
a similar pose to suggest spontaneity, as if the sitter had
just turned to engage the viewer.[202]

At the Chicago exhibition, Whistler's *Fur Jacket* was
displayed on the same wall as Chase's portrait of Emmet.[203]
Although Chase could not have foreseen that placement
at the time he began work on his portrait, he may have had
a hand in determining the layout of the exhibition through
his role on the International Committee of Judges.[204] Chase
had seen *The Fur Jacket* for the first time in 1885 in London,
along with other works being held as surety against Whis-
tler's debts; at that time Chase unsuccessfully tried to pur-
chase the painting for an American collector.[205] Like *The
Fur Jacket, Lydia Field Emmet* depends upon a dark palette,
although Chase alleviated that somberness with a trailing
pink ribbon on the sitter's gown. The black dresses in both
portraits appear against black backgrounds devoid of fur-
nishings or other portrait props. In contrast to Whistler's
methods, however, Chase's style remains that of the vir-
tuoso technician, with a masterful, illusionistic representa-
tion of the lace cuffs and satin ribbons of Emmet's dress.
Rather than the ghostly appearance of Whistler's model
in *The Fur Jacket,* Emmet assumes an assertive, almost con-
frontational demeanor as she turns to look at her former
teacher. —LTJ

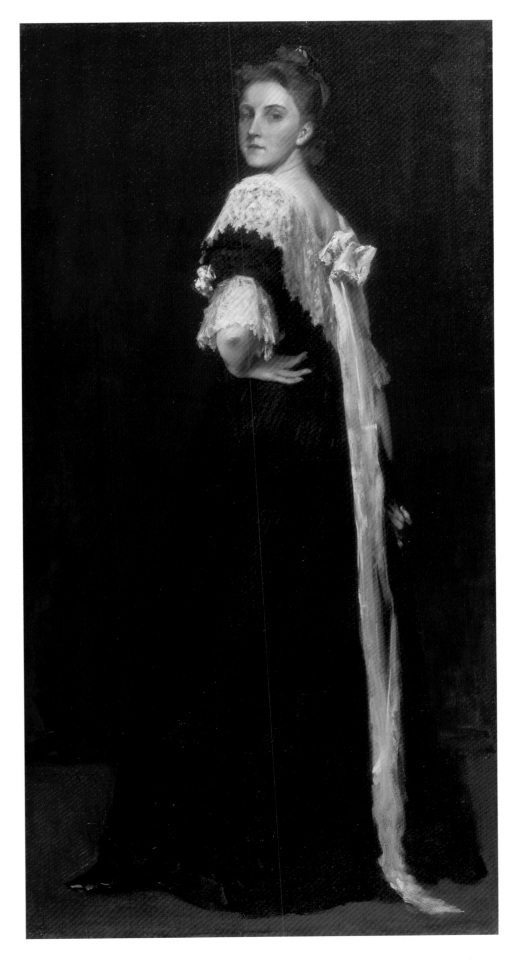

28 | WILLIAM MERRITT CHASE, 1849–1916
Artist's Daughter in Mother's Dress (Young Girl in Black), ca. 1897–1899

Oil on canvas, 60⅛ × 36³/₁₆ inches
Hirshhorn Museum and Sculpture Garden
Smithsonian Institution, Washington, D.C.
Gift of the Joseph H. Hirshhorn Foundation, 1966.887

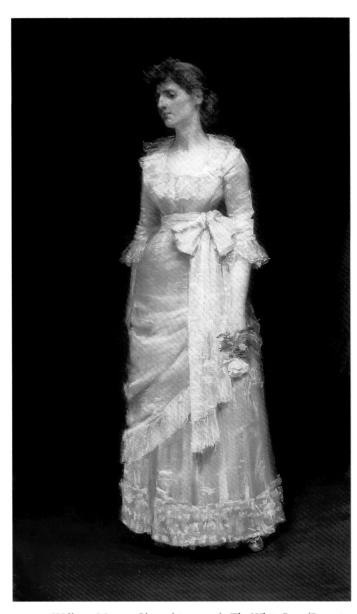

FIG 100 William Merritt Chase (1849–1916), *The White Rose (Portrait of Miss Jessup)*, 1886, pastel on paper and canvas, 69 × 39 inches, Phoenix Art Museum, Arizona, gift of Miss Margaret Mallory.

THE SOLEMN CHILD IN THIS PORTRAIT IS CHASE'S eldest daughter, Alice Dieudonnée (b. 1887), dressed up in her mother's clothes. She may have assumed the serious expression along with the costume, pretending to be one of the society ladies or professional models who customarily posed for her father. Because she is masquerading as a young woman, it is difficult to determine Alice's age—especially since Chase invariably made her look older than she was—but considering her apparent penchant for make-believe, it seems unlikely that she was much older than ten.[206] Alice is known to have strikingly resembled her mother, for whom she was named, and here Chase captures a poignant impression of his little girl grown up too soon, wearing an extravagant black hat that frames her pale features and disarming gaze.

When originally exhibited at the Society of American Artists in 1899, the painting showed Alice resting her left arm on a chair,[207] but Chase's subsequent revisions made the composition more closely resemble Whistler's *Symphony in White, No. 1: The White Girl* (cat. 1). Chase had probably seen that painting for the first time in New York in 1881. A pastel he produced a few years later, *The White Rose (Portrait of Miss Jessup)* (fig. 100), may be regarded as an early homage to Whistler's incalculably influential painting: the subject's pose approximates that of *The White Girl*, although the figure occupies the dark and vacant setting typical of Whistler's later works.[208]

Another indication of Chase's special admiration for *The White Girl* is that he joined J. Alden Weir (see cats. 65–67) to lobby for its purchase by The Metropolitan Museum of Art. The painting, however, slipped into private hands in 1896, and Chase's reinterpretation of the theme in *Artist's Daughter in Mother's Dress* may reflect his disappointment. In it, Chase adopts several of the salient characteristics of Whistler's painting—the nearly monochromatic color scheme, the lightly patterned background curtain, and the model's pose and weary expression, which belie her apparent youth and innocence. Intriguingly, however, Chase reverses the figure's position and shifts the key of his symphony to black, as though envisioning Whistler's *White Girl* in a dark mirror. —LM

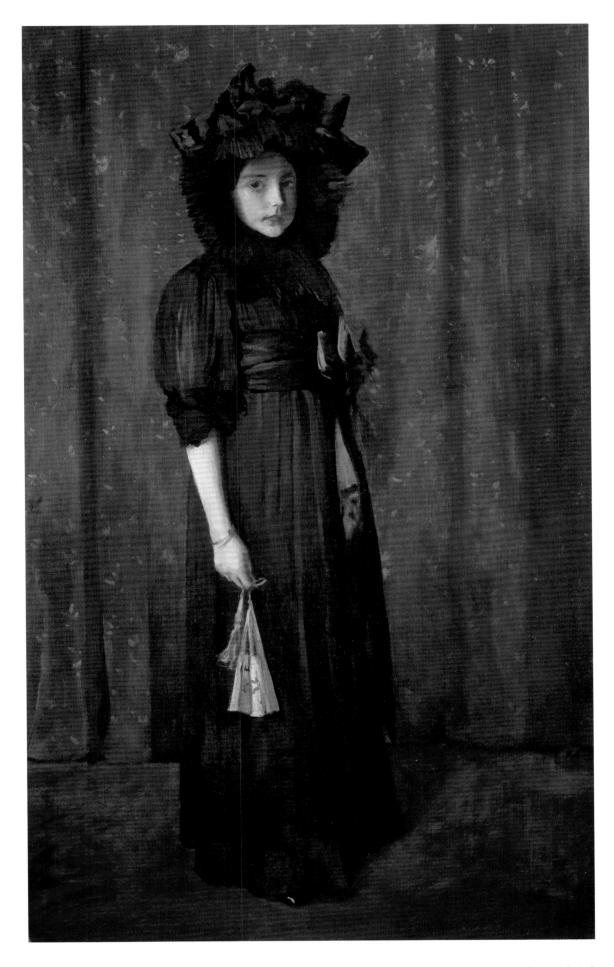

29 | EARL STETSON CRAWFORD, 1877–1965
Turquoise and Buff: Royan, 1899

Oil on panel, 4¾ × 8¾ inches
Fine Arts Museums of San Francisco, California
Museum purchase, Alletta McBean Paintings Acquisitions
Fund, Mary Zlot Fund, and Art Trust Fund, 1989.41

EARL STETSON CRAWFORD STUDIED IN PARIS
with Whistler at the Académie Carmen, in the same
building, 6, passage Stanislas, where he had his own stu-
dio. In his reminiscences about his experiences as Whis-
tler's pupil, Crawford claimed to have known another
side of the artist than the affected, eccentric figure that
Whistler struck in public—what he called "the gentler
side of Mr. Whistler." An unflinching admirer of his
teacher's work, Crawford defended him against detrac-
tors, asserting that Whistler's "ideal has always been to
paint 'the underneath-the-surface of things,' the essence
of the object rather than the object itself." Crawford
described Whistler's canvases as "poem-pictures" and
his Nocturnes as "perfect night poems."[209]

After a stint at the Pennsylvania Academy of the Fine
Arts, Crawford, a member of a prominent Philadelphia
family (his grandfather manufactured the Stetson hat),
enrolled in Whistler's academy by the fall of 1899.[210] He
patterned his work after that of his teacher, sometimes
signing it, as Whistler did, with a letter-picture based on
his monogram.[211] Whistler occasionally visited Crawford
in his studio and gave the aspiring artist individual in-
struction. "It was through these quiet talks and private
criticism," Crawford recalled, "that I profited most in my
work, and learned so highly to respect and admire him as
a man." Whistler acknowledged Crawford's enthusiasm

and loyalty by making him the *massier*, or monitor, of
the school. When critiquing the work of other students,
Whistler would borrow Crawford's palette because he
said it made him "feel at home."[212]

In *Turquoise and Buff: Royan*, Crawford answered Whis-
tler's "poem-pictures" with his own exquisite version
of a poetic seascape. In this small panel, Crawford aimed
to achieve the lyrical characteristics that he admired in
Whistler's work—"the flow, the music, the color-quality
which is to a picture what music is to poetry."[213] In its
small size, the painting resembles Whistler's Notes, sketchy
landscapes or seascapes made with a few broad brush
strokes. Crawford's simple composition in a limited range
of grays, taupes, and blues depicts the sand and water in
eddies of color. The setting is the popular seaside resort
of Royan in Bordeaux, where long stretches of sandy beach
provided Crawford with the perfect subject for his reduc-
tive view of the ocean swirling away from the shore at
low tide.

Crawford led a varied career as a portraitist, illustrator,
designer of stained glass, muralist, and teacher at the Art
Students League in New York. After serving in the armed
forces during World War I, the artist and his wife, Brenetta
Bimm Herrman (1876–1956), whom he met at the Académie
Carmen, moved back to Europe in 1923. For the rest of his
career, Crawford devoted his energies to etching.[214] —*LTJ*

30 | LEON DABO, 1865–1960
Spring—Hudson River, 1912

Oil on canvas, 36 × 27 inches
Jean and Glenn Verrill

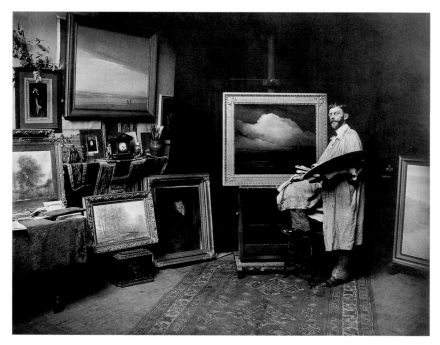

LEON DABO, BORN IN FRANCE, FIRST STUDIED
art with his father, Ignace Scott Dabo (d. 1883), who he
later claimed had known Whistler as a student in the
Paris atelier of Charles Gleyre. In 1871, at the time of the
Franco-Prussian War, Ignace Dabo moved his family to
the United States and settled in Detroit, which Leon later
embraced as his hometown. After his father's death in 1883,
Dabo moved to New York City and worked as an archi-
tectural designer at the J. & R. Lamb Studios. Following a
brief period of study in Paris, he traveled through Europe,
finally settling in London around 1886. He appears to
have been a frequent visitor to Whistler's London studio,
though the extent of their relationship, like much of
Dabo's early biography, remains obscure.[215]

After Dabo returned to New York in 1892, he embarked
upon a career as a mural painter, but by the first years of
the twentieth century, he had found a new role as a land-
scape painter devoted to the Whistlerian aesthetic. He may
have been inspired by a visit to Charles Lang Freer's home
in Detroit, which held an unparalleled collection of Whis-
tler's work.[216] By 1907, a reproduction of Whistler's portrait
by Giovanni Boldini (1842–1931) hung in a place of honor in
Dabo's New York studio (fig. 101).[217] Dabo fashioned him-
self as an expert qualified to authenticate works attributed
to Whistler.[218] His landscapes and seascapes of this period
are similarly tonalist in their choice of subject, reductive
color schemes, and pared-down compositions. *Spring—
Hudson River* is a typical example of the artist's shadowy
depictions of the banks along the Hudson River in the hazy
atmosphere of sunrise or twilight. The painting is signed
with Dabo's monogram in much the same way that Whis-
tler labeled his finished works with a butterfly. —*LTJ*

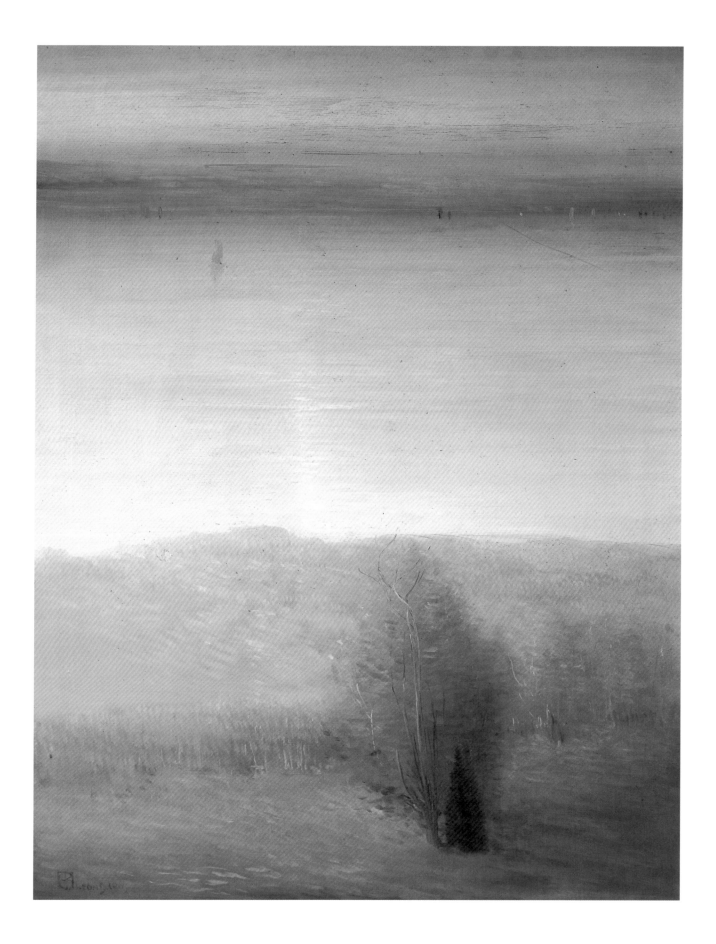

31 | THEODORE SCOTT DABO, 1866–1928
The River Seine, 1905

Oil on canvas, 25 × 30 inches
The Detroit Institute of Arts, Michigan
Gift of the artist, 06.1

THE BIOGRAPHICAL DETAILS OF THE LIFE OF Theodore Scott Dabo, like those of his brother Leon (see cat. 30), have been muddled by a number of misrepresentations that circulated during the artists' lifetimes. It appears that Theodore, or Scott, as he was known— the younger of the two—went to Paris early in 1905 after his work was "discovered" by Edmond Aman-Jean (1860–1936), a French devotee of the Whistlerian aesthetic. Dabo's paintings were exhibited at the autumn Salon that year, and within a few months he had won the praise of French critics such as Octave Mirbeau and Théodore Duret. One of his advocates, Arsène Alexandre, called Dabo's work "the realization of what Whistler attempted."[219]

Dabo's success in Paris, just at the moment that his brother Leon had his first important exhibition in New York, led to a permanent and public rift between the two. The rest of the family sent letters to the *New York Times* in defense of Scott, claiming that Leon had plagiarized his brother's work.[220] The critic Philip Hale of the *Boston Herald* made light of the dispute, writing that "these bold, bad brothers took, or, let us say, conveyed Whistler's child, and now they're quarrelling about which begot it."[221]

When Scott Dabo set off for Paris in 1905, he had left Leon in charge of his affairs. That year Leon arranged a gift of *The River Seine* to The Detroit Institute of Arts as a "representative" work by his brother. Possibly painted during his first summer in Paris, *The River Seine* is one of the hazy, atmospheric landscapes for which Dabo was hailed in France, executed entirely in "golden greenish tones," as Leon described it.[222] The painting's dreamlike mood and abstract nature suggest a sensibility nourished by Whistler's Nocturnes—some of which went on view at the Whistler Memorial Exhibition in Paris that October. Yet the critic Duret, whose *Histoire de J. McN. Whistler et de son oeuvre* had been published the previous year, maintained that Scott Dabo's work was "absolutely unique, comparable to nothing heretofore known."[223] —LTJ

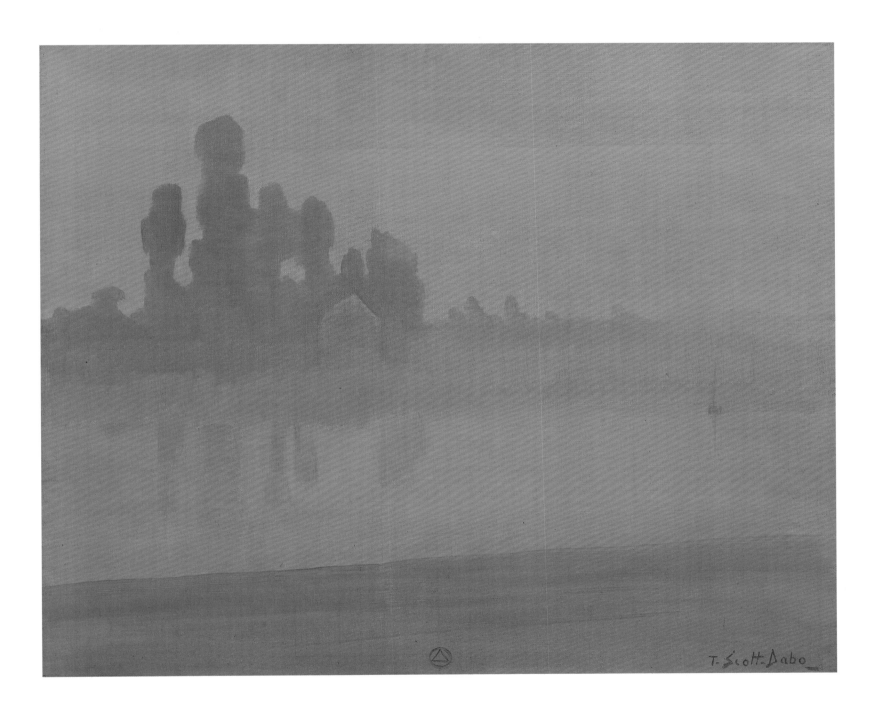

32 | EDITH FAIRFAX DAVENPORT, 1880–1957
Après Whistler, "Arrangement in Grey and Black,
No. 1: Portrait of the Painter's Mother," 1906

Copy after the original by
James McNeill Whistler, 1834–1903
Oil on canvas, 57 × 65½ inches
Whistler House Museum of Art, Lowell, Massachusetts
Gift of the artist, 11.046

EDITH DAVENPORT WAS WHISTLER'S FIRST COUSIN once removed: her grandmother, Isabella McNeill, was Whistler's mother's sister. Like her famous relative and so many other aspiring artists of her generation, Davenport went to Paris to study painting; she remained there eight years, working with Jean-Paul Laurens (1838–1921) at the Académie Julian and in the private studio of Louis-Joseph-Raphaël Collin, a student of Bouguereau (1825–1905). She is said to have been the first American woman officially admitted to the Ecole des Beaux Arts, which did not open its doors to women until 1896. Upon returning to the United States, Davenport studied dynamic symmetry with Howard Giles (1876–1955) and abstract composition with Hans Hofmann (1880–1966). As the critic F. W. Coburn observed, "Miss Davenport, since about 1930, has turned modernist—perhaps without going to extremes which would have irritated her great-uncle [sic]."[224]

In 1906, when Davenport was in Paris, Whistler's inestimably famous portrait of her grandmother's sister (see fig. 5) was hanging in the Musée du Luxembourg.[225] Guy Pène du Bois (1884–1958) recalled that at that time, and in that city, most American artists still revered Whistler: "We had not yet heard of Cézanne and the new movement which was to revolutionize painting, to send men off on a new adventure."[226] Davenport, of course, had a compelling personal interest in Whistler's masterpiece, and because of her familial relationship to the artist was given special permission to paint a replica of Whistler's Mother the same size as the original. Despite its fame, few artists attempted to copy it because, as Edmund H. Wuerpel discovered in 1892, "the canvas was too large to be copied full size, and no one seemed to care either to reduce it or copy it in fragments."[227] Davenport's copy, therefore, is the most complete and accurate extant example. It records the appearance of the portrait at a time when its varnish had yellowed, giving it the aspect of an Old Master painting (the original has since been restored). Davenport even had the original frame replicated for the copy, which she kept in her home in Zellwood, Florida, until around 1950. At that time, she presented it on permanent loan, and later as a bequest, to the Lowell Art Association, which owned the house where Whistler's mother had given birth to her first son.[228] —LM

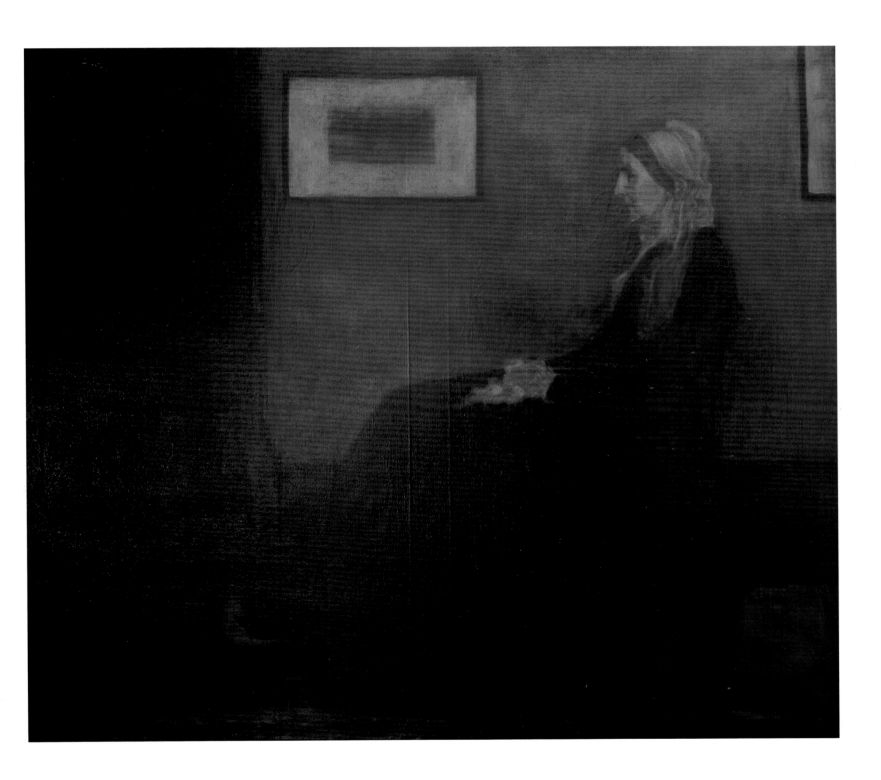

33 | THOMAS WILMER DEWING, 1851–1938
Portrait of DeLancey Iselin Kane, 1887

Oil on canvas, 72 × 48½ inches
Museum of the City of New York
Gift of Miss Georgine Iselin, 40.417

THOMAS DEWING BEGAN HIS CAREER WORKING in a lithography shop in his hometown of Boston. After studying in Paris with Gustave Boulanger (1824–1888) and Jules-Joseph Lefèbvre (1836–1912) at the Académie Julian, Dewing returned to Boston and then, late in 1880, moved to New York City.[229] His friend and colleague William Merritt Chase (see cats. 22–28) served as Dewing's best man when, soon after arriving in New York, he married a fellow artist, Maria Oakey (1845–1927).[230] Whistler, as Maria Oakey Dewing later recalled, "painted in London and filtered into our atmosphere here."[231]

A turning point for Dewing, as for many of his fellow artists in New York, was the exhibition in 1881 and 1882 of Whistler's *Symphony in White, No. 1: The White Girl* (cat. 1) and *Arrangement in Grey and Black, No. 1: Portrait of the Painter's Mother* (see fig. 5). Subsequently, Dewing moved away from the antiquated figures and inscrutable narratives of his early work toward greater simplification of subject matter, compositions, and color schemes. The titles of his paintings from this period, such as *Lady in Yellow* and *Girl in Black,* indicate the artist's increasing devotion to a Whistlerian aesthetic.[232]

Reviewing Dewing's work on display at the Union League Club in 1890, the critic for the *New York Tribune* feared that the artist was "in danger of becoming . . . a devotee of cool, quiet, delicate 'symphonies.'"[233] Dewing's portrait of DeLancey Iselin Kane (1877–1940), like his other portraits from the mid-1880s, appears to move in that direction. Dressed in a white middy, Kane stands upon a polished marble floor in front of a white curtain emblazoned with fleurs-de-lis. As Michael Quick has suggested, the painting may be considered "a younger brother of the large family of White Girls that were produced by American artists in the years after Whistler's painting was shown."[234] American artists such as Dewing and Elizabeth Boott (see cat. 20) appropriated Whistler's monochromatic color scheme for images of children, drawing on the traditional symbolism of white and ignoring the implied narrative of lost innocence in Whistler's *White Girl.*

The fleur-de-lis pattern, family crest, and heraldic inscription of the sitter's name all contribute to the decorative two-dimensionality of Dewing's composition. They also emphasize the importance of Kane's heritage, for he was the offspring of two wealthy families with distinguished histories. Like many other works by Dewing, the painting retains its original frame designed by the artist's close friend, the architect Stanford White (1853–1906).[235] —LTJ

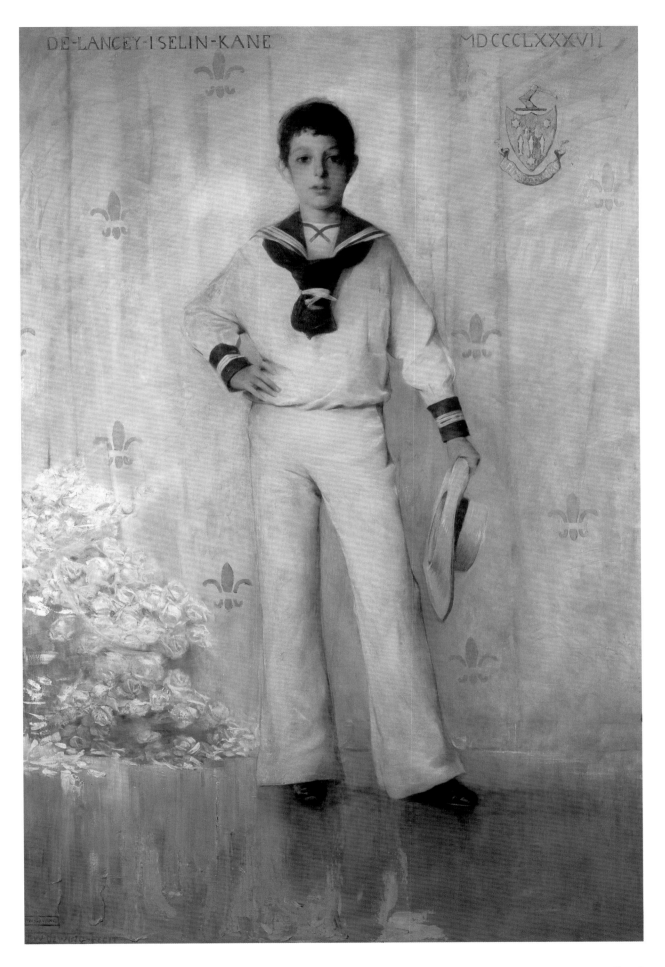

34 | THOMAS WILMER DEWING, 1851–1938
Portrait of a Lady Holding a Rose, 1912

Oil on canvas, 21¼ × 16¼ inches
Terra Foundation for the Arts, Daniel J. Terra Collection,
Chicago, Illinois, 1999.46

AN ASPIRING ACTRESS NAMED GERTRUDE
McNeill posed for a series of Dewing's works portraying women in seated profile. She appears in *Lady in White, No. 2* (fig. 102) wearing a white dress, perhaps an allusion to Whistler's *White Girl* (cat. 1). In *Portrait of a Lady Holding a Rose* she occupies an unadorned interior that, with her strict profile pose and the asymmetry of the composition, recalls Whistler's *Arrangement in Grey and Black, No. 1: Portrait of the Painter's Mother* (see fig. 5). Dewing's composition depends upon a restricted range of tones, as do many of his mature works. On the wall behind McNeill, in the same position as the framed etching in Whistler's portrait, hangs a Japanese scroll of the kind collected by Dewing's most significant patron, Charles Lang Freer.[236]

Dewing would have seen Whistler's famous portrait on exhibition in New York in 1882 and perhaps again in Paris, when he visited Whistler there in November 1894.[237] According to Freer, who arranged the meeting, the two artists "got on together famously."[238] That winter, Whistler invited Dewing to paint alongside him in the studio of his friend, the artist Walter Sickert (1860–1942).[239] Dewing wrote home to Stanford White that he was "painting hard all the time," and that he had "no end of advice" from Whistler.[240] Later, Dewing dismissed the importance of the trip, his second and final voyage across the Atlantic, with the assertion, "There are no great artists in Europe— I met only two, and they were Americans, Whistler and [Frederick] MacMonnies."[241]

With Freer, Dewing attended the opening day of the 1904 Whistler Memorial Exhibition in Boston; a couple of years later, the two visited the collection of John G. Johnson in Philadelphia. The latter trip offered Dewing the opportunity to examine Whistler's *Purple and Rose: The Lange Lijzen of the Six Marks* (cat. 2), which he may have known earlier through reproductions.[242] In *Portrait*

of a Lady Holding a Rose, McNeill, like Whistler's subject, appears as an elongated figure draped in a concealing robe, looking to the left with half-closed eyes. Whistler's admiration for East Asian art may have also been on Dewing's mind after seeing *The Lange Lijzen*, which features a woman decorating a piece of Chinese porcelain. Dewing had firsthand experience with Asian works of art such as the painting in *Portrait of a Lady Holding a Rose*, for he often acted as Freer's agent in New York, purchasing Japanese and Chinese art on his behalf.[243]

Freer's esoteric ideals, as well as his collection of Whistler's work, served as an ongoing inspiration for Dewing, who viewed his own best paintings as "above the heads of the public."[244] Freer himself wrote of "the harmony existing between the work of Whistler and Dewing. They certainly are very near to each other, and yet, distinctly individual."[245] —*LTJ*

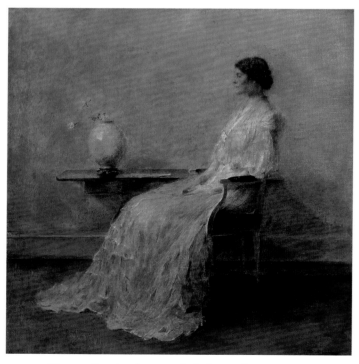

FIG 102 Thomas Dewing (1851–1938), *Lady in White, No. 2*, ca. 1910, oil on canvas, 22⅜ × 21⅜ inches, Smithsonian American Art Museum, Washington, D.C., gift of John Gellatly.

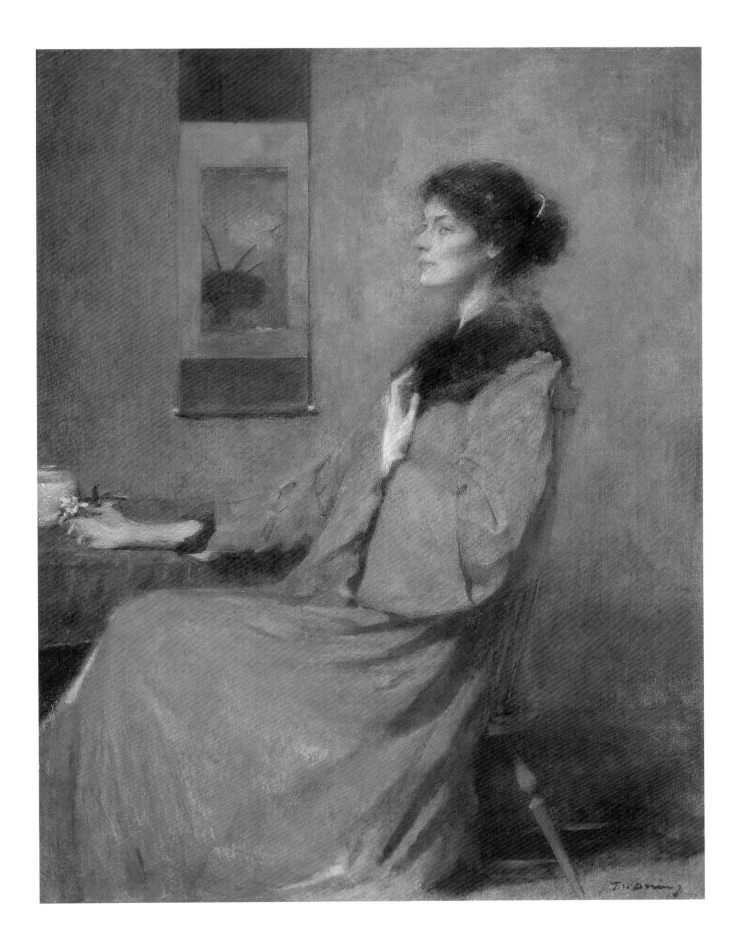

35 | G. RUGER DONOHO, 1857–1916
Moonlight, Mills at Pont Aven, ca. 1901

Oil on canvas, 30 × 36 inches
High Museum of Art, Atlanta, Georgia
Purchase, 31.6; 1999.41

FIG 103 G. Ruger Donoho (1857–1916), *Self-Portrait*, 1886, oil on canvas, 24¾ × 19⅝ inches, Mississippi Museum of Art, Jackson, gift of Gallery Guild, 1979.001.

A NATIVE OF MISSISSIPPI, G. RUGER DONOHO studied with William Merritt Chase (see cats. 22–28) at the Art Students League in New York, then in 1880 at the Académie Julian in Paris. The result of his visit to the nearby town of Grez was his first critical success, *La Marcellerie* (ca. 1882, Brooklyn Museum), which was exhibited at the Salon of 1882. According to Donoho's friend Childe Hassam (see cats. 43–44), Whistler and the French artist Puvis de Chavannes (1824–1898) considered *La Marcellerie* "the very finest landscape."[246] Donoho seems to have returned the compliment a few years later in a rare figural work, his *Self-Portrait* (fig. 103).[247] With its muted grays and greens, this thinly painted canvas calls to mind Whistler's three-quarter-length self-portrait, *Arrangement in Grey: Portrait of the Painter* (cat. 8), in which the artist appears in a similar pose and costume.[248] The tonal, dreamlike landscape in the background also anticipates the Whistlerian nocturnes that Donoho was to paint later in his career. After returning to New York, Donoho exhibited his *Self-Portrait* along with one of his early nocturnes, *Night* (ca. 1887–1888, unlocated), at the exhibition of the Society of American Artists in 1888.[249]

When Donoho settled in East Hampton in 1891, he moved out of the mainstream of American art. "The world did not know it," the critic Royal Cortissoz wrote of Donoho, "but he was obscurely, almost secretly, occupied in the painting of good pictures."[250] Much of his mature work features sunny, dappled scenes of his flourishing garden, perhaps encouraged by the work of Hassam, who became his neighbor. But moonlight scenes continued to figure in Donoho's oeuvre. His treatment of the theme shares with Whistler's an overall dark tonality, thin application of paint, and somber, moody atmosphere. On a trip abroad in 1901 and 1902, Donoho traveled once again to the French countryside, where he probably painted *Moonlight, Mills at Pont Aven*. Writing after the artist's death, Cortissoz compared such night scenes to the Nocturnes of the famous expatriate, though he refused to label Donoho's work as simply derivative. "There is nothing really imitative here," he found, "nothing of convention."[251] Borrowing Whistler's methods but not his delicacy of touch, Donoho composed *Moonlight, Mills at Pont Aven* as a solid organization of masses, a group of buildings seen through the veiled atmosphere of night.

—LTJ

36 | THOMAS EAKINS, 1844–1916
Music, 1904

Oil on canvas, 39¾ × 49¾ inches
Albright-Knox Art Gallery, Buffalo, New York
George Cary, Edmund Hayes, and James G. Forsyth
Funds, 1955

WHISTLER'S WORK WAS FREQUENTLY EXHIBITED at the Pennsylvania Academy of the Fine Arts in Philadelphia, Thomas Eakins's hometown. One day, the secretary of the Academy noticed Eakins carefully studying a Whistler painting, possibly *Nocturne in Black and Gold: The Falling Rocket* (cat. 7), which was on view there in 1900. When asked his opinion, Eakins replied, "I think it is a very cowardly way to paint." As a friend of the artist later explained, "He was wont to term 'cowardly' those paintings that left much to the imagination."[252] Eakins, a determined realist, may have considered Whistler's work lacking in mimetic truth, but he seems to have found it intriguing nevertheless. His most striking response dates to 1904, the year of the Whistler Memorial retrospective in Boston, when Eakins paid homage to Whistler by including a small replica of his *Arrangement in Black: Pablo de Sarasate* (see fig. 18) within his own composition, *Music.*[253]

In *Music,* Eakins depicted an expert but little-known violinist, Hedda van den Beemt (1880–1925), accompanied by Samuel Myers on the piano. Eakins often attended musicales on Saturday afternoons at the Philadelphia studio Myers shared with Frank Linton (1871–1943), one of Eakins's former pupils. It may have been at one of those performances that the idea for *Music* was born.[254] Positioning the image of the internationally renowned Sarasate behind his own subject, Eakins set up a comparison between the virtuoso violinist and the prodigy van den Beemt. The portrait's presence on the studio wall suggests that the young violinist, then twenty-four years old, strives to equal his more famous counterpart, and it may also imply a similar relationship between the two painters. By including the miniature Whistler, Eakins appears to honor the internationally celebrated expatriate whose recent death had generated a flood of popular and critical commentary.

It is not surprising that, out of all Whistler's work, Eakins chose to replicate the portrait of Sarasate, since it embodies the two artistic practices the artists shared: the genre of portraiture and the aspiration toward a musical ideal. For Whistler, music's appeal lay in its abstract qualities. For Eakins, however, it lay in the amount of skill and time required to perform as a professional. Rather than creating abstract color symphonies, Eakins depicted music by portraying musicians in the midst of performances.[255] Here van den Beemt appears to be swept up in his recital, concentrating intently on the music he produces; Sarasate, on the other hand, stands still, holding his violin at his side. As Diana Strazdes has pointed out, the differences between the two violinists parallel those between Eakins's realism and Whistler's aestheticism, or between an artistic practice rooted in diligent labor and one dependent, in Eakins's view, on style and posturing.[256] Perhaps *Music* was less a tribute to Whistler than a reassessment of his art. Whistler was "unquestionably a great painter," Eakins concluded in 1914, "but there are many of his works for which I do not care."[257] —*LTJ*

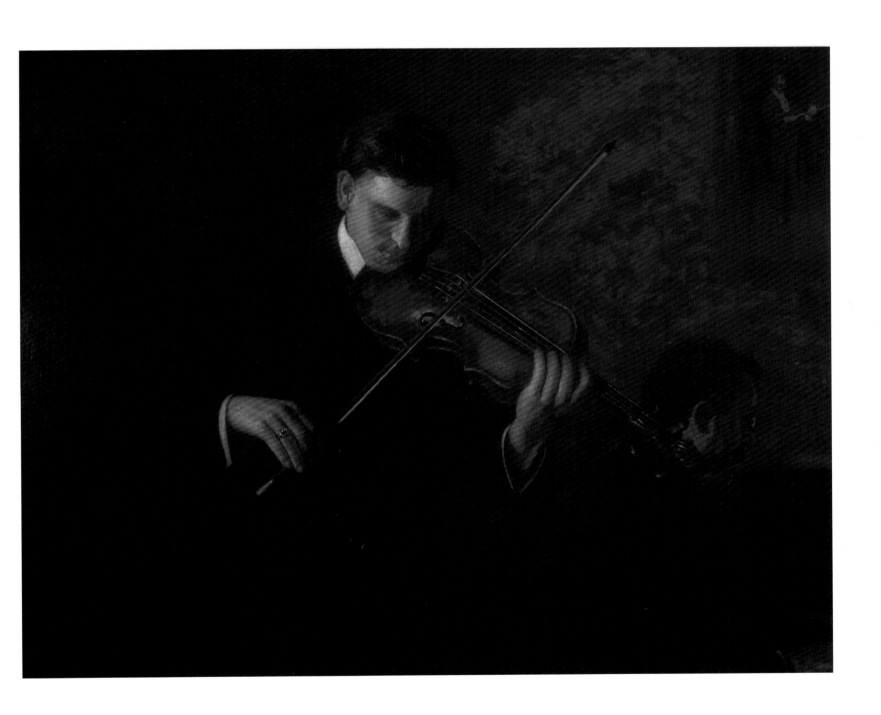

37 | FREDERICK CARL FRIESEKE, 1874–1939
The Yellow Room, ca. 1905–1912

Oil on canvas, 32 × 31⅞ inches
Museum of Fine Arts, Boston, Massachusetts
Bequest of John T. Spaulding, 1948.543

IN 1897, AFTER STUDYING AT THE ART INSTITUTE of Chicago and the Art Students League in New York, Frederick Frieseke left for Europe, where he would live for most of his career. While continuing his studies at the Académie Julian, Frieseke briefly attended Whistler's short-lived atelier, the Académie Carmen. His early work in landscape and figural studies betrays his admiration for the famous expatriate in its limited tonal range—the pinks of *Girl in Pink* (1903, private collection) or the blacks and grays of *The Yellow Tulip* (by 1902, private collection).

Perhaps his most Whistlerian early work is *Hélène* (fig. 104). The framed print hanging on the wall behind the sitter may allude to the famous painting Frieseke would have seen at the Musée du Luxembourg, *Arrangement in Grey and Black, No. 1: Portrait of the Painter's Mother* (see fig. 5). *Hélène* and Frieseke's other early works, like Whistler's portrait of his mother, are thinly painted to leave visible the weave of the canvas. Yet within the blacks and grays of this asymmetrical composition, Frieseke included warm orange tones, a significant departure from the

typically cool Whistlerian palette. As Hugh Ramsay, one of Frieseke's studio-mates, explained, not all American artists really understood Whistler's use of color: "In Paris the swarms of imitators of Whistler, mostly Americans, seem to imagine that if they paint black, they get quality and tone. . . . If these imitators studied Whistler, they'd see that he isn't black at all, but though low in key, quite rich and full and fine and silvery in quality of color."[258] *Hélène* was well placed at the Salon of the Société Nationale des Beaux-Arts in Paris in 1901; subsequently, Frieseke became an associate of that organization. The same year, perhaps because of his skillful adaptation of the Whistlerian manner, Frieseke was invited to exhibit with the International Society of Painters and Sculptors in Paris, which he described as "the one to which Whistler belongs."[259]

In 1905, Frieseke visited Giverny for the first time and fell in with the crowd of American painters gathered near the home of Claude Monet. For more than a decade, at the apex of his career, Frieseke spent each summer in that picturesque region of France, where he befriended both Monet and his son-in-law Theodore Butler (see cat. 21).[260] Frieseke's style changed dramatically during those years, for the artist dropped the muted tones that characterize his early work and adopted a palette of yellows, pinks, and blues in brilliantly colored figural scenes.

Having visited Monet's home, with its yellow dining room and blue porcelain, Frieseke decorated his own living room with "lemon-yellow" walls, providing the setting for *The Yellow Room*.[261] In this square canvas, the walls, cabinets, windowsills, and even the drawer pulls are painted yellow. The sitter's elaborate yellow robe or kimono has a floral pattern of reds and blues that is echoed in the enormous porcelain dish behind her. *The Yellow Room* resonates with Frieseke's continuing interest in the unified color tones and architectonic design of Whistlerian aestheticism. Perhaps Frieseke also recalled Whistler's use of a lower key of such décor in his own exhibitions and interior decoration (see fig. 41).

The Yellow Room belongs to a genre of American kimono pictures inspired by, among other works, Whistler's *La Princesse du pays de la porcelaine* (see fig. 13), which Frieseke would have seen in Chicago in 1893 and then again in Paris, at the Whistler Memorial Exhibition of 1905. The richly textured curtain that dominates the left side of the composition for purely decorative purposes may also be read as a subtle allusion to the drapery that appears in the background of Whistler's famous portrait of his mother.

—*LTJ*

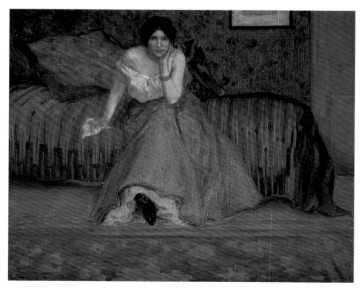

FIG 104 Frederick Carl Frieseke (1874–1939), *Hélène*, 1901, oil on canvas, 25⁹⁄₁₆ × 32 inches, University of Michigan Museum of Art, Ann Arbor, gift of Mr. John B. Tillotson, 1942.3.

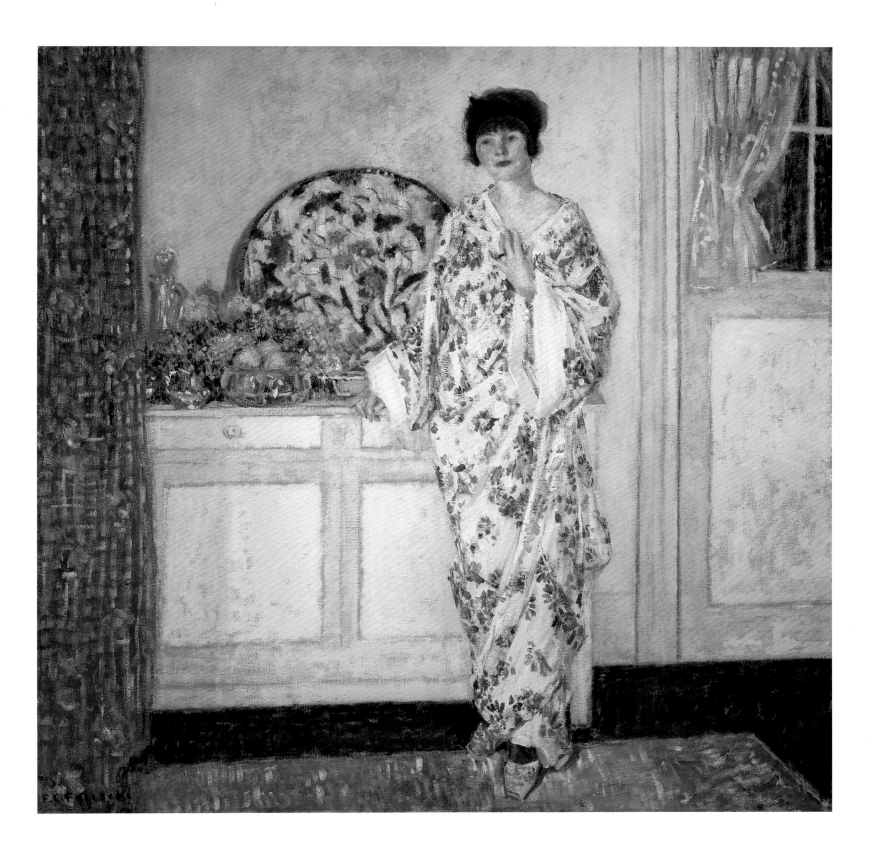

38 | LILLIAN MATHILDE GENTH, 1876–1953
Hong Kong at Night, ca. 1931

Oil on canvas, 29 × 35 inches
The New Britain Museum of American Art, Connecticut
Gift of Mrs. William H. Bender and Miss Edythe Haskell,
1954.53

LILLIAN GENTH BEGAN HER STUDIES IN HER native city at the Philadelphia School of Design for Women. In 1900 she won the Elkins Scholarship, which paid her way to Paris to study with Whistler at the Académie Carmen.[262] Although the Académie remained open only a few months after Genth's arrival, there was enough time for her to assume the role of a "favorite" pupil, which she is said to have "treasured . . . over and above any prize or distinction she ever won or achieved." Whistler reputedly gave Genth one of his palettes, which she kept—and used—until the end of her career.[263]

In 1903, Genth drew critical praise for her entry in the annual exhibition of the Society of American Artists, *Girl with a Mirror* (private collection).[264] She also achieved a measure of popular success for depictions of female nudes in pastoral settings, but in the late 1920s she abandoned such subjects, preferring to paint scenes from her travels through Spain and northern Africa.[265] Like many of Genth's paintings, *Hong Kong at Night* is not dated, but it almost certainly was inspired by the artist's trip to Asia in 1931. The subject, city lights reflected in the water of a bay, recalls Whistler's nocturnal views of London and Venice. The composition, with its nearly abstract passages of lights sparkling against a dark background, may have been inspired by *Nocturne in Black and Gold: The Falling Rocket* (cat. 7), which Genth could have seen in Philadelphia in 1900 and as reproduced in the Pennells' biography of Whistler of 1908. It is tempting to imagine that Genth painted this late reference to Whistler's most notorious Nocturne using his own palette. As she told one reporter, she found guidance throughout her career in Whistler's teachings, of which she kept notes in her diary.[266] Three decades after her studies in Paris, she still evaluated her own work by asking herself, "What would Whistler have said?"[267] —LTJ

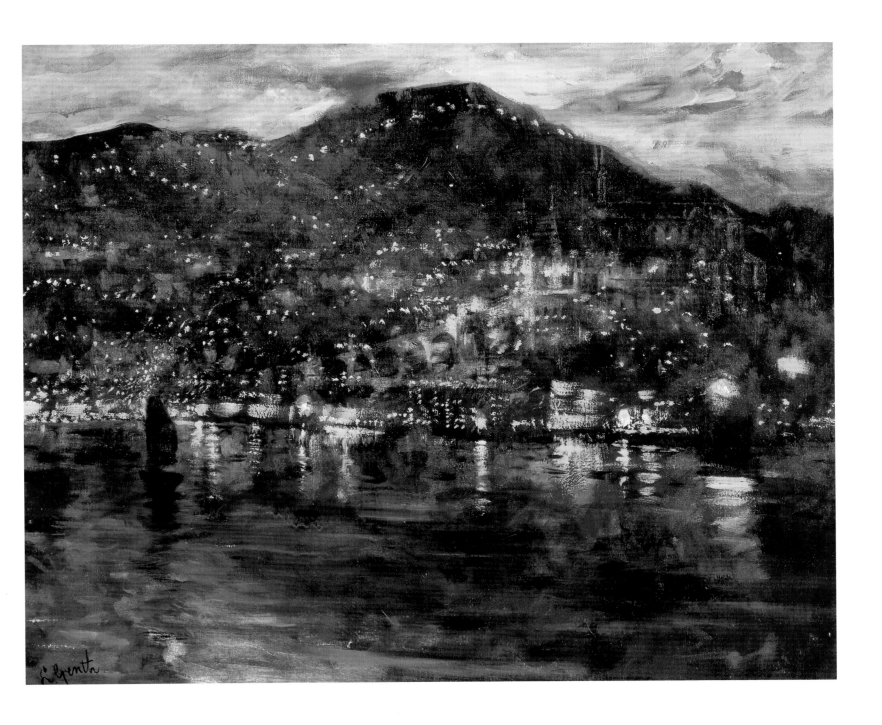

39 | WILLIAM GLACKENS, 1870–1938
Portrait of Charles FitzGerald, 1903

Oil on canvas, 75 × 40 inches
Museum of Art, Fort Lauderdale, Florida
Ira Glackens Bequest

WILLIAM GLACKENS BEGAN HIS CAREER IN THE 1890s as a newspaper illustrator in Philadelphia. Through John Sloan (1871–1951), with whom he attended night classes at the Pennsylvania Academy of the Fine Arts, Glackens met the charismatic realist painter Robert Henri (see cat. 45). Henri, with Glackens, Sloan, and others, would later organize the landmark exhibition of The Eight (1908) in an orchestrated rebellion against the National Academy of Design. Despite Glackens's realist orientation, his earliest oils, including *Philadelphia Landscape* (1893, Museum of Art, Fort Lauderdale), betray his interest in the tonal landscapes of Whistler, a selection of which were exhibited in Philadelphia in 1893.[268] Glackens reportedly looked to Whistler and Edouard Manet (1832–1883) as models for his illustrative work as well, calling them "the two great black-and-white artists of this century."[269]

In 1901, Charles FitzGerald gave Glackens his first sustained critical praise. Having immigrated to the United States from Ireland in the 1890s, FitzGerald had only recently moved to New York and begun working for the *Evening Sun.* The critic found much to admire in Glackens's work shown in New York at the Allan Gallery, together with that of Sloan, Henri, Alfred Maurer (see cat. 50), and others.[270] Subsequently, the artist and critic became close friends and eventually relatives, when FitzGerald married Glackens's sister-in-law. Glackens included a portrait of FitzGerald in his best-known work, *Chez Mouquin* (1905, Art Institute of Chicago), a scene of the New York café that they both frequented.[271]

Glackens painted his full-length portrait of FitzGerald in 1903, the year of Whistler's death, when artists and critics alike attempted to come to terms with the expatriate's significance to American art. In its somber, nearly monochromatic color scheme and the sitter's elegant dress and nonchalant pose, the work resembles Whistler portraits such as *Arrangement in Flesh Color and Brown: Portrait of Arthur Jerome Eddy* (cat. 10). When *Charles FitzGerald* appeared at the 1905 exhibition of the Society of American Artists in New York, the critic for the *New York World* noted a connection to Whistler's work and considered Glackens one of many artists over whom Whistler's shadow still loomed large. Another writer, recognizing the retrospective mood of the portrait, called it a "souvenir of Whistler."[272] —LTJ

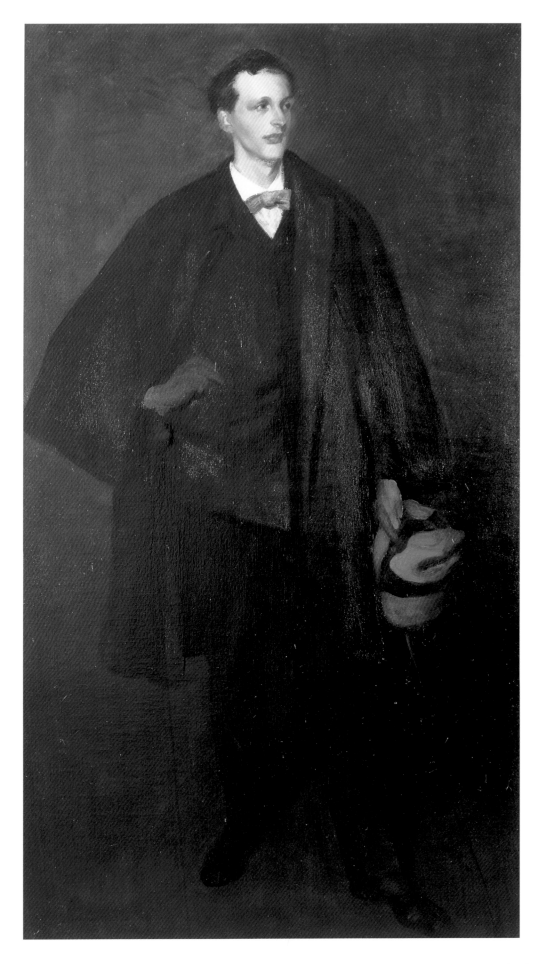

40 | AARON H. GORSON, 1872–1933
Pittsburgh at Night, 1926

Oil on canvas, 34¼ × 36¼ inches
Carnegie Museum of Art, Pittsburgh, Pennsylvania
Gift of Barbara M. Lawson in memory of
Roswell Miller Jr., 1984.72

AT THE AGE OF SEVENTEEN, AARON H. GORSON immigrated to the United States from Lithuania. He enrolled in evening classes at the Pennsylvania Academy of the Fine Arts and then traveled to Paris to continue his studies at the Académie Julian. In 1903 he returned to the United States and settled in Pittsburgh, where he was to discover his best-known subject, the industrial mills of the Steel Age. Gorson's views of Pittsburgh at night, in the early morning, or in the fog found an admiring audience among such leaders of industry as Andrew Carnegie (1835–1919) and Andrew W. Mellon. *Pittsburgh at Night* descended through Carnegie's family until it was given to the Carnegie Museum of Art in 1984.[273]

Shortly after Whistler's death, Gorson told an interviewer that the famous expatriate's Nocturnes had inspired his own nighttime paintings. "Whistler seems to be the one artist of the century," the journalist wrote, "for whom [Gorson] has an unbounded admiration."[274] His industrial scenes, like Whistler's Battersea Nocturnes (see cats. 5–6), often depict a view across the river obscured by fog, smoke, or the darkness of night, although Gorson relied on a much heavier buildup of paint to suggest the force of industrial fires. *Pittsburgh at Night,* an exceptionally dark example, glows with a blast from the Bessemer furnace that lights the dark sky around the Jones and Laughlin steel mills along the Monongahela River.[275] By making art of what was thought to be an eyesore, Gorson did for the Pittsburgh cityscape what Whistler had done for London.

Gorson's Pittsburgh views were studio compositions, like Whistler's. *Pittsburgh at Night* dates from late in Gorson's career, after the artist had moved to New York City in 1921. He often visited his adopted hometown of Pittsburgh, and he returned to its mills as his favorite subject, painting from sketches and recollection in the comfort of his New York studio.[276] —LTJ

41 | BIRGE HARRISON, 1854–1929
Fifth Avenue at Twilight, ca. 1905–1910

Oil on canvas, 30 × 23 inches
The Detroit Institute of Arts, Michigan
City of Detroit purchase, 10.21

A PAINTER OF TWILIGHT, MOONLIGHT, AND winter scenes, Harrison began his career at the Pennsylvania Academy of the Fine Arts in 1874. He later traveled to Paris and studied in the atelier of Emile-Auguste Carolus-Duran (1838–1917) and at the Ecole des Beaux-Arts; in 1882, the French government purchased his submission to the Salon, *November* (1881, Musée des Beaux-Arts et d'Archéologie de Rennes). During the next decade, beset with ill health, Harrison took a sabbatical from painting to see the world, writing and illustrating articles about his travels to Australia, India, and the American West.[277]

After settling in Plymouth, Massachusetts, in 1896, Harrison resumed landscape painting with renewed enthusiasm and a decided preference for what he called "the veiled and half-seen things."[278] He took as his subject the landscape near his home in Plymouth and later in Woodstock, New York. In each of these locales, Harrison chose the most evocative times of day—sunrise, twilight, and moonlight—to fulfill his most important artistic goal, creating a mood. Harrison believed that the way to achieve that effect, as Whistler had done, was with fluid, unobtrusive brushwork and a reserved use of color. "It is not contrast which makes beauty," he wrote, echoing Whistler, "but harmony."[279]

The tall buildings of New York City also captured the artist's attention at the turn of the last century in works such as *Fifth Avenue at Twilight.* This view, looking down Fifth Avenue toward St. Patrick's Cathedral, represents a characteristically dusky, rainy evening in the city, a subject favored by Whistler.[280] The buildings and streets melt into one another through subtle tonal transitions, and an overall cool palette is punctuated with spots of orange to suggest the glow of city lights. Harrison was one of several American artists to recognize the Whistlerian possibilities of New York City (see cats. 43, 48, and 67). "From all my excursions out into the world," he remarked in 1908, "I have returned time and again to the charm of New York streets for my subjects. In spite of the irregularity (because of it, perhaps) New York is certainly one of the most picturesque cities in the world."[281] —LTJ

42 | BIRGE HARRISON, 1854–1929
Quebec from the Harbor, ca. 1910

Oil on canvas, 19⅛ × 24¹/₁₆ inches
High Museum of Art, Atlanta, Georgia
Gift of the Art Study Club, 19.3

IN 1910, BIRGE HARRISON TRAVELED TO QUEBEC and rented the tower room at the Château Frontenac, a well-known hotel with sweeping views of the St. Lawrence River.[282] There he began a series of images of the city in winter, favoring "twilight and pearly dawn, moonlight and mist, the moments when things are glimpsed rather than seen."[283] Like John Twachtman (see cat. 63), Harrison considered snow one of the most intriguing subjects. "Snow is never white!" he wrote. "It is an instrument upon which Nature plays wonderful color symphonies, with never a harsh or a discordant note."[284]

In *Quebec from the Harbor,* Harrison captured the twilight atmosphere of Quebec in a subtle arrangement of the pale, cool blues and grays that the artist regarded as the most restful colors and the most appropriate for landscape painting.[285] *Quebec from the Harbor* corresponds to Harrison's description of Whistler's Nocturnes in his book *Landscape Painting*—"wherein the eye broods dreamily over the whole scene, not resting fixed upon any one given point of interest."[286] Harrison may not have completed the painting while working from his tower window at the Château Frontenac, but he probably began it there. Like Whistler, Harrison relied on his memory to unify and simplify his compositions by suppressing unnecessary details. It is not known whether Harrison had read the writings of Horace Lecoq de Boisbaudran (1809–1897) that inspired Whistler's methods of memory painting, but the artist did encourage at least one young protégé, Alice R. H. Smith (1876–1958) of Charleston, South Carolina, to paint according to similar ideals.[287] "I believe that the final picture must be always painted from memory," Harrison explained. "Of course one must paint what one sees, but one must see with the mind as well as with the eye."[288] Through the dissemination of such advice in his teaching and in his published works, Harrison served as a significant proponent of the Whistlerian aesthetic in the United States. —*LTJ*

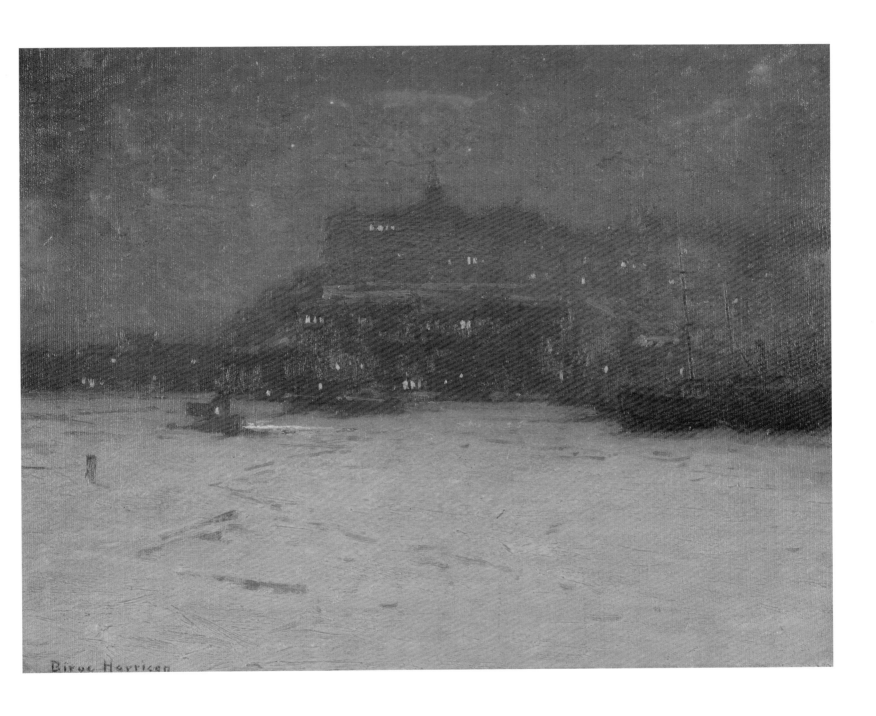

Birge Harrison

43 | CHILDE HASSAM, 1859–1935
Fifth Avenue Nocturne, ca. 1895

Oil on canvas, 24 × 20 inches
The Cleveland Museum of Art, Ohio
Anonymous gift, 1952.538

"I AM SORRY THAT I NEVER KNEW HIM," CHILDE Hassam wrote upon Whistler's death in 1903—"he is surely one of the big men."[289] Indeed, Hassam felt such admiration for the artist that he asserted in 1927, "Europe has produced no painters in comparison to Whistler, Twachtman, J. Alden Weir and others."[290]

After his initial training at the Lowell Institute in Boston, Hassam studied at the Académie Julian from 1886 to 1888. In 1889, he won his first major award, a bronze medal at the Exposition Universelle in Paris.[291] Hassam's letters from his visit to the Exposition provide the earliest documentation of his respect for Whistler.[292] When he returned to New York the following year, he met two of the chief proponents of the Whistlerian aesthetic, J. Alden Weir (see cats. 65–67) and John Twachtman (see cat. 63).[293] In their company, Hassam learned to love the effects of snow and twilight that would become key elements of such cityscapes of the 1890s as *Fifth Avenue Nocturne*. The painting borrows from Whistler's Nocturnes not only its title, but also Whistler's method of painting within a closely modulated range of cool color tones. Typical of Hassam's vertically oriented city views, this one features the golden glow of gaslight and figures hurrying along the city streets as their forms dissolve into the wet pavement and heavy skies. In contrast to Whistler's nocturnal world, which is characteristically silent and still, Hassam's vibrates with after-hours activity.

Calling Hassam a "butterfly artist," critics recognized Whistler and Monet as the two most important influences on his work. "He is as irresponsible as a Frenchman," one wrote, "and bows to the aesthetic deities alone. There is perhaps no American painter who more nearly approaches the ideal of art for art."[294] Having first read Whistler's "Ten O'Clock" in the early 1890s, around the time he would have been working on *Fifth Avenue Nocturne*, Hassam reread the lecture just after Whistler's death. "How true it is!" he wrote to Weir. "And it is reassuring too!"[295] The notion that the artist was primed to see beauty in the modern urban world underlies Hassam's New York nocturnes, which express his keen affection for the city. "To him it is simply the handsomest city in the world," wrote the critic Annie Nathan Meyer after a conversation with the artist:

He is big enough, modern enough, imaginative enough to prefer it to London or Paris; and this, coupled with a certainty of touch exceeded by no one in this country, is the secret of the pictures which lift his visions of New York to be worthy to stand side by side with Monet's tender transcriptions and Whistler's magical evocations of blended strength and mystery. Inevitably do these three names rise linked, to the lips, each in his own way a master of civic expression.[296]

—LTJ

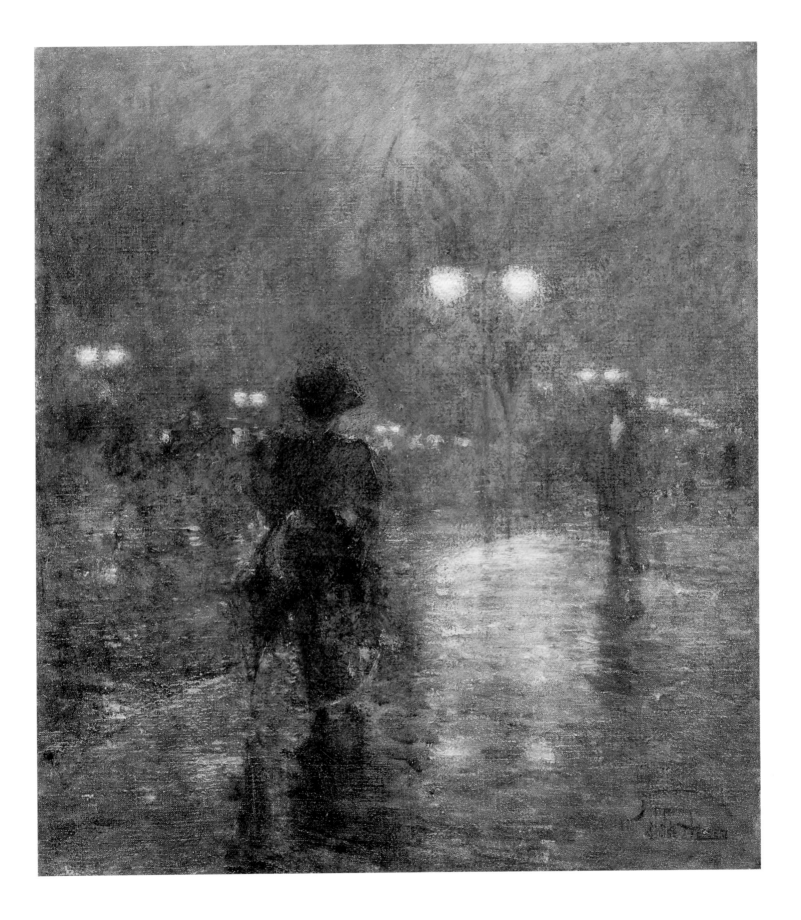

44 | CHILDE HASSAM, 1859–1935
News Depot, Cos Cob, 1912

Oil on panel, 5¼ × 8¾ inches
Florence Griswold Museum, Old Lyme, Connecticut
Gift of the Hartford Steam Boiler Inspection and
Insurance Company

FIG 105 James McNeill Whistler (1834–1903), *An Orange Note: Sweet Shop*, 1884, oil on wood panel, 4¹³⁄₁₆ × 8⁷⁄₁₆ inches, Freer Gallery of Art, Smithsonian Institution, Washington, D.C., gift of Charles Lang Freer, F1904.315.

AFTER THE TURN OF CENTURY, HASSAM BROUGHT new enthusiasm to one of his most Whistlerian themes: simple scenes of little shops lining a city street. Hassam once visited Charles Lang Freer's collection of Whistler's works in Detroit and later recalled how much he had admired Whistler's "small street things," which he compared to his own "little shop windows."[297] He may have had in mind *Chelsea Shops* (ca. 1880–1884, Freer Gallery of Art) and *An Orange Note: Sweet Shop* (fig. 105), both of which Freer had purchased by early 1905. A few years later, during a trip to Portland, Oregon, Hassam crafted his own larger version of the theme, *The Chinese Merchants* (1909, Freer Gallery of Art), perhaps as a ploy for Freer's patronage. If so, he succeeded, for Freer purchased the painting in 1910.[298]

News Depot, Cos Cob matches Whistler's street scenes in its small size, only about five by nine inches. Like such Whistlerian prototypes as *Rose and Red: The Barber's Shop, Lyme Regis* (cat. 12), Hassam's tiny horizontal panel presents an intimate view of a newsstand with a figure standing in the doorway. Windows, doors, and signs organize the scene into a grid, emphasizing the bold, abstract pattern of blue, green, red, and yellow. Hassam found his subject in the fishing village of Cos Cob, Connecticut, on the Long Island Sound, a town that attracted a host of artists around the turn of the nineteenth century. They typically focused on the picturesque clapboard houses and the view of the inner harbor, painting sun-splashed Impressionist works that convey a holiday feeling. Hassam's decision to portray a more mundane scene of village life—a run-down shopfront on a quiet street—suggests that he, like Whistler, sought aesthetic possibilities in unpromising places. Finding them was something of a sport, as Whistler himself suggested by referring to his own Notes as "curious little games."[299] —LTJ

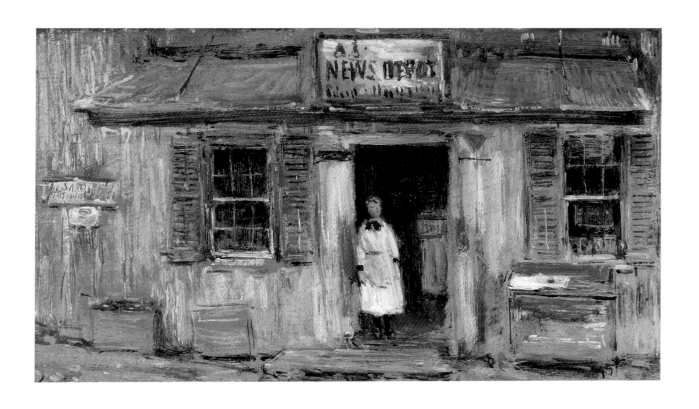

45 | ROBERT HENRI, 1865–1929
The Art Student (Miss Josephine Nivison), 1906

Oil on canvas, 77¼ × 38½ inches
Milwaukee Art Museum, Minnesota
Acquisition fund, M1965.34

ROBERT HENRI REJECTED WHAT HE CALLED "ART for poetry's sake," the genteel, rarefied subjects favored by many of Whistler's followers.[300] He preferred to depict the street scenes and immigrant population of New York City with a slapdash, thickly expressive style. Henri regarded Whistler as a "very great artist," however, and despite the differences between their works, looked to Whistler for inspiration at key moments in his career.[301] One of the most influential instructors of his generation, Henri promoted Whistler's work to his pupils as a worthy example. According to one student's notes, he advised them to "look at Whistler! . . . he had something to say and he painted great pictures."[302]

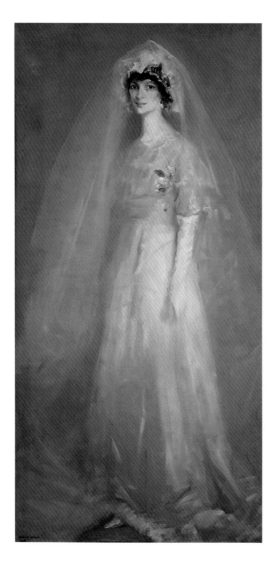

FIG 106 Robert Henri (1865–1929), *Portrait of Miss Eulabee Dix (Becker) in Wedding Gown*, 1910, oil on canvas, 77 × 37 inches, Museum of Nebraska Art, Kearney.

After a couple of years of study at the Pennsylvania Academy of the Fine Arts, Henri moved to Paris in 1888 and lived there intermittently throughout the following decade, just as Whistler's popularity reached its peak. By the turn of the century, Henri had adopted the restricted palette of dark tones associated with Whistler's work, which he used in moody images such as *La Neige (Snow)* (1899, Musée d'Orsay), a loosely brushed view of Paris in snow.[303] Henri described Whistler's painting style as a rejection of traditional notions of finish: his art, Henri said, "may have been done with a smear or two," but it was "complete" and "beautiful in its kind."[304] Filled with excitement after *La Neige* was purchased by the French government, Henri wrote home to his parents: "I still can hardly believe what I am about to tell you. . . . [*La Neige*] has been bought for the Luxembourg . . . [and] will hang in the same room with Whistler's portrait of his mother."[305]

Around 1900, critics began to associate Henri's work with Whistler's.[306] His portraits, especially, with their dark, vacant backgrounds and neutral color schemes, evoked such comparisons. Among the most Whistlerian of these portraits are Henri's depictions of Eulabee Dix Becker (1878–1961), a well-known miniaturist: *Portrait of Miss Eulabee Dix (Becker) in Wedding Gown* (fig. 106) and *Lady in Black Velvet* (1911, High Museum of Art). The wedding portrait offered an irresistible opportunity to essay Whistler's practice of painting in an all-white color scheme. Henri probably saw Whistler's famous *White Girl* (cat. 1) at the Boston Memorial Exhibition in 1904, and he certainly would have known of it as the revolutionary painting that had been exhibited at what Henri called the "Academy of the Rejected."[307]

Henri had fashioned a dark variation of the theme in an earlier portrait, *The Art Student*. His subject, his student Josephine Nivison—later Mrs. Edward Hopper (d. 1968)—stands facing the viewer with her arms "held close to the body and down," as Henri described her, and her red hair a "loose mass in disorder"[308]—much as Whistler had posed his model, Joanna Hiffernan, for *The White Girl*. Pressed into temporary service as a model, Nivison wears an artist's smock over her dress and holds paintbrushes loosely at her side, where Whistler's *White Girl* holds a white lily. *The Art Student* is Henri's unambiguously realist reply to Whistler's example—the portrait of a modern woman with the tools of her trade. —LTJ

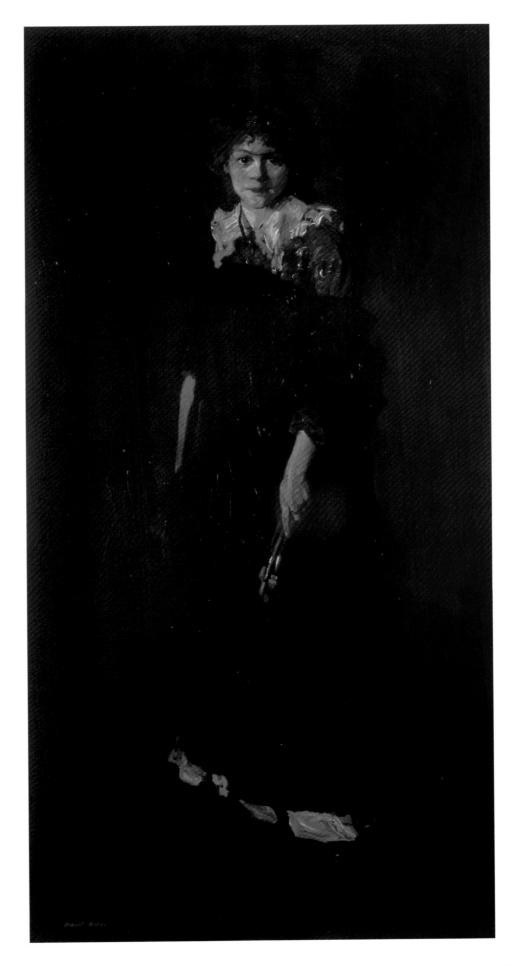

46 | ALBERT HERTER, 1871–1950
Portrait of Bessie, 1892

Oil on canvas, 59 × 32 inches
High Museum of Art, Atlanta, Georgia
Purchase with funds from the Margaret and Terry Stent
Endowment for the Acquisition of American Art and
High Museum of Art Enhancement Fund, 2000.162

ALBERT HERTER, THE SON OF CHRISTIAN HERTER (1840–1883), a leading Aesthetic movement designer, seemed destined for a career in the arts from his early days at the Art Students League. He painted *Portrait of Bessie* upon his return to New York City after completing his studies in Paris. J. Carroll Beckwith (1852–1917), who had been Herter's teacher at the Art Students League, praised the painting for its "dignity and simplicity" and encouraged Herter to submit it to the Society of American Artists exhibition that year. The jury accepted it, but before the show opened, the painting was pulled from the exhibition for lack of space.[309]

Herter's portrait of his childhood friend Elizabeth Newton (1868–1943) combines elements from the two Whistler paintings that had the most profound effect on American artists, *Arrangement in Grey and Black, No. 1: Portrait of the Painter's Mother* (see fig. 5) and *Symphony in White, No. 1: The White Girl* (cat. 1). Herter was only ten years old when *The White Girl* was first shown in New York in 1881, followed the next year by Whistler's portrait of his mother, but it is tempting to speculate that he might have accompanied his father to those exhibitions. Using a predominantly white color scheme as in Whistler's famous "symphony," Herter depicted Bessie seated in profile, facing left, in the celebrated pose of Whistler's mother. He pointedly included the most sensational props from *The White Girl*—the Easter lilies and bearskin rug—but subordinated their symbolic overtones to the tonal harmony of the composition. Indeed, despite the subject and many references to Whistler's *White Girl*, Herter's portrait more nearly approaches the portrait of Whistler's mother in mood and aesthetic sensibility.

Herter continued to borrow Whistlerian motifs and subjects throughout the following decade. Conflating

Asian and Greco-Roman traditions, as Whistler often did, Herter juxtaposed the classical profile of a Western woman with Japanese prints in *Woman Reading* (fig. 107).[310] Herter's submissions to the Salon of 1896, *La Robe japonaise* and *Etude dans l'ombre* (both unlocated), prompted the French critic Henri Rochefort to write: "Albert Herter, who has real talent, has visibly donned the 'Japanese dress' . . . [of] Mr. James McNeill Whistler, who is beginning to be the head of a school."[311] Herter also gave some of his works Whistlerian titles, such as his submission to the Salon of 1898, *Au crepuscule (noir et or)*, or *At Twilight (Black and Gold)*.[312] He sometimes used an emblematic signature based upon the cherry blossom, which he compared to Whistler's butterfly.[313]

After the turn of the century, Herter began to devote more of his time to mural painting and textile production. Following in his father's footsteps, he founded Herter Looms, which produced tapestries, rugs, and wall hangings based upon his designs.[314] —*LTJ*

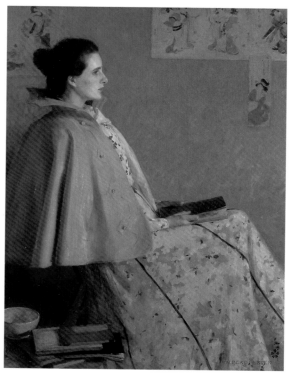

FIG 107 Albert Herter (1871–1950), *Woman Reading*, ca. 1898, oil on canvas, 46 × 35 inches, private collection.

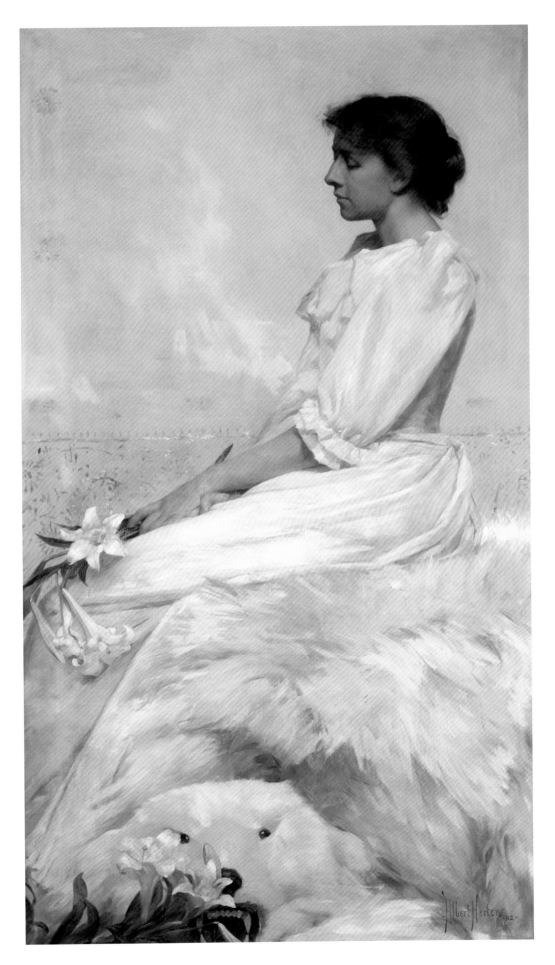

47 | WINSLOW HOMER, 1836–1910
Cape Trinity, Saguenay River, 1904–1909

Oil on canvas, 28¾ × 48¾ inches
Curtis Galleries, Minneapolis, Minnesota
Not in exhibition

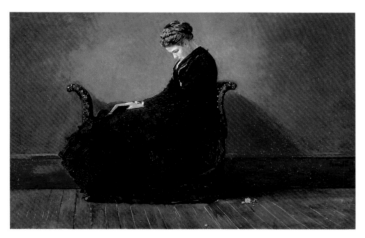

FIG 108 Winslow Homer (1836–1910), *Portrait of Helena de Kay*, 1871–1872, oil on canvas, 12¹³/₁₆ × 10⅝ inches, Museo Thyssen-Bornemisza, Madrid.

WINSLOW HOMER ONCE FEIGNED NOT TO KNOW who Whistler was, asking his brother in jest, "Arthur, am I supposed to know anything about a fellow named Whistler?"[315] This anecdote suggests just how renowned the name of Whistler was at the turn of the century and how reluctant Homer was to associate his work with that of any other artist. Yet the reticent Homer did venture a rare opinion of Whistler in response to the questions of John W. Beatty, Director of Fine Arts at the Carnegie Institute: "I am surprised because [Whistler] did not leave more works," he said. "His mother's portrait and Carlyle are important pictures, but I don't think those symphonies and queer things Ruskin objected to will live any great while. A few other things are knocking about, but his mother and Carlyle are the important ones."[316]

Homer's admiration for Whistler's portrait of his mother may have inspired one of his early paintings, *Portrait of Helena de Kay* (fig. 108), completed in 1872, though how Homer could have known Whistler's portrait at this early date remains a puzzle.[317] *Cape Trinity, Saguenay River,* from the end of Homer's career, provides another evocative comparison to Whistler's work. Homer began this painting in the fall of 1904, the year the Whistler Memorial Exhibition was held in his native city of Boston.[318] Since 1893, Homer had been traveling to the Canadian wilderness, usually up the Saguenay River to the southern side of Lake St. John, about 120 miles north of the city of Quebec.[319] The waters of the river here appear extraordinarily dark under the cloudy moonlit sky as they blend with the black, sheer cliffs of Cape Trinity. The nearly monochromatic blue color scheme of the night view is somewhat unusual for Homer, though he had repeatedly used a restricted palette of grays or browns for more than a decade.[320] The composition is among the most spare in his oeuvre, a simplified, almost geometric repetition of curved forms that echoes Whistler's reductive Nocturnes exhibited that year in Boston. —*LTJ*

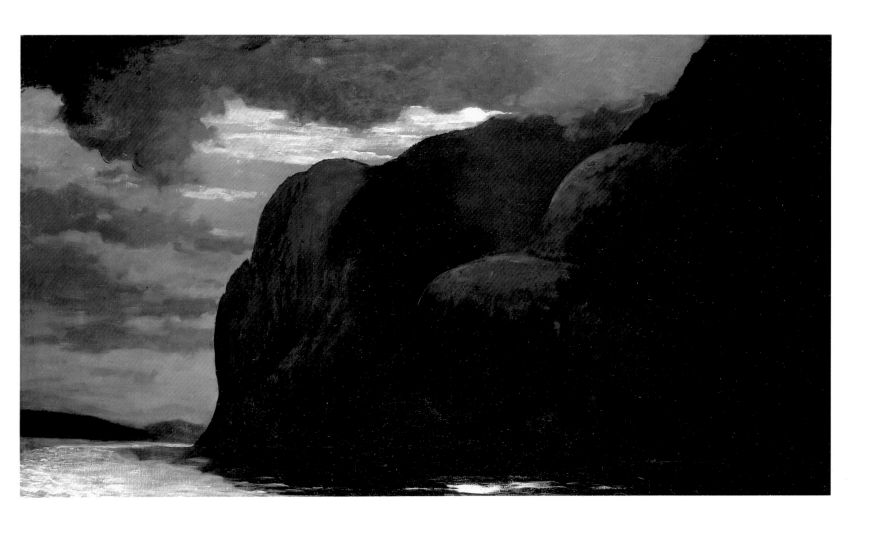

48 | ERNEST LAWSON, 1873–1939
Spring Night, Harlem River, 1913

Oil on canvas, mounted on wood, 25⅛ × 30⅛ inches
The Phillips Collection, Washington, D.C.
Acquired 1920

ALLEN TUCKER (1866–1939), A FELLOW STUDENT of Ernest Lawson in John Twachtman's class at the Art Students League, recalled that Lawson "was the leading member of the class, and a help to the rest of us, for from the first he got hold of things, and painted canvases made of color and filled with light and air."[321] In 1892, Lawson followed Twachtman (see cat. 63) to Cos Cob, Connecticut, where he had recently begun to teach outdoor classes during the summer.[322] Pursuing a traditional course of study for American artists, Lawson traveled to Paris in 1893 and enrolled in the Académie Julian. According to his letters home, he was captivated by the work of Whistler on view in the French capital.[323]

A member of the circle of realist painters known as The Eight, Lawson settled in the Washington Heights area of New York City in 1898 and found his best-known themes in the surrounding neighborhood, including the banks of the Harlem River from Washington Bridge at 181st Street, the subject of *Spring Night, Harlem River.*[324] Lawson often portrayed the city at night in winter or spring, when snow still covered the ground; like Whistler, he typically used a high horizon line and unified his compositions through a restricted color scheme. *Spring Night, Harlem River* was previously called *Moonlight,* the title Whistler initially gave to his Nocturnes.[325] Lawson explained his use of color in such paintings with a Whistlerian comparison to music: "Color affects me like music affects some persons . . . emotionally. . . . I like to play with colors . . . like a composer playing with counterpoint in music."[326]

In contrast to Whistler's techniques, Lawson painted with small, thickly applied brush strokes, perhaps influenced by Alfred Sisley (1839–1899), the French Impressionist painter he had encountered during his years in France. More than Whistler, Lawson relied on painting outdoors, in front of his motifs. (Although he had moved to Greenwich Village by the time he painted *Spring Night,* Lawson frequently brought canvases with him to his favorite haunts in his old neighborhood.)[327] Yet the effect of Lawson's urban landscapes comes close to that of Whistler's Nocturnes. As Holger Cahill observed in 1922, Lawson "plays about the prosaic patches of outlying New York with an exquisite orchestra of color, and invests the most commonplace scene with an opalescent mantle of unexpected beauty."[328]

—LTJ

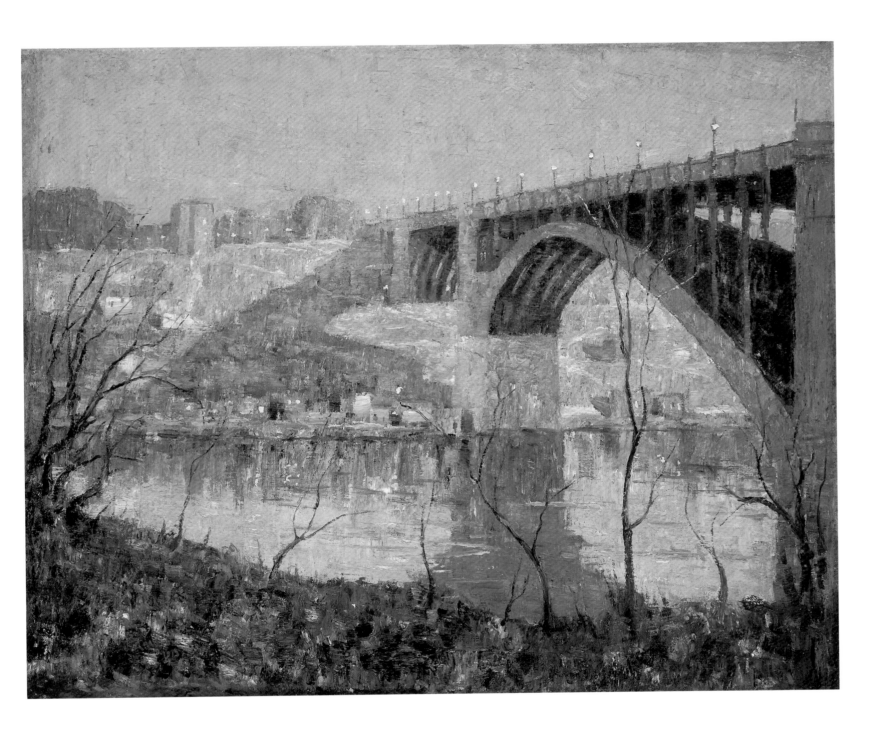

Oil on canvas, 25 × 21¾ inches
Oakland Museum of California
Gift of Concours d'Antiques, the Art Guild, A66.196.25

ARTHUR MATHEWS LEFT HIS HOMETOWN OF
Oakland, California, for Paris in 1885. There he excelled
in his studies at the Académie Julian, and his paintings
of mythological and literary subjects found favor with
the juries of the Paris Salon. In 1889, Mathews returned
to California and took a teaching position at the California
School of Design, of which he became director in 1890.
With his wife Lucia, one of his former pupils, Mathews
returned to Paris in the summer of 1898. During their year-
long stay in Europe, Lucia, alongside several other women
from California, studied at Whistler's Académie Carmen
and embraced a Whistlerian aesthetic in such tonal por-
traits as *Child in White* (fig. 109).[329]

Mathews most likely saw works by Whistler during
the 1880s, but it was not until his second trip to Paris that
his own work began to show the full force of the American
expatriate's influence. Perhaps painted in their Parisian
studio, *Lucia Reading* depicts Mathews's wife as a contem-
plative figure, seated in profile in an unadorned interior;
although reversed and less severe, her pose recalls that
of Whistler's portrait of his mother, then in the Musée
du Luxembourg. Unlike Anna Whistler, however, Lucia
Mathews dons a kimono. Mathews may have been in-
spired to use that costume by paintings such as Whistler's
La Princesse du pays de la porcelaine (see fig. 13), which had
been exhibited in London at the International Society of
Sculptors, Painters and Gravers in 1898.[330]

In Mathews's view, Whistler and another mentor, Puvis
de Chavannes, shared the belief that "every painting must
of necessity have a definite color note as a binding force in
its construction."[331] *Lucia Reading* follows that dictate with
its striking note of reddish pink against a tonal composi-
tion of browns. A restricted range of neutral tones domi-
nates Mathews's landscape paintings as well. In moody,
dreamlike works such as *Cypress Grove* (1903, Oakland
Museum of California), Mathews juxtaposed a golden
sunset with flat areas of dark color for the trees, empha-
sizing the silhouette of the branches and leaves against
the twilight sky.

In his later career, Mathews continued to portray the
mythical and literary figures he had embraced during his
initial studies at the Académie Julian, but he again adopted
Whistlerian themes in two undated paintings: *The Butterfly*
(Oakland Museum of California), which may carry an
allusion to Whistler's signature emblem, and *Mandarin
Robe* (Oakland Museum of California), which includes
a peacock—one of Mathews's, and Whistler's, favorite
symbols. Perhaps in admiration of Whistler's butterfly,
Mathews signed a few of his illustrations with a mono-
gram in the shape of a bee. As a teacher, Mathews became
the leading proponent of Whistlerian aesthetics in Cali-
fornia, influencing such younger artists as Granville Red-
mond (see cat. 54) and Xavier Martinez (see fig. 20).[332]

Striving for harmony in interior decoration, Mathews
designed frames for his own works through the Furniture
Shop, a company he founded with Lucia after the 1906 San
Francisco earthquake. The Furniture Shop was committed
to a modern ideal of craftsmanship according to Mathews's
designs, which became known as the "California Decora-
tive" style.[333] —*LTJ*

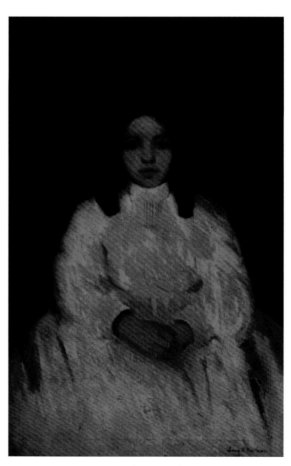

FIG 109 Lucia Mathews (1870–1955), *Child in White*,
undated, oil on canvas, 30 × 19 inches, Mills College Art
Museum, California, gift of Albert M. Bender, 1924.17.

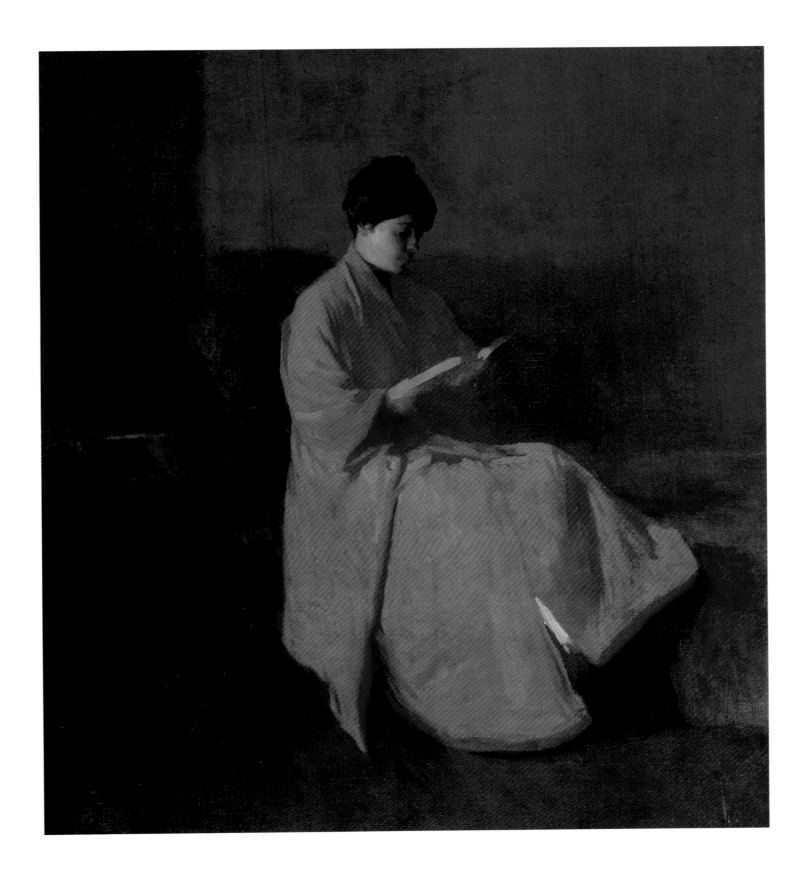

50 | ALFRED H. MAURER, 1868–1932
An Arrangement, 1901

Oil on cardboard, 36 × 31⅞ inches
Whitney Museum of American Art, New York
Gift of Mr. and Mrs. Hudson D. Walker, 50.13

AS HE APPROACHED HIS THIRTIETH BIRTHDAY, Alfred Maurer left New York, where he had studied at the National Academy of Design, for Paris, where he completed his education among the galleries of the French capital.[334] Although there is no evidence that Maurer met Whistler during his stay in Paris, his early work displays a keen understanding of Whistler's art. One of Maurer's paintings was accepted at the 1900 Exposition Universelle, where he would have surely seen Whistler's *Symphony in White, No. 2: The Little White Girl* (1864–1865, Tate Britain). Shortly thereafter, Maurer began his own series of "white girls," including *Girl in White* (ca. 1901, University Gallery, University of Minnesota, Minneapolis) and *Figure Study* (1900, private collection), a painting Nick Madormo has described as "an étude of white, pale blues, yellow, and buff."[335] Whistler's *Symphony in White, No. 1: The White Girl* (cat. 1), which Maurer could have seen at The Metropolitan Museum of Art in 1894, also bears comparison with the limp model in *Figure Study,* who holds a hat loosely and looks off to the right with an unfocused gaze.

Shortly after returning to New York in 1901, Maurer painted *An Arrangement,* his most thoroughly Whistlerian composition and his first resounding critical success.[336] The title alone indicates Maurer's espousal of Whistlerian aesthetics. The painting makes no pretense of serving as a portrait but instead adopts Whistler's principles of harmony and design as its meaning; the model poses obliquely, and the flowing form of her dress takes center stage as we look down upon her from behind. The composition is primarily a harmony of gray, black, white, and gold, with accents of blue and red in the Asian textile, the patterned rug, and the Chinese porcelain vases. As noted by the critic Charles Caffin, who would champion Maurer's later work, it is "a painter's picture . . . entirely directed to securing beauty of tone."[337]

In the wake of his success, Maurer returned to Paris and around 1904 gave up his dark palette for the brilliant colors of Fauvism. Maurer's modernist landscapes came as a shock to some, but for Caffin, they were "a natural evolution from the example of Whistler." In Caffin's view, those "color-harmonies" or "little creations of color beauty" brought Whistler's theories of pictorial unity to their logical conclusion.[338] —LTJ

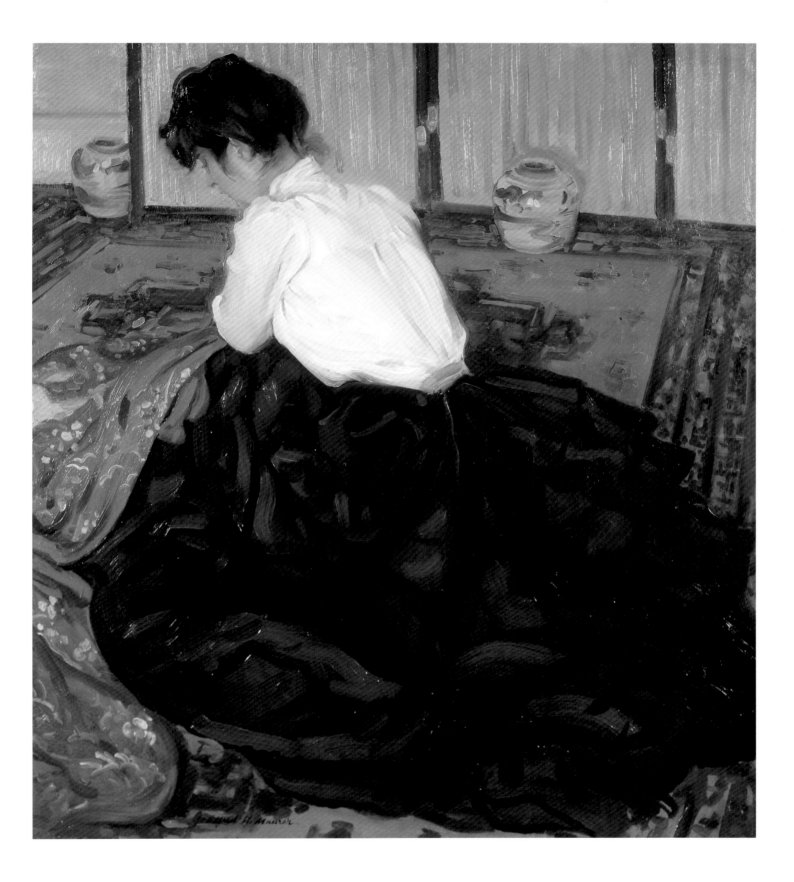

51 | HERMANN DUDLEY MURPHY, 1867–1945
Henry Ossawa Tanner, ca. 1896

Oil on canvas, 28¾ × 19¾ inches
The Art Institute of Chicago, Illinois
Friends of American Art Collection, 1924.37

HERMANN DUDLEY MURPHY CREDITED WHISTLER with having done more to inspire him than anyone, or anything, else.[339] He may have first encountered Whistler's art in 1886 when, at the age of nineteen, he illustrated an article titled "A Whistler Sketch" for *American Art Illustrated.* In 1891 he journeyed to Paris and enrolled at the Académie Julian.[340] It was toward the end of that year that the French government affirmed Whistler's role as the leading American artist of his day by purchasing *Arrangement in Grey and Black, No. 1: Portrait of the Painter's Mother* (see fig. 5).

Murphy's portrait of the artist Henry Ossawa Tanner, who began his studies at the Académie Julian in the same year as Murphy, reveals his interest in Whistler's portraiture during those early days in Paris. Like much of Murphy's early work, it is composed in a limited range of neutral tones with a thin application of paint that creates a diffused, atmospheric effect and leaves the weave of the canvas visible. Although not necessarily dependent upon a specific Whistlerian prototype, the pose of the sitter and the monogram signature resemble those of Whistler's self-portrait, *Arrangement in Grey: Portrait of the Painter* (cat. 8), which Murphy might have seen on exhibition at the Goupil Gallery in London.[341]

Murphy probably painted this portrait of his colleague while the two artists shared a studio on the boulevard St.-Jacques.[342] They were suitable companions, for Tanner's own *Portrait of the Artist's Mother* (cat. 59) suggests that he, too, admired Whistler's work. *Henry Ossawa Tanner* made its debut at the Champ-de-Mars Salon of 1896 and would be exhibited at least seven more times over the next decade. One critic noted the Whistlerian aspect of the work upon its exhibition at The Art Institute of Chicago in the fall of 1896: "A portrait of Mr. Tanner . . . is a most interesting work, with a trifle of [Edward] Burne-Jones and much of Whistler lying back of its worth."[343] —*LTJ*

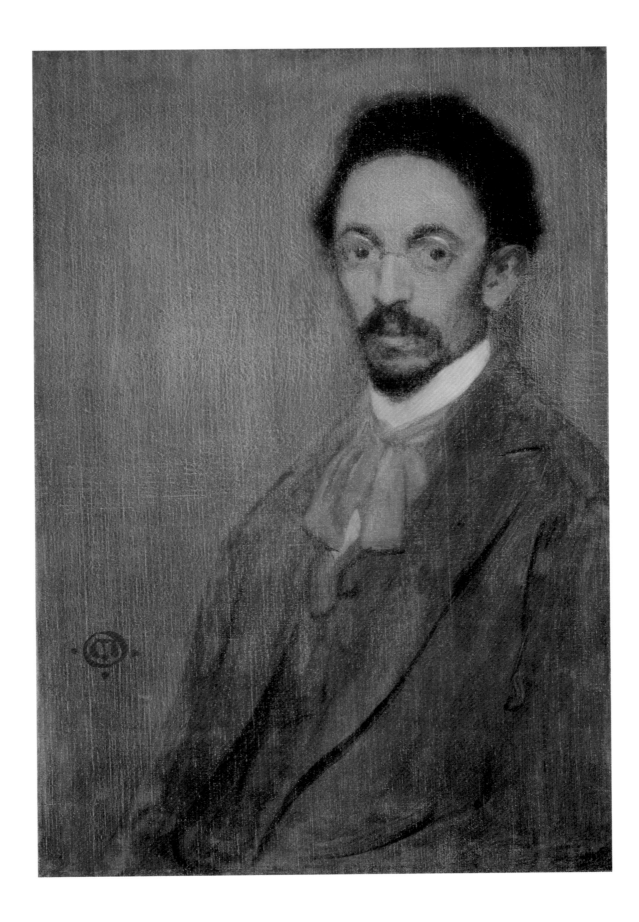

52 | HERMANN DUDLEY MURPHY, 1867–1945
Murano, 1907

Oil on canvas, 20 × 30 inches
Tom Veilleux Gallery, Farmington, Maine

FIG 110 Hermann Dudley Murphy (1867–1945), *Murano* in frame designed by the artist.

AFTER MOVING FROM FRANCE BACK TO THE United States in 1897, Murphy settled with his family in the Boston suburb of Winchester, Massachusetts. There in 1903 he built a house and studio, which he named Carrig-Rohane; Murphy gave the same name to the frame shop he established with Charles Prendergast (1863–1948) in his basement. Inspired by Whistler, who asserted the importance of delicate frames to complement his subtle paintings, Murphy began by designing frames for his own works. He had taught himself the craft of frame-making while a student in Paris, when he could not afford to buy ones of sufficient quality to harmonize with his paintings. In 1905 the frame shop of Carrig-Rohane moved to Boston and became a profitable enterprise that revolutionized American framing.[344] *Murano* is encased in one of Murphy's designs—a flat, hand-carved, gilded frame with a series of banded edges that recede toward the canvas, similar to Whistler's signature reeded frames (fig. 110).

One of Murphy's most Whistlerian views, *Murano* depicts an evening mist falling upon Venice. It dates to the period following Whistler's Memorial Exhibition in Boston, where a number of Nocturnes were on view. Murphy's composition is greatly simplified and his palette so limited that the distinction between water, land, and sky is barely discernible. A sailboat in the middle ground blends into the overall blue tones applied to the canvas in thin layers. Murphy adopted elements of Whistler's style throughout his career, but *Murano* may be the clearest and most artful assimilation of his manner.

When *Murano* appeared at the Albright Gallery in Buffalo in 1909, one critic recognized that it was "strongly suggestive of Whistler" and named it one of the "most beautiful of his pictures" in an exhibition filled with examples of Murphy's "exquisite coloring and refined technique." Exhibited along with several other Venetian views from Murphy's five-month stay in the city in 1908, *Murano* hung in the "Whistler Room," with its "silvery gray walls . . . which give a peculiarly suitable background for works of this character."[345] —LTJ

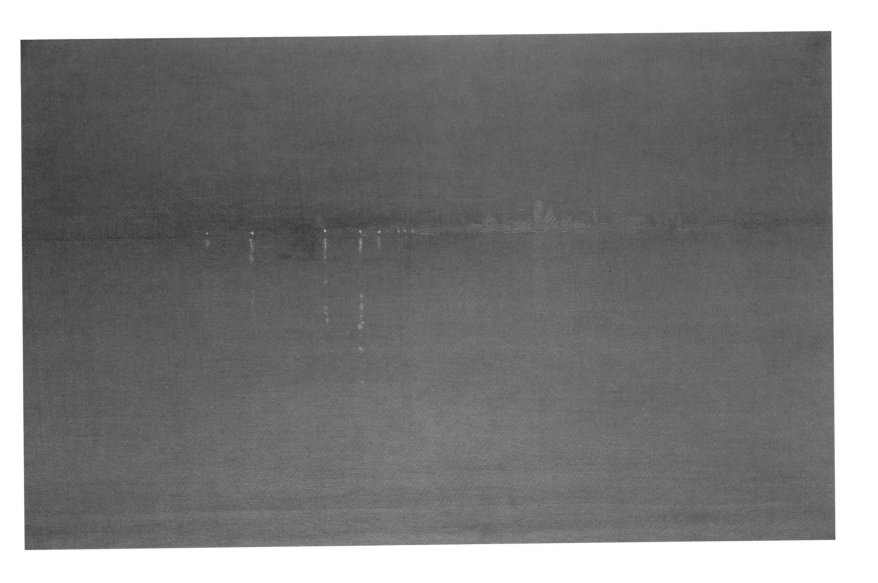

53 | CHARLES ROLLO PETERS, 1862–1928
Nocturnal Street Scene, ca. 1899

Oil on canvas, 16½ × 24⅛ inches
Oakland Museum of California
Museum Acquisition, A67.38

RECALLING THEIR DAYS IN THE LATIN QUARTER of Paris in the 1880s, F. W. Ramsdell (1865–1915) described his friend and fellow artist Charles Rollo Peters as "one of the more serious students, frank, outspoken and straightforward."[346] After spending a couple of years in his native California, Peters returned to Paris in 1891, the year that Whistler's portrait of his mother entered the Musée du Luxembourg.[347] Peters's appreciation of Whistler's work may have been encouraged by his friendship with Alexander Harrison (1853–1930), who set up an atelier for American and British students in Paris.[348] Because Harrison would not provide Peters with an introduction to Whistler—everyone wanted to meet him, he said—Peters reputedly went on his own to Whistler's home in Paris but was

turned away at the door.[349] Despite that rebuff, Peters embraced the theme for which Whistler was perhaps most famous, the nocturne.

A selection of Whistler's paintings exhibited at the Salon Nationale des Beaux-Arts the year after Peters returned to Paris, including *Nocturne: Black and Gold—The Fire Wheel* (see fig. 12), may have inspired him to adopt the nocturne as his own.[350] According to his friend Ramsdell, Peters's earliest moonlit scenes were mystical images of Brittany, figural scenes set in the evening landscape.[351] Peters also composed urban versions of the theme such as *Paris Nocturne* (fig. 111), a dusky view of the Seine. Peters's most Whistlerian works, however, are the dark, nearly abstract compositions that won him the nickname "Prince of Darkness."[352] Thinly painted, like Whistler's, Peters's nocturnes use subtle tonal variations of black and dark blue to depict shadowy buildings, effects comparable to those in another painting exhibited at the Salon in 1892, Whistler's *Nocturne: Grey and Gold—Chelsea Snow* (see fig. 56). Typically in Peters's paintings, the light from a window—or, as in *Nocturnal Street Scene*, a street lamp—casts a glow over the scene, making forms barely discernible in the darkness.

After Peters's 1899 exhibition, *Paintings of the Night*, in New York at the Union League Club, several critics hailed him as one of the foremost painters of such subjects.[353] Peters's mature works often feature the Spanish-style architecture of San Francisco and Monterey, California, and some critics found his nocturnes particularly appealing because of their American settings.[354] According to Peters's devotees, Whistler once said that Peters was the only artist besides himself who was capable of painting a nocturne.[355] —*LTJ*

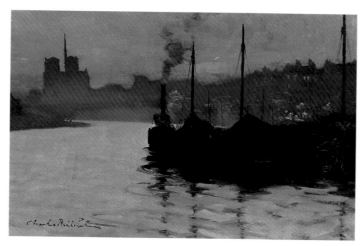

FIG 111 Charles Rollo Peters (1862–1928), *Paris Nocturne*, undated, oil on canvas, 15 × 22 inches, Collection of Mercedes and Richard T. Kerwin.

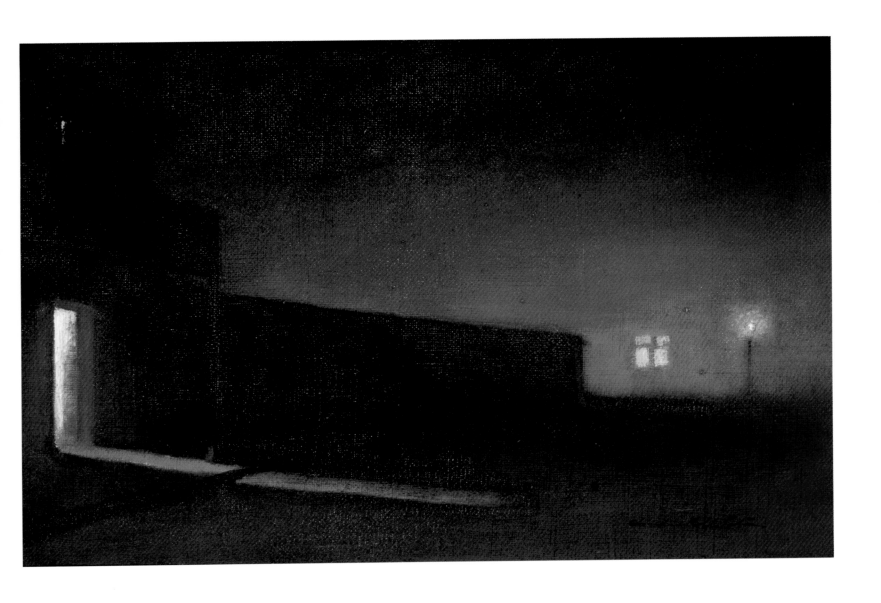

54 | GRANVILLE REDMOND, 1871–1935
Rising Moon, Tiburon, 1916

Oil on canvas, 24 × 29¼ inches
Oakland Museum of California
Gift of Mrs. Frederick G. Novy Jr., A86.33

AT THE AGE OF NINETEEN, GRANVILLE REDMOND, who had been deaf since childhood, enrolled as a full-time student in the California School of Design in San Francisco. He quickly became a leading pupil of the school's director, Arthur Mathews, whose quiet tonal landscapes and contemplative figural scenes such as *Lucia Reading* (cat. 49) instilled a generation of California artists with an admiration for the Whistlerian aesthetic. With the benefit of a scholarship loan, Redmond left for Paris in 1893 to complete his education at the Académie Julian. Although many of his early works have been lost, their titles alone, such as *Poésie du soir (Nocturne)*, from 1897, suggest Redmond's adoption of Whistlerian themes.[356]

After almost five years in Paris, Redmond returned to his home state of California and settled in Los Angeles in 1899.[357] He continued painting nocturnal landscapes, which would remain a significant portion of his oeuvre, but found his most popular subject in the poppy fields and wildflowers of California, which he painted in brilliant color under sunny skies.

Rising Moon, Tiburon depicts the lights across the water at Tiburon, California, where Redmond began sketching in 1912, soon after moving to nearby Menlo Park.[358] The absence of people and the glasslike reflections on the water recall the quiet stillness of Whistler's nocturnal views of the Thames. Thinly painted in predominantly blue gray tones, the moonlit scene appears as a misty vision on a coarsely woven canvas. The yellow-orange reflections of light on the water, indicated by tactile areas of thicker paint, form a syncopated rhythm across the painting. "I could look at it for hours," Redmond's friend the silent-film star Charlie Chaplin said of one of his paintings, "it means so many things."[359] —LTJ

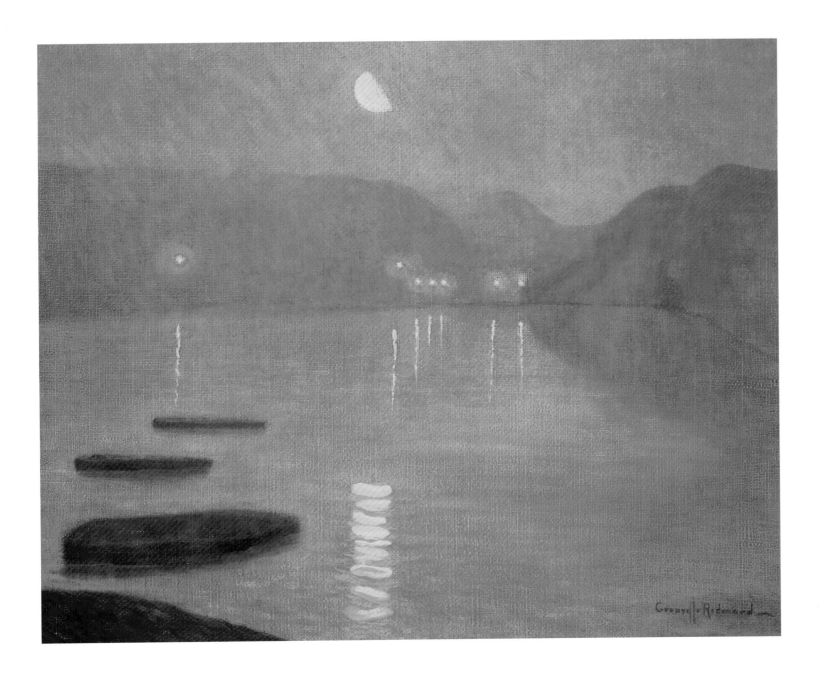

55 | FREDERIC REMINGTON, 1861–1909
Waiting in the Moonlight, ca. 1907–1909

Oil on canvas, 27 × 30 inches
Frederic Remington Art Museum, Ogdensburg,
New York, 66.38

IN HIS ILLUSTRATIONS, PAINTINGS, AND SCULP-
ture, Frederic Remington crafted the turn-of-the-century's
mythic vision of the American West, an action-filled land-
scape of cowboys and Native Americans, horse chases and
gunfights. Remington's narrative paintings stand in con-
trast to Whistler's subtle portraits and muted landscapes,
and it is no surprise that Remington summarily rejected
the notion of art for art's sake. "I stand for the proposition
of 'subjects,'" he wrote, "painting something worth while
as against painting *nothing* well—merely paint."[360] Whis-
tler's art, in particular, perplexed the artist. "How people
can see everything in there I do not know," Remington
recorded in his diary after examining Whistler's work at
the Macbeth Gallery in 1908.[361]

FIG 112 James McNeill Whistler (1834–1903), *Nocturne in Green and Gold (Nocturne in Black and Gold: The Gardens)*, ca. 1876, oil on canvas, 25⅛ × 30⅜ inches, The Met-ropolitan Museum of Art, New York, gift of Harris C. Fahnestock, 1906, 06.286.

The seriousness and ambition that Remington brought to
his art during the last years of his life, however, led him to
investigate Whistler's aesthetic as he had not done before.
He may have read the biography of Whistler by Elizabeth
and Joseph Pennell as well as Arthur Jerome Eddy's *Recol-
lections and Impressions of James A. McNeill Whistler*, both of
which were in his personal library.[362] After a visit to New
York City in January 1908, Remington wrote in his diary,
"There is a Whistler at Met Museum as black as the inside
of a jug."[363] He may have been referring to *Nocturne in
Green and Gold* (fig. 112), which had entered the collection
in 1906, already darkened with age.[364] In the same entry,
Remington found fault with the work of Albert Bierstadt
(1830–1902) for its "hard outlines," concluding that Bier-
stadt "knew nothing of Harmony." Apparently, it was
the aesthetic harmony and subtle coloration of Whistler's
work that intrigued Remington, for he had begun his own
series of diffused, tonalist nocturnes at the turn of the
century.

As Remington's colleague Childe Hassam wrote in 1906
to their mutual friend J. Alden Weir, "We are all doing
moonlights."[365] Whistler's Nocturnes, initially called
"Moonlights," had inspired a craze for the subject that
reached its peak around that time. In 1899, the California
artist Charles Rollo Peters (see cat. 53) displayed a group
of Western moonlight scenes at the Union League Club
in New York, which may also have encouraged Remington
to begin work on his own series.[366]

Unlike the bold narrative pictures of his earlier career—
paintings the critic Royal Cortissoz characterized as "hard
as nails"[367]—Remington's nocturnal scenes often portray
quiet, subdued subjects with a hint of mystery. These late
paintings use predominantly cool tonalities to convey the
shadowy appearance of Western subjects at night. Reming-
ton found that the new method had its share of difficulties.
"Tried to distinguish color in some sketches I took out of
doors," he wrote in his diary, "but it is too subtle a light
and does not differentiate."[368] In *Waiting in the Moonlight*,
Remington took up an unusually romantic subject, a cow-
boy bending from the saddle toward a shadowy, cloaked
female figure. Remington applied his paint more thinly and
fluidly than before so that the rough weave of the canvas
adds texture to the scene.[369] This technique allowed him
to suggest the hazy atmosphere of night and to unify his
composition with the sought-after effect of "harmony."
Despite his repeated objections to Whistler's art, Reming-
ton found within the genre of the nocturne the means to
transform his own work. —*LTJ*

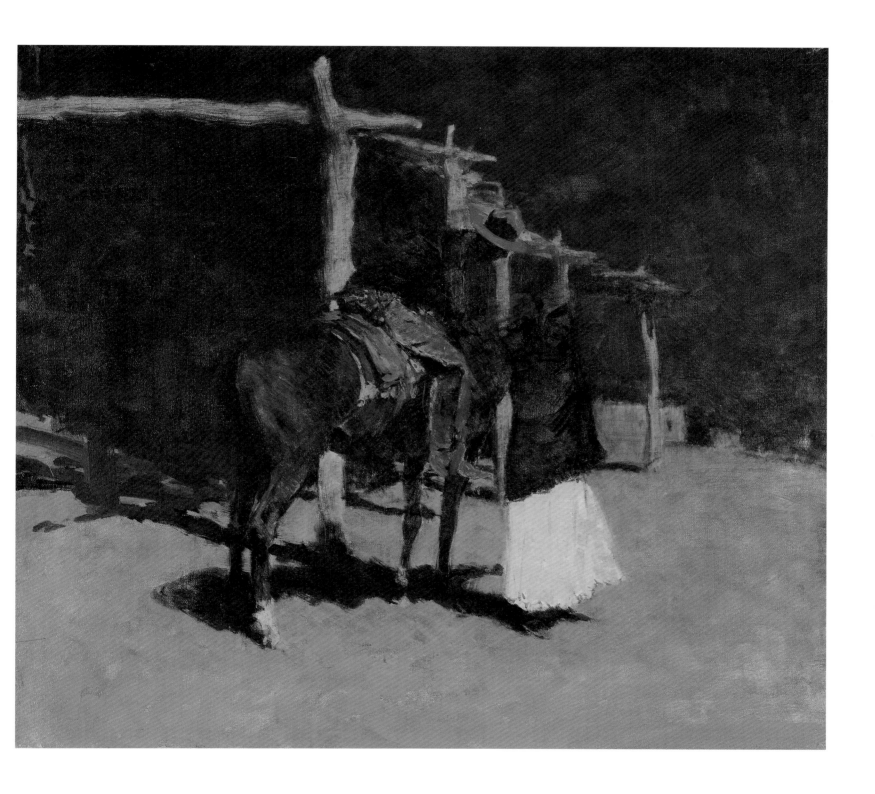

56 | JOHN SINGER SARGENT, 1856–1925
The Spanish Dance, 1879–1880

Oil on canvas, 35¼ × 33¼ inches
The Hispanic Society of America, New York, A152

ACCORDING TO HIS FIRST BIOGRAPHER, JOHN Singer Sargent "used to say that Whistler's use of paint was so exquisite that if a piece of canvas were cut out of one of his pictures one would find that it was in itself a thing of beauty."[370] Born in Florence to American parents, Sargent, like Whistler, lived most of his life in Europe. By the time he entered the Parisian studio of Emile-Auguste Carolus-Duran in 1874, Whistler was already a legendary figure, known chiefly in Paris as the painter of *Symphony in White, No. 1: The White Girl* (cat. 1), shown at the Salon des Refusés in 1863. Although Sargent probably did not meet the older expatriate until 1880, he no doubt heard about Whistler and *The White Girl* from his French teacher and his fellow American students.[371]

Whistler again took center stage in the winter of 1878, when his libel suit against the English art critic John Ruskin went to trial. The artistic object of Ruskin's critique was *Nocturne in Black and Gold: The Falling Rocket* (cat. 7), which Whistler described in court as representing "a distant view of Cremorne, with a falling rocket and other fire-works."[372] The trial captivated the English and American press and brought attention to the artist on an international scale.[373] Although Sargent probably did not see Whistler's *Falling Rocket* before 1879, he would certainly have heard about it, and its subject, through news of the Ruskin trial.

Sargent may have had Whistler's work in mind when he took up a similar subject during his trip to Spain the following fall.[374] Among the sketches he brought back to his Parisian studio were a series of drawings of tango dancers under a starry sky, perhaps based on his experiences in Seville.[375] From those preparatory works came *The Spanish Dance*, a rare nighttime scene on an almost square canvas. Sargent apparently viewed *The Spanish Dance* as unfinished, however, for he never exhibited it.[376] Barely distinguishable in the blackness of the night are three couples swirling through the outdoor celebration while a group of musicians plays in the background. In its color scheme of black and gray, its mysterious mood, and the suggestion of fireworks against a darkened sky, Sargent's painting makes an evocative comparison with *The Falling Rocket.* —LTJ

57 | JOHN SINGER SARGENT, 1856–1925
W. Graham Robertson, 1894

Oil on canvas, 90¾ × 46¾ inches
Tate Britain, London
Presented by W. Graham Robertson, 1940
Not in exhibition

SARGENT MOST LIKELY MET WHISTLER IN VENICE in the fall of 1880. At that time, the two artists may have worked side by side, or at least in the same location, for the setting of Sargent's *Venetian Interior* (see fig. 37) closely resembles that of Whistler's pastel *The Palace in Rags* (see fig. 38). Sargent had followed in the older expatriate's footsteps, arriving in Venice after Whistler had been there for about a year. The pattern continued when Sargent moved into Whistler's former studio at 13 Tite Street, London, in 1886.[377] Despite the sense of rivalry prompted by their roles as the leading American portraitists of their day, Whistler "had no dislike for Sargent," according to his biographers the Pennells: "On the contrary he held him in great friendliness. . . . But the excessive praise of Sargent, then the fashion, got on his nerves."[378] The friendship between the two artists is documented by their correspondence: letters from Whistler to Sargent, such as the one with which he sent the younger artist the French translation of his "Ten O'Clock" lecture; and Sargent's letters to Whistler, such as those attempting to secure a place for him in the Boston Public Library mural program or to find a suitable owner for the Peacock Room.[379]

The international press had linked Sargent and Whistler during the 1880s and had the opportunity to point out Whistler's influence again when Sargent's *W. Graham Robertson* appeared at the Royal Academy in 1895 and the Champ-de-Mars Salon in 1896.[380] The limited tonalities, full-length format, elegant costume, and simplified composition of Sargent's portrait recall some of Whistler's best-known paintings, including his most recent work, shown at the Salon of 1894, *Arrangement in Black and Gold: Comte Robert de Montesquiou-Fezensac* (see fig. 73). According to Robertson (1866–1948), Sargent had already completed much of his portrait when he went to Paris and saw Whistler's painting in the Salon. "It's just like this!" Sargent told Robertson. "Everybody will say that I've copied it."[381] Some critics did compare the two, but "of imitation," the critic Claude Phillips wrote, "there can, of course, be no question between two artists of this calibre."[382] Other critics described Whistler's influence in more general terms, and a few used a Whistlerian vocabulary to praise Sargent's work as a "harmony" or an "arrangement."[383]

Perhaps the most Whistlerian feature of the composition is the setting, much more somber and spare than those of Sargent's other portraits from this period. Against a black lacquered screen, the pale, almost ghostly figure of Robertson stands wrapped in a long, dark overcoat. Robertson's reddish lips and glistening hair, along with his jade-tipped cane and the poodle's bow, provide hints of color within an otherwise neutral tonal scheme. Robertson was the ideal candidate for Sargent's most Whistlerian portrait; his slender physique, blond hair, and boyish features coincided precisely with current literary descriptions of aesthetes, such as Dorian Gray, from Oscar Wilde's 1890 novel. Robertson may also have inspired Sargent to portray him in such a manner because he was Whistler's friend, a collector of his art, and a painter himself.[384] —LTJ

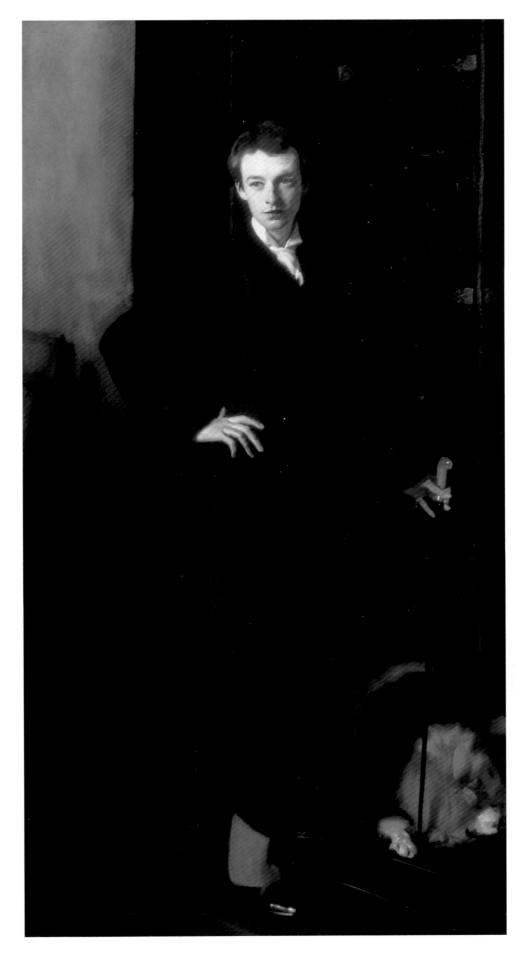

58 | EDUARD J. STEICHEN, 1879–1973
Shower on Lake, 1903

Oil on canvas, 15 × 18 inches
Federal Reserve Board, Washington, D.C.
Gift of Ronald Abramson, Alsdorf Foundation,
The Dillon Fund, Gerald D. Hines, David L. Kreeger,
Ronald S. Lauder, William M. Martin, Irving Mathews,
Robert Rogers, Swig Foundation, The Washington
Post Co., Harold Williams, and an anonymous donor

FIG 113 Eduard J. Steichen (1879–1973), *Brooklyn Bridge at Night*, 1903, gelatin silver print, 17 × 14 inches.

"WHISTLER, WHOSE INFLUENCE FEW IF ANY moderns have escaped . . . affected this young man profoundly," the critic Charles Caffin wrote of Eduard Steichen's paintings in 1910. "He found in the great artist not only technical example but a kinship of spirit."[385] Though better known for his inestimable contributions to the history of modern photography, Steichen began his career as both a painter and a photographer and continued working in both media until 1923, when he accepted a position as a commercial photographer for Condé Nast.[386] As a boy, Steichen had discovered Whistler's work in reproductions at the Milwaukee Public Library. He probably saw Whistler's paintings for the first time at the World's Columbian Exposition of 1893.[387] After Steichen moved to Paris at the age of twenty-one, he wrote to his early mentor, Alfred Stieglitz, of his admiration for Whistler.[388] He wanted to include the famous expatriate among the other artists and writers he photographed in Europe, but the opportunity did not arise.[389] By the time Steichen returned to New York, he had embraced a Whistlerian aesthetic. Photographs such as *Brooklyn Bridge at Night* (fig. 113) share a subject and style with Whistler's Nocturnes: a misty atmospheric view of a bridge and lights reflected in the water at night.

It was in 1903, the year of Whistler's death, that Steichen painted *Shower on Lake*, one of his most Whistlerian canvases. Steichen had worked alongside Stieglitz at Lake George, and this canvas probably originated there, along with a series of moonlit scenes.[390] Steichen chose the passing of a rainstorm as the setting for this subtle view of the water. Caffin regarded such subjects, rather than more obviously mysterious night scenes, as "an advance beyond the nocturnes even of Whistler."[391] Sheets of rain veil the almost monochromatic composition, thinly painted in shades of white with pale green on the horizon. Following the ideal of harmony between the canvas and its setting, the reeded frame, designed by the artist George Of (1876–1954), is toned to suit the palette of the painting. —*LTJ*

59 | HENRY OSSAWA TANNER, 1859–1937
Portrait of the Artist's Mother, 1897

Oil on canvas, 29¼ × 39½ inches
Philadelphia Museum of Art, Pennsylvania
Partial gift of Dr. Rae Alexander-Minter and purchased
with the W. P. Wilstach Fund, the George W. Elkins
Fund, the Edward and Althea Budd Fund, and with funds
contributed by the Dietrich Foundation, 1993

HENRY OSSAWA TANNER, THE SON OF A DISTIN-
guished minister of the A.M.E. Church, grew up in Wash-
ington, D.C., and later moved to Philadelphia. At the age
of twenty-one, he began his career as a student of Thomas
Eakins (see cat. 36) at the Pennsylvania Academy of the
Fine Arts. After a fruitless attempt to establish a photog-
raphy studio in Atlanta, Tanner left for Europe in 1891
and enrolled at the Académie Julian in Paris. His early
and best-known paintings, such as *The Banjo Lesson* (1893,
Hampton University Museum), depict African American
genre subjects, but his first major success in Paris was a
religious narrative, *The Raising of Lazarus* (1896, Musée
d'Orsay), selected from the Salon of 1897 for the Musée
du Luxembourg, the renowned collection that housed
Whistler's portrait of his mother.[392]

Tanner returned to the United States in 1897, triumphant
with the news that the French government had purchased
his most recent painting. On a visit to his parents in Kan-
sas City, he painted a portrait of his own mother, the daugh-
ter of a slave—perhaps, as Darrel Sewell has suggested, as a
"gentle intellectual joke" about his recent success in Paris.[393]
In a clever appropriation of Whistler's famous portrait,
Tanner placed his mother, Sarah Elizabeth Miller Tanner,
seated and facing left, in a shallow space demarcated by
drapery in the background, with a simply framed work
of art on the wall. Tanner chose a limited color scheme,
though he favored warm tones over the austere grays of
Whistler's canvas. Mrs. Tanner sits in a rocking chair,
suggestive of her nurturing role as a mother, and light
streaming from the left illuminates her forehead, indicat-
ing her intelligence. Inscribed "to my dear mother," Tan-
ner's portrait served as both an affectionate tribute and an
acknowledgment of his own recent achievement. As Rachel
Arauz has suggested, however, underlying Tanner's efforts
was the African American artist's continued struggle for
a race-blind assessment of his art. Ironically, his formal
exercise in Whistler's aestheticism became an "act of
racial self-assertion," a proud recognition of his family's
heritage.[394] —LTJ

60 | HENRY OSSAWA TANNER, 1859–1937
The Seine, ca. 1902

Oil on canvas, 9 × 13 inches
National Gallery of Art, Washington, D.C.
Gift of the Avalon Foundation, 1971.57.1

FOLLOWING HIS EARLY SUCCESS AT THE SALON, Tanner remained an expatriate and kept a studio in Paris for the rest of his career.[395] *The Seine,* painted a decade after Tanner settled there, is a rare informal sketch of the contemporary urban scene. Tanner's treatment of his subject, a twilight view across the river to the Palais du Trocadéro and the Pont Royal, is Whistlerian in its limited tonal range, although the painting's hues are much warmer than Whistler's customary palette.[396] Against a high horizon line, the waters of the Seine and the buildings and bridges of Paris appear to melt into each other in the rosy light of sunset. *The Seine* is unusual in Tanner's oeuvre because of its nonnarrative content and simple composition and may have been painted as a respite between complex figural narratives.[397] Never exhibited during the artist's lifetime, it was a gift to his friend Frederick Gutekunst (1831–1917), a Philadelphia photographer.[398] —LTJ

61 HENRY OSSAWA TANNER, 1859–1937
The Disciples See Christ Walking on the Water,
ca. 1907

Oil on canvas, 51½ × 42 inches
Des Moines Art Center Permanent Collection, Iowa
Gift of the Des Moines Association of Fine Arts, 1921.1
Not in exhibition

AROUND THE TURN OF THE NINETEENTH CENTURY, Tanner began to place his religious scenes in nocturnal settings. Using a palette of blues and violets, he depicted shadowy figures in classic Christian narratives with night-time settings, including *Nicodemus Visiting Jesus* (1899, Pennsylvania Academy of the Fine Arts) and *The Flight into Egypt* (1899, The Detroit Institute of Arts). *The Disciples See Christ Walking on the Water* presents the miracle of Christ walking on the Sea of Galilee: as Christ appears on the water, He calms the storm that had raged around the boat carrying the disciples, who look to Him in fear and awe. The painting's asymmetrical composition, high horizon, watery reflections, and dominant blue tones suggest the most distinctive elements of Whistler's Nocturnes. The saturated blues of Tanner's night scene recall in particular Whistler's *Nocturne: Blue and Silver—Bognor* (fig. 114), a view of boats on the ocean at night, which Tanner could have seen at the Memorial Exhibition in Paris in 1905. The geometric structure of Tanner's composition emphasizes its surface design, yet in contrast to Whistler's poetic and primarily aesthetic themes, the subject of Tanner's painting remains of principal importance. —LTJ

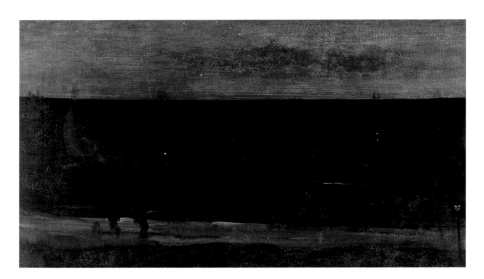

FIG 114 James McNeill Whistler (1834–1903), *Nocturne: Blue and Silver—Bognor*, 1871–1876, oil on canvas, 19¹³⁄₁₆ × 31⅝ inches, Freer Gallery of Art, Smithsonian Institution, Washington, D.C., gift of Charles Lang Freer, F1906.103.

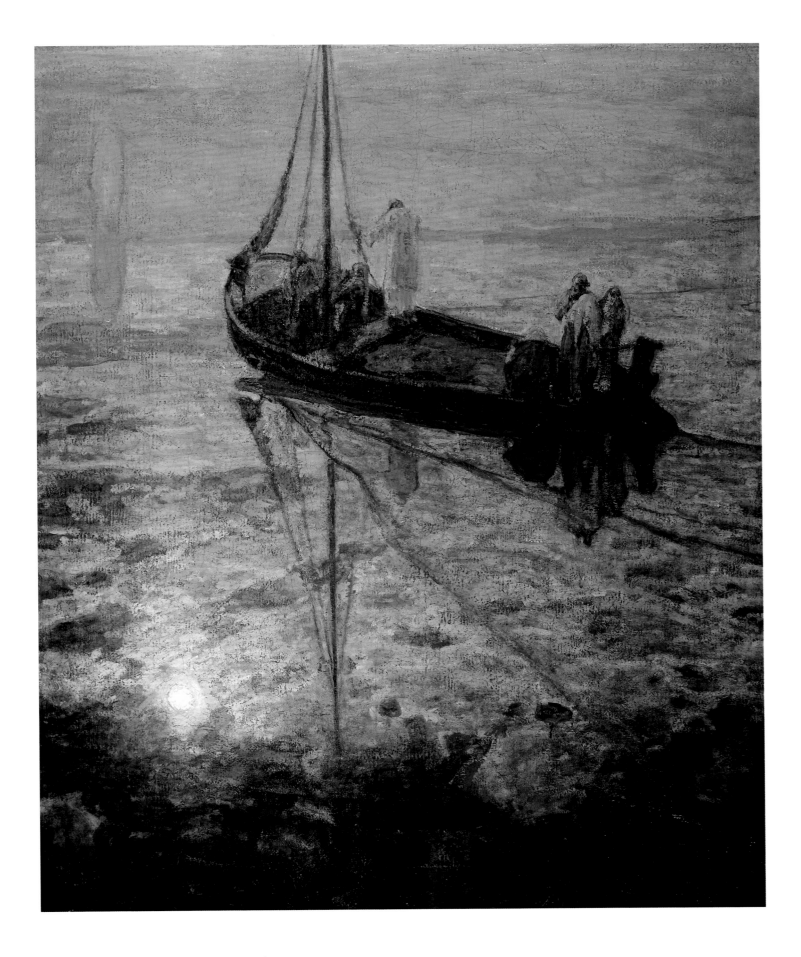

62 | EDMUND C. TARBELL, 1862–1938
Girl Cutting Patterns, 1907–1908

Oil on canvas, 25 × 30 inches
Marie and Hugh Halff

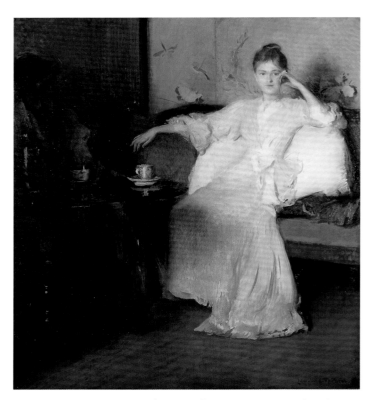

FIG 115 Edmund C. Tarbell (1862–1938), *Arrangement in Pink and Gray (Afternoon Tea),* ca. 1894, oil on canvas, 44⅞ × 43¹¹/₁₆ inches, Worcester Art Museum, Worcester, Massachusetts, anonymous gift of 50% ownership, 1995.73.

EDMUND TARBELL BEGAN HIS STUDIES IN 1879 at the School of Drawing and Painting of the Museum of Fine Arts in Boston. Five years later, he embarked upon a course of study popular with American artists by enrolling at the Académie Julian in Paris. Back in Boston by 1886, Tarbell eventually accepted a teaching position at the Museum of Fine Arts School and in 1890 was named the School's co-director, with Frank Benson (1862–1851).[399]

Tarbell counted Whistler among his favorite painters.[400] An early example of his interest is *The Artist's Grandmother Knitting* (ca. 1880s, private collection), a portrait of his grandmother in a black dress seated before a folding screen, a subject reminiscent of Whistler's portrait of his mother.[401] In paintings of the 1890s such as *Arrangement in Pink and Gray* (fig. 115), Tarbell adopted Whistler's preference for "arrangements" of a few choice colors. Indeed, the critic for the *New York Evening Post* praised *Arrangement in Pink and Gray* as "symphonious in color" and noted that Tarbell had titled his painting in "Whistlerian parlance."[402]

Tarbell's greatest critical success came with his images of contemplative female figures surrounded by objets d'art, scenes in which he combined a Whistlerian aesthetic with that of Jan Vermeer (1632–1675), the Dutch master of quiet interiors.[403] *Girl Cutting Patterns,* which may be Tarbell's most explicitly Whistlerian painting, belongs to the genre of kimono-clad female images inspired largely by Whistler's *La Princesse du pays de la porcelaine* (see fig. 13). Tarbell's painting specifically recalls *Caprice in Purple and Gold: The Golden Screen* (see fig. 86), which he could have seen among the photographs after Whistler's work published by the Goupil Gallery in 1892.[404] Just as Asian objects appear scattered about Whistler's painting, Tarbell included a Chinese vase in *Girl Cutting Patterns.*[405] In both paintings, the female subjects take a rather eccentric pose for the time, sitting on a carpeted floor with a Japanese folding screen behind them and occupying themselves with artwork.

—*LTJ*

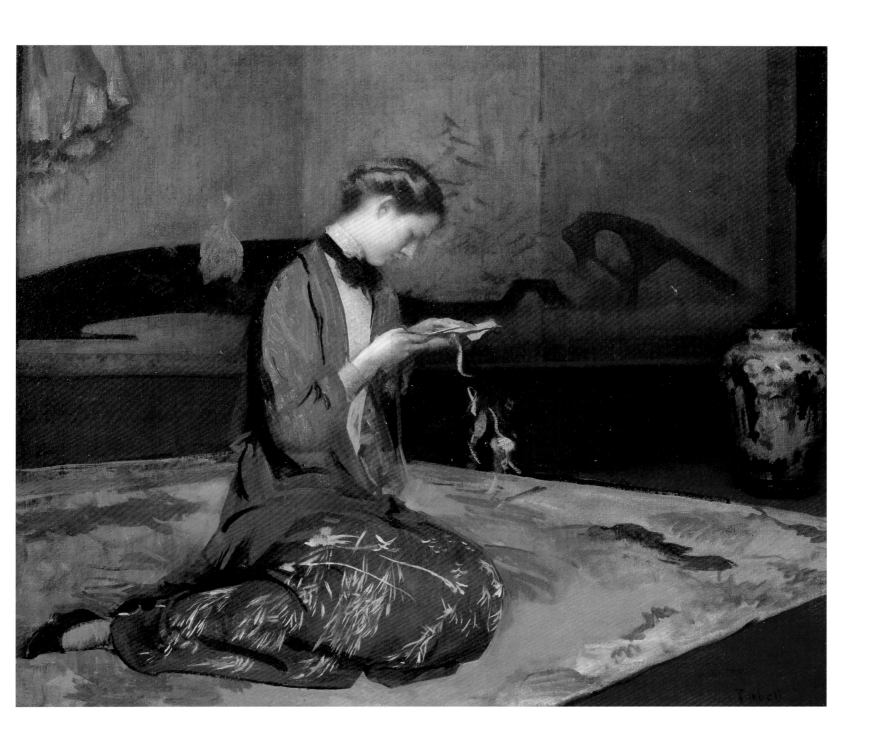

63 | JOHN HENRY TWACHTMAN, 1853–1902
Along the River, Winter, ca. 1887–1888

Oil on canvas, 15⅛ × 21¹¹/₁₆ inches
High Museum of Art, Atlanta, Georgia
J. J. Haverty Collection, 49.28

HAVING STUDIED BRIEFLY WITH FRANK DUVENECK in his hometown of Cincinnati, Twachtman traveled to Europe with his teacher and joined him and William Merritt Chase (see cats. 22–28) in Venice in 1877. Although he seems to have missed meeting Whistler during his trips to Italy, Twachtman would surely have heard about him from his friends among the Duveneck Boys.[406] After he had been back in the United States for a couple of years, Twachtman decided to go abroad again in 1883 to continue his course of study at the Académie Julian in Paris. There he would have had many opportunities to become acquainted with Whistler's work, including an exhibition of Nocturnes at the Galerie Georges Petit in the year that he arrived.[407]

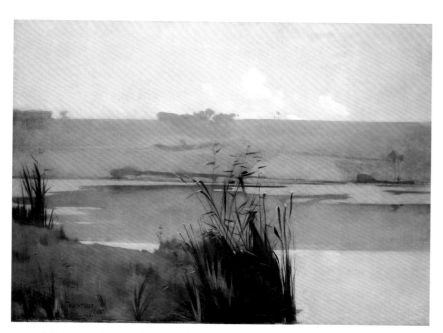

FIG 116 John Twachtman (1853–1902), *Arques-la-Bataille,* 1885, oil on canvas, 60 × 78⅞ inches, The Metropolitan Museum of Art, New York, Morris K. Jesup Fund, 1968, 68.52.

Twachtman adopted a Whistlerian aesthetic in his monumental submission to the Salon of 1885, *Arques-la-Bataille* (fig. 116), which he appears to have later retitled *Decorative Landscape.*[408] The new title refocuses attention from the location of the scene to the formal aspects of the painting, its nearly abstract composition and artificially narrow and low-keyed color scheme. Using thin washes of paint, Twachtman bathed the river landscape in atmospheric haziness, recalling Whistler's views of the foggy banks of the Thames. Such effects captivated Twachtman, as he later described in a letter to his neighbor and colleague J. Alden Weir (see cats. 65–67): "To-night is full moon, a cloudy sky to make it mysterious and a fog to increase mystery. Just imagine how suggestive things are."[409]

Snow was among Twachtman's favorite subjects, perhaps because it, too, adds mystery to a landscape. "We must have snow and lots of it," he wrote to Weir. "Never is nature more lovely than when it is snowing. Everything is so quiet and the whole earth seems wrapped in a mantle."[410] Painting the snow-covered countryside also met the Whistlerian challenge of painting within a white color scheme, an accomplishment for which Whistler had praised Canaletto (1697–1768), saying he "could paint a white building against a white cloud."[411] In *Along the River, Winter,* a bleak, rural landscape is shrouded by a fresh snowfall marred only by the dark, jagged lines of carriage tracks. The dismal isolation of the scene suggests that it may have been painted in the suburbs of Cincinnati, where Twachtman endured a period of hopelessness before settling in Greenwich, Connecticut, his home for the rest of his career. Twachtman's Greenwich snow scenes, such as *Winter Harmony* (early 1890s, National Gallery of Art), are painted in a more impressionist manner but retain the delicacy of Whistler's art. As one critic remarked, "Twachtman painted day as Whistler painted night."[412]

In 1897, Twachtman played an instrumental role in forming a new exhibition society called the Ten American Painters. Through his paintings, pastels, and etchings, Twachtman conveyed his understanding of a Whistlerian aesthetic to a generation of students, including Ernest Lawson (see cat. 48), at the Art Students League in New York. —*LTJ*

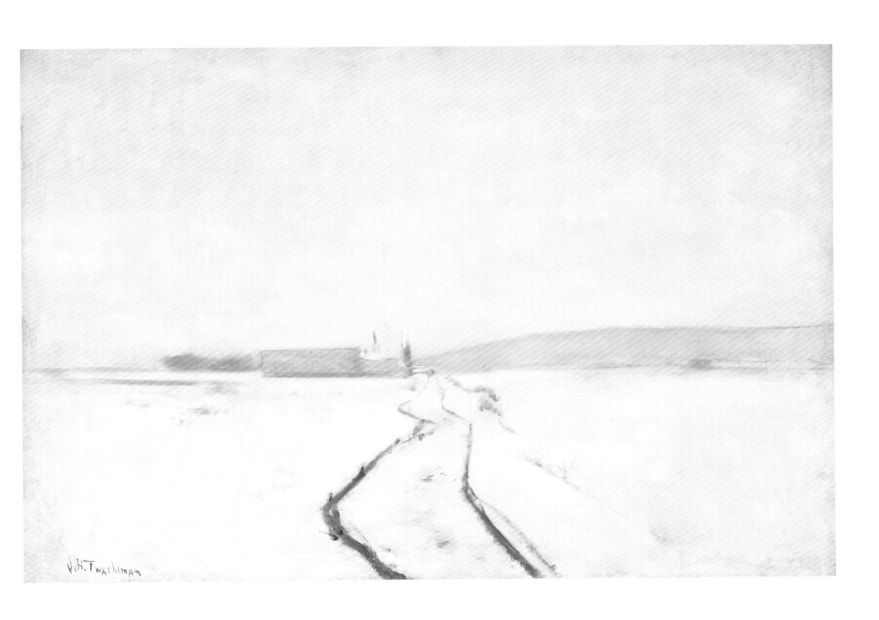

64 | EVERETT L. WARNER, 1877–1963
Gloucester, ca. 1908

Oil on canvas board, 6¼ × 9⁷⁄₁₆ inches
Pennsylvania Academy of the Fine Arts, Philadelphia
Gift of Vera White, 1956.3.3

EVERETT WARNER SPENT MUCH OF HIS YOUTH in Washington, D.C., and beginning at the age of eighteen wrote as the art critic for the Washington *Evening Star.* After studying at the Art Students League in New York, where he met John Twachtman (see cat. 63), Warner left for Paris in 1903 and enrolled in the Académie Julian.[413] Whistler, Warner later told his son Thomas, was all the rage among American artists in Paris at the time.[414] Although much of Warner's early work consists of etchings, watercolors, and pastels, in Paris he began to paint in oils, composing nocturnes of the city and the French countryside such as *Moonlight in Montreuil* (ca. 1904, Thomas E. Warner).[415] By this date, Whistler was acknowledged as the master of the nocturne; the American artist and writer Kenyon Cox recognized him as such in 1904: "No one else has so well painted night, no one else so suggested mystery, no one so created an atmosphere."[416]

In 1908, Warner visited Gloucester, Massachusetts, where, alongside Twachtman and others, he had often summered since his early days in Washington.[417] *Gloucester,* perhaps produced that year, recalls Whistler's Notes in its low, cool tones of gray and blue (see cats. 11, 13, and 14).[418] Warner may have seen similar Notes by Whistler at the Memorial Exhibition of 1905 held at the Ecole des Beaux-Arts.[419]

—LTJ

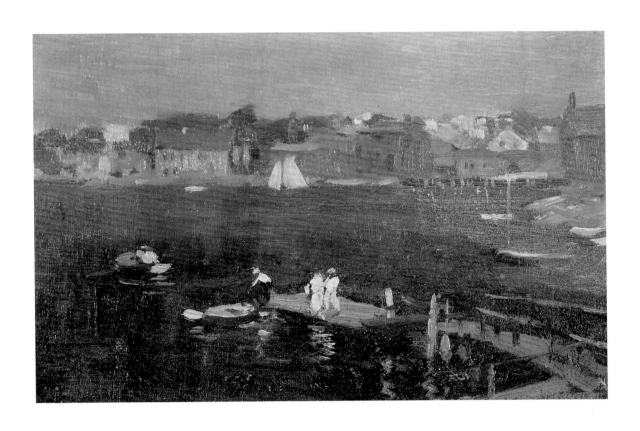

65 | J. Alden Weir, 1852–1919
Silver Chalice, Japanese Bronze, and Red Taper,
ca. 1884–1889

Oil on canvas, 17⅛ × 11⅝ inches
Florence Griswold Museum, Old Lyme, Connecticut
Gift of the Hartford Steam Boiler Inspection and
Insurance Company

FIG 117 James McNeill Whistler, 1885, The National Portrait Gallery, London, P356.

WHEN WHISTLER STUDIED DRAWING WITH Robert W. Weir during his short-lived career at West Point, he could not have foreseen that his teacher's son, Julian Alden, would become one of his most sympathetic American colleagues. Later, Whistler claimed that he had known J. Alden Weir as a child, but this, as Childe Hassam surmised, seems unlikely.[420] It appears that the two met for the first time in August 1877, when Weir visited Whistler at his studio in London. He was initially disappointed in the expatriate painter's work but determined to examine Whistler's etchings in the British Museum and "settle him decidedly" in his mind.[421] Such "settling" did not occur, for Weir's admiration for his American colleague continued to grow, and he found himself drawn to Whistler's work throughout his life.

Weir had begun his career at the National Academy of Design in New York, followed by studies at the Ecole des Beaux-Arts in Paris, with early success in still-life painting and portraiture. In 1882 he purchased a farm in Branchville, Connecticut, where he would paint for many years, often in the company of John Twachtman (see cat. 63) and Childe Hassam (see cats. 43–44).[422] There, his friends remembered, a print by Whistler hung over his fireplace.[423]

Weir's friendship with Whistler had begun in earnest in 1881, when the two artists met again, this time at the National Gallery in London. Weir was making a copy of a portrait by Velázquez when he "became conscious of one man walking up and down, up and down past his easel, looking at his work. Finally he was heard to murmur, 'Not bad—not bad at all!'" Whistler reintroduced himself, and the artists arranged to have dinner together. They spent much of the evening darting about the city in attempts to find a satisfactory place to dine, only to return to Whistler's home and find a formal party awaiting his arrival.[424]

Shortly after Whistler's *Symphony in White, No. 1: The White Girl* (cat. 1) was shown in New York in 1881, Weir crafted his own version of a woman in white against a white background holding white flowers, *Flora (Carrie Mansfield Weir)* (1882, Brigham Young University Museum of Art). A few years later, Weir moved the silver chalice that appears on the right side of *Flora* into the foreground of the still-life painting *Silver Chalice, Japanese Bronze, and Red Taper.* Just visible to the left of center are Whistler's signature and butterfly emblem, inscribed on what appears to be the mat of a photograph Whistler had given to Weir as a token of friendship—possibly a photogravure attributed to Mortimer Menpes (fig. 117).[425] By including Whistler's image in this intimate glimpse of his studio, Weir may be suggesting that he feels the artist's presence as he works—that Whistler is always watching over his shoulder, as he had that day in the National Gallery. —LTJ

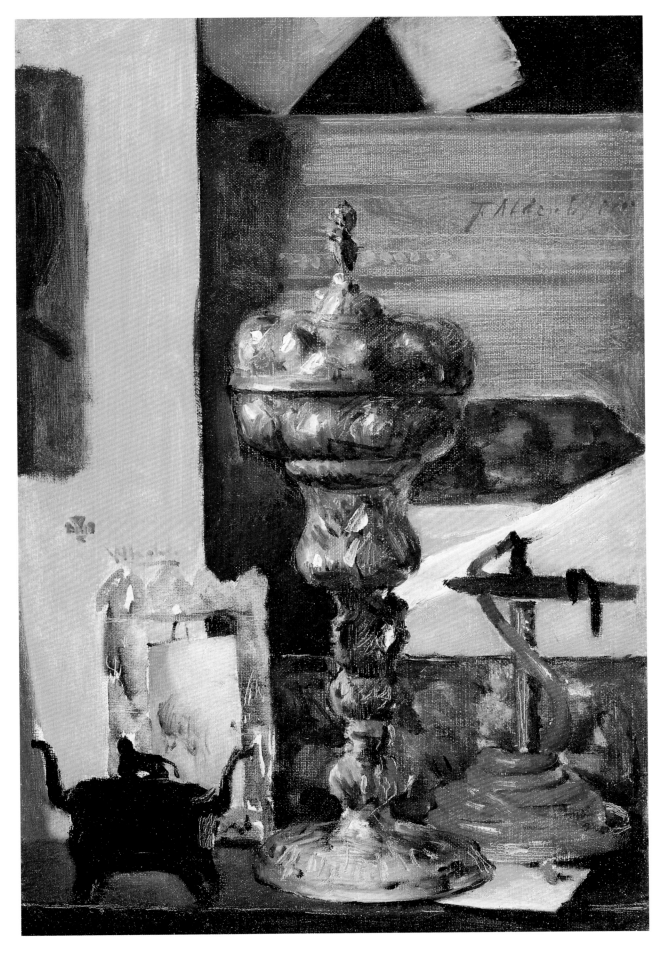

66 | J. Alden Weir, 1852–1919
Face Reflected in a Mirror, 1896

Oil on canvas, 24¼ × 18⅝ inches
Museum of Art, Rhode Island School of Design,
Providence
Jesse Metcalf Fund, 03.004

After attending the World's Columbian
Exposition in Chicago, Weir declared that Whistler's *La
Princesse du pays de la porcelaine* (see fig. 13) was the best
work on display.[426] *Face Reflected in a Mirror,* though a small
canvas, presents Weir's own figure study in *japonisme,* for
his knowledge of Japanese prints informs the strong geom-
etry of the composition. Framing devices such as the win-
dow, mirror, and bedpost divide the image and compress
the space around the central figure.[427]

Weir's subject appears to be his bride, Ella Baker (b. 1852),
the sister of his late first wife, who turns away from a mir-
ror to reveal her profile.[428] Although the painting's meth-
ods are not dependent upon a specific prototype, aspects
of the work recall a number of Whistler's paintings. His
wife's unusual pose—her back to the viewer and her left
arm akimbo—resembles that of Maud Franklin in Whistler's
Arrangement in Black and Brown: The Fur Jacket (cat. 9),
another of the artist's contributions to the 1893 Exposition
in Chicago. The setting's architectonic structure and the
dark, Japanesque drapery call to mind Whistler's portrait
of his mother, as well as *Harmony in Green and Rose: The
Music Room* (see fig. 6), one of the first of his works to be
shown in the United States.[429] In *The Music Room,* Whistler
positioned several figures in a similarly flattened space
through the use of a gridlike geometric composition.

—LTJ

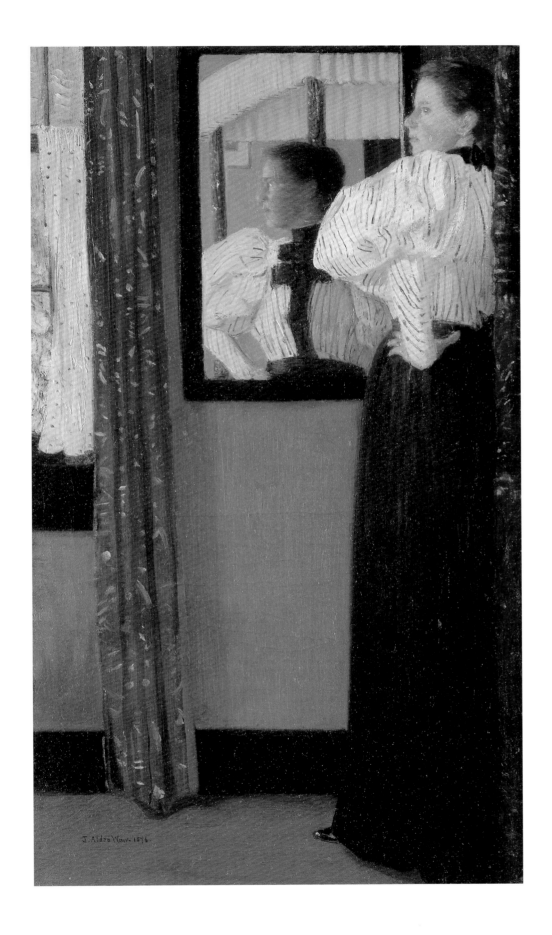

67 | J. ALDEN WEIR, 1852–1919

The Bridge: Nocturne (Nocturne: Queensboro Bridge),
1910

Oil on canvas, mounted on wood, 29 × 39½ inches
Hirshhorn Museum and Sculpture Garden,
Smithsonian Institution, Washington, D.C.
Gift of Joseph H. Hirshhorn, 1966.5507

FIG 118 J. Alden Weir (1852–1919), *The Plaza: Nocturne,* 1911, oil on
canvas, mounted on wood, 29 × 39½ inches, Hirshhorn Museum
and Sculpture Garden, Smithsonian Institution, Washington, D.C.,
gift of Joseph H. Hirshhorn, 1966.

ALTHOUGH HE MAY HAVE PAINTED MOONLIT
scenes as early as the 1880s, Weir's better-known views of
the night date to the decade following Whistler's death.[430]
"Moonlights" were among the most fashionable subjects
of the day, not only because of Whistler's Nocturnes but
also because of the popular moonlit landscapes of Albert
Pinkham Ryder (1847–1917), a close friend whose work
Weir greatly admired.[431] Both Ryder's small visions of
rural moonlight encrusted with thick layers of paint
and Whistler's delicate, tonal Nocturnes inspired Weir
to tackle his own version of the theme in such works
as *Moonlight* (ca. 1905, National Gallery of Art).

The Nocturnes exhibited at the Whistler retrospective
held at The Metropolitan Museum of Art in 1910 may also
have inspired Weir to take up the subject of New York
City at night, an American translation of Whistler's Lon-
don theme. In *The Bridge: Nocturne* and *The Plaza: Nocturne*
(fig. 118), Weir portrayed the city lit with electric lights,
as he would have viewed it from his Manhattan apartment
at Park Avenue and 58th Street.[432] Taking its title from
Whistler's views of the Thames, *The Bridge: Nocturne*
differs from them in that it depicts a recognizable view
of a specific landmark, the Queensborough Bridge, which
had officially opened in 1909. In 1911, Weir exhibited *The
Bridge: Nocturne* at the annual exhibition of the Ten Ameri-
can Painters, a group he had founded in 1897 with John
Twachtman (see cat. 63), Childe Hassam (see cats. 43–44),
and others. At least one critic praised Weir's painting by
noting that it "suggests Whistler."[433] —*LTJ*

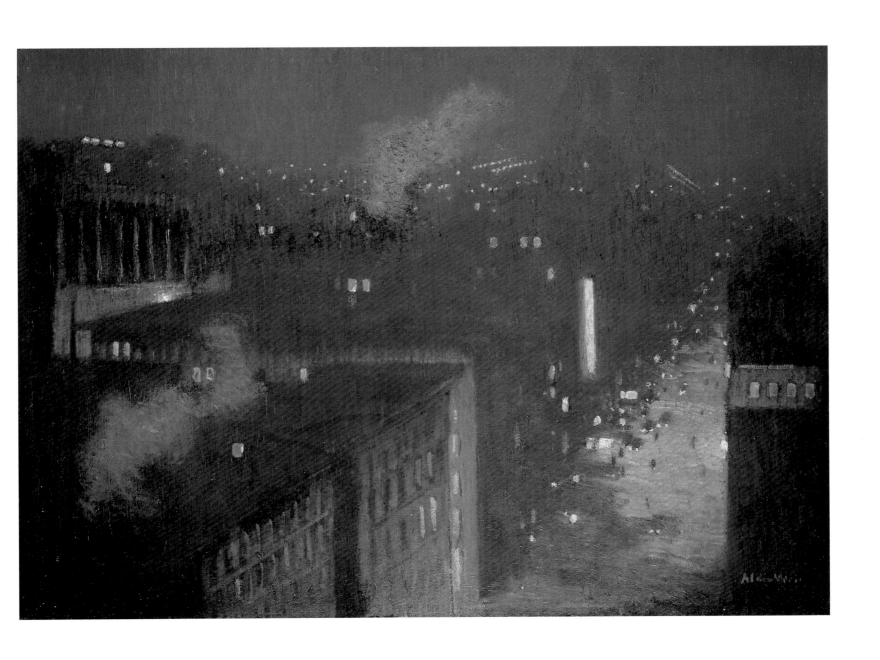

68 | ELISHA KENT KANE WETHERILL,
1874–1929
Seascape No. 1

Oil on panel, 5 × 7¹/₁₆ inches
Pennsylvania Academy of the Fine Arts, Philadelphia
Gift of Vera White, 1956.3.5

A NATIVE OF PHILADELPHIA, ELISHA KENT KANE Wetherill studied with Whistler at the Académie Carmen in Paris and lived abroad for much of his career. His prior education consisted of classes at the Pennsylvania Academy of the Fine Arts, where he would have studied with Thomas Anshutz and perhaps William Merritt Chase (see cats. 22–28), and then at the Académie Julian in Paris, under Jean-Paul Laurens.[434] *Seascape No. 1* reveals Whistler's continuing influence, apparently illustrating his dictum: "Paint should not be applied thick. It should be like the breath on the surface of a pane of glass."[435] In the spirit of Whistler's Notes, Wetherill's seaside sketch depends upon a restricted palette of cool tones, fluidly brushed onto a small canvas.[436] —LTJ

1. For discussions of *The White Girl* as an essay in Realist painting, see Dorment and MacDonald, *James McNeill Whistler*, p. 77; Merrill, *Peacock Room*, pp. 47–48; and Spencer, "Whistler's 'The White Girl.'"

2. Young et al., *Paintings of Whistler*, no. 38. Collins's *Woman in White* was first published in 1860.

3. Whistler to the *Athenaeum*, July 1, 1862, in Thorp, *Whistler on Art*, no. 6, p. 12.

4. Unidentified clipping [Baltimore], March 18, 1876, GUL, BP II Press Cuttings, vol. 1, p. 73.

5. Ibid.; and W. W. C., "Baltimore Art-Exhibition," *Art Journal* (May 1876), p. 136, quoted in Torchia, *American Paintings*, p. 242.

6. "The Union League. The Regular Monthly Meeting of the Club and an Exhibition of Pictures," unidentified newspaper [New York, ca. April 10], 1881, GUL, BP II Press Cuttings, vol. 4, p. 61.

7. At the Metropolitan Museum, where it was exhibited from May through October 1881 in *Loan Collection of Paintings*, it was titled *The White Girl*.

8. Nicolai Cikovsky Jr. with Charles Brock, "Whistler and America," in Dorment and MacDonald, *James McNeill Whistler*, p. 34.

9. "The Society of American Artists," *New York Daily Tribune*, March 25, 1883, p. 5, quoted in Gallati, *Chase: Modern American Landscapes*, p. 161 n. 76.

10. *Loan Collection*, July 1894 to December 1895, The Metropolitan Museum of Art, New York. The owner of the painting (Thomas D. Whistler, the late George Whistler's son) lent the painting to the museum to avoid paying insurance (Pennell and Pennell, *Whistler Journal*, p. 4). In January 1895 he offered it to the Metropolitan Museum, reputedly for $15,000 (E. G. Kennedy to Whistler, January 29, 1895, GUL, Whistler W1234).

11. Pennell and Pennell, *Whistler Journal*, p. 4; and D. Young, *Life and Letters of Weir*, p. 204.

12. Cox, "Whistler Memorial Exhibition," p. 168.

13. Metropolitan Museum, *Paintings by Whistler*, p. 4.

14. Child, "American Artists," pp. 494–495.

15. "Fine Arts."

16. Anna Whistler to James H. Gamble, February 10, 1864, in Thorp, *Whistler on Art*, no. 9, p. 25.

17. Van Hook, "Decorative Images of American Women," p. 62.

18. Young et al., *Paintings of Whistler*, no. 47.

19. Pennell journal, June 4, 1912, PWC, box 353.

20. Hobbs, *Art of Dewing*, p. 33.

21. Merrill, *Peacock Room*, pp. 80–81. Nigel Thorp has discovered documents in the Library of Congress confirming this report (see Simon Grant, "Whistler's Call to Arms").

22. Pennell and Pennell, *Life of Whistler*, vol. 1, p. 135.

23. Young et al., *Paintings of Whistler*, no. 71.

24. The painting was probably exhibited *Nocturne in Grey and Gold* at the Dudley Gallery, London, in 1872. Ibid., no. 117.

25. Whistler to Frederick R. Leyland [November 1872], in Thorp, *Whistler on Art*, no. 14, pp. 46–47.

26. "Winter Exhibition," p. 568.

27. Ferber, *William Trost Richards*, p. 34.

28. The Metropolitan Museum purchased *Nocturne in Green and Gold* (see fig. 112) from the American artist Walter Gay, who had bought it on the museum's behalf from a Parisian dealer. The painting was accessioned as *The Falling Rocket* (its subtitle in the catalogue of the 1905 London Memorial Exhibition of Whistler's works), although its title was later changed to *Nocturne in green and gold: Cremorne Gardens, London, at night* (06.286). In 1912, the Metropolitan Museum bought a finer example, *Cremorne Gardens, No. 2* (ca. 1872–1877). The Philadelphia Museum of Art acquired *Nocturne: Grey and Silver* (ca. 1873–1875) through a bequest from John G. Johnson in 1917, and Isabella Stewart Gardner left one to her museum in 1924 (cat. 5), but the next purchase of a Nocturne by a public institution did not come until 1942, when the Museum of Fine Arts, Boston, acquired *Nocturne in Blue and Silver: The Lagoon, Venice* (1879/1880).

29. Tharp, *Mrs. Jack*, pp. 62–63.

30. MacDonald, *Whistler: Drawings, Pastels, and Watercolours*, no. 1116.

31. Whistler to Isabella Stewart Gardner [October 29/30, 1886], Isabella Stewart Gardner Museum, Boston.

32. Hooper, a Boston collector, had acquired an early painting attributed to Whistler, *Interior* (ca. 1855–1858, Thomas M. Evans), by 1879, when he lent it to the second annual exhibition of the Society of American Artists in New York. In 1890, Hooper purchased *A Red Note: Fête on the Sands, Ostend* (ca. 1887, private collection) and offered Whistler one of his first American commissions for a portrait of his daughter (*Portrait of Ellen Sturgis Hooper*, 1890, Willard Clark Collection).

33. Gardner to Whistler [November/December 1892], GUL, Whistler G7.

34. Walter M. Whitehill, "The Making of an Architectural Masterpiece—The Boston Public Library," *American Art Journal* 2 (Fall 1970), pp. 13–35, quoted in Young et al., *Paintings of Whistler*, no. 396.

35. *Town Topics*, 1892, quoted in Tharp, *Mrs. Jack*, p. 168.

36. Gardner to Whistler [November/December 1892].

37. Merrill, *Peacock Room*, p. 316. Whistler thought the idea of installing the Peacock Room "in bits!" in Bates Hall a preposterous idea and referred to "Mrs. Jack" in a letter to his wife as "a most dangerous busy body" (Whistler to Beatrix Whistler, November 3, 1895, GUL, Whistler W626). In 1904, when Charles Lang Freer secretly purchased the Peacock Room, it was rumored in London that Mrs. Gardner—by then an internationally renowned collector—was its new owner: "It may easily be supposed that the lady who thought nothing of carrying a chapel over from Italy to Boston will think less of importing this mere husk of a London drawing-room" ("Art Notes," 1904).

38. Young et al., *Paintings of Whistler*, no. 152. Whistler's receipt, dated June 25, 1895, indicating that Gardner paid six hundred guineas for the painting, is in the Isabella Stewart Gardner Museum. See also Hendy, *Paintings in the Gardner Museum*, p. 291. Only Samuel Untermyer, who purchased *Nocturne in Black and Gold: The Falling Rocket* (cat. 7) in 1892, and John G. Johnson of Philadelphia, who acquired *Nocturne: Grey and Silver* (ca. 1873–1875, Philadelphia Museum of Art) in 1894, preceded Gardner in purchasing Nocturnes.

39. Whistler to Gardner [1895?], Isabella Stewart Gardner Museum, Boston.

40. Siewert, "Suspended Spectacle," p. 44.

41. Ronald Pisano, Introduction to Cohen, *Eliot Clark*, p. 18.

42. Yale Center for British Art records; and Ingram, "Win for Yale," p. 33. See also Young et al., *Paintings of Whistler*, no. 151.

43. Whistler to Sidney Starr, September 26, 1892, FGAA, no. 78.

44. Young et al., *Paintings of Whistler*, no. 170.

45. Merrill, *Pot of Paint*, p. 154.

46. "Home Notes and News," *New York Herald*, October 29 [1883], GUL, Whistler Press Cuttings, vol. 3, p. 37.

47. The painting has a spurious signature, lower right, "Whistler, 1890," and a spurious butterfly emblem in the lower left corner. Among the candidates for artists that scholars have suggested in recent years are Harper Pennington, Frank Boggs (1855–1926), and Eugene Vail (1857–1934) (Philadelphia Museum of Art curatorial files).

48. At the time of the Goupil Gallery exhibition in London, Whistler probably placed the painting in its present reeded frame. Its earlier frame, a matter of discussion in *Whistler v. Ruskin*, was "traced with black," as Whistler explained, "and the black mark on the right side is my monogram, which was placed in its position so as not to put the balance of color out" (Merrill, *Pot of Paint*, p. 153).

49. Whistler to D. C. Thomson, director of the Goupil Gallery, London, postmarked November 6, 1892, PWC, box 16.

50. Whistler to Starr, September 26, 1892.

51. Whistler to Samuel Untermyer, September/October 1892, GUL, Whistler U15.

52. Untermyer to Whistler, October 11, 1892, GUL, Whistler U16.

53. Ibid., November 7, 1892, GUL, Whistler U18.

54. A painting titled *Nocturne in Green and Gold, The Falling Rocket* was shown at the London Memorial Exhibition in 1905 and subsequently purchased by The Metropolitan Museum of Art as the famous *Falling Rocket*. Its title was later changed to *Nocturne in Green and Gold* (*Nocturne in Black and Gold: The Gardens*) (see fig. 112).

55. Kobbé, "Epoch-Making Picture," pp. 8–9.

56. Cortissoz, *Art and Common Sense*, p. 203.

57. Richardson, "Nocturne in Black and Gold," p. 9.

58. Detroit Institute of Arts, *American Paintings*, pp. 235–237.

59. Chase, "Two Whistlers," pp. 220–221.

60. Young et al., *Paintings of Whistler*, no. 122.

61. The painting was initially exhibited at the Grosvenor Gallery in 1877 as *Arrangement in Brown*. It was subsequently shown in Brussels (1888) as *Arrangement en noir No. 3*, in Amsterdam (1889) as *The Fur Jacket. Arrangement in black No. 3*, in Brussels (1890) as *The fur jacket*, in Liverpool (1891) as *Arrangement in Black—The Fur Jacket*, in London at the Goupil Gallery (1892) as *Arrangement in Black and Brown. The Fur Jacket*, in Munich (1892) as *Die Peltzjacke*, and in Chicago (1893), Philadelphia (1893–1894), and Pittsburgh (1896–1897) as *The Fur Jacket* (Young et al., *Paintings of Whistler*, no. 181).

62. Whistler to Alexander Reid [August 2, 1892], GUL, Whistler Letterbook, vol. 4, p. 40.

63. *Arrangement in Black and Brown* was the earliest of Whistler's portraits to be given a title that referred to the subject's costume. At around the same time that he began calling it *The Fur Jacket*, Whistler was working on two portraits of his sister-in-law Ethel Philip named for the model of evening dress she wore—*Mother of Pearl and Silver: The Andalusian* (see fig. 92) and *Rose et or: La Tulipe* (ca. 1894, Hunterian Art Gallery, University of Glasgow). It was also in the 1890s that he began to give his paintings titles, or subtitles, referring to an article of clothing or an accessory, for example, *The Rose Scarf; Harmony in Brown: The Felt Hat; Green and Gold: The Little Green Cap; The Little Red Glove; The Jade Necklace; Blue and Coral: The Little Blue Bonnet; Violet and Blue: The Red Feather;* and *The Black Hat—Miss Rosalind Birnie Philip*.

64. Bailey Van Hook discusses the significance of Whistler's impersonal titles in "Decorative Images of American Women," pp. 51–52. Among the countless Whistlerian paintings named in this fashion are Robert Blum, *The Blue Obi*, ca. 1890–1893; Alson Clark, *The Green Parasol*, 1906; William Merritt Chase, *The Kimono*, ca. 1895; Thomas Dewing, *The Palm Leaf Fan*, 1906; Frederick Frieseke, *The Green Sash*, 1904; and Hermann Dudley Murphy, *The Pink Sash*.

65. Merrill, *Pot of Paint*, p. 127.

66. Young et al., *Paintings of Whistler*, no. 181.

67. Morris, *Confessions in Art*, p. 45.

68. Alexander Reid to Whistler, July 11, 1894, GUL, Whistler R59.

69. William Burrell to Charles Lang Freer, September 4 and October 8, 1903, FGAA.

70. G. E. Francis to Elizabeth Pennell, August 10, 1903, PWC, box 283.

71. The correspondence with the Worcester Art Museum begins with a letter from Freer dated December 23, 1907, and continues through April 14, 1908 (FGAA, Letterbooks 23–24). The painting sent to Worcester was *Violet and Rose: Carmen qui rit* (ca. 1898), now in the Hunterian Art Gallery at the University of Glasgow.

72. Philip J. Gentner, director of the Worcester Art Museum, to H. Velten of Obach & Co., London dealers, September 24, 1909, copy, Worcester Art Museum Archives.

73. Gentner to William Macbeth, December 22, 1909, copy, Worcester Art Museum Archives.

74. From a review published in *Contributor's Magazine*, quoted in Kruty, "Eddy," p. 41.

75. Eddy to Whistler, November 20, 1894, GUL, Whistler E6.

76. Kruty, "Eddy," p. 41.

77. Eddy to Whistler, December 5 and 16, 1894, GUL, Whistler E7 and E8.

78. Elizabeth and Joseph Pennell write that the portrait was commissioned in 1893, but there is no evidence of their contact before 1894, when we know the portrait was painted (Pennell and Pennell, *Life of Whistler*, vol. 2, p. 156; see also Young et al., *Paintings of Whistler*, no. 425).

79. Eddy to Whistler, September 15 [1894], GUL, Whistler E4.

80. Eddy, *Recollections and Impressions*, p. 241.

81. Eddy to Whistler, October 4, 1895, GUL, Whistler E13.

82. Ibid., December 5 [1894], GUL, Whistler E7. Presumably, Eddy had the painting varnished before it was exhibited for the first time at the Boston Memorial Exhibition in 1904.

83. Ibid., September 15 [1894].

84. Ibid., November 20, 1894, GUL, Whistler E6a.

85. Ibid., December 3, 1897, GUL, Whistler E16.

86. Ibid., December 5 [1894].

87. Kruty, "Eddy," p. 43.

88. Eddy, *Cubists and Post-Impressionism*, pp. 13, 14.

89. Eddy, quoted in Kruty, "Eddy," p. 45.

90. De Kay, "Whistler," p. 1.

91. Young et al., *Paintings of Whistler*, no. 295. This painting appears to be in its original, Whistler-designed frame.

92. "The tiny panel is rather a favourite of mine" (Whistler to Humphrey Roberts, September 16, 1901, quoted in Young et al., *Paintings of Whistler*, no. 444). This painting appears to be in its original, Whistler-designed frame.

93. The alternate title is recorded in the object records of the Georgia Museum of Art. A letter in the museum files from the Reverend Paul Ayling to the director, Richard S. Schneiderman, January 27, 1986, speculates that the figure in the painting is the writer's grandmother, Lillian Staples Fredilis, whose father had been the barber in Lyme Regis: "Indeed, since she had the most beautiful flaming red hair, I would hazard a guess that the painter was more interested in the Barber's family than his shop!" John Siewert proposes that the model is Rosie Randall, *The Little Rose of Lyme Regis* (see fig. 17) (see Siewert, "From the Collection").

94. Freer to H. H. Benedict, November 26, 1901, quoted in Lawton and Merrill, *Freer*, p. 41.

95. A member of a prominent New England family, Lowell first published sonnets in the *Atlantic Monthly* in 1910. She eventually met Ezra Pound and is credited with bringing Imagist poetry to America.

96. The painting is undated, and the catalogue raisonné of Whistler's paintings assigns a date of circa 1898 (Young et al., *Paintings of Whistler*, no. 499). Amy Lowell's correspondence and reminiscences indicate, however, that she bought *Blue and Silver* from Whistler in the autumn of 1896 (see Damon, *Amy Lowell*, pp. 118–119).

97. Pennell journal, March 8, 1921, PWC, box 351. Although Lowell told the Pennells that Mrs. Heinemann had taken her to visit Whistler, William Heinemann did not marry until 1899.

98. Ibid.

99. Lowell, quoted in Damon, *Amy Lowell*, p. 119.

100. Pennell journal, March 8, 1921. Lowell told the Pennells that she paid Whistler six hundred pounds for the painting, but the letter from Whistler to Lowell indicates that she paid 120 guineas.

101. Whistler to Amy Lowell [1896], Houghton Library, Harvard University, Cambridge, Massachusetts. The present frame is not the original, but a replica Whistler-style frame acquired for the painting in 1971.

102. Downes, "Whistler and His Work," pp. 17–18.

103. Young et al., *Paintings of Whistler*, no. 537.

104. Pennell and Pennell, *Life of Whistler*, vol. 2, p. 259.

105. *Oils, Water Colors, Pastels and Drawings by James McNeill Whistler lent by Mr. Richard Canfield*, March 7–April 27, 1911, Fine Arts Academy, Albright Art Gallery, Buffalo.

106. Moore, "John White Alexander," pp. 36–37.

107. "How Whistler Posed for Alexander," p. 5994.

108. Elizabeth Alexander, interview by DeWitt M. Lockman, January 24, 1928, John White Alexander Papers, AAA, microfilm 1727, frame 148.

109. Unidentified clippings, Alexander Papers, AAA, microfilm 1729, frame 932.

110. Moore, "John White Alexander," p. 63.

111. Alexander to Col. Allen, July 16, 1884, Dordrecht, Holland, Alexander Papers, AAA, microfilm 1728, frame 326. See also Goley, "Alexander's *Panel for Music Room*," pp. 6–7. Alexander presumably was referring to the National Academy of Design's annual exhibition, though he had also exhibited with the Society of American Artists for the first time in 1884 (Moore, "John White Alexander," pp. 70–71).

112. Jan Ramirez, exhibition wall label, *Paintings and Drawings from the Permanent Collection, 1830–1910*, 1986, Hudson River Museum, Yonkers, New York. My thanks to Laura Vookles, Chief Curator of Collections, Hudson River Museum, for her assistance with this entry.

113. "Opening of the Exhibition at the American Art Galleries," *Brooklyn Daily Record*, November 8, 1885, Alexander Papers, AAA, microfilm 1729, frame 936. Goley first suggested the possible identification of *Azalea* as the portrait exhibited at the American Art Galleries (Goley, "Alexander's *Panel for Music Room*," p. 7; see also "At the American Galleries").

114. Alexander, "Whistler as We Knew Him," pp. 16–17. Alexander had also visited Whistler in England in 1886 while working on a series of portraits for *Century* magazine. Alexander's portraits from that year include a charcoal drawing of Whistler (see fig. 1) (Moore, "John White Alexander," p. 84).

115. Alexander, interview by Lockman, February 1, 1928, frame 166.

116. Alexander to E. E. Phelps, August 18, 1893, Seabright, New Jersey, Alexander Papers, AAA, microfilm 1728, frame 438. See also Moore, "John White Alexander," pp. 126, 136.

117. *Petit Parisien*, May 9, 1893; *Le Temps* (Paris), May 9, 1893; *Petit Havre*, May 19, 1893; A. Pallier, "Le Salon de 1893," *La Liberté*; and other unidentified clippings, Alexander Papers, AAA, microfilm 1729, frames 959–961, 964.

118. Alexander may have seen *Arrangement in Brown and Black: Portrait of Miss Rosa Corder* at the Champ-de-Mars Salon of 1891, which opened soon after he arrived in Paris (Moore, "John White Alexander," pp. 121–123).

119. Louis Fourcaud noted as much when he coined the phrase "le gris Whistler" (the gray Whistler) (ibid., p. 126).

120. Ibid., p. 131.

121. McSpadden, *Famous Painters of America*, p. 370. Alexander used especially absorbent canvases with a coarse weave, canvases that one fellow artist described as "sometimes hardly more than stained" (Blashfield, *Tribute to Alexander*, p. 8; and Moore, "John White Alexander," p. 131).

122. Moore, "John White Alexander," pp. 227–228.

123. McSpadden, *Famous Painters of America*, p. 357.

124. For the most recent and varied look at Beaux's art and life, see Leibold and Tappert, *Cecilia Beaux*.

125. The Mary Smith Prize was established in 1879 by the artistic patriarch Russell Smith at the request of his dying daughter, also a noted Philadelphia painter. It was given to the best work, regardless of subject, by a local woman artist in the Academy annual exhibition and carried a cash value of $100. Susan Macdowell (later Eakins) won the inaugural year, followed by such respected figures as Catherine Drinker Janvier—Beaux's distant relative and first art teacher—and Emily Sartain. Beaux herself received the award four times (in 1885, 1887, 1891, and 1892) (see Falk, *Exhibition Record of the Pennsylvania Academy*, vol. 2, p. 35).

126. Beaux, *Background with Figures*, pp. 87–88. At the Salon *Les Derniers jours* was, according to Beaux, "well hung on a center wall." Apparently this French validation encouraged her to complete her artistic training in Paris at the progressive Académie Julian (see ibid., p. 99).

127. Morris, *Confessions in Art*, p. 197. Whistler's name does not even appear in the index to Beaux's autobiography, *Background with Figures*, a publication that may be viewed as the artist's vehicle of self-construction at the end of her life. Sargent, alternatively, is frequently cited as a mentor and respected colleague. In another telling instance of denial, Beaux once wrote, apologetically, to William Sartain

regarding a newspaper review that identified her as a student of Eakins: "I am annoyed to see that what merit there is in [my work] should be accredited to the Academy and to Mr. Eakins. I owe very little to the Academy and nothing whatsoever to Eakins" (Beaux to Sartain, November 10, 1884, William Sartain scrapbooks, vol. 4, Archives of the Pennsylvania Academy of the Fine Arts).

128. Goodyear, *Cecilia Beaux*, p. 51. See also Morris, *Confessions in Art*, p. 197.

129. Genevieve Lacambre, "Whistler and France," in Dorment and MacDonald, *James McNeill Whistler*, p. 142.

130. Maureen O'Brien, "Edward August Bell," in Blaugrund, *Paris 1889*, p. 114.

131. "Tragedy of 'Lady in Gray.'"

132. Although not listed in the exhibition catalogue, Whistler's portrait of his mother is known to have been shown in Munich as *Der Künstler's Mutter* and awarded a second-class medal (Young et al., *Paintings of Whistler*, no. 101).

133. "Society of American Artists," 1890.

134. Bell to Nelson C. White, Nelson C. White Papers, AAA, microfilm 2807.

135. In a letter to his parents, Blum wrote that Whistler "is very busy making an etching from my window" (Blum Family Correspondence, June 27, 1880, quoted in Weber, "Robert Frederick Blum," p. 108).

136. Birnbaum, *Catalogue of a Memorial Loan Exhibition*, p. 9; and Weber, "Robert Frederick Blum," pp. 115, 126.

137. Birnbaum, *Catalogue of a Memorial Loan Exhibition*, p. 3.

138. Cook, "Water-Color Society's Exhibition," p. 75.

139. "Professors of Pastels."

140. Carol M. Osborne, "Lizzie Boott at Bellosguardo," in Jaffee, *Italian Presence in American Art*, pp. 188–195.

141. Ibid., p. 195.

142. Unidentified clipping, Frank Duveneck Papers, AAA, microfilm 1151, frame 654.

143. Ibid., frames 645–646, 648, 654.

144. Love, *Theodore Earl Butler*, pp. 415–416.

145. Butler to Philip L. Hale [July] 1894, Giverny, and Butler to Hale [1897], Philip L. Hale Papers, AAA, microfilm D-98, frames 702–705, 734.

146. Love, *Theodore Earl Butler*, pp. 264–265, 308; and Adelson Galleries, *American Impressionism and Realism*, no. 6.

147. Butler heard Monet reminisce of his earlier encounters with Whistler and recorded one of these in a letter to his friend Philip L. Hale (Butler to Hale [July] 1894, Hale Papers, AAA, microfilm D-98, frame 703). Monet had praised Whistler's work as early as 1887 in a letter to Durand-Ruel. One example of the close relationship between the two artists is Monet's condolence letter sent upon the death of Beatrix Whistler in which the artist called himself "an old friend" and reminded Whistler "how much I love you" (Monet to Durand-Ruel, Giverny, May 13, 1887, and Monet to Whistler, Giverny, May 18, 1896, in Wildenstein, *Claude Monet*, nos. 788, 1349 [author's translation]).

148. Butler to Hale, May 17, 1905, Giverny, Hale Papers, AAA, microfilm D-98, frame 779.

149. "I firmly believe," Chase continued, "the day will come when he will be classed with the best that ever was" (lecture notes and speeches, William Merritt Chase Papers, AAA, microfilm N69-137, frame 474).

150. Bienenstock, "Society of American Artists," p. 146 n. 35.

151. Gallati, *William Merritt Chase*, p. 28.

152. Peck and Irish, *Candace Wheeler*, pp. 174, 178. Chase had apparently encouraged his student to exhibit at the Society of American Artists' exhibition in 1880, as one critic noted: "The picture is exhibited by no will of hers, but by her teacher, Mr. Chase, who takes, as rumor runs, great pleasure in the promise of his clever pupil" ("Society of American Artists, Third Annual Exhibition").

153. Peck and Irish, *Candace Wheeler*, pp. 174–175. Others speculated that the tapestry behind Wheeler represents her own textile work, though it bears little resemblance to her extant designs (see Weinberg, Bolger, and Curry, *American Impressionism and Realism*, p. 41). The Venetian tapestry in Chase's studio (see fig. 96) included a circular motif representing "a horse and a griffin, as nearly as one can make out, struggling in a forest" and was perhaps the inspiration for the two feline creatures in *Dora Wheeler* (Moran, "Studio-Life in New York," p. 345).

154. Marling, "Miss Dora Wheeler," pp. 47, 56 n. 6.

155. *Dora Wheeler* won an honorable mention at the Salon, and later that year Chase sent it to the International Exhibition in Munich, where it received a gold medal (Peck and Irish, *Candace Wheeler*, p. 175 n. 5).

156. See, for example, Brownell, "American Pictures at the Salon," p. 494; and "Mr. Chase's Art." See also Bienenstock, "Society of American Artists," pp. 169–170.

157. Cikovsky in Dorment and MacDonald, *James McNeill Whistler*, pp. 34–35; and Marling, "Miss Dora Wheeler," p. 56 n. 6.

158. "Society of American Artists," 1884.

159. Gallati, *William Merritt Chase*, p. 31.

160. Chase's painting is also known as *Study of a Young Girl*, *Portrait* and *An Idle Moment* (A. Gerdts, *American Collection*, p. 78).

161. Ibid.

162. Chase and John Singer Sargent (see cats. 56–57) were the invited artists from the United States; Whistler, one of the invited artists from Britain.

163. A. Gerdts, *American Collection*, p. 78; and Ormond and Kilmurray, *John Singer Sargent*, p. 54.

164. Chase, "Two Whistlers," p. 220.

165. Chase to Whistler, September 3, 1885, GUL, Whistler C94: "My *only* thought in asking you to paint *me* was that you might feel perfect liberty to do as you like."

166. "William M. Chase and Whistler"; and Whistler to Chase [September 1/3, 1885], quoted in Roof, *Life and Art of Chase*, p. 141.

167. See Chase to Alice Gerson, July 5 and August 8, 1885, William Merritt Chase Papers, AAA, microfilm N69-137.

168. Young et al., *Paintings of Whistler*, no. 322.

169. Mortimer Menpes showed the photograph to Joseph Pennell on November 16, 1906 (Pennell journal, PWC, box 353).

170. Chase to Gerson, August 8, 1885.

171. Chase, "Two Whistlers," p. 222.

172. Pisano, *Leading Spirit in American Art*, p. 82.

173. Chase, "Two Whistlers," p. 219.

174. Review by "Mahlstick" in *Society*, July 18, 1885, cited in Nigel Thorp, "Studies in Black and White: Whistler's Photographs in Glasgow University Library," in Fine, *James McNeill Whistler*, p. 93.

175. At least one contemporary critic made this connection, writing that Chase's portrait of Whistler was "painted in the murky, gloomy manner characteristic of Whistler's 'Sarasate'" ("My Notebook"). Chase had painted his own portrait of Pablo de

Sarasate (*Portrait of a Violinist*) around 1875 (Los Angeles County Museum of Art).

176. Chase to Gerson, August 8, 1885; and Whistler to Chase [September 1/3, 1885], in Roof, *Life and Art of Chase*, p. 142.

177. "New York and Vicinity." On caricatures and portraits of Whistler, see Denker, *In Pursuit of the Butterfly*.

178. Chase, "Two Whistlers," p. 220.

179. Whistler to Chase [September 1/3, 1885], in Roof, *Life and Art of Chase*, p. 141; and Chase to Gerson, August 8, 1885.

180. Whistler to Chase [September 1/3, 1885], in Roof, *Life and Art of Chase*, p. 141.

181. Chase to Whistler, September 3, 1885.

182. Whistler to an unknown correspondent, letter published in "Whistler Coming to America" and later reprinted as "Nostalgia" in Whistler, *Gentle Art*, pp. 184–185.

183. Milgrome, "Art of Chase," p. 77.

184. Pennell journal, July 23, 1906, PWC, box 353.

185. "Boston Estimate of New York Painter."

186. "William M. Chase Exhibition."

187. Chase, "Two Whistlers," p. 223.

188. Whistler to Beatrix Whistler [June 11, 1891], in Thorp, *Whistler on Art*, no. 44, p. 122.

189. "Museum to Get a Whistler," *American Art News*, December 8, 1917, PWC, box 199; and letter from M. T. Buel, October 19, 1937, Metropolitan Museum of Art Archives, cited in D. Burke, *Catalogue of Works*, p. 84.

190. Pennell to Henry McBride, December 22, 1917, published in "News and Comment."

191. Weber to Henry McBride, February 19, 1918, published in "Mr. Pennell, Mr. Weber, Mr. Chase, Mr. Whistler," *New York Sun*, March 10, 1918, William Merritt Chase vertical file, Thomas J. Watson Library, Metropolitan Museum of Art, New York.

192. Gallati, *Chase: Modern American Landscapes*, pp. 38–39, 51, 87.

193. Chase recalled going to an exhibition with Whistler, probably the *Sixty-Second Annual Exhibition* of the Society of British Artists, on display from March until August 1885, though Chase mistakenly remembered seeing Nocturnes there (Chase, "Two Whistlers," p. 219).

194. Ives, "Suburban Sketching Grounds," p. 80.

195. "Notes on Mr. Wm. M. Chase's Criticism at the Studio— Shinnecock Hills Art School, 1892," Reynolds Beal Papers, AAA, microfilm 286.

196. Ives, "Suburban Sketching Grounds," p. 80. See also Gallati, *Chase: Modern American Landscapes*, p. 87.

197. Gallati, *William Merritt Chase*, p. 33.

198. Moran, "Studio-Life in New York," p. 345.

199. Gallati, *William Merritt Chase*, p. 50; and Bryant, *William Merritt Chase*, p. 114.

200. Chase is known to have owned a work titled simply *Portrait*, which he lent to the *Seventy-Third Annual Exhibition* of the Pennsylvania Academy of the Fine Arts in 1904. He also owned a pastel of a nude and a painting called *The Cello Player*, both of which were sold at auction (Mitchell Kennerley, The Anderson Galleries, New York, to J. Pennell, January 12, 1920, PWC, box 290; and unidentified clipping, William Merritt Chase vertical file, Thomas J. Watson Library, Metropolitan Museum of Art).

201. Emmet began her studies in Paris at the Académie Julian, alongside her sister Rosina and Dora Wheeler (see cat. 22). Back in New York, she studied with Chase at the Art Students League and worked for Associated Artists, the textile design firm recently reopened by Candace Wheeler. She later assisted Chase during his summers at the Shinnecock School of Art, where from 1891 to 1893 she taught the "preparatory" class (Gallati, *William Merritt Chase*, pp. 104–106; and Peck and Irish, *Candace Wheeler*, p. 228 n. 1).

202. Joaneath Spicer has found this pose prevalent within Dutch companion portraits in which the man points his elbow out toward the audience of the painting (Spicer, "The Renaissance Elbow," in Bremmer and Roodenburg, *Cultural History of Gesture*, pp. 84–128).

203. Huntington, *Quest for Unity*, p. 97.

204. Carr et al., *Revisiting the White City*, p. 186.

205. Pennell journal, Monday, July 23 [1906], PWC, box 353.

206. The painting has traditionally been dated circa 1899, when Alice would have been twelve years old. Robin Jaffee Frank discusses Chase's tendency to "accelerate" Alice's maturity in *A Private View*, pp. 33–35.

207. There is an early photograph of the painting in the Chase Archives at the Parrish Art Museum, Southampton, New York, and a caricature of the work in its original state is reproduced in an article on the Society of American Fakirs, students from the Art Students League who parodied paintings shown at the Society of American Artists (see "Fakes and Fakirs," p. 320). Ronald Pisano made the discovery in 1977 (Pisano to Judith Zilczer, October 18, 1977, Hirshhorn Museum and Sculpture Garden Archives).

208. Pisano noted its Whistlerian aspect and described it as an "ensemble in white" (Pisano, *William Merritt Chase*, p. 38).

209. Crawford, "Gentler Side of Mr. Whistler," pp. 388–390.

210. Retif, "E. Stetson Crawford"; and Whistler to Mrs. Addams [September 1899] and [October 2, 1899], GUL, Whistler A37, A42.

211. Crawford's colophon consists of a C and an S with a coronet on top (Retif, "E. Stetson Crawford").

212. Crawford, "Gentler Side of Mr. Whistler," pp. 387–388.

213. Ibid., p. 390.

214. Retif, "E. Stetson Crawford."

215. Arleen Pancza, "Leon Scott Dabo (1865–1960)," in Sweeney, *Artists of Michigan*, pp. 155–156, 199 nn. 14–15. Dabo remembered that his father "at intervals had corresponded with Whistler" (Dabo to Armand Griffith, Director of The Detroit Institute of Arts, July 14, 1905, Leon Dabo Papers, AAA, microfilm 677, frame 911). Dabo referred to himself as Whistler's pupil, but no documents have been found to support his assertion. Perhaps his relationship with Whistler was a brief, informal one, since Dabo later recalled that "being [Whistler's] pupil meant sweeping his studio, going out for vermilion and paying for the tube without being reimbursed" (Gimpel, *Diary of an Art Dealer*, p. 327). Pancza's essay amends the birth dates of both Leon Dabo and his brother, Theodore (see cat. 31).

216. Sweeney, *American Painting*, p. 100.

217. This photograph of Dabo in his studio appeared in Amelia Von Ende, "The Art of Leon Dabo," *The Sketch Book* (November 1907), p. 278, as reproduced in the Leon Dabo

Papers, AAA, microfilm D-388, frame 1569. The Boldini portrait, dated 1897, is now in the Brooklyn Museum.

218. Pancza in Sweeney, *Artists of Michigan*, p. 156; and unidentified exhibition catalogue of paintings attributed to Whistler, Art Reference Library, Albright-Knox Art Gallery, Buffalo.

219. Leon Dabo to Armand Griffith, June 10 and July 14, 1905, Leon Dabo Papers, AAA, microfilm 677, frames 906, 908–911; and Von Ende, "Art of Leon and Theodore Scott Dabo," pp. 13–14.

220. Pancza in Sweeney, *Artists of Michigan*, pp. 155, 159.

221. Philip L. Hale, "'Dabo?' or I Will Take?," *Boston Herald*, unidentified clipping in PWC, box 199 (1909).

222. Leon Dabo to Griffith, June 10 and November 21, 1905, Leon Dabo Papers, AAA, microfilm 677, frames 906, 912.

223. Von Ende, "Art of Leon and Theodore Scott Dabo," p. 14.

224. F. W. Coburn, *Whistler and His Birthplace*, ed. by E. Burger and L. Cheney (Lowell, Mass.: Whistler House Museum of Art, 1988), copy in Whistler House Museum of Art, Lowell, Massachusetts.

225. Young et al., *Paintings of Whistler*, no. 101.

226. Pène du Bois, *Artists Say the Silliest Things*, p. 106.

227. Wuerpel, "Whistler—The Man," pp. 248–249.

228. The portrait undoubtedly held sentimental meaning for Davenport, since she made a replica of the copy to keep for herself. She eventually presented that second work to the Community of Zellwood, and it remains today in the Zellwood Historical Society, Museum, and Library.

229. Hobbs, "Thomas Wilmer Dewing," pp. 13–14, 24.

230. Hobbs, *Art of Dewing*, p. 6.

231. Dewing, "Abbott Thayer," p. vii.

232. Hobbs, *Art of Dewing*, pp. 13, 23. Whistler's influence on Dewing's pastels, too, has often been noted. Shortly after a large group of Whistler's pastels were exhibited in 'Notes'—'Harmonies'—'Nocturnes' (H. Wunderlich & Co., March 1889), Dewing began his first works in the medium. Charles Lang Freer, the artist's major patron, encouraged Dewing in this enterprise by providing for him the type and size of colored paper that Whistler used (p. 199).

233. "Union League Exhibition."

234. Quick, *American Portraiture*, p. 214.

235. Hobbs, *Art of Dewing*, pp. 122–123.

236. Ibid., p. 41. The painting is in a frame designed by Stanford White.

237. Ibid., p. 124. In November, Dewing and Freer visited the artist's studio as well as galleries, and they hosted a dinner in his honor. See also Merrill, *With Kindest Regards*, pp. 20–21, 97–103.

238. Freer to Tryon, December 9, 1894, typescript, quoted in Lawton and Merrill, *Freer*, p. 171.

239. Dewing to Robert Macbeth, February 17, 1919, typescript, Macbeth Gallery Papers, AAA microfilm NMc42, frame 556.

240. Dewing to White, February 14 [1895], quoted in Hobbs, *Art of Dewing*, p. 124; and Dewing to White, October 12 and December 1, 1894, quoted in Hobbs, "Thomas Dewing in Cornish," p. 19.

241. Burns, "Poetic Mode in American Painting," p. 250. Frederick MacMonnies was a sculptor who taught at Whistler's Académie Carmen during its first year. Following his stay in London, Dewing moved to Paris and rented a studio near MacMonnies's own. Soon the two artists began to commute to Giverny together four days each week (Hobbs, *Art of Dewing*, pp. 25–26;

and H. Barbara Weinberg, "Frieseke's Art before 1910," in Kilmer and McWhorter, *Frederick Carl Frieseke*, p. 59).

242. Hobbs, *Art of Dewing*, p. 33. *The Lange Lijzen* appeared in the Goupil album of photographs, *Nocturnes, Marines & Chevalet Pieces*, published in 1892. Perhaps discussing the Goupil portfolio, Dewing wrote to Freer at Christmas in 1893, "The Whistler photographs are beautiful. We have looked at them constantly" (Dewing to Freer, December 26, 1893, Freer Papers, AAA, microfilm 4721, frame 976).

243. Hobbs, *Art of Dewing*, pp. 23, 37.

244. Dewing to Freer, February 16 [1901], Freer Papers, AAA, microfilm 4721, frame 1148.

245. Freer to John Gellatly, March 30, 1904, Freer Papers, AAA, microfilm 4736, frame 842.

246. Childe Hassam, interview by DeWitt M. Lockman, February 2, 1927, New-York Historical Society, DeWitt Lockman Papers. My thanks to Margaret Heilbrun, Vice President, Library Services, for her assistance with the Lockman Papers. See also Barilleaux and Beck, *G. Ruger Donoho*, pp. 20–21, 25, 29, 32, 43 n. 1; and Pisano, *G. Ruger Donoho*, n.p.

247. Barilleaux and Beck, *G. Ruger Donoho*, pp. 34–35.

248. Donoho would have seen Whistler's self-portrait in 1883 at the *Exposition Internationale de Peinture, Deuxième Année*, at the Galerie Georges Petit in Paris (Young et al., *Paintings of Whistler*, no. 122).

249. Barilleaux and Beck, *G. Ruger Donoho*, p. 35.

250. Royal Cortissoz, "Ruger Donoho and Some Others: An Artist Made Better Known Since His Death," *New York Tribune*, November 1916, Macbeth Gallery Papers, AAA, microfilm NMc2, frame 354.

251. Ibid.

252. Goodrich, *Thomas Eakins*, vol. 2, p. 15.

253. Eakins may have seen Whistler's portrait for the first time at the Carnegie Institute, which purchased the work in 1896. Eakins served as a juror for the Carnegie Institute's International Exhibitions for five years beginning in 1899 (Siegl, *Thomas Eakins Collection*, p. 44).

254. Ibid., pp. 161–162; and Goodrich, *Thomas Eakins*, vol. 2, pp. 83, 86.

255. Sewell, *Thomas Eakins*, p. 93. According to his friend Leslie Miller, Eakins loved music and "he used to say that what he liked especially was to *see* the men play" (Goodrich, *Thomas Eakins*, vol. 2, p. 83).

256. Strazdes, "Thomas Eakins at the Carnegie."

257. Goodrich, *Thomas Eakins*, vol. 2, p. 270.

258. Fullerton, *Hugh Ramsay*, p. 88.

259. Kilmer and McWhorter, *Frederick Carl Frieseke*, pp. 21, 61, 120–121. It was just the beginning of honors for Frieseke, whose *Before the Mirror (Nude)* entered the Musée du Luxembourg three years later.

260. Ibid., pp. 83, 89, 121.

261. MacChesney, "Frieseke." The painting's date is based upon the list of titles exhibited in 1912 at Frieseke's one-man show at the Macbeth Galleries in New York.

262. Smith, *Lillian Mathilde Genth*, pp. 6–8.

263. *First Memorial Exhibition of Paintings by Lillian Genth, A.N.A.* (Bronxville Public Library, Bronxville, 1958), Lillian Genth Papers, AAA, microfilm 3090, frame 137.

264. Caffin, "American Studio Talk," p. cxxvi.

265. *First Memorial Exhibition of Paintings by Lillian Genth, A.N.A.*; and "Lillian Genth Goes to Paint Siam King," *New York City Post*, September 15, 1931, Genth Papers, AAA, microfilm 3090, frame 16.

266. Thomas Whipple Dunbar, "The Art of Lillian Genth, An Appreciation," unidentified clipping, Genth Papers, AAA, microfilm 3090, frames 19–20.

267. Fred Hogue, "Women and Art," *Los Angeles Times*, January 20, 1930, Genth Papers, AAA, microfilm 3090, frame 131.

268. W. Gerdts and Santis, *William Glackens*, pp. 13–15; and Danly, *Light, Air, and Color*, p. 17.

269. Armstrong, "Representative Young Illustrators," p. 109.

270. Glackens, *William Glackens and the Eight*, pp. 29–30; and Zurier, Snyder, and Mecklenburg, *Metropolitan Lives*, pp. 193, 202.

271. W. Gerdts and Santis, *William Glackens*, p. 54; and Zurier, Snyder, and Mecklenburg, *Metropolitan Lives*, p. 193.

272. W. Gerdts and Santis, *William Glackens*, p. 57; and "Society of American Artists," 1905. For another comparison between Glackens and Whistler, see "Six Impressionists."

273. Strazdes, *American Paintings and Sculpture*, pp. 202–205.

274. Thomas Seltzer, "A Jewish Artist," *Jewish Criterion*, October 23, 1903, p. 3, quoted in Youngner, *Power and the Glory*, n.p.

275. Strazdes, *American Paintings and Sculpture*, p. 204.

276. Ibid., pp. 203–205; and Youngner, *Power and the Glory*, n.p.

277. A. Gerdts, *American Collection*, p. 110.

278. Harrison, "'Mood' in Modern Painting," p. 1015.

279. Ibid., p. 1017; and Harrison, "Appeal of the Winter Landscape," p. 193.

280. W. Gerdts, *Impressionist New York*, p. 50.

281. "Picturesqueness of New York Streets," p. 398.

282. Borgmeyer, "Birge Harrison," p. 599.

283. Harrison, "'Mood' in Modern Painting," pp. 1015–1016.

284. Harrison, "Appeal of the Winter Landscape," p. 195.

285. Burns, "Poetic Mode in American Painting," p. 263.

286. Harrison, *Landscape Painting*, pp. 53–54.

287. Severens, *Charleston Renaissance*, p. 52. For Whistler's memory painting, see Dorment and MacDonald, *James McNeill Whistler*, pp. 120–121.

288. Borgmeyer, "Birge Harrison," p. 604.

289. Hassam to J. Alden Weir, July 17, 1903, Lyme, Connecticut, transcript, Childe Hassam Papers, American Academy of Arts and Letters, New York, AAA, microfilm NAA-2, frame 67.

290. Hassam to Carlo Beuf, May 27, 1927, Hassam Papers, American Academy of Arts and Letters, New York.

291. Adelson, Cantor, and Gerdts, *Childe Hassam*, pp. 233–235.

292. Ibid., p. 29.

293. Ibid., p. 235. Hassam, alongside his friends Weir and Twachtman, and together with Thomas Dewing, Edmund Tarbell, Frank Benson, Joseph Rodefer DeCamp, Willard Metcalf, Robert Reid, and Edward Simmons, formed the Ten American Painters, an influential exhibition society that set itself in competition with the National Academy of Design and the Society of American Artists in New York.

294. "The Fine Arts: Watercolor Drawings by Childe Hassam at Doll & Richards's," unidentified clipping, Hassam Papers, American Academy of Arts and Letters, New York, AAA, microfilm NAA-1, frame 490. See also Clark, "Childe Hassam," p. 174; and Royal Cortissoz, "The Traits of the Late Childe Hassam," *Herald Tribune* (New York), October, p. 10, undated clipping, Hassam Papers, AAA, microfilm NAA-1, frame 607.

295. Hassam to Weir, August 12, 1903, Appledore House, transcript, Hassam Papers, American Academy of Arts and Letters, New York, AAA, microfilm NAA-2, frame 68.

296. A. Meyer, "City Picture," p. 139.

297. Hassam, interview by DeWitt M. Lockman, February 2, 1927, New-York Historical Society, DeWitt Lockman Papers.

298. Hoopes, *Childe Hassam*, p. 74.

299. Whistler to Charles W. Deschamps [January 8, 1884], PWC, box 1.

300. Henri, "New York Exhibition of Independent Artists," p. 161.

301. Henri to his parents, Mr. and Mrs. Richard H. Lee, February 18, 1897, quoted in Homer, *Robert Henri and His Circle*, p. 87.

302. Alice Klauber manuscript, 1912, in Perlman, *Robert Henri*, p. 140.

303. The earliest reference to Whistler in Henri's diaries is a mention of Whistler's lithographs on view in Paris (Robert Henri diary, February 22, 1897, Robert Henri Papers, Mrs. Janet Le Clair, AAA, microfilm 885, frame 670). Henri later recounted the story of a colleague's encounter with Whistler in the Louvre (Henri diary, August 13, 1898, frames 690–691).

304. Henri, "Practical Talk to Those Who Study Art."

305. Henri to his parents, June 1899, quoted in Perlman, *Robert Henri*, p. 43.

306. One critic proclaimed that Henri was "largely indebted" to the famous expatriate (unidentified clipping, Macbeth Gallery Papers, Scrapbook 1902–1910, AAA, microfilm NMc1, frame 19). See also Pène du Bois, "Robert Henri," p. 215; Cole, "American Artists in Paris," p. 200; Isham, *History of American Painting*, p. 506; "Six Impressionists"; and "Robert Henri and Others." One critic compared the physique of the two artists: "Robert Henri is as much of an eccentricity in appearance as was 'Jimmy' Whistler" ("Robert Henri," p. 590). Reviews from the exhibition of The Eight mentioned Whistler as one of many influences on the eight artists and especially on Henri (unidentified clippings, Macbeth Gallery Papers, AAA, microfilm NMc1, frames 144a, 145a).

307. Barrell, "Robert Henri," p. 1430.

308. Documentation files, Milwaukee Art Museum.

309. Albert Herter to Adele McGinnis, New York, April 19, 26, and May 5, 1892, Adele McGinnis and Albert Herter Papers, 1882–1946, AAA, microfilm 2543, frames 1430–1431, 1452–1454, 1475; and Berry-Hill Galleries, *American Paintings V*, p. 106.

310. Inspired by Herter's eclectic borrowing from East and West, one critic wrote a recipe for painting Herters: "Take l'art Japonaise—much Frenchified, / And borrowing motives far and wide, / Mix well the decorative arts / From Greece and Rome, in equal parts" ("American Studio Talk," p. vi).

311. Rochefort, "Salon in the Champ de Mars."

312. Fink, *American Art*, p. 356.

313. Herter, "Story of Koto," in *Dubious Lineage*, p. 64.

314. Curran, "Herter Looms"; and de Kay, "Albert Herter."

315. Beam, *Homer at Prout's Neck*, p. 205.

316. John W. Beatty, "Recollections of an Intimate Friendship," in Goodrich, *Winslow Homer*, p. 213.

317. Dressed in black and turned in profile to the left, de Kay rests her hands in her lap and occupies a shallow, sparsely decorated space. Whistler did have photographs taken of his mother's portrait soon after its completion; it is possible that Homer had access to those through Helena's brother, the writer Charles de Kay, whose novel *The Bohemian*, published in 1878, documents

an early awareness of Whistler's work (Cikovsky and Kelly, *Winslow Homer*, pp. 122–123; and Young et al., *Paintings of Whistler*, no. 101).

318. Cikovsky and Kelly, *Winslow Homer*, p. 374.

319. Ibid., pp. 373, 376 n. 28; and Beam, *Homer at Prout's Neck*, pp. 126–127.

320. B. Robertson, *Reckoning with Winslow Homer*, pp. 58–59.

321. Tucker, *John H. Twachtman*, p. 8.

322. Hill and Hill, *Ernest Lawson*, p. 20; and Peters, *John Henry Twachtman*, p. 107.

323. This correspondence is summarized in Hill and Hill, *Ernest Lawson*, p. 20.

324. Leeds, *Ernest Lawson*, pp. 19–21, 111.

325. The full title was *Moonlight, Harlem River* (Passantino and Scott, *Eye of Duncan Phillips*, p. 345). My thanks to Joseph Holbach and Randy Hunt, The Phillips Collection, for their assistance with this entry.

326. Henry Cavendish, "Lawson, Noted American Painter, Now Visiting Miami, Says He Plays with Colors As Composer with Tones," *Herald*, undated clipping, Margaret Bensco Papers, AAA, microfilm 1788, frame 1026. The critic James Huneker, too, spoke of Lawson's painting using a Whistlerian vocabulary. "The color" of Lawson's *River in Winter* (1907, unlocated), he wrote, "is symphonic" (unidentified clipping, *Sun*, February 4, 1907, Bensco Papers, AAA, microfilm 1788, frame 1052; and Leeds, *Ernest Lawson*, pp. 18–19).

327. Karpiscak, *Ernest Lawson*, p. 8; and Leeds, *Ernest Lawson*, p. 111.

328. Cahill, "Ernest Lawson and His America," p. 72.

329. Jones, *Mathews*, pp. 13–22.

330. Mathews spent part of the summer of 1898 in London (ibid., p. 22). He may have also seen the reproduction of *La Princesse* in the *Art Journal* from August of that year. For a full exhibition and publication history, see Young et al., *Paintings of Whistler*, no. 50.

331. Jones, *Mathews*, p. 33.

332. Ibid., pp. 49, 60.

333. Ibid., pp. 83–85.

334. McCausland, *A. H. Maurer*, pp. 41, 51; and Madormo, "Early Career of Maurer," pp. 6–8.

335. Madormo, "Early Maurer Works." See also McCausland, *A. H. Maurer*, pp. 63–64.

336. For a summary of the work's history, see Epstein, *Alfred H. Maurer*, p. 17. *An Arrangement* won first prize at the Carnegie Institute's annual exhibition and established Maurer's reputation as a rising young American painter. When later writers attempted to chart the course of Maurer's career, *An Arrangement* became the key example of his early Whistlerian period (McCausland, *A. H. Maurer*, pp. 67, 217; and Mellquist, *Emergence of an American Art*, p. 176).

337. McCausland, *A. H. Maurer*, p. 67.

338. Ibid., p. 108.

339. Morrell, "Hermann Dudley Murphy," p. 54.

340. Ibid., p. 53; and Coles, *Hermann Dudley Murphy*, pp. 7–10.

341. Whistler's painting was shown at the Goupil Gallery in 1892 and again in 1895 (Young et al., *Paintings of Whistler*, no. 122).

342. Mosby, Sewell, and Alexander-Minter, *Henry Ossawa Tanner*, p. 38; and Mathews, *Henry Ossawa Tanner*, p. 98. Tanner rented this studio from 1895 until 1904.

343. "At the Art Institute," *Chicago News*, October 25, 1896, Art Institute of Chicago Scrapbooks, vol. 2, documentation files, Art Institute of Chicago.

344. Coles, *Hermann Dudley Murphy*, pp. 7, 10–11. See also Brandt, "'All Workmen, Artists, and Lovers of Art': The Organizational Structure of the Society of Arts and Crafts, Boston," in M. Meyer, *Inspiring Reform*, pp. 53–54.

345. "Hermann Dudley Murphy," p. 167; and Coles, *Hermann Dudley Murphy*, p. 21.

346. Ramsdell, "Charles Rollo Peters," pp. 207–208.

347. Ibid.

348. Browne, "Alexander Harrison." Alexander Harrison was the brother of Birge Harrison (see cats. 41–42).

349. Hailey, *California Art Research*, pp. 118–119.

350. Young et al., *Paintings of Whistler*, no. 169.

351. Ramsdell, "Charles Rollo Peters," p. 208.

352. Jones, *Twilight and Reverie*, p. 10.

353. "Week in Art"; and Ramsdell, "Charles Rollo Peters," pp. 205–212. See also *Art Amateur* 42 (December 1889), p. 4. Gabriel Paulin noted the preponderance of "moonlights" among the work of American artists in Paris in 1899 (Paulin, "Exhibition of the American Art Association").

354. "Exhibitions," p. 407.

355. Corn, *Color of Mood*, p. 11.

356. Jones and Haley, *Granville Redmond*, pp. 1, 5–8, 14, 103–106.

357. Ibid., p. 104.

358. Ibid., p. 106.

359. A. V. Ballin, "Granville Redmond, Artist," *The Silent Worker* (November 1925), p. 90, quoted in ibid., p. 30. Chaplin collected Redmond's work, and the artist himself appeared in a few bit parts in Chaplin's films.

360. Remington to Al Brolley, December 8 [1909], in Splete and Splete, *Remington—Selected Letters*, pp. 434–435. Special thanks to Nancy Anderson for reading a draft version of this entry.

361. Remington diary, March 19, 1908, Frederic Remington Art Museum.

362. Nemerov, *Remington & Turn-of-the-Century America*, p. 44. A diary entry from March 24, 1909, suggests that Remington may have been reading about Whistler's wit: "Whistlers [*sic*] talk was light as air and the bottom of a cook stove was like his painting" (Remington diary, Frederic Remington Art Museum).

363. Ibid., January 16, 1908.

364. Young et al., *Paintings of Whistler*, no. 166.

365. Hassam to Weir, July 7, 1906, transcript, Hassam Papers, American Academy of Arts and Letters, New York, AAA, microfilm NAA-2, frame 72. See also Samuels and Samuels, *Frederic Remington*, pp. 379, 431–432.

366. Hassrick, *Remington: Paintings, Drawings, and Sculpture*, p. 32; and Thomas, "Recollections of Remington," p. 357.

367. Cortissoz, "Frederic Remington," p. 186.

368. Remington diary, January 19, 1908, Frederic Remington Art Museum.

369. Hassrick, *Remington: Late Years*, p. 40. On the romantic aspect of Remington's late work, see Nemerov, *Remington & Turn-of-the-Century America*, pp. 45–47.

370. Charteris, *John Sargent*, p. 21.

371. In the 1860s, Sargent's teacher Carolus-Duran had associated with the Realist circle of artists that included Whistler, Henri Fantin-Latour, and Edouard Manet. In the novel

Grave Impudence (1880), the critic Philippe Burty, an early supporter of Manet and Carolus-Duran, described Whistler as the infamous artist of *The White Girl* and one of the originators of the Impressionist movement (Burty, *Grave Impudence*, pp. 84–85; see also Geneviève Lacambre, "Whistler and France," in Dorment and MacDonald, *James McNeill Whistler*, pp. 41, 45).

372. Merrill, *Pot of Paint*, p. 153.

373. One of Sargent's American colleagues in Paris, J. Alden Weir, heard of the lawsuit in August 1877, at the time of his first visit to Whistler's studio (D. Young, *Life and Letters of Weir*, p. 133). By July 1879, Whistler's pamphlet about the trial was already in its seventh edition. See also Lacambre in Dorment and MacDonald, *James McNeill Whistler*, p. 45.

374. Kilmurray and Ormond, *John Singer Sargent*, p. 74.

375. Ibid.; and Volk, *Sargent's "El Jaleo,"* pp. 25, 146, 150.

376. Kilmurray and Ormond, *John Singer Sargent*, p. 74.

377. Olson, *John Singer Sargent*, p. 128.

378. Pennell and Pennell, *Whistler Journal*, p. 34.

379. Whistler to Sargent [1889], GUL, Whistler S22; and Sargent to Whistler, December 13 [1892], and November 1 [1897], S29, S30, S34.

380. For reviews from the 1880s, see Simpson, *Uncanny Spectacle*, pp. 46, 54, 143–145, 150.

381. W. Robertson, *Time Was*, p. 236.

382. C. Phillips, "Fine Art," p. 407.

383. E. Pennell, "Royal Academy," p. 419; "Royal Academy"; Michel, "Salons de 1896"; Michel, "Paris Salons," p. 784; Adam, "Salons de 1896," pp. 5, 11–12; Haras, "Royal Academy, London"; and Slade, "Royal Academy of Arts." See also Jordan, "Sargent's Images of Artists," pp. 135–160.

384. Robertson had met Whistler in 1890 after purchasing two of his paintings at auction: *Crepuscule in Flesh Colour and Green: Valparaíso* (1866, Tate Britain) and *Arrangement in Brown and Black: Portrait of Miss Rosa Corder* (ca. 1878, Frick Collection) (W. Robertson, *Time Was*, p. 188).

385. Caffin, "Art of Eduard J. Steichen," p. 34.

386. Goley, *From Tonalism to Modernism*, pp. 2–3.

387. Niven, *Steichen*, p. 47; and Cookman, "Steichen's Self-Portraits," p. 65.

388. Niven, *Steichen*, p. 92; and Homer, "Steichen as Painter and Photographer," pp. 47–48.

389. Homer, "Steichen as Painter and Photographer," p. 49.

390. Ibid., p. 53; and Goley, *From Tonalism to Modernism*, p. 9.

391. Caffin, "Art of Eduard J. Steichen," p. 34.

392. Mosby, Sewell, and Alexander-Minter, *Henry Ossawa Tanner*, pp. 35–41, 142. See also Arauz, "Identity and Anonymity," p. 50. Tanner likely saw Whistler's Mother for the first time at the Pennsylvania Academy of the Fine Arts in Philadelphia in 1881.

393. Mosby, Sewell, and Alexander-Minter, *Henry Ossawa Tanner*, p. 142; and documentation files, Philadelphia Museum of Art.

394. Arauz, "Identity and Anonymity," p. 54.

395. For biographical details of Tanner's career, see Kathleen James and Sylvia Yount, "Chronology," in Mosby, Sewell, and Alexander-Minter, *Henry Ossawa Tanner*, pp. 35–53.

396. Torchia, *American Paintings*, p. 198.

397. Mosby, Sewell, and Alexander-Minter, *Henry Ossawa Tanner*, p. 132.

398. Torchia, *American Paintings*, pp. 196–198.

399. Strickler, Docherty, and Hirshler, *Impressionism Transformed*, pp. 20–21.

400. "Degas, Bazille, Whistler . . . were among his favorite painters," recalled Maurice Goldberg, director of the Doll & Richards Gallery (Pierce, *Tarbell and the Boston School*, pp. 17, 232 n. 3).

401. Buckley, *Edmund C. Tarbell*, pp. 37–38.

402. "Academy of Design."

403. Buckley, *Edmund C. Tarbell*, pp. 93–94. Examples include *A Girl Crocheting* (ca. 1905, Canajoharie Library and Art Gallery) and *A Girl Mending* (ca. 1906, Indiana University Art Museum).

404. Tarbell also produced a painting titled *The Golden Screen* (ca. 1898, Pennsylvania Academy of the Fine Arts).

405. Buckley, *Edmund C. Tarbell*, p. 95.

406. Peters, *John Henry Twachtman*, pp. 21–26, 46, 174–175 n. 18.

407. Peters, "Twachtman and the American Scene," p. 228 n. 73. The exact date of Twachtman's arrival in Paris, however, is unknown.

408. Ibid., pp. 217–218.

409. Twachtman to Weir, December 16, 1891, Weir Family Papers, Harold B. Lee Library Archives, Brigham Young University, Provo, Utah (MSS 41), reproduced in Peters, "Twachtman and the American Scene," p. 545.

410. Peters, *John Henry Twachtman*, p. 123.

411. Bacher, *With Whistler in Venice*, p. 29.

412. Cournos, "John H. Twachtman," p. 246.

413. *Boston Sunday Herald*, October 26, 1902, Everett L. Warner Archives, courtesy of Thomas Warner.

414. My thanks to Thomas Warner for his contributions to this entry.

415. Fusscas, *World Observed*, pp. 9–13.

416. Cox, "Art of Whistler," p. 480.

417. Fusscas, *World Observed*, pp. 9, 14; and *Boston Sunday Herald*, October 26, 1902, Warner Archives, courtesy of Thomas Warner.

418. Danly, *Light, Air, and Color*, p. 84.

419. Warner was in Europe until late in 1905 (Fusscas, *World Observed*, p. 42).

420. Childe Hassam, "Reminiscences of Weir," in D. Phillips et al., *Julian Alden Weir*, p. 72.

421. Weir to his parents, August 22, 1877, London, in D. Young, *Life and Letters of Weir*, p. 133.

422. D. Burke, *J. Alden Weir*, pp. 293–295.

423. D. Young, *Life and Letters of Weir*, p. 193. Weir subscribed to Whistlerian printmaking methods, such as using old papers cut close to the image (Getscher, *Stamp of Whistler*, p. 161).

424. D. Young, *Life and Letters of Weir*, pp. 146–147; and D. Phillips et al., *Julian Alden Weir*, p. 72. William Merritt Chase relates the same story in "Two Whistlers," p. 223. Weir's copy of Velázquez's *Philip IV* may be the work now housed at the Museum of Fine Arts, Brigham Young University, Provo, Utah.

425. The lower right-hand section of this photograph shows the broad outline of Whistler's back and walking stick. Other photographs with similar poses include one taken by H. S. Mendelssohn in 1886 (frontispiece). Weir's interest in photographs of Whistler continued for some time after this painting; he wrote to Whistler in 1901, asking for a

photograph like the one Whistler had given to Claude Monet (Weir to Whistler, December 30, 1901, GUL, Whistler W286).

426. Theodore Robinson diary, November 10, 1893, Frick Art Reference Library, New York. My thanks to Mariko Iida, Reference Associate, Frick Art Reference Library, for her assistance with this document.

427. D. Burke, *J. Alden Weir*, p. 216.

428. Rhode Island School of Design, *American Paintings*, pp. 189, 190 n. 21.

429. Weir might also have known *The Music Room* from the Goupil portfolio of photographs published in 1892.

430. Torchia, *American Paintings*, pp. 230–232.

431. Weir wrote in February 1904 after seeing the Whistler Memorial Exhibition in Boston, "I think him a master of the first rank. I was talking to Pinkey [Ryder] about him who seemed very much inclined to patronize him. I think it is simply that he does not know his work. One eccentric man never likes another" (D. Young, *Life and Letters of Weir*, p. 221).

432. Lerner, *Hirshhorn Museum and Sculpture Garden*, p. 758.

433. T., "'The Ten's' Annual Show."

434. Wetherill was enrolled at the Pennsylvania Academy of the Fine Arts from 1894 to 1898, then later in the drawing class, from 1906 to 1909. My thanks to Cheryl Leibold, Archivist, for providing this information about Wetherill's studies at the Academy. See also Getscher, *Stamp of Whistler*, p. 266.

435. Dorment and MacDonald, *James McNeill Whistler*, p. 121.

436. Danly, *Light, Air, and Color*, p. 89.

Bibliography

Manuscript Collections

Archives of American Art. Smithsonian Institution, Washington, D.C. John White Alexander Papers. Otto Bacher Papers. Reynolds Beal Papers. Margaret Bensco Papers. Chapellier Gallery Papers. William Merritt Chase Papers. Copley Society Records. Leon Dabo Papers. Frank Duveneck Papers. Lillian Genth Papers. Charles Lang Freer Papers. Philip L. Hale Papers. Childe Hassam Papers. Robert Henri Papers. Adele McGinnis and Albert Herter Papers. Macbeth Gallery Papers. Nelson C. White Papers.

Freer Gallery of Art Archives. Smithsonian Institution, Washington, D.C. Charles Lang Freer Papers.

Glasgow University Library, Scotland. Special Collections. James McNeill Whistler Papers, comprising the Rosalind Birnie Philip Papers and the Joseph W. Revillon Papers.

Library of Congress, Washington, D.C. Manuscript Division, Pennell Whistler Collection, comprising the papers of Joseph Pennell, Elizabeth Robins Pennell, and James McNeill Whistler.

Publications and Dissertations

"Academy of Design." *New York Evening Post,* April 3, 1894, p. 7.

Adam, Paul. "Les Salons de 1896." *Gazette des Beaux-Arts* 16 (July 1, 1896), pp. 5–35.

Adelson, Warren, Jay E. Cantor, and William H. Gerdts. *Childe Hassam: Impressionist.* New York: Abbeville, 1999.

Adelson Galleries. *American Impressionism and Realism.* New York: Adelson Galleries, 2001.

Alexander, Elizabeth. "Whistler as We Knew Him." In "Whistler Memorial Program." *The American Magazine of Art,* supplement 27, part 2 (September 1934), pp. 12–19.

"The American Artists' Exhibition." *Art Amateur* 6 (May 1882), pp. 114–115.

"American Studio Talk." *International Studio* 3 (February 1898), pp. v–viii.

Anderson, Ronald, and Anne Koval. *James McNeill Whistler: Beyond the Myth.* London: John Murray, 1994.

Andrews, William W. *Otto H. Bacher.* 1935. Reprint, Madison, Wisconsin: Education Industries, 1973.

Arauz, M. Rachel. "Identity and Anonymity in Henry Ossawa Tanner's *Portrait of the Artist's Mother.*" *Rutgers Art Review* 19 (2001), pp. 37–57.

Armstrong, Regina. "Representative Young Illustrators: Third Paper." *Art Interchange* 43 (March 1899), pp. 106–109.

"Art Lectures at the Albright Gallery." *Academy Notes* (Buffalo) 4 (March 1909), p. 176.

"Art Notes," *Art Interchange* 20 (May 19, 1888), pp. 161–162.

"Art Notes." *Brush and Pencil* 3 (November 1898), p. 126.

"Art Notes." *Illustrated London News,* June 18, 1904, p. 932.

"The Artist who Sued Ruskin." Letter to the editor of the *New York Semi-Weekly Tribune,* December 26, 1878, p. 3.

"At the American Galleries." *New York Times,* November 20, 1885, p. 4.

Bacher, Otto. "With Whistler in Venice, 1880–1886." *Century* 73 (December 1906), pp. 207–218.

———. *With Whistler in Venice.* New York: Century, 1908.

Baldry, A. L. "James McNeill Whistler. His Art and Influence." *Studio* 29 (September 1903), pp. 237–245.

Baldwin, M. "Whistler Memorial Exhibition." *New England Magazine,* May 1904, pp. 291–292.

Barilleaux, René Paul, and Victoria J. Beck. *G. Ruger Donoho: A Painter's Path.* Jackson: Mississippi Museum of Art, 1995.

Barrell, Charles Wisner. "Robert Henri—'Revolutionary,'" *Independent,* June 25, 1908, pp. 1427–1432.

Beam, Philip C. *Winslow Homer at Prout's Neck.* Boston: Little, Brown, 1966.

Beaux, Cecilia. *Background with Figures.* New York: Houghton Mifflin, 1930.

Bell, Lynne. "Fact and Fiction." Ph.D. diss., University of East Anglia, 1987.

Belloc, Marie Adelaide. "Lady Artists in Paris." *Murray's Magazine* 8 (September 1890), pp. 371–384.

Benson, E. M. *John Marin: The Man and His Work.* Washington, D.C.: American Federation of Arts, 1935.

Berry-Hill Galleries. *American Paintings V.* New York: Berry-Hill Galleries, 1988.

Bienenstock, Jennifer A. Martin. "The Formation and Early Years of the Society of American Artists." Ph.D. diss., City University of New York, 1983.

Birnbaum, Martin. *Catalogue of a Memorial Loan Exhibition of the Works of Robert Frederick Blum.* New York: Berlin Photographic Company, 1913.

Blashfield, Edwin H. *Commemorative Tribute to John White Alexander.* New York: American Academy of Arts and Letters, 1922.

Blaugrund, Annette. *Paris 1889: American Artists at the Universal Exposition.* Philadelphia: Pennsylvania Academy of the Fine Arts, 1989.

Boime, Albert. *The Academy and French Painting in the Nineteenth Century.* New Haven: Yale University Press, 1971.

Bolger, Doreen, Mary Wayne Fritzsche, Jacqueline Hazzi, Marjorie Shelley, Gail Stavitsky, Mary L. Sullivan, Marc Vincent, and Elizabeth Wylie. *American Pastels in the Metropolitan Museum of Art.* New York: Metropolitan Museum of Art, 1989.

Borgmeyer, Charles Louis. "Birge Harrison—Poet Painter." *Fine Arts Journal* 29 (1913), pp. 582–606.

"A Boston Estimate of a New York Painter." *Art Interchange,* December 4, 1886, p. 179.

Bremmer, Jan, and Herman Roodenburg, eds. *The Cultural History of Gesture.* Ithaca: Cornell University Press, 1991.

Brinton, Christian. "Whistler and Inconsequence." *Critic* 38 (January 1901), p. 32.

———. "Whistler from Within." *Munsey's Magazine* 36 (October 1906), pp. 3–20.

Brown, Rollo Walter. *Lonely Americans.* New York: Coward-McCann, 1929.

Browne, Charles Francis. "Alexander Harrison—Painter." *Brush and Pencil* 4 (June 1899), p. 143.

Brownell, W. C. "Whistler in Painting and Etching." *Scribner's Monthly* 18 (August 1879), pp. 481–495.

———. "American Pictures at the Salon." *Magazine of Art* 6 (1883), pp. 492–501.

———. "The Paris Exposition: Notes and Impressions." *Scribner's Magazine* 7 (January 1890), pp. 18–35.

Bryant, Keith L., Jr. *William Merritt Chase: A Genteel Bohemian.* Columbia: University of Missouri Press, 1991.

Bryson, John, ed. *Dante Gabriel Rossetti and Jane Morris: Their Correspondence.* Oxford: Oxford University Press, 1976.

Buckley, Laurene. *Edmund C. Tarbell: Poet of Domesticity.* New York: Hudson Hills, 2001.

Burke, Carolyn. *Becoming Modern: The Life of Mina Loy.* New York: Farrar, Straus and Giroux, 1996.

Burke, Doreen Bolger. *A Catalogue of Works by Artists Born between 1846 and 1864.* Vol. 3 of *American Paintings in the Metropolitan Museum of Art.* New York: Metropolitan Museum, 1980.

———. *J. Alden Weir: An American Impressionist.* Newark: University of Delaware Press, 1983.

Burns, Sarah. "The Poetic Mode in American Painting: George Fuller and Thomas Dewing." Ph.D. diss., University of Illinois at Urbana-Champaign, 1979.

———. "Old Maverick to Old Master: Whistler in the Public Eye in Turn-of-the-Century America." *American Art Journal* 22 (1990), pp. 28–49.

———. *Inventing the Modern Artist: Art & Culture in Gilded Age America.* New Haven: Yale University Press, 1996.

Burty, Philippe. *Grave Impudence.* Paris: Charpentier, 1880.

Caffin, Charles H. "American Studio Talk: Exhibition of the Society of American Artists." *International Studio* 19 (June 1903), pp. cxxiii–cxxvi.

———. "James McNeill Whistler." *International Studio* 20, supplement (September 1903), pp. clii–civi.

———. "The Art of Eduard J. Steichen." *Camera Work* 30 (April 1910), pp. 33–40.

Cahill, Holger. "Ernest Lawson and His America." *Shadowland* 6 (March 1922), pp. 23, 72.

Carr, Carolyn Kinder, Robert W. Rydell, Brandon Brame Fortune, and Michelle Mead. *Revisiting the White City: American Art at the 1893 World's Fair.* Washington, D.C.: National Museum of American Art and National Portrait Gallery, 1993.

Cartwright, Julia. "The Artist in Venice. I–III." *Portfolio* 15 (1884), pp. 17–22, 37–42, 45–48.

Catalogue of the First Annual Exhibition of the Philadelphia Society of Etchers. Philadelphia: Pennsylvania Academy of the Fine Arts, 1882.

Cather, Willa. *The World and the Parish: Willa Cather's Articles and Reviews, 1893–1902.* 2 vols. Edited by William M. Curtin. Lincoln: University of Nebraska Press, 1970.

Champney, Elizabeth W. "The Golden Age of Pastel." *Century* 43 (December 1891), pp. 264–274.

Charteris, Evan. *John Sargent.* New York: Scribner's, 1927.

Chase, William M. "The Two Whistlers: Recollections of a Summer with the Great Etcher." *Century* 80 (June 1910), pp. 218–226.

Child, Theodore. "American Artists at the Paris Exposition." *Harper's* 79 (September 1889), pp. 488–521.

Chitty, Susan. *Gwen John.* New York: Franklin Watts, 1987.

Cikovsky, Nicolai, Jr., and Franklin Kelly. *Winslow Homer.* Washington, D.C.: National Gallery of Art, 1995.

Clark, Eliot. "Childe Hassam." *Art in America* 8 (June 1920), pp. 172–180.

Cohen, Mildred Thayer. *Eliot Clark, 1883–1980, Artist, Scholar, World Traveler.* New York: Marbella Gallery, 1990.

Cole, Helen. "American Artists in Paris." *Brush and Pencil* 4 (July 1899), pp. 199–202.

Coles, William A. *Hermann Dudley Murphy (1867–1945).* New York: Graham Gallery, 1982.

Collier, Peter, and Robert Lethbridge, eds. *Artistic Relations: Literature and the Visual Arts in Nineteenth-Century France.* New Haven: Yale University Press, 1994.

Cook, Clarence. "The Water-Color Society's Exhibition." *Art Amateur* 6 (March 1882), pp. 72–76.

———. "The Painters in Pastel: A Noteworthy Little Display." *Springfield Republican,* June 27, 1888, p. 9.

Cookman, Claude. "Edward Steichen's Self-Portraits." *History of Photography* 22 (Spring 1998), pp. 65–71.

Corn, Wanda M. *The Color of Mood: American Tonalism, 1880–1910.* San Francisco: M. H. De Young Memorial Museum and California Palace of the Legion of Honor, 1972.

———. "Who Was Modern? Rethinking Artistic Practices, 1915–1945." Paper presented at "Defining American Modernism" symposium, Georgia O'Keeffe Museum, Santa Fe, July 2001.

Cortissoz, Royal. "Egotism in Contemporary Art." *Atlantic Monthly* 73 (May 1894), pp. 644–652.

———. "Whistler." *New York Tribune*, February 27, 1904, p. 9.

———. "Frederic Remington: A Painter of American Life." *Scribner's* 47 (February 1910), pp. 181–195.

———. *Art and Common Sense.* New York: Scribner's, 1913.

———. "The Field of Art." *Scribner's Magazine* 81 (March 1927), pp. 216–224.

Cournos, John. "John H. Twachtman." *Forum* 52 (August 1914), pp. 245–248.

Cox, Kenyon. "The Whistler Memorial Exhibition." *Nation* 78 (March 3, 1904), pp. 167–168.

———. "The Art of Whistler." *Architectural Record* 15 (May 1904), pp. 467–481.

———. "Whistler and 'Absolute Painting.'" *Scribner's Magazine* 35 no. 5 (May 1904), pp. 637–638.

———. *Old Masters and New: Essays in Art Criticism.* New York: Fox, Duffield, 1905.

Crawford, Earl Stetson. "The Gentler Side of Mr. Whistler: Reminiscences of a Pupil." *Reader* (Indianapolis) 2 (September 1903), pp. 387–390.

"Critic and Painter." *New York Tribune*, December 9, 1878, p. 4.

Cuneo, Cyrus. "Whistler's Academy of Painting: Some Parisian Recollections." *Pall Mall* 38 (November 1906), pp. 530–540.

Curran, Grace Wickham. "The Herter Looms." *Palette and Bench* 2 (March 1910), pp. 137–140.

Curry, David Park. *James McNeill Whistler at the Freer Gallery of Art.* Washington, D.C.: Freer Gallery of Art, 1984.

Damon, S. Foster. *Amy Lowell: A Chronicle, with Extracts from Her Correspondence.* Boston: Houghton Mifflin, 1935.

Danly, Susan. *Light, Air, and Color: American Impressionist Paintings from the Collection of the Pennsylvania Academy of the Fine Arts.* Philadelphia: Pennsylvania Academy of the Fine Arts, 1990.

de G. S., A. "James M'Neil [*sic*] Whistler." *New York Times*, April 6, 1879.

de Kay, Charles. "Whistler: The Head of the Impressionists." *Art Review* 1 (November 1886), pp. 1–3.

———. "Albert Herter." *Art and Progress* 5 (February 1914), pp. 130–137.

Denker, Eric. *In Pursuit of the Butterfly: Portraits of James McNeill Whistler.* Washington, D.C.: National Portrait Gallery, 1995.

Detroit Institute of Arts. *American Paintings in the Detroit Institute of Arts.* Vol. 2, *Works by Artists Born between 1816 and 1847.* New York: Hudson Hills Press, 1997.

Dewing, Maria Oakey. "Abbott Thayer—A Portrait and an Appreciation." *International Studio* 74 (August 1921), pp. vii–xiv.

Dorment, Richard, and Margaret F. MacDonald. *James McNeill Whistler.* London: Tate Gallery, 1994.

Downes, William Howe. "American Paintings in the Boston Art Museum." *Brush and Pencil* 6 (August 1900), pp. 204–205.

———. "Whistler the Colorist." *Boston Evening Transcript*, February 27, 1904, p. 20.

———. "Whistler and His Work." *National Magazine* (Boston) 20 (April 1904), pp. 15–18.

"Du Maurier and Whistler." *Munsey's Magazine* 12 (October 1894), pp. 8–11.

du Maurier, George. "Trilby." *Harper's Monthly Magazine* 88–89 (January–August 1894).

Duret, Théodore. *Histoire de J. McN. Whistler et de son oeuvre.* Paris: H. Floury, 1904.

Eddy, Arthur Jerome. *Recollections and Impressions of James A. McNeill Whistler.* Philadelphia: Lippincott, 1903.

———. *Cubists and Post-Impressionism.* Chicago: McClurg, 1914.

Epstein, Stacey B. *Alfred H. Maurer: Aestheticism to Modernism.* New York: Hollis Taggart Galleries, 1999.

"Exhibitions." *Arts for America* 8 (May 1, 1899), pp. 405–407.

"Fakes and Fakirs." *Century* 59 (December 1899), pp. 320–322.

Falk, Peter Hastings, ed. *The Annual Exhibition Record of the Pennsylvania Academy of the Fine Arts.* Vol 3. Madison, Connecticut: Sound View Press, 1989.

Fehrer, Catherine, Robert Kashey, and Elisabeth Kashey. *The Julian Academy, Paris 1868–1939.* New York: Shepherd Gallery, 1989.

Ferber, Linda S. *William Trost Richards: American Landscape & Marine Painter, 1833–1905.* Brooklyn: Brooklyn Museum, 1973.

Fetherolf, Grace Moser. *James Henry Moser, His Brush and His Pen.* Phoenix: Fetherolf, 1982.

Fildes, L. V. *Luke Fildes, R.A.* London: Michael Joseph, 1968.

"Fine Arts. The Royal Academy." *Spectator*, June 18, 1864, p. 711.

Fine, Ruth E. *Drawing Near: Whistler Etchings from the Zelman Collection.* Los Angeles: Los Angeles County Museum of Art, 1984.

———, ed. *James McNeill Whistler: A Reexamination.* Vol. 19 of *Studies in the History of American Art.* Washington, D.C.: National Gallery of Art, 1987.

Fink, Lois. *American Art at the Nineteenth-Century Paris Salons.* Washington, D.C.: National Museum of American Art, 1990.

Foster, Kathleen, and Cheryl Leibold. *Writing about Eakins: The Manuscripts in Charles Bregler's Thomas Eakins Collection.* Philadelphia: University of Pennsylvania Press, 1989.

Frank, Robin Jaffee. *A Private View: American Paintings from the Manoogian Collection.* New Haven: Yale University Art Gallery, 1993.

Fried, Michael. *Manet's Modernism or, The Face of Painting in the 1860s.* Chicago: University of Chicago Press, 1996.

Fullerton, Patricia. *Hugh Ramsay: His Life and Work.* Hawthorn, Victoria: Hudson Publishing, 1988.

Fusscas, Helen K. *A World Observed: The Art of Everett Longley Warner 1877–1963.* Old Lyme, Connecticut: Florence Griswold Museum, 1992.

Gallati, Barbara Dayer. *William Merritt Chase.* New York: Abrams in association with the National Museum of American Art, 1995.

———. *William Merritt Chase: Modern American Landscapes, 1886–1890.* Brooklyn: Brooklyn Museum of Art in association with Abrams, 1999.

Garb, Tamar. *Sisters of the Brush: Women's Artistic Culture in Late Nineteenth-Century Paris.* New Haven: Yale University Press, 1994.

Geffroy, Gustave. *La Vie artistique.* Vol. 2. Paris: H. Floury, 1897.

Gerdts, Abigail Booth. *An American Collection: Paintings and Sculpture from the National Academy of Design*. New York: National Academy of Design, 1989.

Gerdts, William H. *American Impressionism*. Seattle: Henry Art Gallery, University of Washington, 1980.

———. *Art across America: Two Centuries of Regional Painting, 1710–1920.* 3 vols. New York: Abbeville, 1990.

———. *Impressionist New York*. New York: Abbeville, 1994.

Gerdts, William H., and Jorge H. Santis. *William Glackens*. Fort Lauderdale: Museum of Art, Fort Lauderdale, 1996.

Getscher, Robert H. "Whistler and Venice." Ph.D. diss., Case Western Reserve University, 1970.

———. *The Stamp of Whistler*. Oberlin, Ohio: Allen Memorial Art Museum, Oberlin College, 1977.

Gimpel, René. *Diary of an Art Dealer*. Translated by John Rosenberg. London: Hodder and Stoughton, 1966.

Glackens, Ira. *William Glackens and the Eight: The Artists Who Freed American Art*. New York: Horizon Press, 1957.

Glazer, Lee. "Reopening the Whistler Question at the 1904 Memorial Exhibition." *The Whistler Review: Studies on James McNeill Whistler and Nineteenth-Century Art* 1 (1999), pp. 54–60.

Goley, Mary Anne. *From Tonalism to Modernism: The Paintings of Eduard J. Steichen*. Washington, D.C.: Federal Reserve Board, 1988.

———. "John White Alexander's *Panel for Music Room*." *Bulletin of the Detroit Institute of Arts* 64 (1989), pp. 4–15.

Goodrich, Lloyd. *Winslow Homer*. New York: Whitney Museum of American Art, 1944.

———. *Thomas Eakins*. 2 vols. Cambridge: Harvard University Press, 1982.

Goodyear, Frank. *Cecilia Beaux: Portrait of an Artist*. Philadelphia: Pennsylvania Academy of the Fine Arts, 1974.

Grant, Simon. "Whistler's Call to Arms." *Art News* (September 2001), p. 76.

Grant, Susan. "Whistler's Mother Was Not Alone: French Government Acquisitions of American Paintings, 1871–1900." *Archives of American Art Journal* 32 (1992), pp. 2–15.

Grieve, Alastair. *Whistler's Venice*. New Haven: Yale University Press, 2000.

Hailey, Gene, ed. *California Art Research*. Vol. 10, *Monographs*. San Francisco: Works Progress Administration, 1937.

Halperin, Joan Ungersma. *Félix Fénéon, Aesthete and Anarchist in Fin-de-siècle Paris*. New Haven: Yale University Press, 1988.

Haras, S. "The Royal Academy, London." *American Architect and Building News* 48 (June 22, 1895), p. 122.

Harrison, Birge. "The 'Mood' in Modern Painting." *Art and Progress* 4 (July 1913), pp. 1015–1020.

———. "The Appeal of the Winter Landscape." *Fine Arts Journal* 30 (April 1914), pp. 191–196.

———. *Landscape Painting*. Rev. ed. New York: Scribner's, 1923.

Hartmann, Sadakichi. *The Whistler Book*. Boston: L. C. Page, 1910.

Hassrick, Peter H. *Frederic Remington: Paintings, Drawings, and Sculpture in the Amon Carter Museum and the Sid W. Richardson Foundation Collections*. New York: Abrams, 1973.

———. *Frederic Remington: The Late Years*. Denver: Denver Art Museum, 1981.

Henderson, Helen W. *The Pennsylvania Academy of the Fine Arts and Other Collections of Philadelphia*. Boston: L. C. Page, 1911.

Hendy, Philip. *European and American Paintings in the Isabella Stewart Gardner Museum*. Boston: Gardner Museum, 1974.

Henri, Robert. "A Practical Talk to Those Who Study Art." *Philadelphia Sunday Press*, May 12, 1901, p. 6.

———. "The New York Exhibition of Independent Artists." *The Craftsman* 18 (May 1910), pp. 160–172.

Henry, Paul. *An Irish Portrait*. London: B. T. Batsford, 1951.

"Hermann Dudley Murphy. His Third Special Exhibition at the Albright Gallery." *Academy Notes* (Buffalo) 4 (March 1909), pp. 167–169.

Herter, Albert. *A Dubious Lineage: Short Stories*. San Francisco: Herter Studios, 1998.

Hill, Henry, and Sidney Hill. *Ernest Lawson: American Impressionist, 1873–1939*. Leigh-on-Sea, England: F. Lewis, 1968.

Hobbs, Susan A. "Thomas Wilmer Dewing: The Early Years, 1851–1885." *American Art Journal* 13 (Spring 1981), pp. 4–35.

———. "Thomas Dewing in Cornish, 1885–1905." *American Art Journal* 17 (Spring 1985), pp. 2–32.

———. *The Art of Thomas Dewing: Beauty Reconfigured*. Brooklyn: Brooklyn Museum, 1996.

Homer, William Innes. "Eduard Steichen as Painter and Photographer, 1897–1908." *American Art Journal* 6 (November 1974), pp. 45–55.

———. *Pictorial Photography in Philadelphia: The Pennsylvania Academy's Salons, 1898–1901*. Philadelphia: Pennsylvania Academy of the Fine Arts, 1984.

———. *Robert Henri and His Circle*. New York: Hacker Art Books, 1988.

Honour, Hugh, and John Fleming. *The Venetian Hours of Henry James, Whistler, and Sargent*. Boston: Little, Brown, 1991.

Hoopes, Donelson. *Childe Hassam*. New York: Watson-Guptill, 1988.

Hopkinson, Martin. *No Day without a Line: The History of The Royal Society of Painter-Printmakers 1880–1999*. Oxford: Ashmolean Museum, 1999.

Howells, William Dean. *A Hazard of New Fortunes*. 2 vols. New York: Harper, 1890.

"How Whistler Posed for John W. Alexander." *World's Work* 9 (March 1905), pp. 5993–5994.

Huneker, James Gibbons. *The Pathos of Distance*. New York: Scribner's, 1913.

Huntington, David C. *The Quest for Unity: American Art between World's Fairs 1876–1893*. Detroit: Detroit Institute of Arts, 1983.

Huysmans, J.-K. *Certains*. Paris: Tresse & Stock, 1889.

Ingram, Terry. "A Win for Yale." *Art News* (February 1995), p. 33.

Isham, Samuel. *The History of American Painting*. New York: Macmillan, 1905.

Ives, A. E. "Suburban Sketching Grounds: Talks with Mr. W. M. Chase, Mr. Edward Moran, Mr. William Sartain and Mr. Leonard Ochtman." *Art Amateur* 25 (September 1891), pp. 80–82.

Jackson, Louise W. "Mr. Whistler as a Teacher." *Brush and Pencil* 6 (April 1900), pp. 141–143.

Jaffee, Irma B., ed. *The Italian Presence in American Art 1860–1920*. New York: Fordham University Press, 1992.

"Jam at the Whistler Exhibition." *Boston Globe*, February 24, 1904, p. 5.

"James Abbott McNeill Whistler." *American Architect and Building News* 22 (November 26, 1887), pp. 258–259.

James, Henry. *The Painter's Eye: Notes and Essays on the Pictorial Arts*. Edited by John L. Sweeney. Madison: University of Wisconsin Press, 1989.

John, Augustus. *Autobiography*. London: Jonathan Cape, 1975.

Jones, Harvey L. *Mathews: Masterpieces of the California Decorative Style*. Santa Barbara: Peregrine Smith, 1980.

———. *Twilight and Reverie: California Tonalist Painting 1890–1930*. Oakland: Oakland Museum of California, 1995.

Jones, Harvey L., and Mary Jean Haley. *Granville Redmond*. Oakland: Oakland Museum of California, 1988.

Jordan, Lacey. "John Singer Sargent's Images of Artists in an International Context." Ph.D. diss., Emory University, 1999.

Karpiscak, Adeline L. *Ernest Lawson 1873–1939*. Tucson: University of Arizona Museum of Art, 1979.

Kennedy, Edward G. *The Etched Work of Whistler*. San Francisco: A. Wofsy, 1978.

Kennedy, S. B. *Paul Henry*. New Haven: Yale University Press, 2000.

Kilmer, Nicholas, and Linda McWhorter. *Frederick Carl Frieseke: The Evolution of an American Impressionist*. Savannah, Georgia: Telfair Museum of Art; Princeton, New Jersey: Princeton University Press, 2001.

Kilmurray, Elaine, and Richard Ormond, eds. *John Singer Sargent*. London: Tate Gallery, 1998.

Kling, Jean L. *Alice Pike Barney*. Washington, D.C.: National Museum of American Art, 1994.

Kobbé, Gustav. "An Epoch-Making Picture: Nocturne in Black and Gold—The Falling Rocket." *Lotus* 1 (April 1910), pp. 7–26.

Koehler, Sylvester R. *Exhibition of American Etchings*. 3rd ed. Boston: A. Mudge, 1881.

———. "Mr. Bacher's Venetian Etchings." *American Art Review* 2, no. 11 (1881), pp. 231–232.

Koval, Anne. *Whistler in His Time*. London: Tate Gallery, 1994.

Kruty, Paul. "Arthur Jerome Eddy and His Collection: Prelude and Postscript to the Armory Show." *Arts Magazine* 61 (February 1897), pp. 40–47.

Lawton, Thomas, and Linda Merrill. *Freer: A Legacy of Art*. Washington, D.C.: Freer Gallery of Art, 1993.

Leeds, Valerie Ann. *Ernest Lawson*. New York: Gerald Peters Gallery, 2000.

Leibold, Cheryl, and Tara Leigh Tappert, eds. *Cecilia Beaux: Philadelphia Artist*. Special issue of *Pennsylvania Magazine of History and Biography* 124 (July 2000).

Leja, Michael. "Art, Modernity, and Deception in New York, ca. 1900." Paper presented at "Defining American Modernism" symposium, Georgia O'Keeffe Museum, Santa Fe, July 2001.

Lerner, Abram, ed. *The Hirshhorn Museum and Sculpture Garden*. New York: Abrams, 1974.

Lewis, Lloyd, and Henry J. Smith. *Oscar Wilde Discovers America*. 1936. Reprint, New York: B. Blom, 1967.

Lochnan, Katharine A. *The Etchings of James McNeill Whistler*. Toronto: Art Gallery of Ontario; New Haven: Yale University Press, 1984.

Love, Richard H. *Theodore Earl Butler: Emergence from Monet's Shadow*. Chicago: Haase-Mumm, 1985.

Lovell, Margaretta. *Venice: The American View, 1860–1920*. San Francisco: Fine Arts Museums of San Francisco, 1984.

———. *A Visitable Past: Views of Venice by American Artists 1860–1915*. Chicago: University of Chicago Press, 1989.

Low, Will H. *A Chronicle of Friendships, 1873–1900*. New York: Scribner's, 1908.

———. *A Painter's Progress, Being a Partial Survey along the Pathway of Art in America and Europe*. 1910. Reprint, New York: Garland, 1977.

Lucas, E. V. *Edwin Austin Abbey, Royal Academician: The Record of His Life and Work*. 2 vols. New York: Scribner's, 1921.

MacChesney, Clara T. "Frieseke Tells Some of the Secrets of His Art." *New York Sun*, June 7, 1914, sec. 6, p. 7.

MacDonald, Margaret F. "Whistler: The Painting of the 'Mother.'" *Gazette des beaux-arts* 85 (February 1975), pp. 73–88.

———. *James McNeill Whistler: Drawings, Pastels, and Watercolours: A Catalogue Raisonné*. New Haven: Yale University Press, 1995.

———. *Palaces in the Night: Whistler in Venice*. Berkeley: University of California Press, 2001.

MacInnes, Margaret F. "Whistler's Last Years: Spring 1901—Algiers and Corsica." *Gazette des beaux-arts* 73 (May–June 1969), pp. 323–342.

Madormo, Nick. "The Early Career of Alfred Maurer: Paintings of Popular Entertainments." *American Art Journal* 15 (Winter 1983), pp. 4–34.

———. "Early Alfred Maurer Works Located on the West Coast." *American Art Journal* 18 (1986), pp. 75–77.

Mahey, John A. "The Letters of James McNeill Whistler to George A. Lucas." *Art Bulletin* 49 (September 1967), pp. 247–257.

Marling, Karal Ann. "Portrait of the Artist as a Young Woman: Miss Dora Wheeler." *Bulletin of the Cleveland Museum of Art* 65 (February 1978), pp. 46–57.

Mathews, Marcia M. *Henry Ossawa Tanner*. Chicago: University of Chicago Press, 1969.

Mauclair, Camille. *De Watteau à Whistler*. Paris: E. Fasquelle, 1905.

McCausland, Elizabeth. *A. H. Maurer*. New York: A. A. Wyn, 1951.

McSpadden, J. Walker. *Famous Painters of America*. New York: Dodd, Mead, 1916.

Mellquist, Jerome. *The Emergence of an American Art*. New York: Scribner's, 1942.

"Memorable Exhibition." *Boston Herald*, February 24, 1904, p. 5.

Menpes, Mortimer. *Whistler as I Knew Him*. London: Adam and Charles Black, 1904.

Meredith, Michael, ed. *More Than Friend: The Letters of Robert Browning to Katharine de Kay Bronson*. Waco, Texas: Armstrong Browning Library of Baylor University; Winfield, Kansas: Wedgestone Press, 1985.

Merrill, Linda. *A Pot of Paint: Aesthetics on Trial in Whistler v. Ruskin*. Washington, D.C.: Smithsonian Institution Press, 1992.

———. *The Peacock Room: A Cultural Biography*. Washington, D.C.: Freer Gallery of Art; New Haven: Yale University Press, 1998.

——, ed. *With Kindest Regards: The Correspondence of Charles Lang Freer and James McNeill Whistler, 1890–1903*. Washington, D.C.: Freer Gallery of Art and Smithsonian Institution Press, 1995.

Metropolitan Museum of Art. *Paintings in Oil and Pastel by James A. McNeill Whistler*. New York: Metropolitan Museum, 1910.

Meyer, Annie Nathan. "A City Picture: Mr. Hassam's Latest Painting of New York." *Art and Progress* 2 (March 1911), pp. 137–139.

Meyer, Marilee Boyd, ed. *Inspiring Reform: Boston's Arts and Crafts Movement*. Wellesley, Massachusetts: Wellesley College, 1997.

Michel, André. "Les Salons de 1896." *Journal des débats* (Paris), May 23, 1896, p. 2.

——. "The Paris Salons." *Athenaeum*, June 13, 1896, pp. 783–784.

Milgrome, David. "The Art of William Merritt Chase." Ph.D. diss., University of Pittsburgh, 1969.

Monroe, Lucy. "Chicago Letter." *Critic* 22 (May 27, 1893), pp. 351–352.

Moore, Sarah J. "John White Alexander (1856–1915): In Search of the Decorative." Ph.D. diss., City University of New York, 1992.

Moran, John. "Studio-Life in New York." *Art Journal* 41 (November 1879), pp. 343–345.

Morrell, Dora M. "Hermann Dudley Murphy." *Brush and Pencil* 5 (November 1899), pp. 49–57.

Morris, Harrison. *Confessions in Art*. New York: Sears Publishing, 1930.

Mosby, Dewey F., Darrell Sewell, and Rae Alexander-Minter. *Henry Ossawa Tanner*. Philadelphia: Philadelphia Museum of Art, 1991.

Moser, James Henry. "Art Topics." *Washington Post*, February 21, 1904, p. 10.

"Mr. Whistler's Personality." *Scribner's Monthly* 18 (August 1879), pp. 636–637.

"Mr. William M. Chase's Art." *Art Interchange* 12 (June 19, 1884), p. 148.

Mullikin, Mary Augusta. "Reminiscences of the Whistler Academy by an American Art Student." *International Studio* 25 (May 1905), pp. 237–241.

"My Notebook by Montezuma." *Art Amateur* 25 (August 1891), p. 48.

Nelson, Carolyn Querbes. "The Society of Painters in Pastel, 1884–1890." Master's thesis, University of Texas at Austin, 1983.

Nemerov, Alexander. *Frederic Remington & Turn-of-the-Century America*. New Haven: Yale University Press, 1995.

"News and Comment." *New York Sun*, December 30, 1917, p. 12.

Newton, Joy. "Whistler and La Société des Vingt." *Burlington Magazine* 143 (August 2001), pp. 480–488.

"New York and Vicinity." *New-York Commercial Advertiser*, March 8, 1889, p. 4.

Niven, Penelope. *Steichen: A Biography*. New York: Clarkson Potter Publishers, 1997.

"Notes." *Quartier Latin* 5 (October 1898), pp. 163–164.

"No Whistler Academy." *New York Times*, October 29, 1898, p. 727.

Olson, Stanley. *John Singer Sargent: His Portrait*. New York: St. Martin's, 1986.

O'Malley, Frank Ward. "Mr. Whistler and the Expatriated." *Catholic World* 69 (June 1899), pp. 340–344.

Ormond, Richard, and Elaine Kilmurray. *John Singer Sargent: Complete Paintings*. Vol. 1, *The Early Portraits*. New Haven: Yale University Press, 1998.

Passantino, Erika D., and David W. Scott, eds. *The Eye of Duncan Phillips: A Collection in the Making*. New Haven: Yale University Press, 1999.

"The Pastels of Edwin A. Abbey." *Scribner's Monthly* 18 (August 1879), pp. 135–147.

Pattison, E. F. S. "The Exhibition of the Royal Academy of Arts." *Academy* 3 (May 15, 1872), pp. 184–185.

Paulin, Gabriel. "Exhibition of the American Art Association of Paris." *Brush and Pencil* 4 (May 1899), p. 106.

Payne, George Henry. "A Living Old Master. Whistler Seen at Close Range." *Saturday Evening Post* 171 (February 25, 1899), pp. 552–553.

Peck, Amelia, and Carol Irish. *Candace Wheeler: The Art and Enterprise of American Design, 1875–1900*. New Haven: Yale University Press, 2001.

Pène du Bois, Guy. "Robert Henri—Realist and Idealist." *Arts and Decoration* 2 (April 1912), pp. 213–215, 230.

——. *Artists Say the Silliest Things*. New York: American Artists Group, 1940.

Pennell, Elizabeth Robins. *Nights: Rome, Venice in the Aesthetic Eighties; London, Paris in the Fighting Nineties*. London: Heinemann, 1916.

——[N. N., pseud.]. "The Royal Academy." *Nation* 60 (May 30, 1895), pp. 419–420.

Pennell, Joseph. "James McNeill Whistler." *North American Review* 177 (September 1903), pp. 378–384.

Pennell, Elizabeth Robins, and Joseph Pennell. *The Life of James McNeill Whistler*. 2 vols. Philadelphia: Lippincott, 1908.

——. *The Whistler Journal*. Philadelphia: Lippincott, 1921.

Pennington, Harper. "Artist Life in Venice." *Century* 69 (October 1902), pp. 835–842.

——. "The Whistler I Knew." *Metropolitan Magazine* 31 (March 1910), pp. 769–776.

Perlman, Bennard B. *Robert Henri: His Life and Art*. New York: Dover, 1991.

Peters, Lisa N. "John Twachtman (1853–1902) and the American Scene in the Late Nineteenth Century: The Frontier within the Terrain of the Familiar." Ph.D. diss., City University of New York, 1995.

——. *John Henry Twachtman: An American Impressionist*. Atlanta: High Museum of Art, 1999.

Phillips, Claude. "Fine Art: The Royal Academy, I." *Academy*, May 11, 1895, pp. 407–408.

Phillips, D., E. Carlsen, R. Cortissoz, C. Hassam, J. B. Millet, and H. de Rassloff. *Julian Alden Weir: An Appreciation of His Life and Works*. New York: Dutton, 1922.

"The Picturesqueness of New York Streets." *Craftsman* 13 (January 1908), pp. 397–399.

Pierce, Patricia Jobe. *Edmund C. Tarbell and the Boston School of Painting, 1889–1980*. Hingham, Massachusetts: Pierce Galleries, 1980.

Pilgrim, Dianne H. "The Revival of Pastels in Nineteenth-Century America." *American Art Journal* 10 (November 1878), pp. 43–62.

Pisano, Ronald G. *G. Ruger Donoho (1857–1916)*. New York: Hirschl & Adler, 1977.

——. *William Merritt Chase*. New York: Watson-Guptill, 1979.

——. *A Leading Spirit in American Art: William Merritt Chase, 1849–1916*. Seattle: Henry Art Gallery, University of Washington, 1983.

Poole, Emily. "The Etchings of Frank Duveneck." *Print Collector's Quarterly* 25 (October and December 1938), pp. 312–331, 447–463.

Pound, Ezra. "Patria Mia." In *Selected Prose*. New York: New Directions, 1973, p. 117. Originally published in *The New Age*, October 24, 1912.

"Professors of Pastels." *New York Times*, May 5, 1888, p. 4.

Quick, Michael. *American Portraiture in the Grand Manner: 1720–1920*. Los Angeles: Los Angeles County Museum of Art, 1981.

Ramsdell, F. W. "Charles Rollo Peters." *Brush and Pencil* 4 (July 1899), pp. 204–212.

Retif, Earl. "E. Stetson Crawford, American Etcher Abroad." *Journal of the Print World* 12 (Summer 1989), p. 25.

Rhode Island School of Design Museum of Art. *Selection VII: American Paintings from the Museum's Collection, c. 1800–1930*. Providence: Rhode Island School of Design Museum of Art, 1977.

Richardson, E. P. "Nocturne in Black and Gold: The Falling Rocket by Whistler." *Art Quarterly* 10 (Winter 1947), pp. 2–11.

"Robert Henri." *Broadway Magazine* 19 (February 1907), pp. 589–590.

"Robert Henri and Others." *New York Sun*, January 21, 1907, p. 6.

Robertson, Bruce. *Reckoning with Winslow Homer: His Late Paintings and Their Influence*. Cleveland: Cleveland Museum of Art, 1991.

Robertson, W. Graham. *Time Was*. London: Hamish Hamilton, 1945.

Rochefort, Henri. "Salon in the Champ de Mars." *New York Herald* (Paris), April 24, 1896, p. 6.

Roe, Sue. *Gwen John: A Painter's Life*. New York: Farrar, Straus and Giroux, 2001.

Roof, Katherine Metcalf. *The Life and Art of William Merritt Chase*. New York, 1917. Reprint, New York: Hacker Art Books, 1975.

Rose, Barbara. *American Art since 1900: A Critical History*. London: Thames and Hudson, 1967.

Rose, George B. "Whistler and His Influence." *Art World* 3 (October 1917), pp. 12–16.

"The Royal Academy." *Daily Telegraph* (London), May 20, 1895, p. 4.

Samuels, Peggy, and Harold Samuels. *Frederic Remington: A Biography*. Garden City, New York: Doubleday, 1982.

Schjeldahl, Peter. "Naked Punch: Tate Britain Celebrates Lucian Freud." *New Yorker* (July 8, 2002), pp. 72–74.

Schneider, Rona. "The American Etching Revival: Its French Sources and Early Years." *American Art Journal* 14 (Autumn 1982), pp. 40–65.

Scott, W. "Reminiscences of Whistler Continues. Some Venice Recollections." *Studio* 30 (November 1903), pp. 97–107.

Severens, Martha R. *The Charleston Renaissance*. Spartanburg, South Carolina: Saraland Press, 1998.

Sewell, Darrel. *Thomas Eakins: Artist of Philadelphia*. Philadelphia: Philadelphia Museum of Art, 1982.

Shinn, Earl [Edward Strahan, pseud.]. "Works of American Artists Abroad: The Second Philadelphia Exhibition." *Art Amateur* 6 (December 1881), pp. 4–6.

Sickert, Bernhard. *Whistler*. New York: Dutton, 1908.

Siegl, Theodor. *The Thomas Eakins Collection*. Philadelphia: Philadelphia Museum of Art, 1978.

Siewert, John. "From the Collection: *Rose and Red: The Barber's Shop, Lyme Regis*." *Georgia Museum of Art News* (Summer 1991), n.p.

———. "Suspended Spectacle: Whistler's *Falling Rocket* and the Nocturnal Subject." *Bulletin of the Detroit Institute of Arts* 69 (1995), pp. 37–48.

Simmons, Edward. *From Seven to Seventy: Memories of a Painter and a Yankee*. New York: Harper, 1922.

Simpson, Marc, with Richard Ormond and H. Barbara Weinberg. *Uncanny Spectacle: The Public Career of the Young John Singer Sargent*. New Haven: Yale University Press, 1997.

"Six Impressionists: Startling Works by Red-Hot American Painters." *New York Times*, January 20, 1904, p. 9.

Slade, R. Jope. "The Royal Academy of Arts, 1895." *Art Journal* 57 (June 1895), p. 179.

S[malley], G[eorge] W. "Mr. Whistler: His Entrance into the Luxembourg—His Place in England—His Place in the World of Art." *New York Daily Tribune*, January 17, 1892, p. 16.

Smart, Mary, with E. Adina Gordon. *A Flight with Fame: The Life and Art of Frederick MacMonnies (1863–1937)*. Madison, Connecticut: Sound View Press, 1996.

Smith, Todd D. *Lillian Mathilde Genth: A Retrospective*. Hickory, North Carolina: Hickory Museum of Art, 1990.

"Society of American Artists." *Independent*, June 12, 1884, p. 744.

"Society of American Artists." *New York Daily Tribune*, April 26, 1890, p. 7.

"Society of American Artists." *New York Evening Post*, March 27, 1905, p. 4.

Society of American Artists: Fourth Annual Exhibition. New York: Society of American Artists, 1881.

"Society of American Artists, Third Annual Exhibition, Second Notice." *New York Daily Tribune*, March 25, 1880, p. 5.

Spencer, Robin. "Whistler's 'The White Girl': Painting, Poetry and Meaning." *Burlington Magazine* 140 (May 1998), pp. 300–311.

———, ed. *Whistler: A Retrospective*. New York: Hugh Lauter Levin, 1989.

Splete, Allen P., and Marilyn D. Splete, eds. *Frederic Remington—Selected Letters*. New York: Abbeville, 1988.

Stern, Jean. *Alson S. Clark*. Los Angeles: Petersen Publishing, 1983.

Stratis, Harriet K., and Martha Tedeschi, eds. *The Lithographs of James McNeill Whistler*. Vol. 1 of *A Catalogue Raisonné*. Chicago: The Art Institute of Chicago in association with the Arie and Ida Crown Memorial, 1998.

Strazdes, Diana. "Thomas Eakins at the Carnegie: Private Ambition, Public Enigma." *Carnegie Magazine* 59 (January–February 1988), pp. 25–26.

———. *American Paintings and Sculpture to 1945 in the Carnegie Museum of Art*. New York: Hudson Hills, 1992.

Strickler, Susan, Linda J. Docherty, and Erica E. Hirshler. *Impressionism Transformed: The Paintings of Edmund C. Tarbell*. Hanover, New Hampshire: University Press of New England, 2002.

Sweeney, J. Gray. *American Painting*. Muskegon, Michigan: Muskegon Museum of Art, 1980.

———. *Artists of Michigan from the Nineteenth Century*. Muskegon, Michigan: Muskegon Museum of Art, 1987.

Swinth, Kirsten. *Painting Professionals: Women Artists and the Development of Modern American Art, 1870–1930*. Chapel Hill: University of North Carolina Press, 2001.

Symons, Arthur. "The Decadent Movement in Literature." *Harper's* 87 (November 1893), pp. 858–869.

T., J. B. "'The Ten's' Annual Show." *American Art News* 9 (March 25, 1911), p. 2.

Taubman, Mary. *Gwen John.* London: Scolar Press, 1985.

Tharp, Louise Hall. *Mrs. Jack: A Biography of Isabella Stewart Gardner.* New York: Peter Weed Books, 1965.

Thomas, Augustus. "Recollections of Frederic Remington." *Century* 86 (July 1913), pp. 354–361.

Thorp, Nigel. "Whistler and His Students at the Académie Carmen." *Journal of the Scottish Society for Art History* 4 (1999), pp. 42–47.

———, ed. *Whistler on Art: Selected Letters and Writings, 1849–1903, of James McNeill Whistler.* Manchester: Carcanet Press Limited, 1994.

Torchia, Robert Wilson, with Deborah Chotner and Ellen G. Miles. *American Paintings of the Nineteenth Century.* Vol. 2 of *The Collections of the National Gallery of Art Systematic Catalogue.* Washington, D.C.: National Gallery of Art; distributed by Oxford University Press, 1998.

"Tragedy of 'Lady in Gray' Revealed in Letter by Artist." *Memphis Commercial Appeal,* August 23, 1933.

"Trilbyana." *Critic* 25 (November 17, 1894), pp. 331–332.

Tucker, Allen. *John H. Twachtman.* New York: Whitney Museum of American Art, 1931.

Twenty-Fifth Annual Report of the Copley Society of Boston, with Lists of the Officials and Members, 1903–1904. Boston: Copley Society, 1904.

"The Union League Exhibition: American Figure Paintings." *New York Tribune,* February 14, 1890, p. 7.

Van Dyke, John C. "What Is All This Talk about Whistler?" *Ladies' Home Journal* 21 (March 1904), p. 10.

———. *American Painting and Its Tradition.* New York: Scribner's, 1919.

Van Hook, Bailey. "Decorative Images of American Women: The Aristocratic Aesthetic of the Late Nineteenth Century." *Smithsonian Studies in American Art* (Winter 1990), pp. 45–68.

Van Rensselaer, M. G. "Art Matters. The Water-Color Exhibition in New York." *Lippincott's Magazine* 29 (April 1882), pp. 417–420.

———. "American Etchers." *Century* 25 (February 1883), pp. 483–499.

———. "American Painters in Pastel." *Century* 29 (December 1884), pp. 204–210.

"Varied British Topics," *New York Times,* March 17, 1883, p. 2.

Volk, Mary Crawford. *John Singer Sargent's "El Jaleo."* Washington, D.C.: National Gallery of Art, 1992.

Von Ende, Amelia. "The Art of Leon and Theodore Scott Dabo." *Brush and Pencil* 17 (January 1906), pp. 3–14.

Way, Thomas R. *Memories of James McNeill Whistler, the Artist.* New York: John Lane, 1912.

———. "Whistler's Lithographs." *Print Collector's Quarterly* 3 (October 1913), pp. 277–309.

Weber, Bruce. "Robert Frederick Blum (1857–1903) and His Milieu." Ph.D. diss., City University of New York, 1985.

Wedmore, Frederick. "Mr. Whistler's Theories and Mr. Whistler's Art." *The Nineteenth Century* 6 (August 1879), pp. 334–343.

"The Week in Art." *New York Times Saturday Review,* November 11, 1899, p. 767.

Weinberg, H. Barbara. *The Lure of Paris: Nineteenth-Century American Painters and Their French Teachers.* New York: Abbeville, 1991.

Weinberg, H. Barbara, Doreen Bolger, and David Park Curry. *American Impressionism and Realism: The Painting of Modern Life, 1885–1915.* New York: Metropolitan Museum of Art, 1994.

Weintraub, Stanley. *Whistler: A Biography.* New York: Weybright and Talley, 1974.

Weisberg, Gabriel P., and Jane R. Becker, eds. *Overcoming All Obstacles.* New York: Dahesh Museum; New Brunswick: Rutgers University Press, 1999.

"A Whistle for Whistler." *Punch* 60 (June 17, 1871), p. 245.

Whistler, James McNeill. *The Gentle Art of Making Enemies.* 1892. Reprint, New York: Dover, 1967.

———. *Nocturnes, Marines and Chevalet Pieces.* London: Goupil Gallery, 1892.

"Whistler Coming to America." *New York Tribune,* October 12, 1886, p. 1.

"Whistler Exhibit Finest in Years." *Boston Transcript,* February 24, 1904, p. 7.

"The Whistler-MacMonnies School." *New York Times,* December 31, 1898, p. 882.

"Whistler Pictures Viewed." *Evening Transcript,* February 24, 1904, p. 7.

White, Barbara Ehrlich. "Renoir's Trip to Italy." *Art Bulletin* 51 (December 1969), pp. 333–351.

Wilde, Oscar. *Oscar Wilde: The Artist as Critic.* Edited by Richard Ellmann. Chicago: University of Chicago Press, 1969.

Wildenstein, Daniel. *Claude Monet: Biographie et catalogue raisonné.* Vol. 3. Paris: Bibliothèque des Arts, 1979.

"William M. Chase and His Friend Whistler." *Boston Herald,* March 28, 1911, p. 6.

"The William M. Chase Exhibition." *Art Amateur* 16 (April 1887), p. 100.

"The Winter Exhibition of Cabinet Pictures in Oil, Dudley Gallery." *Athenaeum* 70 (November 2, 1872), pp. 568–570.

Woods, Alice. *Edges.* Indianapolis: Bowen-Merrill, 1902.

Wuerpel, Edmund H. "Whistler—The Man." *American Magazine of Art* 27 (May–June 1934), pp. 248–253, 312–321.

Wylie, Elizabeth. *Explorations in Realism: 1870–1880: Frank Duveneck and His Circle from Bavaria to Venice.* Framingham, Massachusetts: Danforth Museum of Art, 1989.

Young, Andrew McLaren, Margaret MacDonald, and Robin Spencer, with Hamish Miles. *The Paintings of James McNeill Whistler.* 2 vols. New Haven: Yale University Press, 1980.

Young, Dorothy Weir. *The Life and Letters of J. Alden Weir.* Edited by Lawrence W. Chisolm. New Haven: Yale University Press, 1960.

Youngner, Rina. *The Power and the Glory: Pittsburgh Industrial Landscapes by Aaron Harry Gorson (1872–1933).* New York: Spanierman Gallery, 1989.

Yount, Sylvia, and Elizabeth Johns. *To Be Modern: American Encounters with Cézanne and Company.* Philadelphia: Pennsylvania Academy of the Fine Arts, 1996.

Zurier, Rebecca, Robert W. Snyder, and Virginia M. Mecklenburg. *Metropolitan Lives: The Ashcan Artists and Their New York.* New York: Norton, 1995.

Notes on Contributors

ROBYN ASLESON is a former Research Associate of the National Gallery of Art and of the Huntington Library, Art Collections, and Botanical Gardens. Her recent publications include a monograph on Whistler's associate Albert Moore (2000). She is also principal author of *British Paintings at The Huntington* (2001) and *Great British Paintings from American Collections: Holbein to Hockney* (2001). She has edited two studies of British theatrical painting: *A Passion for Performance: Sarah Siddons and Her Portraitists* (1999) and *Notorious Muse: The Actress in British Art and Culture, 1776–1812* (2003).

LEE GLAZER is an art historian based in Washington, D.C., specializing in turn-of-the-century American painting. She has published articles on Whistler and Romare Bearden and was the curator of *Choice Spirits: Works by Thomas Dewing and Dwight Tryon* at the Freer Gallery of Art (1996).

LACEY TAYLOR JORDAN received her Ph.D. from Emory University in 1999. She is preparing essays for publication based upon her dissertation, "John Singer Sargent's Images of Artists in an International Context."

LINDA MERRILL is the author of *The Peacock Room: A Cultural Biography* (1998), *A Pot of Paint: Aesthetics on Trial in Whistler v. Ruskin* (1992), and *An Ideal Country: Paintings by Dwight William Tryon in the Freer Gallery of Art* (1990); editor of *With Kindest Regards: The Correspondence of Charles Lang Freer and James McNeill Whistler* (1995); and coauthor, with Thomas Lawton, of *Freer: A Legacy of Art* (1993). Now an independent scholar, she was for many years curator of American art at the Freer Gallery in Washington and, more recently, at the High Museum in Atlanta.

JOHN SIEWERT is assistant professor at The College of Wooster, Ohio, where he teaches modern and contemporary art and architectural history. Among his publications are *Whistler: Prosaic Views, Poetic Vision* (1994), the catalogue for a touring exhibition of which he was co-curator; and "Whistler's Decorative Darkness" in *The Grosvenor Gallery: A Palace of Art in Victorian England* (1996).

MARC SIMPSON serves as the Associate Director of the Williams College Graduate Program in the History of Art, Williamstown, Massachusetts. While a curator at the Fine Arts Museums of San Francisco, he organized exhibitions on Winslow Homer (1988), Eastman Johnson (1990), William M. Harnett (1992, with Doreen Bolger and John Wilmerding), and William Stanley Haseltine (1992). More recently he organized *Uncanny Spectacle: The Public Career of the Young John Singer Sargent* (Clark Art Institute, 1997) and contributed to the catalogue *Thomas Eakins* (Philadelphia Museum of Art, 2001).

SYLVIA YOUNT is the Margaret and Terry Stent Curator of American Art at the High Museum. Prior to this she served as chief curator at the Pennsylvania Academy of the Fine Arts. Her exhibitions in Philadelphia for which she authored catalogues include *To Be Modern: American Encounters with Cézanne and Company* (1996) and *Maxfield Parrish, 1870–1966* (1999). She is currently organizing a traveling retrospective of the work of Cecilia Beaux, scheduled to open in Atlanta in 2005. She has lectured and published widely on late nineteenth- and twentieth-century American art and culture.

Lenders to the Exhibition

Albright-Knox Art Gallery, Buffalo, New York
The Art Institute of Chicago, Illinois
Brooklyn Museum of Art, New York
Carnegie Museum of Art, Pittsburgh, Pennsylvania
The Cleveland Museum of Art, Ohio
The Detroit Institute of Arts, Michigan
Federal Reserve Board, Washington, D.C.
Fine Arts Museums of San Francisco, California
Florence Griswold Museum, Old Lyme, Connecticut
Frederic Remington Art Museum, Ogdensburg, New York
Georgia Museum of Art, University of Georgia, Athens
Gilcrease Museum, Tulsa, Oklahoma
Marie and Hugh Halff
High Museum of Art, Atlanta, Georgia
Hirshhorn Museum and Sculpture Garden, Smithsonian Institution, Washington, D.C.
The Hispanic Society of America, New York
The Hudson River Museum, Yonkers, New York
Hunter Museum of American Art, Chattanooga, Tennessee
Isabella Stewart Gardner Museum, Boston, Massachusetts
Kristy Stubbs Gallery, Dallas, Texas
The Louise and Alan Sellars Collection of Art by American Women, Indianapolis, Indiana
Mr. and Mrs. Allen P. McDaniel
Memphis Brooks Museum of Art, Memphis, Tennessee
The Metropolitan Museum of Art, New York
Milwaukee Art Museum, Minnesota
Musée d'Orsay, Paris
Museum of Art, Fort Lauderdale, Florida
Museum of Art, Rhode Island School of Design, Providence

Museum of Fine Arts, Boston, Massachusetts
Museum of the City of New York
National Academy of Design, New York
National Gallery of Art, Washington, D.C.
The New Britain Museum of American Art, Connecticut
Oakland Museum of California
The Parrish Art Museum, Southampton, New York
Pennsylvania Academy of the Fine Arts, Philadelphia
Philadelphia Museum of Art, Pennsylvania
The Phillips Collection, Washington, D.C.
Jean and Glenn Verrill
Terra Foundation for the Arts, Daniel J. Terra Collection, Chicago, Illinois
Tom Veilleux Gallery, Farmington, Maine
Whistler House Museum of Art, Lowell, Massachusetts
Whitney Museum of American Art, New York
Worcester Art Museum, Massachusetts
Yale Center for British Art, New Haven, Connecticut

Illustrations are indicated by the use of *italic* type.

Whistler oil paintings are identified in the index by the catalogue number (Y) in Young et al., *Paintings of Whistler*; pastels, drawings, and watercolors, by the catalogue number (M) in MacDonald, *Whistler: Drawings, Pastels, Watercolours*; etchings, by the title and catalogue number (K) in Kennedy, *Etched Work of Whistler*; and lithographs, by the title and catalogue number (C) in Stratis and Tedeschi, *Lithographs of Whistler*.